3 1994 01328 9464

SANTA ANA PUBLIC LIBRARY

D0635874

Watercolour Landscapes

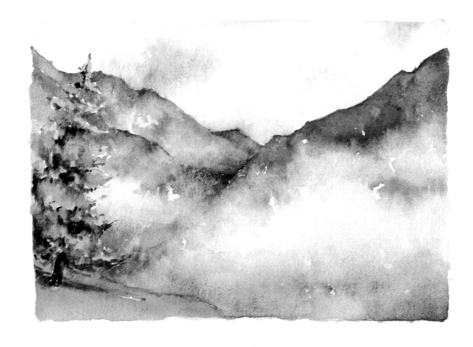

Richard Taylor

COLLINS & BROWN

Watercolour
Landscapes

751.422 TAY
Taylor, Richard S.
Watercolour landscapes

$19.95
CENTRAL 31994013289464

Richard Taylor

COLLINS & BROWN

First published in Great Britain in 2003 by
Collins & Brown Limited

An imprint of **Chrysalis** Books Group plc

The Chrysalis Building, Bramley Road,
London W10 6SP

Originally published as single volumes in 2001
by Collins and Brown Limited

Distributed in the United States and Canada by Sterling Publishing Co., 387 Park Avenue
South, New York, NY 10016, USA

Copyright © Collins & Brown Limited 2001
Text copyright © Richard Taylor 2001
Illustration copyright © Richard Taylor 2001

The right of Richard Taylor to be identified as the author of this work has been asserted
by him in accordance with the Copyright, Designs and Patents Act, 1988.

All rights reserved. No part of this publication may be reproduced, stored in a retrieval
system, or transmitted in any form or by any means, electronic, mechanical,
photocopying, recording or otherwise, without the prior written permission of the
copyright owner.

1 3 5 7 9 10 8 6 4 2

British Library Cataloguing-in-Publication Data:
A catalogue record for this book
is available from the British Library.

ISBN 1 84340 193 2

Reproduction by Classicscan, Singapore
Printed and bound in Singapore by Kyodo

This book was typeset using Rotis Sans Serif.

Contents

INTRODUCTION

The natural world always has, and, I believe, always will be one of the greatest sources of inspiration to artists.

It is, however, neither essential nor desirable to always paint a landscape – the elements that make up a landscape are certainly worthy of individual studies within their own rights. This is where sketchbook studies become important. A few visual notes made with a pencil on the texture of a gnarled oak trunk, or a 'thumbnail' sketch of a moored boat on a calm lake can be of immense value – especially to our understanding of the smaller features of the landscape. Armed with this knowledge of the component parts we can begin to consider composing the larger scene.

Then we can absorb ourselves in the activity of making a watercolour landscape painting – not necessarily a photographic image, as these can look unnatural in the hands of painters, but a personal response to the beauty of the landscape in which we find ourselves.

This book is intended to guide you through the stages of producing a landscape painting from first sketch to the finishing touches – I hope you enjoy the challenges and the rewards that come in between these stages.

TOOLS AND MATERIALS

This book is intended as a reference guide to help you when painting different aspects of the landscape. This chapter therefore looks at some of the tools and materials that I find most useful to carry with me when working outdoors.

TOOLS AND MATERIALS

When selecting your tools and materials it is important to bear in mind that they need to be portable and suitable for outdoor use.

Start by choosing your paper. Sketchpads are the most useful – in particular those that are ringbound, as they give a hard-backed surface on which to work. These sketchpads come in a wide range of types and sizes – I prefer a 210 x 297 mm (8¼ x 11¾ in) or 297 x 420 mm (11¾ x 16½ in) pad of at least 300 gsm weight watercolour paper. This is best as it allows me to use a lot of water in the knowledge that the paper will stay reasonably flat and not 'cockle'.

It is also advisable to carry a small pocket-size drawing pad for making quick pencil sketches and notes of the linear and tonal structure of the subject matter before starting work on the finished picture.

WATERCOLOUR AND PENCIL (OPPOSITE)
The translucent qualities of watercolour paints allow them to work particularly well with pencil – not just as guidelines. You can also enhance a watercolour painting by drawing a few well chosen lines on top of a dry wash.

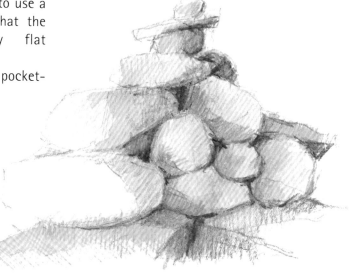

WATERCOLOUR PENCIL STUDY
You can utilize the water-soluble and the graphic/linear qualities of water-soluble pencils particularly well when sketching rocks and boulders. Building up a series of tones becomes great fun using these highly portable materials.

PADS AND SKETCHBOOKS
Watercolour and cartridge-paper pads are essential for outdoor use, because they are compact and allow you to keep all of your work flat and held together. They can be used for visual notes to remind you of the scene, and personal thoughts, as well as for more 'finished' paintings (which are rarely completed on-site).

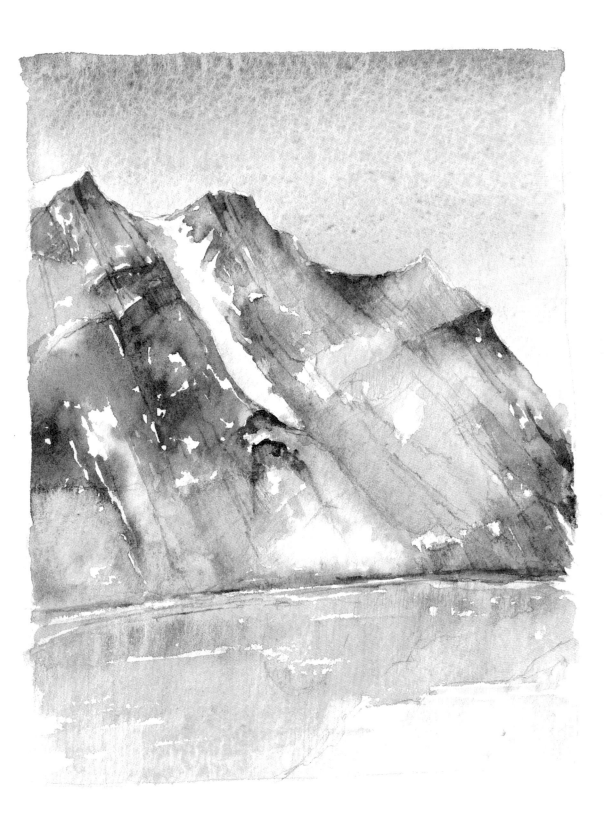

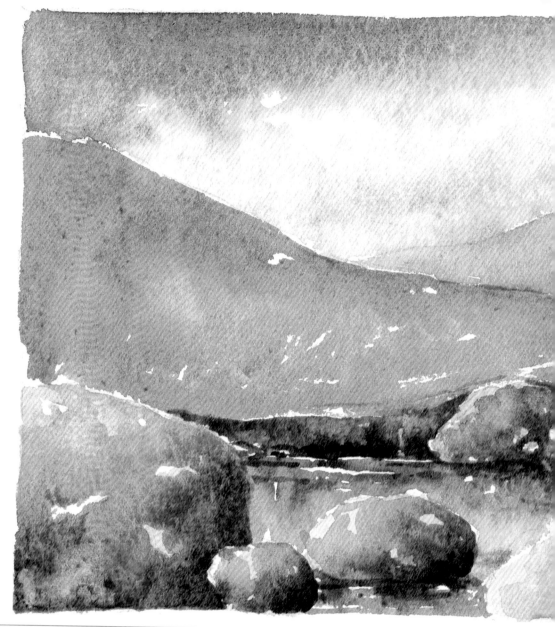

Travelling Light

A few selected pencils are a valuable asset to your sketching kit – carrying too many only complicates matters, as you have to think about which ones to use. Graphite pencils come in a variety of grades. Artists usually make use of the B (soft) grade pencils: 6B is the softest and gives rich, dark tones, while B is the lightest and offers a subtle range of greys.

B

2B

4B

6B

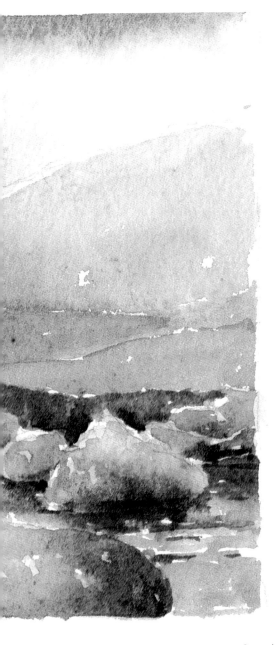

Using the Paper

Watercolour can be particularly effective in producing sharp highlights – leave a flash of the white paper showing through the initial wash to allow your paintings to 'sparkle'.

Sketching pencils are very soft graphite pencils with thick leads, and are good for making quick, bold sketches. They are readily available and come in a wide range of grades – B is the hardest grade used by most artists, and 6B the softest for practical use.

Water-soluble pencils make a normal graphite mark, but have an additional quality – the mark can be washed over with water to produce a soft, watercolour-type grey tone. Water-soluble pencils are available in different grades, although these are usually limited to soft, medium and hard.

There are many advantages of tonal sketching. First, try squinting by half-closing your eyes – you will see a simplified, tonal version of your subject. By recording these tones you will see where the dark, medium and light areas of your composition are before you begin to paint. Second, you can draw or make a sketch on any type of paper – you can even use water-soluble pencils effectively on drawing paper. Third, sketching materials are easily portable – you can slip a pencil and a small pad into your pocket wherever you go.

When drawing and sketching, practise your techniques – hold your pencil in two different ways. To sketch a quick outline, hold your pencil as you would if you were writing, and draw with the tip. However, when you want to shade or block in an area, you will need to change you grip. Place your finger along the length of the pencil so that you draw with the edge of the lead. Each style of drawing serves a very different purpose, and it is well worth practising to master each style.

Sketching in monochrome can often be a very useful method of assessing and analysing the tonal values of your subject without getting too concerned with colour at an early stage. Various tools can be used for drawing in monochrome: graphite sketching pencils are the most useful to carry in your sketching kit. These can be divided into two categories – standard drawing pencils and water-soluble pencils.

Sometimes it is a good idea to make a few 'visual notes' using coloured pencils to capture the nature of your subject – the colour, shape and structure, for example – especially when you are short of time, or in an inhospitable environment.

Standard coloured pencils are highly effective for sketches. They are available in a large range of colours but I strongly recommend that you limit yourself to seven: deep green, sap green, olive green, yellow, raw sienna, burnt umber and ultramarine.

Water-soluble colour pencils are much softer than standard coloured pencils as they are solidified sticks of watercolour pigment. They create highly-textured marks when used on watercolour paper. They are, however, most effective when water is washed over them, turning the pigment into watercolour paint. You can also dip them into water and use them to draw directly onto painted areas, darkening such sections as you choose – again, this is something that you will need to practise

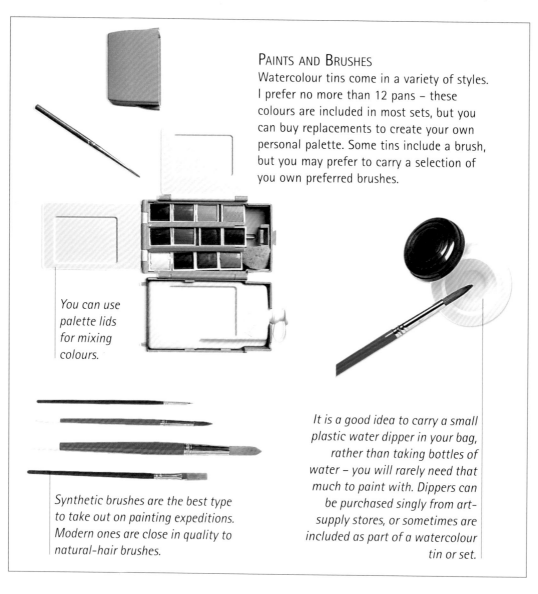

Paints and Brushes

Watercolour tins come in a variety of styles. I prefer no more than 12 pans – these colours are included in most sets, but you can buy replacements to create your own personal palette. Some tins include a brush, but you may prefer to carry a selection of you own preferred brushes.

You can use palette lids for mixing colours.

It is a good idea to carry a small plastic water dipper in your bag, rather than taking bottles of water – you will rarely need that much to paint with. Dippers can be purchased singly from art-supply stores, or sometimes are included as part of a watercolour tin or set.

Synthetic brushes are the best type to take out on painting expeditions. Modern ones are close in quality to natural-hair brushes.

and experiment with to discover the method of working that suits you best.

A small watercolour tin that holds pan paints fits easily into a pocket, and I can change the colour pans to suit the mood of the day and the subject matter. These tins often come with a retractable brush, and more elaborate models sometimes have a small water container built-in as well. I keep my selection of brushes simple – I use one large wash brush, one medium and one small detail brush (all round-headed), plus one flat-headed or chisel brush. For outdoor expeditions I use synthetic brushes as these are a perfectly acceptable alternative to animal-hair brushes, and are considerably cheaper to replace when lost. However, I do use natural sable brushes when working in the studio. All of my outdoor painting items are kept in a strong canvas backpack that can withstand rough treatment in hilly or mountainous environments.

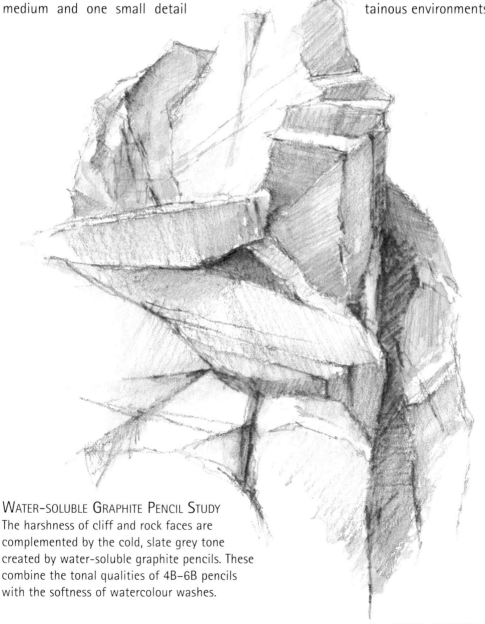

WATER-SOLUBLE GRAPHITE PENCIL STUDY
The harshness of cliff and rock faces are complemented by the cold, slate grey tone created by water-soluble graphite pencils. These combine the tonal qualities of 4B–6B pencils with the softness of watercolour washes.

TECHNIQUES

The techniques for painting skies,
mountains, forests and lakes are as
varied as the types of landscapes
you are likely to find in any part of
the world. This chapter, however, is
concerned with a few of the 'key'
techniques, which, with a little
practise, you will be able to master
fully. Once you have done this
you will be able to apply these
techniques to any situation
that you wish to paint, making
it your own.

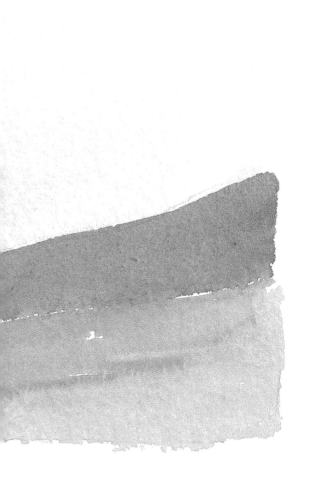

GRADUATED WASH

The one thing that you can't help but notice when standing in open, rolling countryside is that the hills in the far distance will usually appear to be lighter in tone than those closer to you in the immediate foreground. To help to record this sense of space and distance, you can apply a graduated wash across the landscape and, when this has dried, identify the physical features of the landscape by painting onto the established 'underpainting'.

The first part of the graduated wash involves applying water to the entire 'ground' area with a large brush. Before this

CREATING A GRADUATED WASH

1 *Lightly dampen the paper with clean water. From the top of the paper, wash raw sienna down towards the centre using a smooth, unhurried side-to-side motion.*

2 *Next, from the base of the paper, apply sap green and a touch of raw sienna and wash this upwards using the same motion as with raw sienna. When the two colours meet, allow them to mix naturally.*

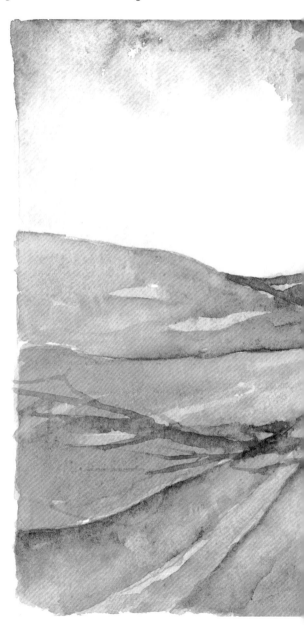

has time to dry, apply a watery wash of raw sienna and, using side-to-side brushstrokes, pull the paint down towards the base of the composition. Then, quickly, create a mixture of sap green with a hint of raw sienna (this prevents the colour mix from looking too unnatural) and reverse the process. Apply the green paint to the base of the paper and pull the paint upwards, still using side-to-side brushstrokes. This will blend with the raw sienna underwash, creating a covering of paint that goes from light on the horizon to dark in the immediate foreground without any obvious break.

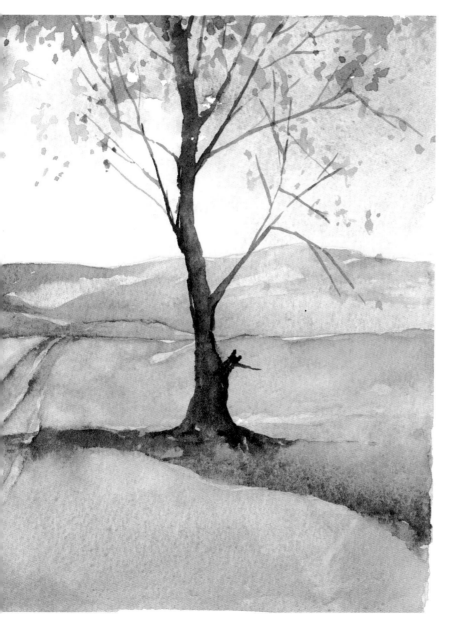

DISTANT HILLS
This spring scene was alive with the movement of shadows cast by clouds scudding across the cool sky. The muted tones of the distant hills change subtlely towards the foreground.

FORMAT

Traditionally, artists have had to make a major decision before embarking on a painting – should they paint the subject on a 'landscape' (horizontal) or 'portrait' (vertical) format. Often the subject will dictate the answer, but this is not always the case. Most sky paintings suit a landscape format, however, it is worth experimenting with different formats, as the unexpected can often have much more visual impact.

Landscape is the traditional format for paintings containing large areas of sky or panoramic views, and has the advantage of allowing a wide angle vista to be painted, enhancing the feeling of open spaces. This format also allows more room for expressive brush work through vertical brushstrokes, but considerably more vigorous brushstrokes can be developed along the length of the horizon to record movement in clouds. Overall, the landscape format conveys a general feeling of calm and tranquillity.

The portrait format, however, can produce a much more exciting, visually dynamic composition. The height of this format allows a very 'high' view of towering clouds to be painted, enhancing the effect of 'pressure' on the horizon. This can often be used to dramatic effect when painting storm clouds or clouds with a great amount of 'height', allowing for more attention to be given to specific cloud shapes than an overall 'sky' view.

LANDSCAPE
The broad, landscape format is traditionally used by artists for expanses of sky and land.

PORTRAIT
This format, when applied to landscapes, is often used to add impact to the visual dynamics of the composition.

USING DIFFERENT BRUSHES

Understanding and learning to use colours is very important for painters but it is equally important to understand the implements used for applying these colours to paper – brushes.

There are many types of brushes available in art stores, and they all have their uses, but a simple choice of just three or four brushes will be all that you could ever need for painting out of doors in 'out of the way' places.

The most important thing to remember is that different brushes make different marks – this is the key choice that you need to make: do you choose a large brush which will hold a lot of water and deposit this in a swathe of paint that will run and bleed onto wet paper, or do you choose a small brush that will make marks similar to thick pencil lines? Both have a valuable role to play in the painting process – but when to choose each brush?

Usually, your choice of a large brush will be for laying a background wash where little detail is required – a large brush helps you to complete this quickly without any fussy brushstrokes.

A smaller brush will be used more frequently in the foreground where the detail will be sharper and cracks in rocks, and the individual shapes of pebbles and stones can be suggested with much more control over the flow of paint.

DIFFERENT BRUSHES

1 *A large brush will effortlessly cover a large area of paper, leaving no evidence or suggestion of brush marks.*

2 *A small brush will create a very different finish. As they hold less paint they have to be reloaded frequently. These are best for 'drawing' fine details.*

ROCK FACE
The sheer scale of these rock faces was intimidating at first but it is easy to become totally absorbed in the painting process and to forget such things. A large brush was used for the solid rock and a smaller brush for the detailed cracks and fissures.

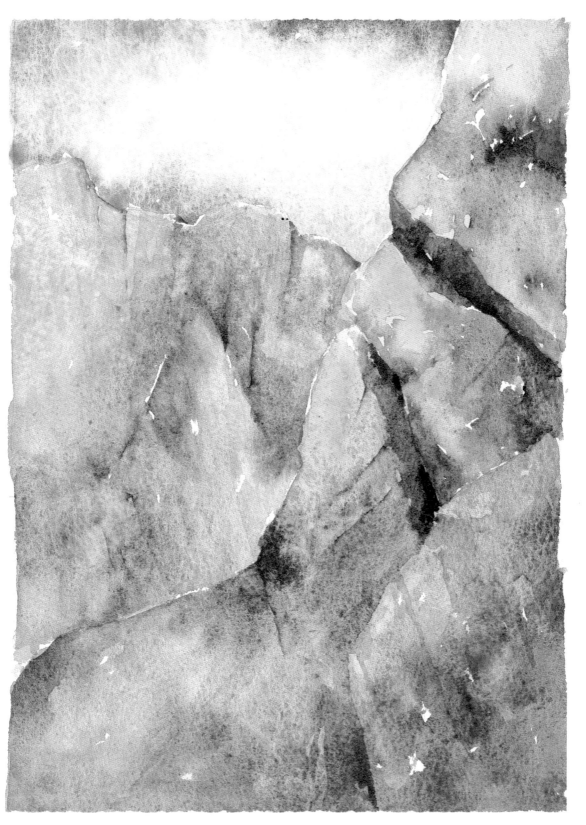

BLOTTING AND SPONGING

Light clouds can either be created by leaving an area of white paper and painting around it, or by allowing paint to flood the entire sky and then removing some of the wash while it is still damp by sponging or blotting.

When you first look at your sky and begin to plan your composition, it is important to identify the size of clouds and exactly how much of the composition they will take up. Once you have done this, dampen all of the paper and apply the sky colours. These paints will run and bleed quickly, so make sure they are applied to the area directly around the clouds. Within seconds the sky colour will have bled into the tops and bottoms of the areas that you wish to make into clouds, so some of this paint will have to be removed.

Timing is important at this stage – if you wait too long the paint will have dried, but if you try to remove the paint too soon you will only remove the surface water, leaving the paint to bleed into the damp paper. Wait until a 'sheen' appears on the paper – this will tell you that the surface water has been absorbed and that the fibres of the paper are still damp and that any paint can now be soaked up or blotted accordingly.

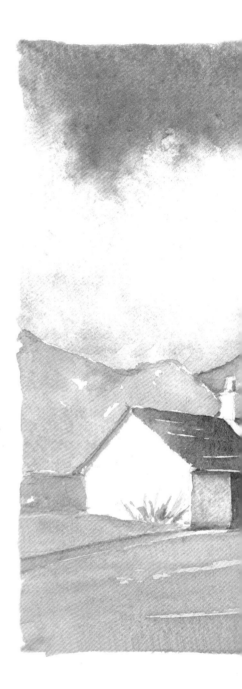

BLOTTING
Kitchen paper can also be used to remove wet paint, but this is much harsher and leaves very clear marks, making it more suited to creating moving, wispy clouds with definition.

SPONGING
Using a sponge to mop up, or remove, watery paint from watercolour paper leaves a soft edge around the sponged area and is suitable for creating summer clouds.

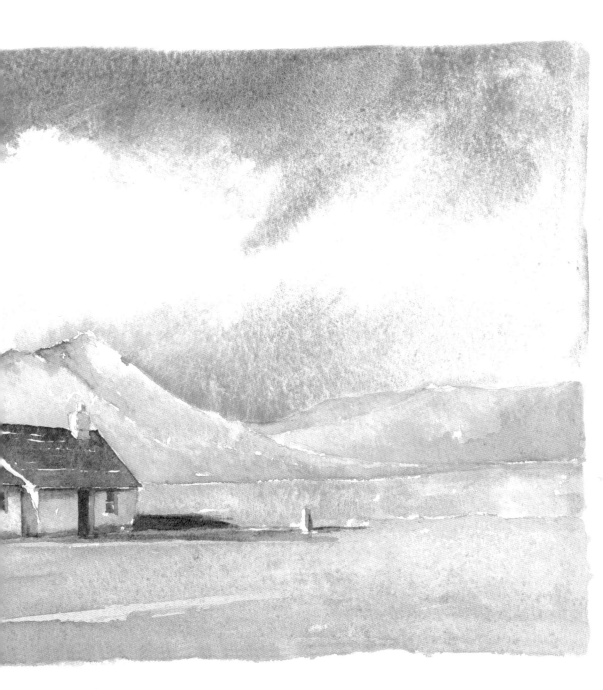

Cloud Shapes

The different types of clouds form a major part of this
scene. Although the differences are subtle – the larger
cloud on the left and the softer, hazy cloud on the
right – they are still very much a part of the sky.

POSITIVE AND NEGATIVE EFFECTS

Sometimes the colour value (the strength or lightness) of a sky is influenced by the objects in the immediate foreground of a composition – the darkness of a spring day can be enhanced by including white sheets blowing in the wind, for example – the light objects making the sky appear darker. Alternatively, a soft, hazy sky can be made to appear even lighter and more distant by including a dark tree in the foreground – the darker this is, the lighter and more distant the sky will appear to be.

ULTRAMARINE

ALIZARIN CRIMSON

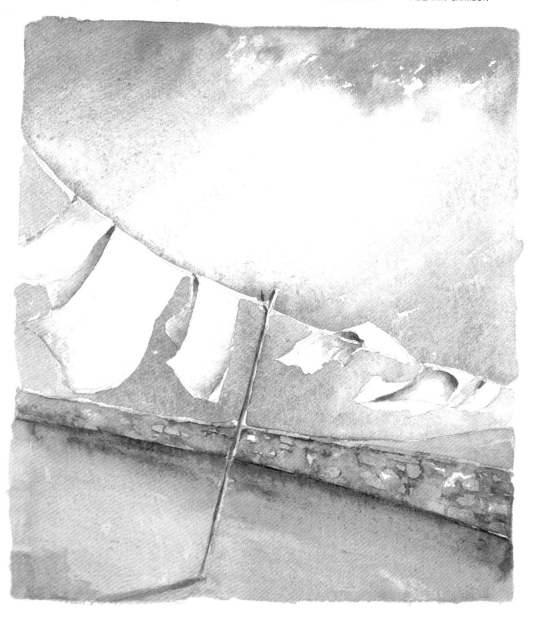

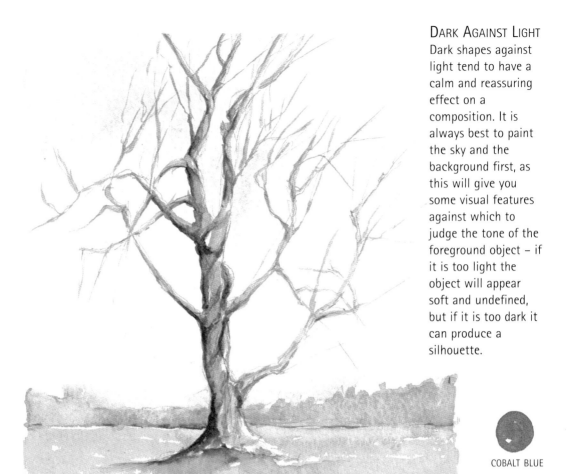

Dark shapes against light tend to have a calm and reassuring effect on a composition. It is always best to paint the sky and the background first, as this will give you some visual features against which to judge the tone of the foreground object – if it is too light the object will appear soft and undefined, but if it is too dark it can produce a silhouette.

COBALT BLUE

Negative shapes occur when the object in the foreground appears lighter than the background. Whilst it is possible to create these lighter shapes by applying masking fluid before overlaying a wash, it does produce shapes with unnaturally hard edges.

LIGHT AGAINST DARK

Light against dark is a tool that artists often use to create impact in their compositions. Objects, such as washing billowing or silver tree trunks – even white houses – are best left largely unpainted as the clarity of white paper is always sharper than white paint.

Even though painting around the lighter shape will disturb the natural flow of the sky, it is worthwhile in order to achieve softer edges. By first painting around the negative shapes with water will help to create a smoother application of colour.

Positive shapes stand out clearly against a sky, usually dominating the foreground with their presence. These shapes need to be painted onto dry paper as the sharpness of their form is critical to the success of the painting. Use a small brush and try not to overwork the shapes as this will diffuse the sharpness required.

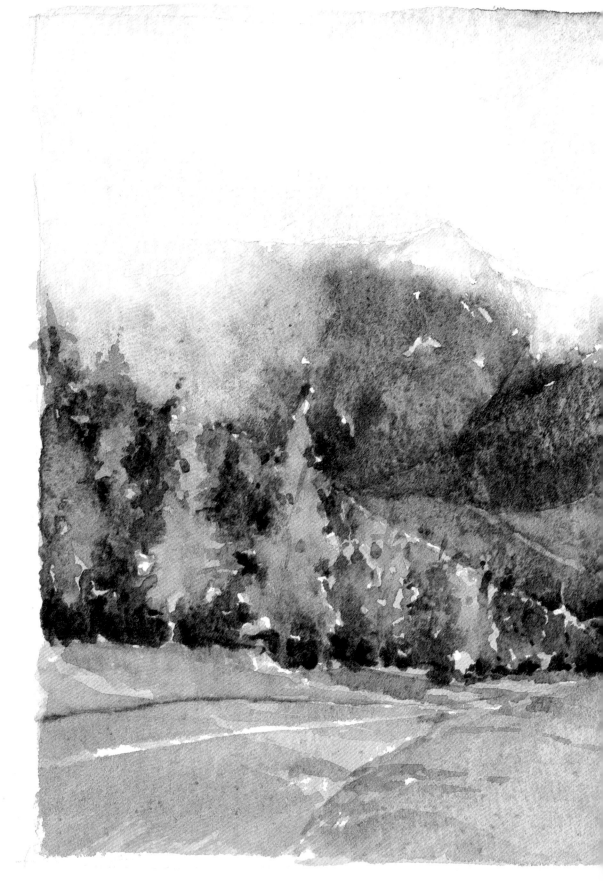

Hills and Mountains

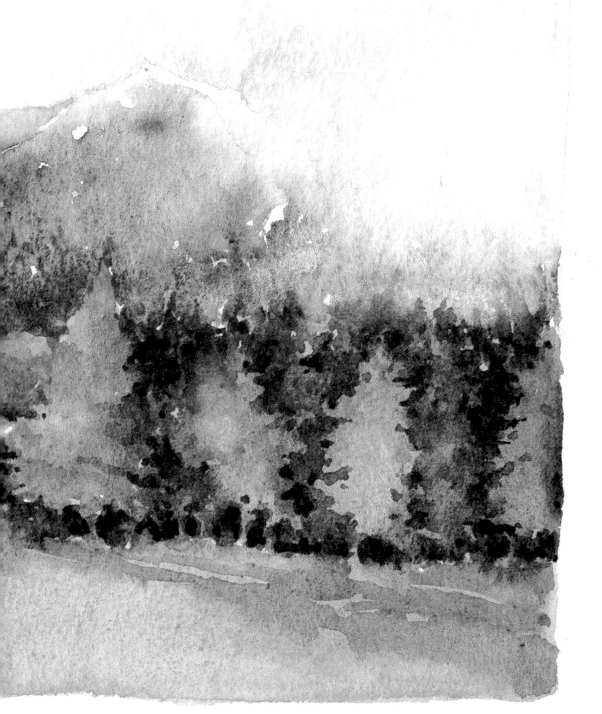

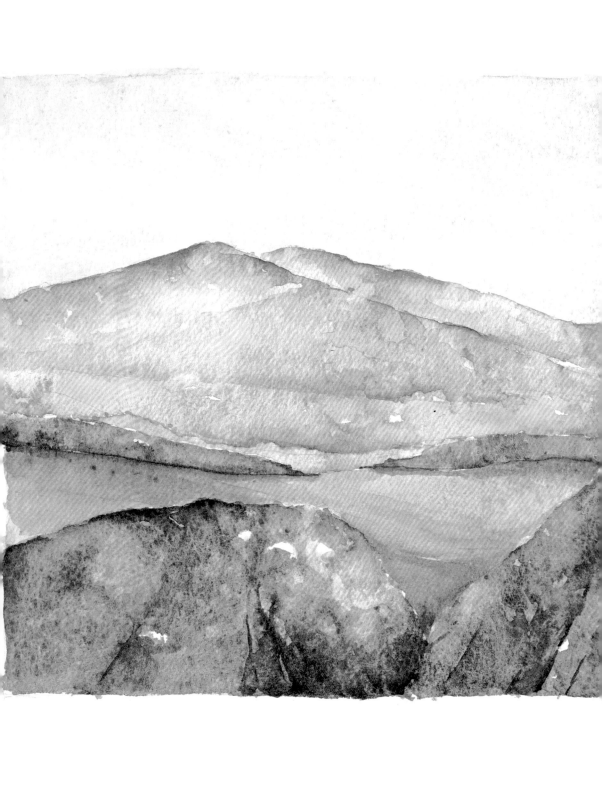

FOOTHILLS

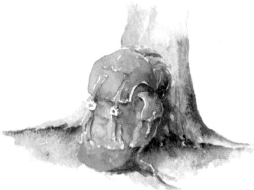

The far distant sight of violet tinged, softly rolling hills is one that invariably makes artists want to reach for their watercolour tins. The soft greens of these gentle terrains combined with the natural siennas are a pleasure to paint in any season, and in most weather conditions – torrential rain, of course, excepted!

Tone and Distance

The effect of distance, evident in all panoramic landscapes, is best created by the use of tone – that is making colours lighter in parts and darker in other areas.

Sometimes it can be helpful to practise creating tones by using just one colour (monochrome) or even with a grey toned water-soluble graphite pencil, looking to ensure that the tone always increases from a light distant background to a considerably darker foreground.

When you feel that you are happy with creating tones with single colours, then try mixing some colours, such as the violets that often appear to cloak distant hills, and again, create as many different tones as you can. This can be done either by changing the balance of the paint mixture to darken the tone, or by diluting with more water to lighten it, creating a tint.

Changing Tones
The effect of distance is conveyed in this painting by lightening the tone of the overlapping hills as they recede.

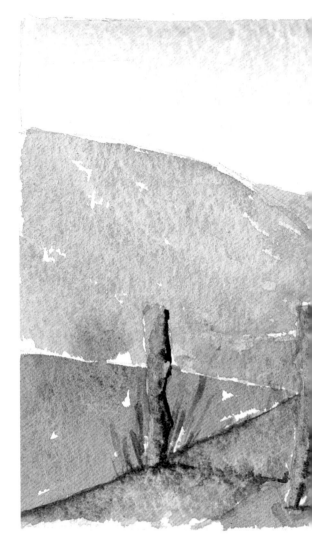

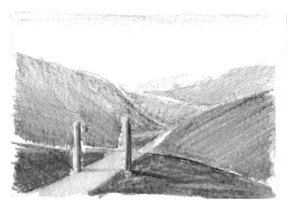

Pencil Study
Water-soluble graphite pencils are highly portable and excellent for making quick preliminary sketches.

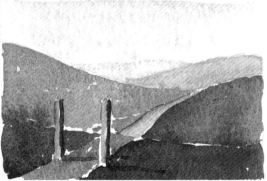

Monochrome Study
A single colour tonal study helps you to 'see' the range of tones that you will need to create in a composition.

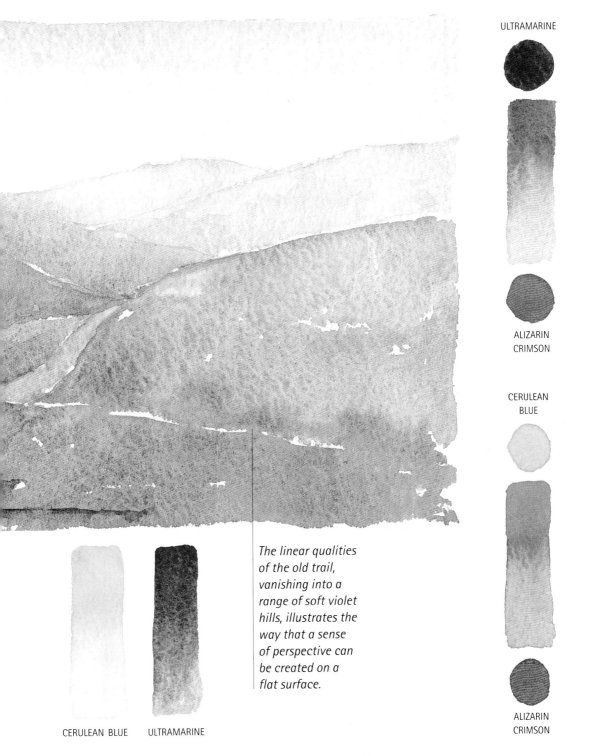

ULTRAMARINE

ALIZARIN
CRIMSON

CERULEAN
BLUE

ALIZARIN
CRIMSON

The linear qualities of the old trail, vanishing into a range of soft violet hills, illustrates the way that a sense of perspective can be created on a flat surface.

CERULEAN BLUE ULTRAMARINE

Adding Water
Experiment with single colours at first – how much water can you add until you lose the colour completely?

Mixing Colours
Now try mixing colours. This introduces a new element. How much of each colour do you need to mix to alter the tone?

Tonal Mixing

The variety of green tones required to paint a well-lit hillside landscape can be extensive – for this reason it is a good idea to practise using a manufactured green and altering the tone to both light and dark. Sap green is a particularly good colour for this type of exercise. On its own it is not a particularly 'natural' green, but this can be altered easily without losing the clarity of the colour. Add cadmium yellow to the sap green to produce a lighter green, seeing how far you can take the tone (by adding water) before it becomes almost invisible. Then, work in the other direction. Add ultramarine to sap green and see how dark you can make the colour whilst still maintaining a hint of green.

Once you can do this, you will be more than ready to paint grass covered hills in any lighting conditions.

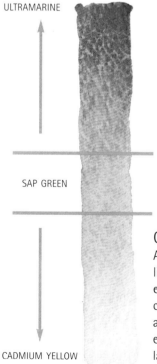

ULTRAMARINE

SAP GREEN

CADMIUM YELLOW

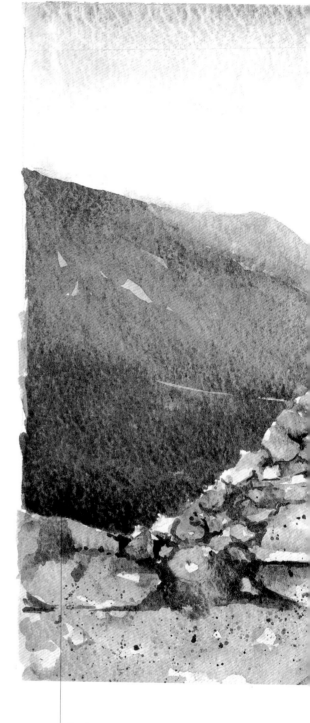

Green Tones
Adding darker and lighter colours to an existing 'medium' colour can provide a wealth of different tones for use in landscapes.

Dark tones can be used when painting hills to help define specific shapes. A shadow painted 'behind' a small hillock will usually push it forward into the middle ground or foreground.

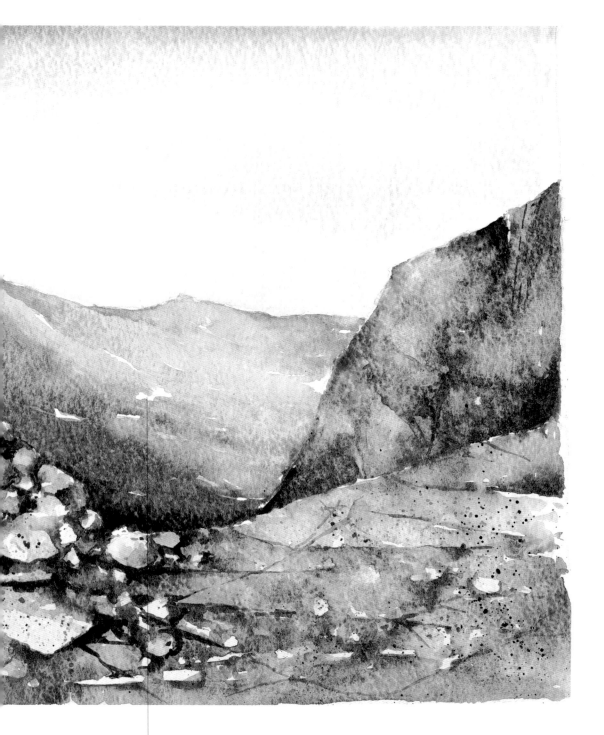

Highlights in the landscape, often seen when directional sunlight is hitting patches of ground, are best created by the addition of yellow to the grass mixture.

HIGHLIGHTS

The contrast between the highlights on the tops of the hills and the shadows in the valley made this particular scene very appealing to paint.

SHADOWS

Watching clouds roll over the far horizon, casting shadows across the open hillside, is a wondrous sight to observe. It can, however, complicate the issue for painters. Suddenly, you find that you need a much wider range of greens to cope with the transient effects of the weather.

It's time now to practise extending the potential of sap green, cadmium yellow and ultramarine by the addition of burnt umber – try as many combinations as possible and compare these with greens created by mixing your own greens from blues and yellows.

Also, you will find that introducing olive green into the far distant hills (mixed with a touch of raw sienna) at the graduated wash stage will increase the tonal variety. Paint with as many of these greens as you can when establishing the basic green of the hills. When this has dried, mix the darkest and use a small brush to 'draw' the shadows onto the green paint surface.

CHANGING LIGHT
The way that the light fell onto these rolling hills, changing tone and thrusting flashes of highlight forward, required an instant response to the scene.

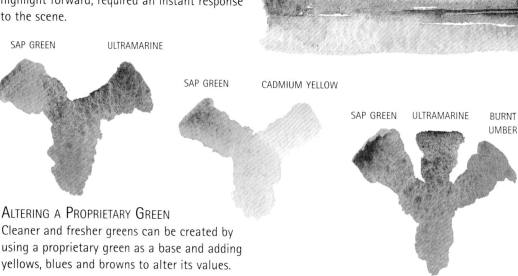

SAP GREEN ULTRAMARINE

SAP GREEN CADMIUM YELLOW

SAP GREEN ULTRAMARINE BURNT UMBER

ALTERING A PROPRIETARY GREEN
Cleaner and fresher greens can be created by using a proprietary green as a base and adding yellows, blues and browns to alter its values.

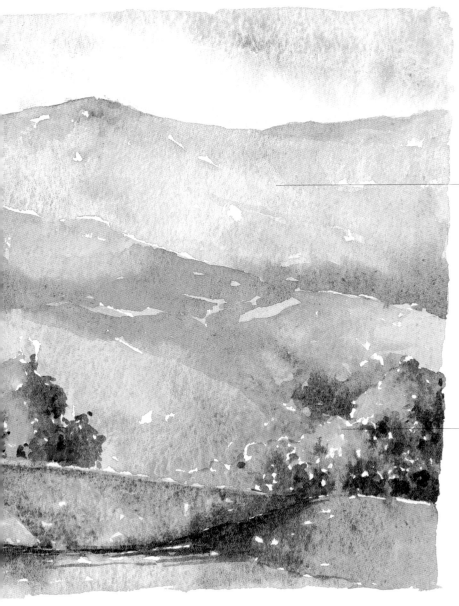

The hills in the distance need to be applied freely with a large brush - they should also contain an element of blue or violet to ensure that they 'sink' into the background.

The foreground greens need to 'sparkle' a little to suggest a sharper focus - even dark greens can be bright. This is achieved by not mixing muddying browns in with them.

OLIVE GREEN

SAP GREEN

| ULTRAMARINE | CADMIUM YELLOW | ULTRAMARINE | RAW SIENNA |

MIXING GREENS
Try creating your own greens by mixing different combinations of blue and yellow – they will often turn out to be 'muddy' colours.

BACKPACK STUDY

Having come this far along the trail, through the foothills and lush meadows, it is perfectly acceptable to sit down and take a break. This could, however, be seen as a waste of painting time!

Instead you could take a few moments to make a sketch or two and why not turn to your equipment?

Most modern backpacks are designed with personal safety in mind and are, therefore, usually very bright colours, creating a marked contrast with the olive greens and soft violets of the landscape.

Cadmium orange is a good colour to use as a base, adding cadmium yellow to create the lighter patches, and using ultramarine and alizarin crimson for the shaded areas. Subjects like this are best painted onto dry paper – this allows you to achieve some broken brushstrokes as the paint drags across the textured watercolour paper surface, allowing highlights to develop naturally, adding a slightly old and 'well worn' appearance to the backpack.

Most mountaineering or trail-walking equipment today is designed to be spotted from a long distance – cadmium orange was the ideal colour for this backpack.

QUICK STUDY
The slightly battered and faded look of this well-used backpack added to its 'character' and ultimate appeal as a subject for a quick sketchbook study.

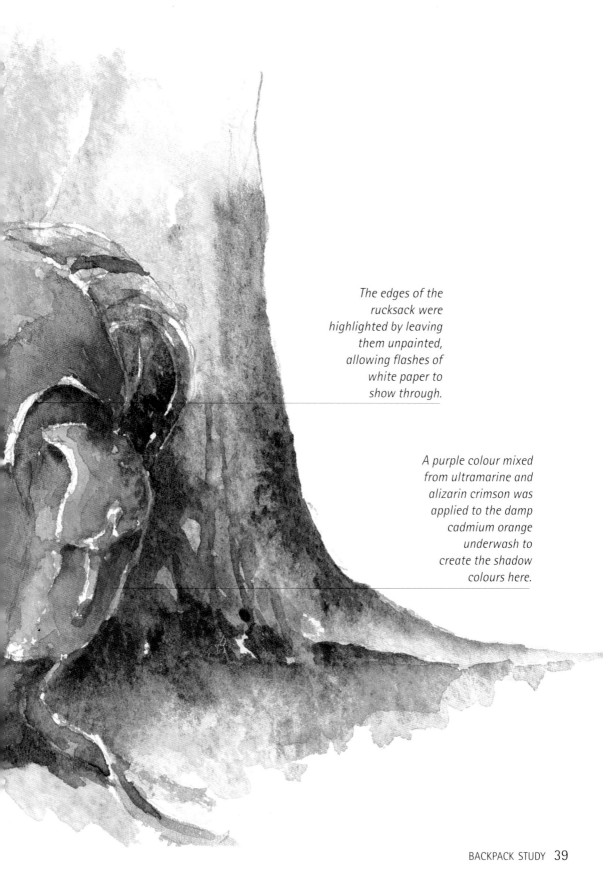

The edges of the
rucksack were
highlighted by leaving
them unpainted,
allowing flashes of
white paper to
show through.

A purple colour mixed
from ultramarine and
alizarin crimson was
applied to the damp
cadmium orange
underwash to
create the shadow
colours here.

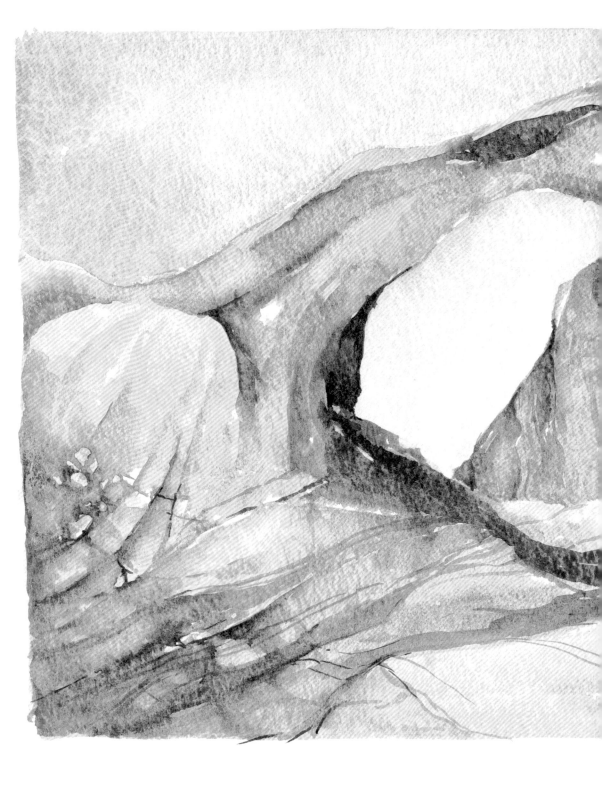

ROCKS

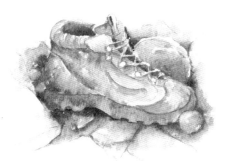

Sooner or later, you will leave the
soft green foothills behind and
encounter rocks and boulders. This
is a much harsher environment
where the soft shapes and tones of
the hills give way to hard cracks
and fissures. These require not just
different colours, but different
brushes and a whole new, sharper
way of painting.

Rock Faces

The very nature of rocks and crags means that you do not have to concentrate quite so much on colour – more on form, shape and suggested detail.

To paint a group of rock faces, start by loosely pulling a wet brush loaded with raw sienna across dry paper, covering the entire rocky area. The result will be an uneven covering of paint with several white flashes of paper showing where the brush has not fully covered the paper. These flashes will act as highlights along the rock edges.

Flat-headed Brushes

1 A large, chisel-headed brush will create a very broad sweep of paint, with excellent covering power.

2 Use a small chisel-headed brush on its side to produce much sharper, linear marks which are particularly suited to sharp rock faces.

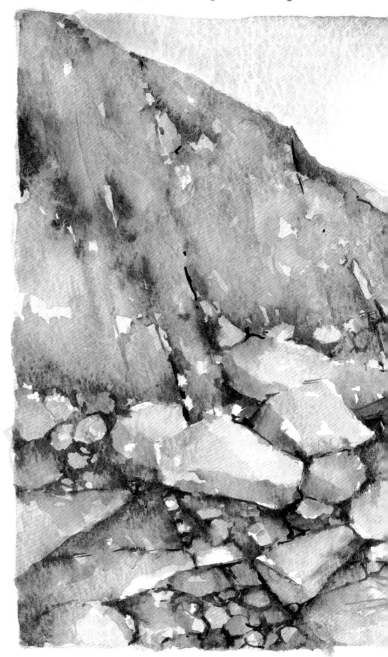

Next, mix a dark, stone-coloured wash using raw umber, burnt sienna and ultramarine and quickly wash this onto the shaded or darkest areas of rock that you can see. As long as the underwash is still slightly damp this will dry with soft edges.

When this has fully dried, you can start to paint the sharp shadows underneath the rocks and in between the cracks and fissures with a darker mix, using the tip of a small brush to obtain really sharp foreground definitions.

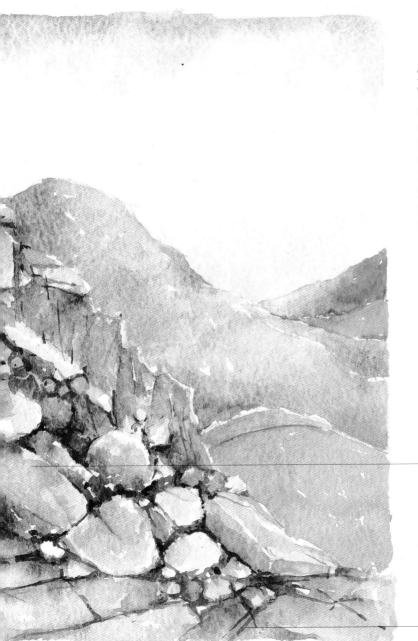

STREWN BOULDERS

Whilst a collection of so many rocks and boulders may initially appear off-putting, the painting method is not so difficult as it might seem – the key is to make the underwash work for you to 'suggest' the different textures.

The tops of flat rocks are best created by simply leaving the underwash to show through and creating the three-dimensional effect by painting the sides of the rock.

Cracks are best created by 'drawing' onto dry paper with the edge of a chisel-headed brush, or the point of a small brush, using a colour mixture of burnt umber and ultramarine.

STEPPING STONES

The main feature of these stepping stones is the way in which water has been used to create a wealth of wet-looking textures.

By applying clean water to drying paint you can achieve this effect – the water pushes the paint outwards, breaking up its regular drying pattern, scattering the particles of paint. As they dry, so the 'watermark' can be seen, providing an appearance of wetness and texture. This is a particularly appropriate technique to use when painting stepping stones, or any rocks and boulders in or on the edge of rivers.

RAW UMBER BURNT UMBER ULTRAMARINE

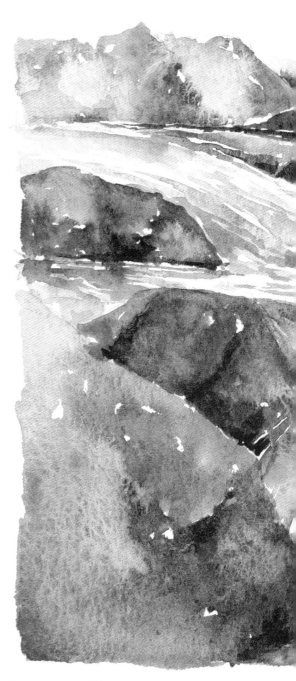

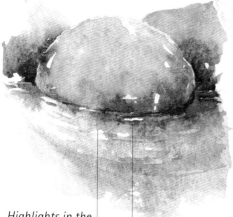

Highlights in the water 'lift' this study and are created by painting around tiny flashes of white paper.

The boulder colours are reflected in the water with the same colours as the boulders, but much diluted.

REFLECTIONS
Observe how the shadows at the base of this boulder follow the gradual curve of the rock – work onto damp paper to help create this smoothness in your painting.

FAST-FLOWING WATER
Highlights and shadows are more predictable on these rounded rocks than on harsher rock faces. Watermarks – created when wet paint is applied onto dry paint – suggest texture.

The texture on boulders such as these is best obtained by applying the appropriate colour and, just as the paint is beginning to dry, drop some pure water from a small brush onto the paint – this creates a textured effect as it dries.

Rocks and boulders do contain colour - always look carefully for the green algae tinge, or the mineral veins which are best painted with burnt sienna.

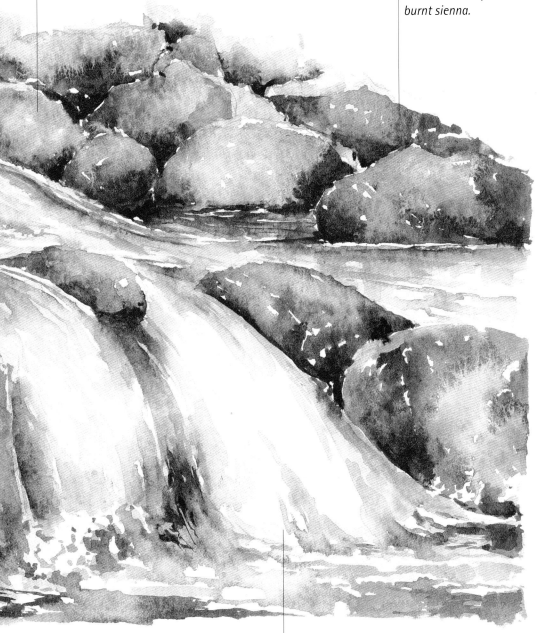

The key to painting moving water is to leave as much white paper as you dare, using only the paint from the rocks to create coloured reflections.

HIKING BOOT STUDY

After scrambling over rocks, the relief of removing hiking boots is unparalleled – and a wonderful opportunity for a quick sketch.

The very nature of this particular subject will offer a slightly different approach from usual. First, apply a raw sienna underwash to dry paper and quickly wash in the darkest areas using burnt umber with just a touch of ultramarine.

When this is dry you may find it helpful to recreate the details – laces, eyelets, ribbed soles – by drawing onto the watercolour with a water-soluble pencil. This gives a sharp linear quality to the study, yet still allows you the option of softening any of the lines with a plain water wash at any time.

Once you are happy with the boot, create a very strong mixture of burnt umber and ultramarine and paint this directly underneath the sole using a small brush to create the shadows which will visually anchor the boot to the ground.

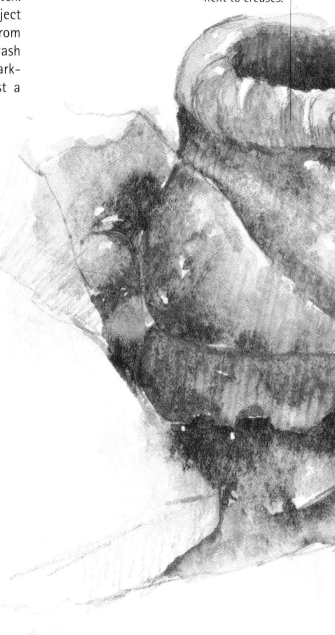

The curves on this boot were created by allowing the underwash to show, complemented by a few flashes of white paper to suggest highlights next to creases.

USING WATER-SOLUBLE PENCIL
This old boot was almost camouflaged, positioned between sandy coloured rocks and stones. This forced the addition of a new set of marks – pencil – to really make sure that it stood out from the background watercolour wash.

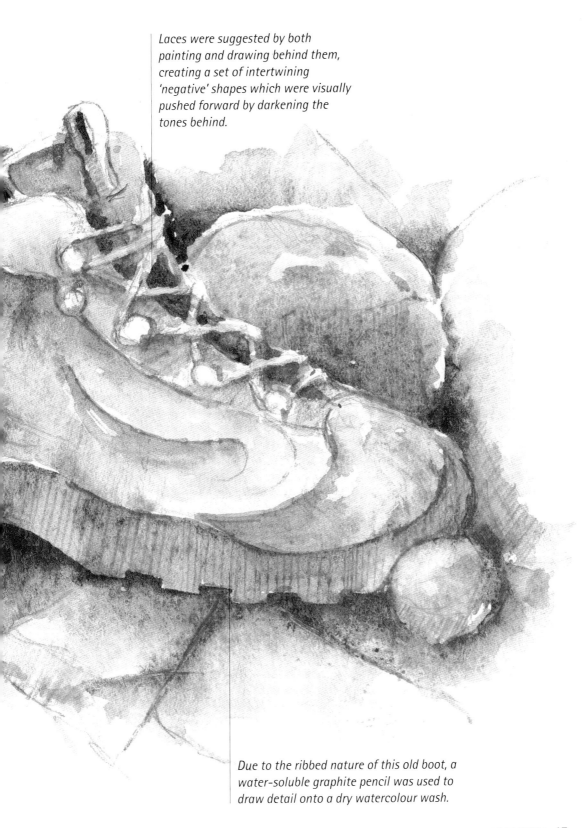

Laces were suggested by both painting and drawing behind them, creating a set of intertwining 'negative' shapes which were visually pushed forward by darkening the tones behind.

Due to the ribbed nature of this old boot, a water-soluble graphite pencil was used to draw detail onto a dry watercolour wash.

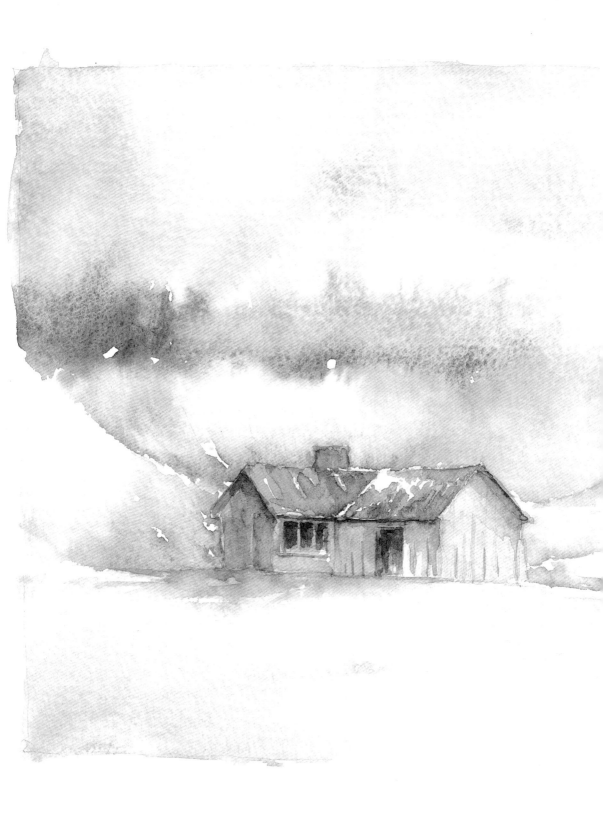

HUTS AND SHELTERS

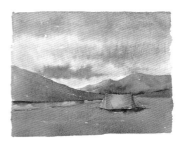

Anyone who has ventured into the higher hills during the winter season will know how welcoming the sight of a solid mountain shelter can be. But these are not the only kinds of shelter to be found in the landscape – tents and wooden cabins each serve different purposes, but are just as valuable when the weather turns bad or night begins to fall.

TENTS

Having put up your tent and cooked a meal in wild, remote country, there is often little to do as dusk encroaches but paint the scene in which you find yourself.

The colour of modern tents always makes them stand out clearly from the backdrop, whatever the weather conditions. The key elements to consider when painting tents is the tautness of the canvas and the sharp edges that these create – all of these are best painted onto dry paper, using a small brush to almost 'draw' the tight creases onto a highly coloured base. This also applies to ropes – use a suggestion of a few key supports only, as over fussy detail can detract from the central image.

 CADMIUM YELLOW

CADMIUM RED

 ULTRAMARINE

ALIZARIN CRIMSON

The edges of the taut canvas are best left as plain white paper – a very thin sliver will work well.

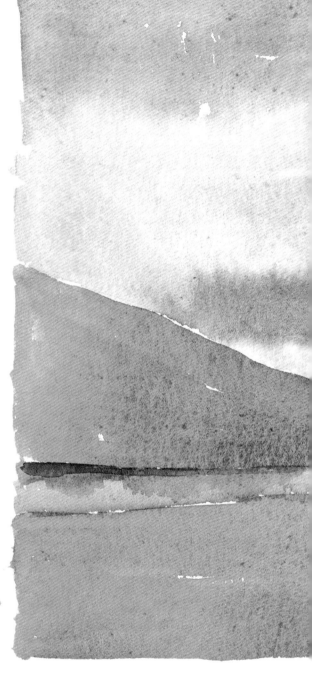

TAUT CANVAS
The way in which ropes and pegs exert pressure on the bottoms and tops of tents creates the tautness and tension of the canvas – these sections are worthy of special attention before embarking on a full-scale painting.

TWILIGHT TONES
The soft violet tones forming in the dusk sky settled gently across the landscape and the tent, producing an irresistible subject, awash with colour and contrasts.

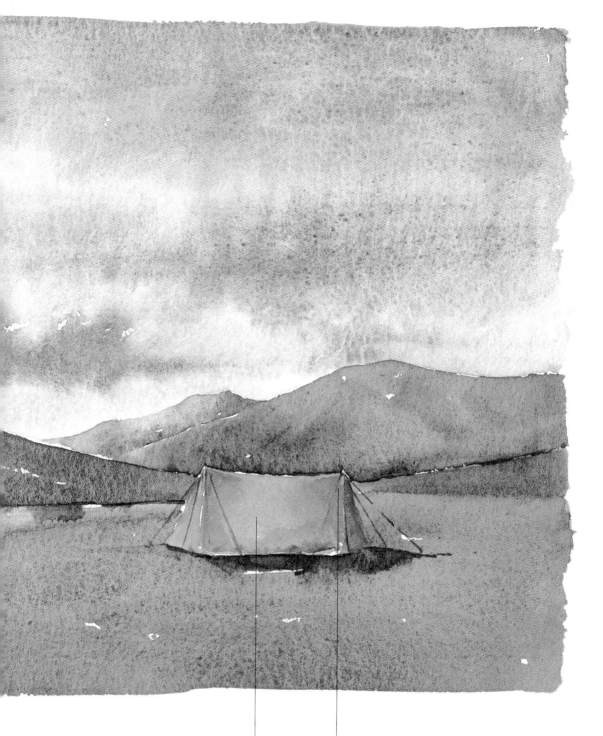

Canvas tents can hold a wide range of tones. The highlights – either faded canvas or where the light is catching – can be created by blotting the damp paint during the drying process.

The taut nature of stretched canvas is a key feature of tents. This is best recorded with smooth brushstrokes and hard edges at the point where the canvas is tightest.

Stone Mountain Shelter

Stone is a universal building material, often found in mountainous areas where it is quarried from the rock faces.

The very nature of the system for obtaining rocks means that the individual stones will be of different shapes and sizes – this is part of the appeal to the artist as a stone wall can often appear like a complex pattern full of light and dark tones.

I find that the best way to paint stone walls is to apply a watery wash of raw umber and encourage this to dry unevenly by dropping water onto the paint as it dries. This will disturb the gum arabic binder and disperse the pigment in the paint. When this irregular colour wash has dried, I use a small brush to almost 'draw' in between the shapes of some of the rocks with burnt umber. I then wash some of this colour into the surrounding stones to avoid lots of hard edges. When this is dry, I sometimes sharpen a few selected lines with a dark mixture of burnt umber and ultramarine.

First, apply a watery underwash with a medium brush.

Sharpen a few lines around the stones once the paper is dry – this will avoid 'bleeds'.

Establish the colour of the stone by dropping paint onto the underwash while it is still damp.

Corner stones are often the biggest to be found in a building. Try to paint one side of the corner stone a little darker than the other to create a three dimensional effect.

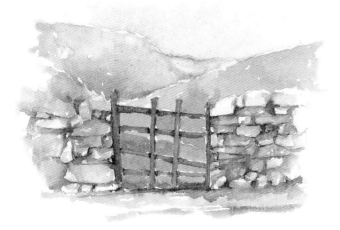

Stone Wall
Allow the dark stone colour to run down onto the grass or ground colour. This helps to visually 'anchor' the wall to the ground.

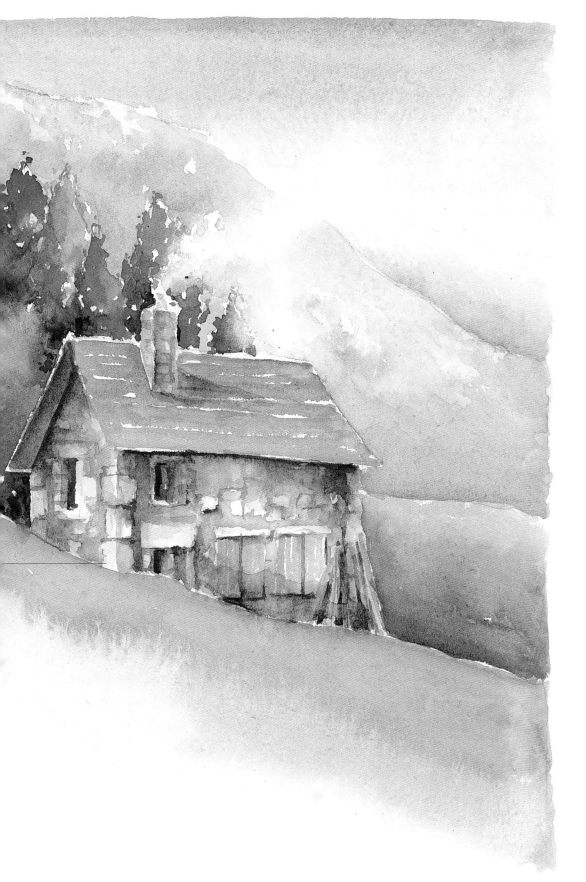

WOODEN HUTS

Wooden huts or shelters are, naturally enough, frequently found in highly-wooded mountainous regions and appeal to artists – painting structures made from natural materials in their own environment.

Wooden huts are best painted by applying an underwash of raw sienna, washed onto dry paper, allowing a few flecks of white paper showing to indicate or suggest the areas where planks are joined. Next, add raw umber to the damp paper, creating a slightly different tone (not all wood planks are the same tone). When this has dried, use a small brush loaded with burnt umber and ultramarine and paint any shadows cast onto the hut. The last application is the 'drawing' of a few selected lines to suggest individual planks of wood.

WOOD GRAIN
The roughness of the wood texture combined with the soft warmth of natural wood tones, creates a study which relies equally on washing paint with a large brush, and 'drawing' with a small brush.

RAW SIENNA

RAW UMBER

BURNT UMBER

ULTRAMARINE

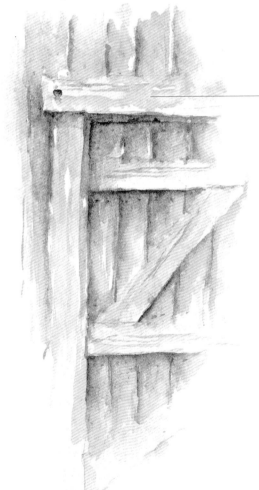

Rather like planks in a complete building, suggest wood grain by employing a few well placed lines of paint 'drawn' with a small brush. The underwash can also be used to show as light areas of grain.

Shadows from wooden structures fall across raised wooden planks and logs, creating an uneven cast. This also necessitates changes in tone, so observe these areas.

It is neither possible nor desirable to paint every single plank whilst sketching wooden huts on site – so choose a few to emphasise, suggesting that the others also exist.

WARM PALETTE
Set amongst the reds, golds and siennas of a flaming forest at the turn of the year, the warmth of the wood in this wooden hut clearly echoed the qualities of the season and was a delight to paint using limited colours.

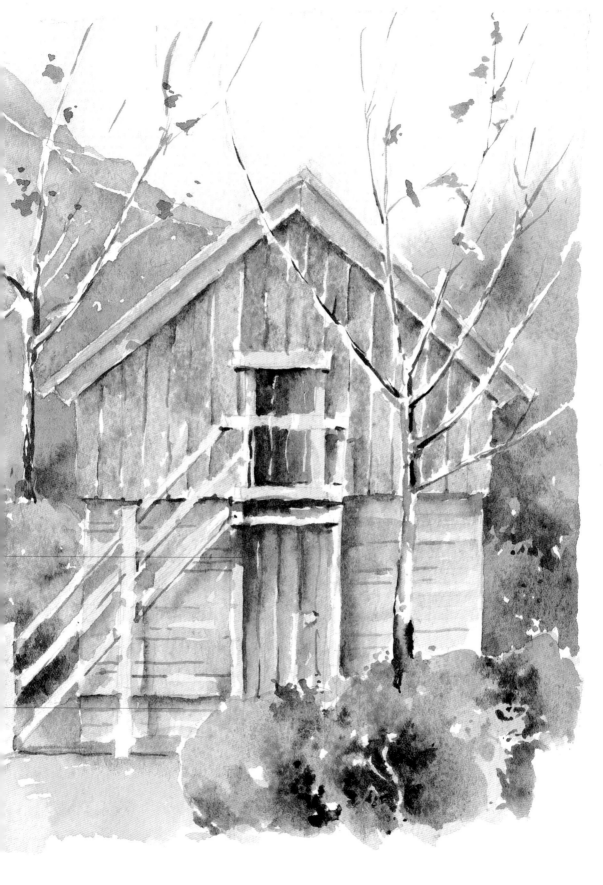

COOKING STOVE STUDY

Survival in the wilderness involves cooking and eating, and camping gas stoves are ideal for creating a hot meal in cold conditions. They are also good subjects to sketch while waiting for the heat to reach cooking temperature – or, in the case of this particular study, while waiting for the boiled soup to cool a little.

Metal objects, especially curved ones, require some practise as you will need to employ a 'once only' technique – that is, you dampen the paper, pull the paint around the curve of the object with a confident sweeping motion and leave it to dry to a perfectly smooth finish. If you go back to the subject and try to manipulate the paint a little, you will break the surface tension of the drying paint and introduce a brush mark into the otherwise smooth metallic canister.

You may use this technique with cooking pots and pans as well – for best results, any stains or dents should be painted after the initial wash has dried.

The highlights created in the centre (or often to the sides) of canisters can be painted by pulling wet paint into the centre from the left and right, and leaving a very small gap where they join.

TORN LETTERING
Sometimes a boost of energy is required through chocolate or glucose bars. The torn lettering here makes an interesting study.

SMOOTH SHAPES
The softness of the reflections combined with the symmetry of these curved objects provided a marked contrast with the harsh, sharp, rocky environment, offering a welcome opportunity for gentle tonal mixing.

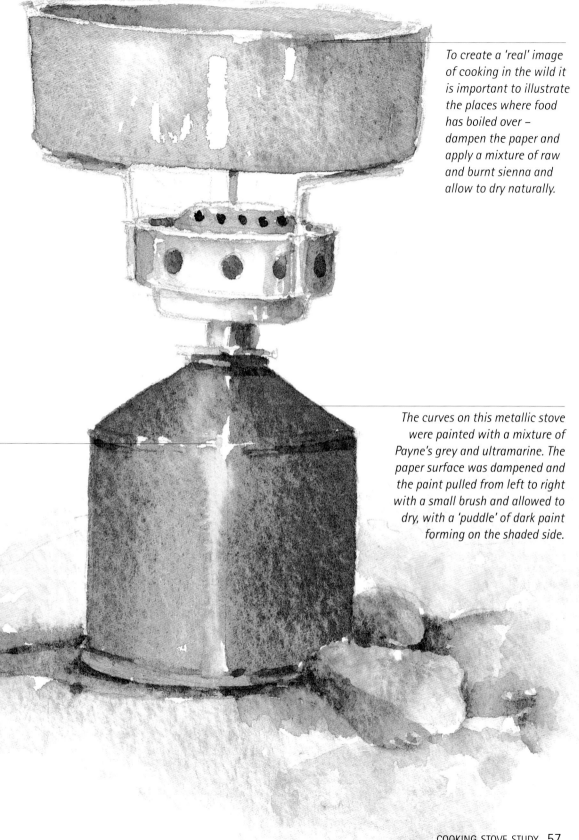

To create a 'real' image of cooking in the wild it is important to illustrate the places where food has boiled over – dampen the paper and apply a mixture of raw and burnt sienna and allow to dry naturally.

The curves on this metallic stove were painted with a mixture of Payne's grey and ultramarine. The paper surface was dampened and the paint pulled from left to right with a small brush and allowed to dry, with a 'puddle' of dark paint forming on the shaded side.

ABOVE THE TIMBERLINE

As you climb higher, above the timberline, the air becomes thinner and clouds frequently obscure your view – often you will be looking down onto clouds forming in the valleys below. Also, snow and ice will gradually begin to make an appearance in the landscape as it becomes increasingly inhospitable, yet visually appealing.

Looking Down into Valleys

It is a spectacular sight to stand on a high vantage point and look down into the valley below. The most striking aspect is the way in which the peaks of the mountains on the far side of the valley are visually sandwiched between the sky and clouds in the top of the scene, and the mist rising from the valley below, forming thick banks of rolling moisture.

These scenes are probably best painted by starting with the sky and then painting the hills and peaks in the distance – but don't allow the base to dry. Quickly dampen the area of mist or cloud and drop raw sienna towards the top and alizarin crimson and ultramarine mix towards the base. Use as much water as you dare to keep the edges soft and the paint bleeding freely.

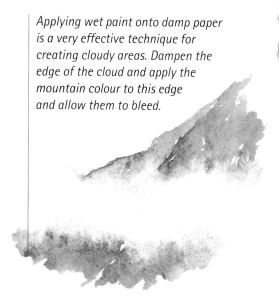

Applying wet paint onto damp paper is a very effective technique for creating cloudy areas. Dampen the edge of the cloud and apply the mountain colour to this edge and allow them to bleed.

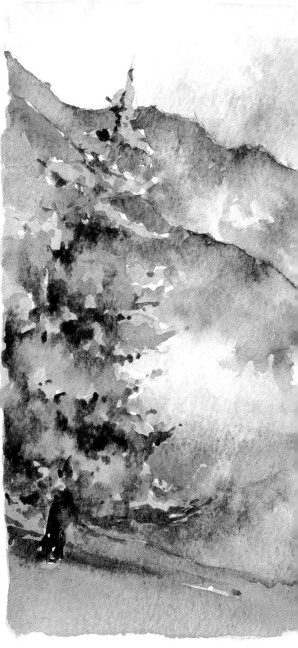

Cloud Edges
If possible, find an area where you can see above and below the cloud to practise blending and softening the tops and bottoms, sandwiching the 'negative' cloud in the middle.

RAW SIENNA ULTRAMARINE ALIZARIN CRIMSON

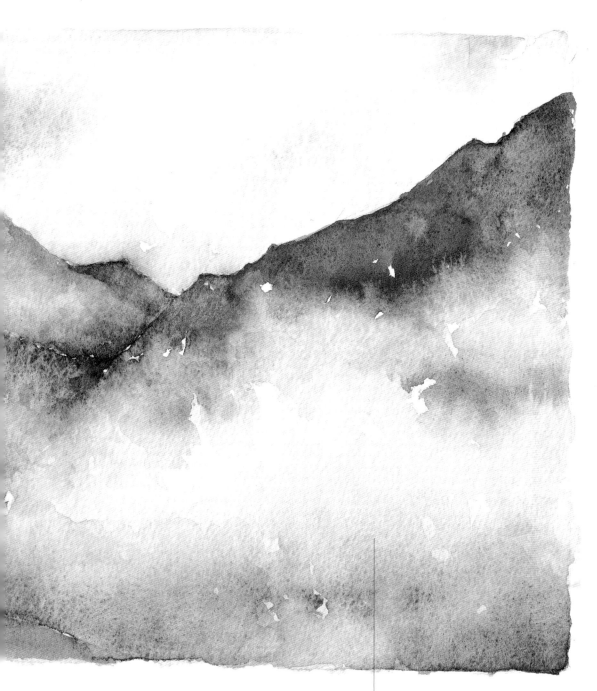

RISING CLOUDS

The early morning period is one of the most magnificent times to paint in mountains and valleys – especially as the light breaks and the colours of the day begin to grow in the clouds as they rise from the deep valleys below your feet.

Clouds hold much colour depending on the atmospheric conditions – with the main colours mixed from raw sienna, ultramarine and alizarin crimson.

Looking Down onto Clouds

Looking down onto clouds nestling along the tops of ridges and peaks is an inspiring sight – something that we rarely see unless we are in aircraft.

The key to recording such scenes successfully is to ensure that the cloud appears to roll gently over the top of the peaks in a non-uniform way – clouds are just moisture, which does not sit naturally in a straight line.

First, apply lots of water to the cloud area and drop in a few touches of Payne's grey with a hint of alizarin crimson – this will soon disappear to only a faint, neutral tone. Before this has time to dry, paint the hills and rocks, taking the colour right up to the cloud edge which will soften the paint as the two wet elements meet.

Should the colours blend too quickly, obliterating the white areas around the ridge, blot these areas with a sponge or some kitchen paper to soak up the wet paint. This also dries the paper, preventing any further accidental 'overbleeds'.

Soft Edges

A certain degree of haste was required to complete this picture as the rising cloud would soon engulf the entire ridge, leaving nothing of any physical substance left to paint.

Blotting

Kitchen paper can be used to remove wet paint, but this is a much harsher medium and leaves very clear marks, making it more suitable for moving, wispy clouds where definition is required.

Sponging

Using a sponge to mop up, or remove, watery paint from watercolour paper leaves a soft edge around the sponged area and is suitable for creating soft summer clouds.

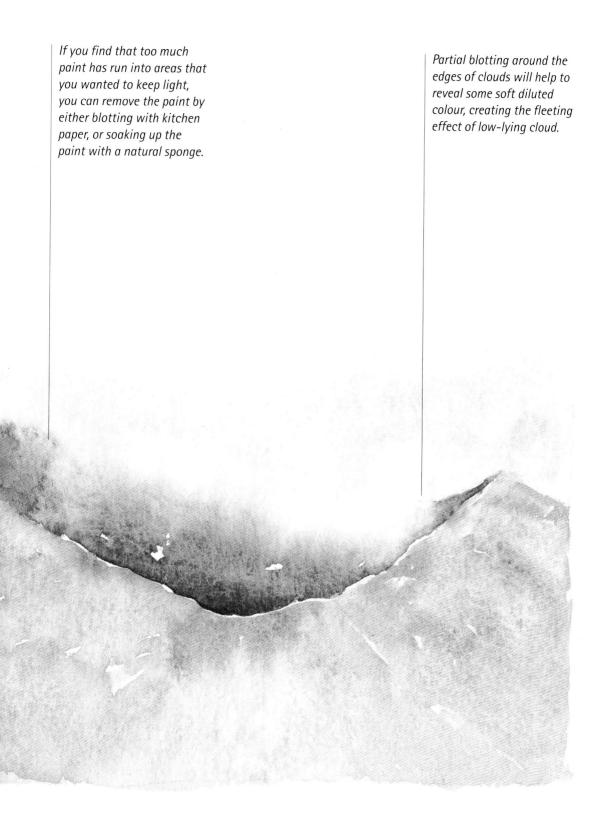

If you find that too much paint has run into areas that you wanted to keep light, you can remove the paint by either blotting with kitchen paper, or soaking up the paint with a natural sponge.

Partial blotting around the edges of clouds will help to reveal some soft diluted colour, creating the fleeting effect of low-lying cloud.

Colours in Ice

Some ice that has been created from dirty water will hold a muddy brown colour, otherwise the colours viewed will be largely those reflected from the sky, or those that we as artists choose to apply to suit our particular purpose.

The key to recording ice 'colours' is in the choice of colours used for the shadow mixes. Whilst some colours will impart a sense of cold, others will suggest slightly warmer feelings. Cerulean blue is a fairly cold colour and, when mixed with a very thin, watery alizarin crimson, you will have a shadow paint suitable for freshly frozen ice. However, older ice on slightly less chilly days will benefit from being mixed with Winsor blue, which helps to create a feeling of greater depth and warmth.

To create a soft shadow, apply the paint with a small brush to a previously dampened area of paper. For harder shadows, work directly onto dry paper.

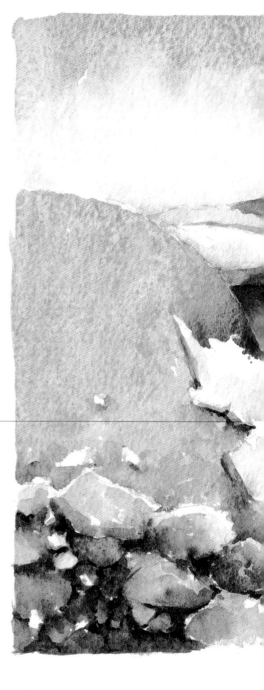

Ice does have a degree of 'thickness' and this can be recorded by painting a hard line of dark violet paint onto dry paper with a small brush.

Ice Tones
Direct sunlight cast onto ice can create 'warm' tones, whilst those areas in direct shade require 'cooler' tones. Try experimenting to see how different you can make any two violet tones.

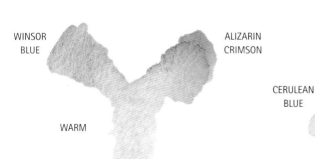

WINSOR BLUE

ALIZARIN CRIMSON

WARM

CERULEAN BLUE

ALIZARIN CRIMSON

COLD

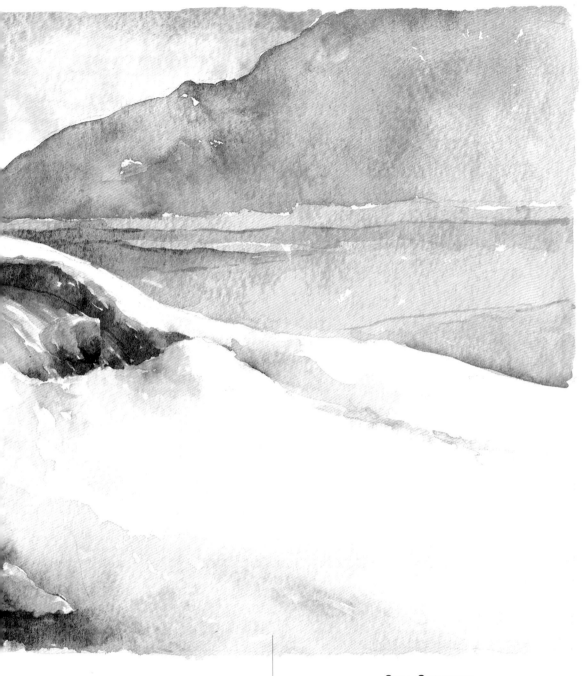

CERULEAN
BLUE

WINSOR
BLUE

ALIZARIN
CRIMSON

The lighter colours reflected from ice are based upon a watery mix of cool blues and violets.

COOL CONTRASTS

Ice bridges can still remain long after the once frozen water has melted, and form an uneasy visual relationship with their immediate environment – but this element of surprise is part of the appeal of painting in hills and mountains.

Rope Study

The higher mountainous regions sometimes require the use of some basic safety equipment – and the bright colours of many of these objects make them ideal subjects for sketchbook studies in the few moments that occur whilst unpacking and checking the working condition of all your backpack contents.

This particular study relies heavily on the linear qualities of the folded rope and possibly owes more to the initial pencil drawing than any specific watercolour painting technique.

Although the way in which the rope was tied did not create a perfect curve, the method used for painting curved surfaces was still applied.

Using a medium size brush loaded with cadmium orange, pull the paint 'around' the curve of the bulk of the rope – work onto dry paper as this will allow some natural 'highlights' to occur. As the paint dries, apply a shadow colour mixed from ultramarine and alizarin crimson to the shaded areas, working carefully around the overlapping ropes.

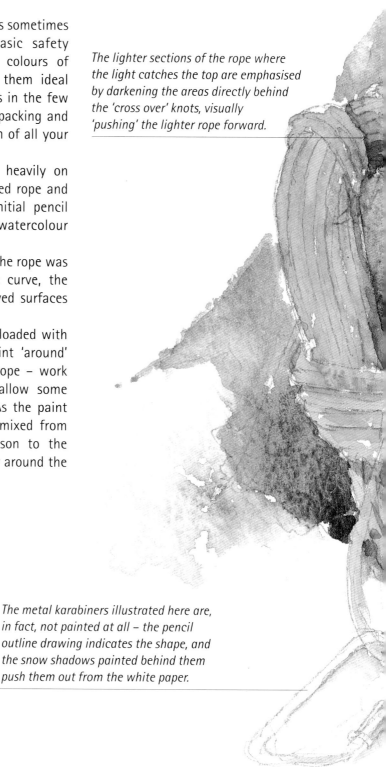

The lighter sections of the rope where the light catches the top are emphasised by darkening the areas directly behind the 'cross over' knots, visually 'pushing' the lighter rope forward.

The metal karabiners illustrated here are, in fact, not painted at all – the pencil outline drawing indicates the shape, and the snow shadows painted behind them push them out from the white paper.

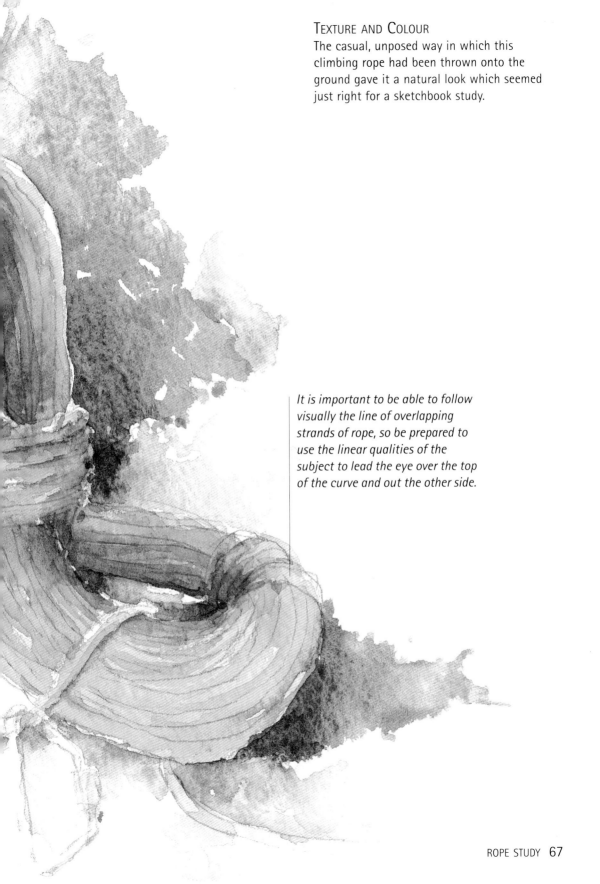

TEXTURE AND COLOUR

The casual, unposed way in which this climbing rope had been thrown onto the ground gave it a natural look which seemed just right for a sketchbook study.

It is important to be able to follow visually the line of overlapping strands of rope, so be prepared to use the linear qualities of the subject to lead the eye over the top of the curve and out the other side.

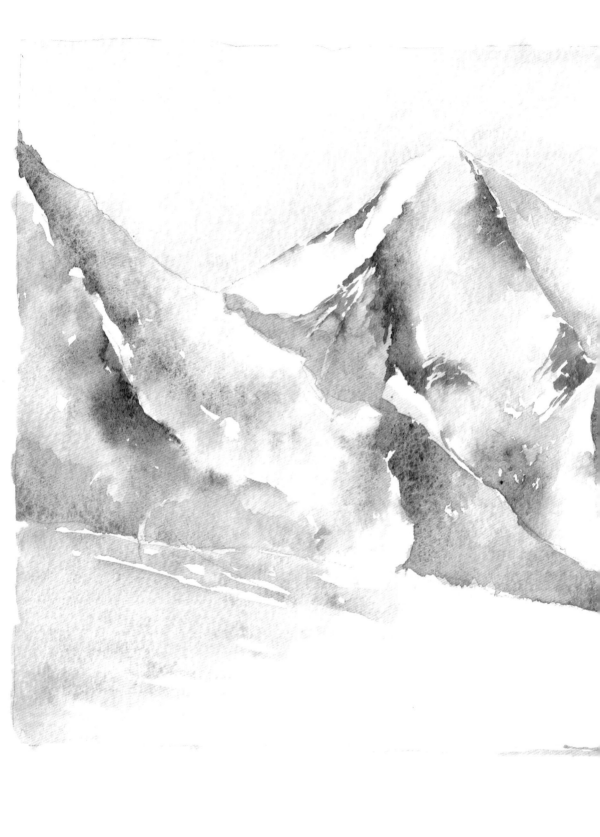

Snow and Ice

The sharp blast of ice cold air that welcomes artists brave enough to venture up above the snowline, is indicative of the conditions to come. A world
of white, cold greys and the occasional flash of colour
await hardy painters – but as always, the rewards are worth any of the discomforts.

ICED-OVER RIVER

Frozen rivers and lakes require very simple treatment – they hold only the colours they reflect from the surrounding hills, woodlands or rocks and crags – and so only require a limited paint range. Most of the colours will be tinged with grey – either made with Payne's grey, ultramarine and umber, or a combination of blues, sienna and crimsons. Use thin washes to exploit the stark quality of the white paper.

FROZEN REFLECTIONS
The bare, skeletal branches of the winter trees provided some fascinating reflections in the frozen river – both positive and negative shapes bouncing from the solid ice.

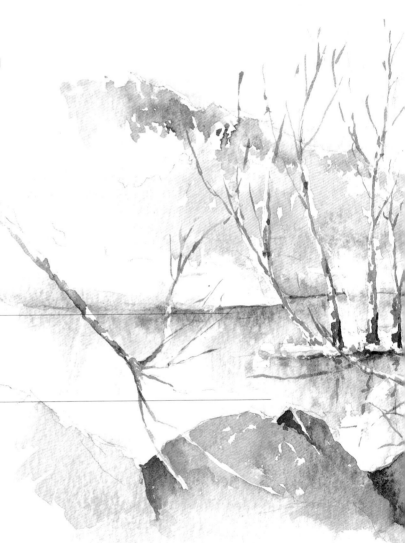

Painting reflections in ice involves single, one-stroke applications of paint, applied to a dry surface, using horizontal or vertical brushstrokes.

Only 'thin' colours should be used on ice – colours that have been diluted with a lot of water – as they go on easily and dry to a very soft, near translucent tone.

You do not need complex techniques. Use a brushstroke with a 'one stroke' vertical action to pull the paint downwards in clean, clear streaks, leaving flashes of pure white paper in between, reinforcing the 'high key' of the ice.

The range of tones in this study was crucial – the more warm and cool tones you use, the more the ice in your picture will 'sparkle'.

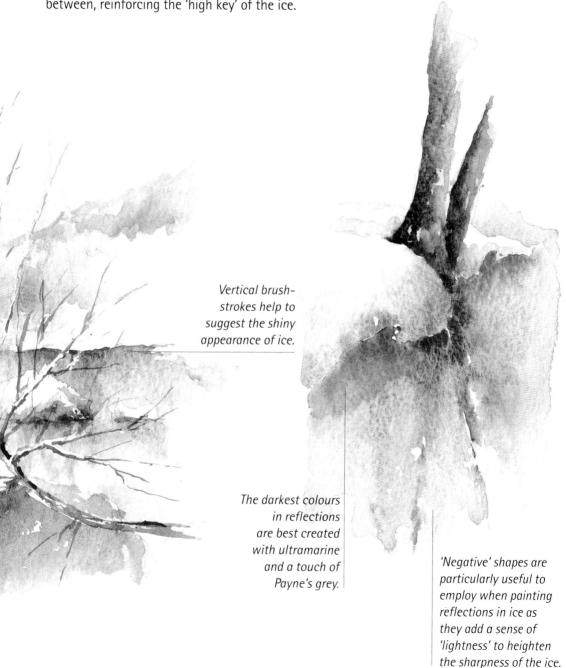

Vertical brush-strokes help to suggest the shiny appearance of ice.

The darkest colours in reflections are best created with ultramarine and a touch of Payne's grey.

'Negative' shapes are particularly useful to employ when painting reflections in ice as they add a sense of 'lightness' to heighten the sharpness of the ice.

Snow-capped Peaks

Colours and shadows often become sharper and more intense in the fresher, thinner air of the higher peaks. Whilst the snow is usually pure and freshly fallen, it still needs to be treated to colour in the areas that fall in the shade of the mountain. Strangely, in these extreme atmospheric conditions, it is quite possible to use 'warm' and 'cold' colours within the same composition.

The side of the peak facing the sun can be treated to very gentle toning using a 'warm' mixture of ultramarine and alizarin crimson, reinforcing the fact that the sun is shining on the snow.

The side of the mountain that is in shadow, however, needs to be treated to a 'cold' shadow mixture of Payne's grey and ultramarine – these colours are applied to the snow on the shaded side.

The two warm and cool tones of the shadow colour are blended on the glacier as the two elements join to create the foreground.

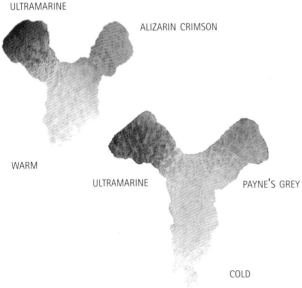

ULTRAMARINE

ALIZARIN CRIMSON

WARM

ULTRAMARINE

PAYNE'S GREY

COLD

Different Mixes
Snow visually reflects and absorbs colour – especially the areas in strong shadow. As with ice, experiment to see which tones you can mix to emphasise the differences – 'warm' and 'cold'.

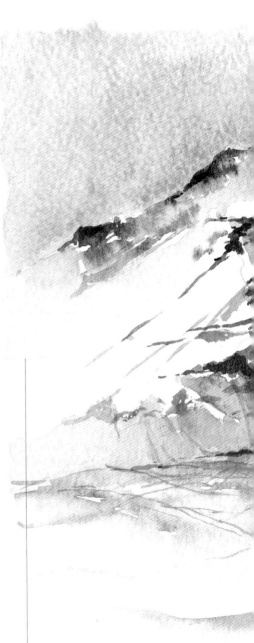

It is important to work onto dry paper, ensuring that much white paper is allowed to 'work' for you, representing the areas of pure, highlighted snow.

...e contrast between the dark rocks and ...e pure unpolluted snow is enhanced by ...ense dark greys mixed with Payne's grey, ...ramarine and burnt umber.

 BURNT UMBER

 ULTRAMARINE

 PAYNE'S GREY

 ALIZARIN CRIMSON

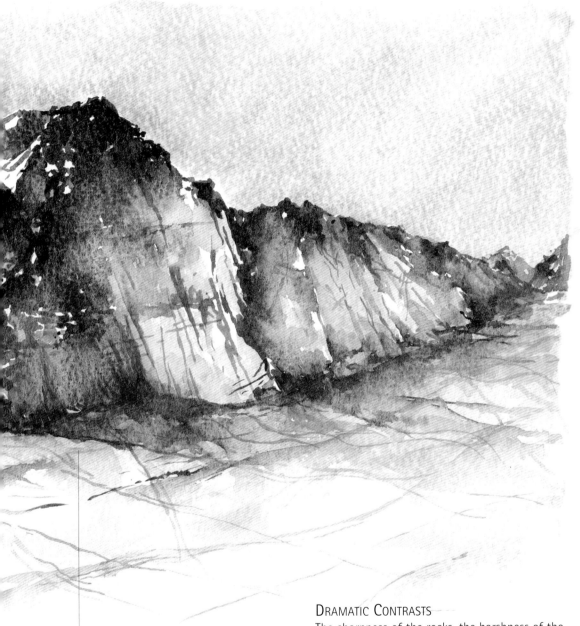

A chisel-headed brush can be particularly useful for recording the sharp, angular glacial ice often found at the base of many high mountains.

DRAMATIC CONTRASTS

The sharpness of the rocks, the harshness of the light and the brilliance of the reflecting snow faces made this high level peak a challenge to paint as many contrasting elements needed to be gently synthesised using only watercolour paints.

BLIZZARD

Blizzards can occur at any time in the high, snow-clad mountains, but the ferocity of the storm is all part of their visual appeal.

To create the effect of snow, dip an old toothbrush into some masking fluid and flick this onto the paper, creating a random coverage. Masking fluid is a water resistant, rubbery liquid that can be peeled off the paper once paint has been washed over it, leaving flecks of white paper untouched.

Next, flood the sky or cloud area with water and immediately drop burnt umber,

USING MASKING FLUID

1 First dip an old toothbrush into masking fluid solution, angle the head, and flick the rubbery solution across your paper.

2 When it has dried, gently wash you first coat of paint across the paper – taking care not to dislodge any dried spots of masking fluid. You can now flood the paper with as many colours as you wish, as the paper under the masking fluid is fully protected.

ultramarine, Payne's grey and raw sienna onto the paper – the colours will run and bleed on the surface water, creating a complex set of shapes and tones.

Then, add any appropriate shading to the foreground – this will rarely hold any colour in the middle of a storm – a simple, plain grey will suffice.

When the paper is totally dry, gently rub the surface of the painting to remove the masking fluid, exposing the white paper left untouched by paint.

To create the idea of snow swirling around you, flick masking fluid in a variety of directions, rotating your paper with each 'flick'.

A variety of 'tobacco' colours are often to be seen in storm clouds and are best created by applications of burnt umber, raw sienna and Payne's grey.

It is important to maintain a few flashes of white paper, clearly defining the peaks of the hills.

Snow Storm

When confronted with such an awe-inspiring scene as an approaching snow storm in the mountains, the main area of consideration is to capture an overall impression of the scene through rapid use of colour onto very wet paper – the detail in the foreground becomes surprisingly unimportant.

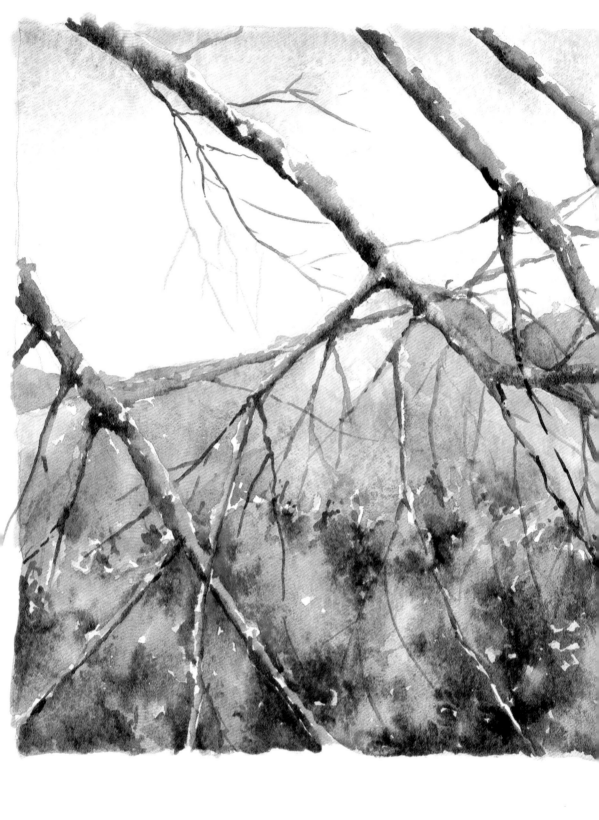

Practise your Skills

The journey through the foothills, mountain passes and high peaks undertaken so far has examined a variety of techniques and colour mixes. Now it is time to examine the techniques involved in completing a full-scale painting, taking you through the processes 'step by step'.

A Natural Palette

The picture painted for this project relied heavily on some 'natural colours' – raw sienna and burnt umber – both pigments dug from the foothills of the European Alps, as well as the more natural looking olive green. Of course, other colours were used either directly, or as 'mixers', but the overall tone was set by the siennas and umbers. This is something to bear in mind when painting in any outdoor environment – the more 'natural' colours (as opposed to those created by chemists), the more at ease they will look when incorporated in the scene that you are painting.

In the study I made prior to starting this composition, it soon became obvious that the more limited the number of colours used, then the more tones of those colours I would be forced to mix. A box full of colours taken straight from an art store shelf will look very appealing. But what do you do with all those colours other than just use them? This could mean that you will end up using the wrong colours just because you have them. My advice, therefore, is to start off with only a handful of paints and practise mixing as many different tones of these colours as you can.

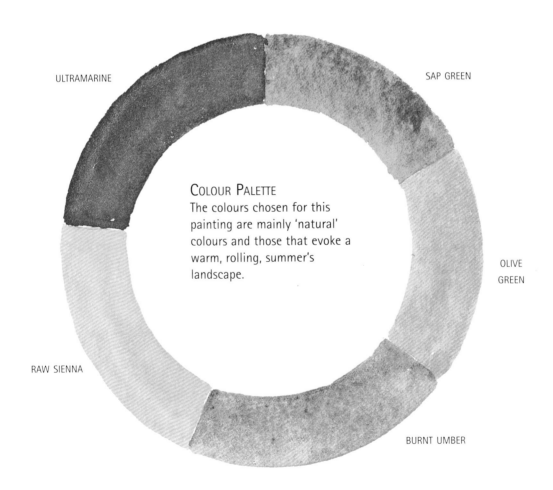

ULTRAMARINE

SAP GREEN

OLIVE GREEN

RAW SIENNA

BURNT UMBER

Colour Palette
The colours chosen for this painting are mainly 'natural' colours and those that evoke a warm, rolling, summer's landscape.

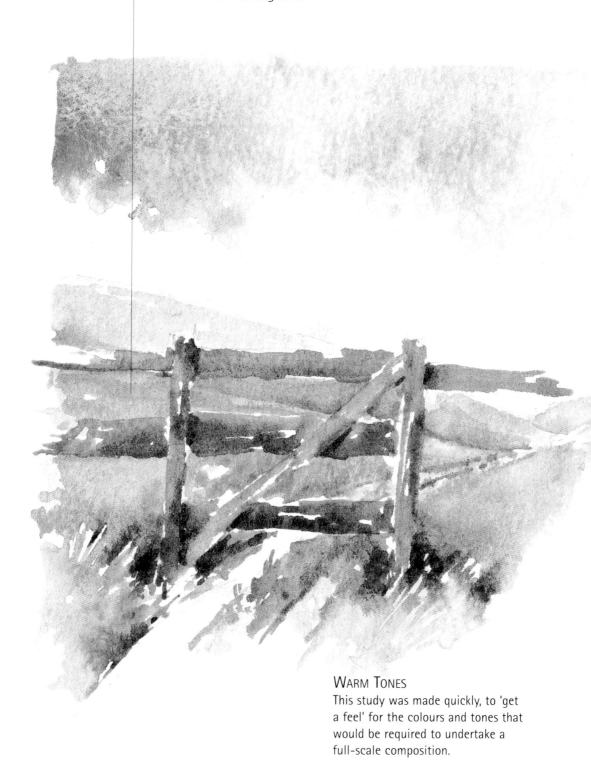

A raw sienna underwash 'underpins' the olive green, allowing the natural warmth of each colour to work together.

WARM TONES
This study was made quickly, to 'get a feel' for the colours and tones that would be required to undertake a full-scale composition.

ROLLING HILLS

The space between your feet and the horizon is the hardest area to capture effectively in paint. This project examines the use of tones of green tones to suggest distance – the lightest on the far horizon, and the darkest close up in the immediate foreground, with a wide range of tones for the details in between.

Defining the gently rolling hills by the use of shadows is also another feature of this project, again, using tone at all times.

MATERIALS

- 425 gsm (200 lb) watercolour paper

- Brushes – 1 large (size 12), 1 medium (size 8), 1 small (size 2)

- Watercolour pan paints – ultramarine, raw sienna, burnt umber, olive green, sap green

1 The first stage of this painting was to establish the overall mood of the day by painting the sky – this involved dampening the sky area and applying ultramarine to the top using a large brush, letting the paint bleed downwards to create the cloud shapes.

2 While the paper was still damp, I pulled a wash of raw sienna along the base of the cloud shapes and allowed that to bleed upwards into the clouds.

3 The next stage was to paint a watery wash of raw sienna onto the ground. This was laid onto dry paper, working around the fence to create broken brushstrokes and a few light 'highlight' flashes of white paper.

4 Once this underwash had dried, I used pure olive green and, using a small brush, began to paint the hills in the far distance.

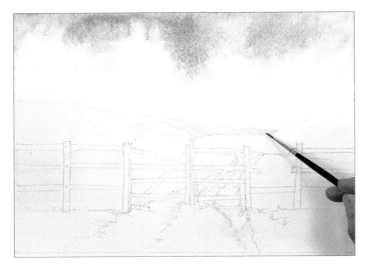

5 Changing to a medium brush, I continued, starting to define the individual hills with varied tones of olive green and raw sienna.

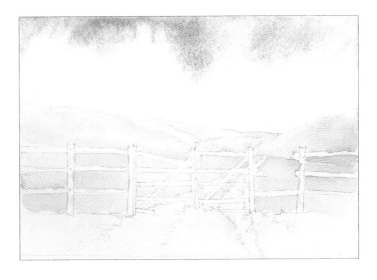

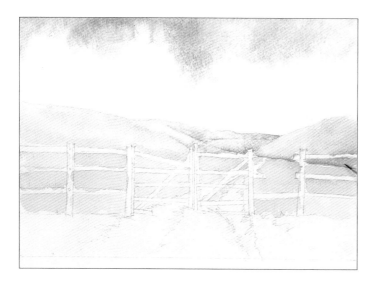

6 Again, this coat of paint was allowed to dry. Sharper definition of the hills was still required, so I introduced some sap green mixed with a little ultramarine and began to paint 'behind' the hills, creating shadows which visually pushed the tops of the hills forward.

7 The foreground now had to be brought into sharper focus. I intensified the sap green and ultramarine mixture, dampened the area of paper in the immediate foreground and dropped the paint on – it instantly bled outwards creating a feathery grass blade effect.

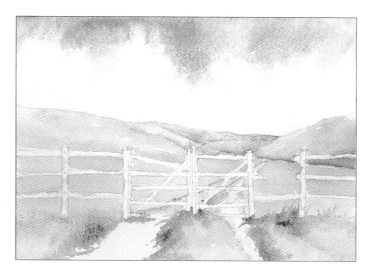

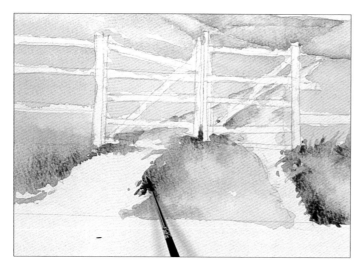

8 As the foreground wash dried, I ran another line of paint along the base of the tufts of grass with a small brush to create a sense of shading and shadow.

9 *The rickety old fence could now be painted using a mixture of raw sienna, burnt umber and ultramarine, leaving some flashes of white paper to act as highlights.*

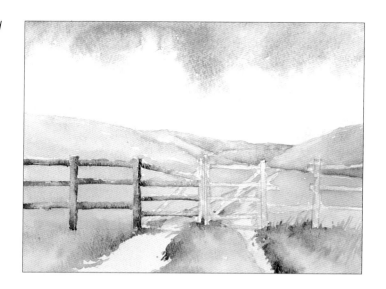

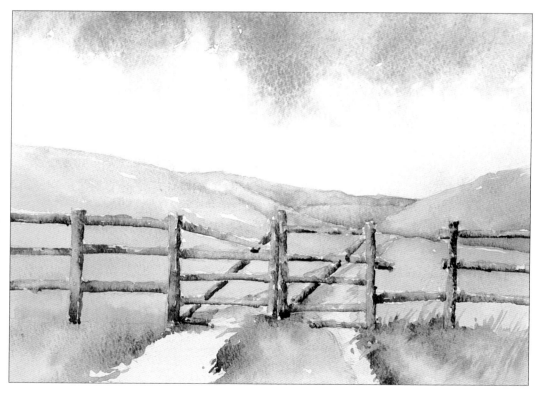

10 *Once the entire fence was completed the whole composition needed to be 'brought together' by the addition of a little sandy colour on the path using raw sienna, and by adding some shadows under the line of the fence.*

DISTANCE

The sense of distance in this gentle landscape has been created by the use of mixtures of green – especially the addition of blue to the hills in the furthest distance. The fence acts as a centre of focus – without this the landscape would still recede away into the distance, but the whole composition would appear very dull without any one specific feature to attract our interest.

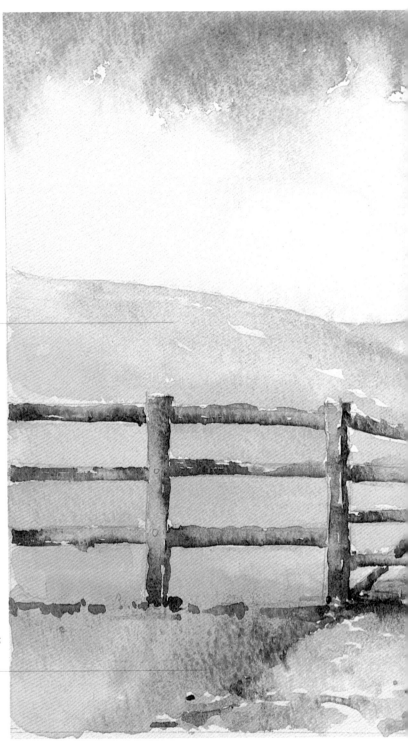

The raw sienna underwash can clearly be seen through the thin layer of green paint, adding an element of 'warmth' to the scene.

Shadows underneath the fence visually 'anchor' it to the ground – these were painted with the fence colours mixed with a little green.

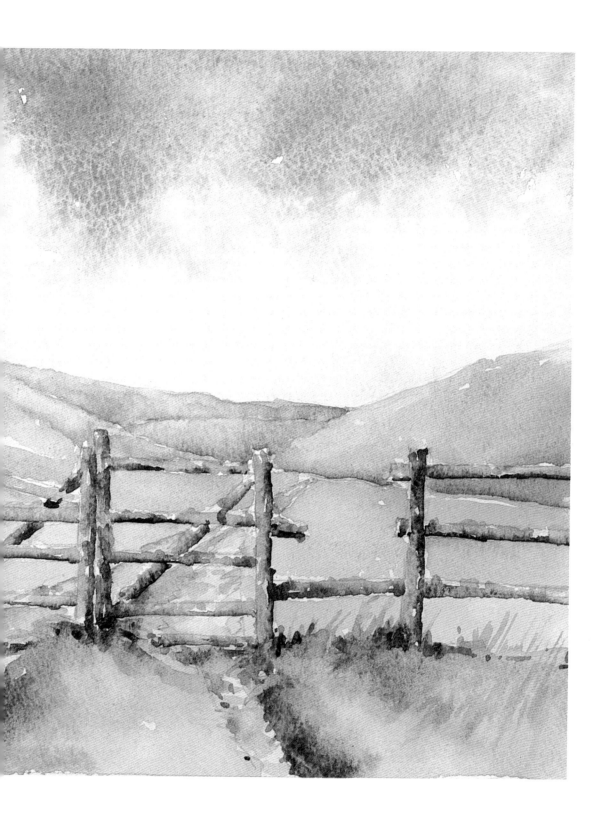

Mountain Scene

Mountains come in a wide variety of shapes and sizes, and you can never be absolutely certain whether you will be able to see all, or just simply part, of any one at any time. But this level of unpredictability is possibly part of the appeal of painting in the mountain environment.

The coolness of the mist-laden day on which this particular scene was painted required the choice of some 'cold' paints, that is, colours which will impart a sense or feeling of being cold. I used Prussian blue and Payne's grey.

The study made prior to planning out the full-scale painting relied heavily on the use of water-soluble graphite pencil. These are highly portable sketching tools that can be used with or without water, and also help to add to the 'cold' impression by virtue of the greyness of the graphite used in their manufacture. These pencils combine well with watercolour paints when sketching, as they very quickly provide an element of solidity which can take a long time to build up with just watercolour paint, due in part to its natural translucency.

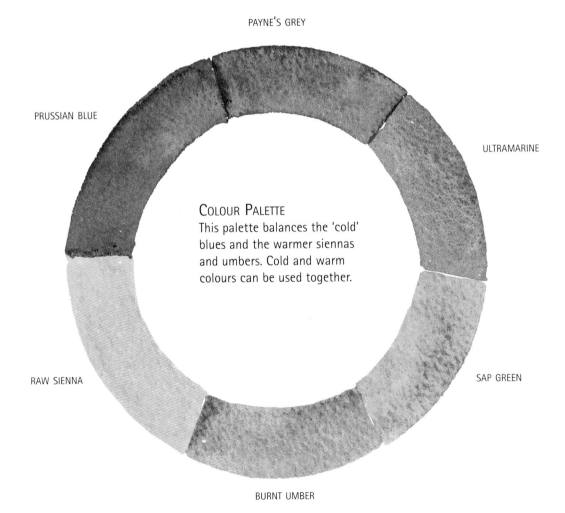

PAYNE'S GREY

PRUSSIAN BLUE

ULTRAMARINE

COLOUR PALETTE
This palette balances the 'cold' blues and the warmer siennas and umbers. Cold and warm colours can be used together.

RAW SIENNA

SAP GREEN

BURNT UMBER

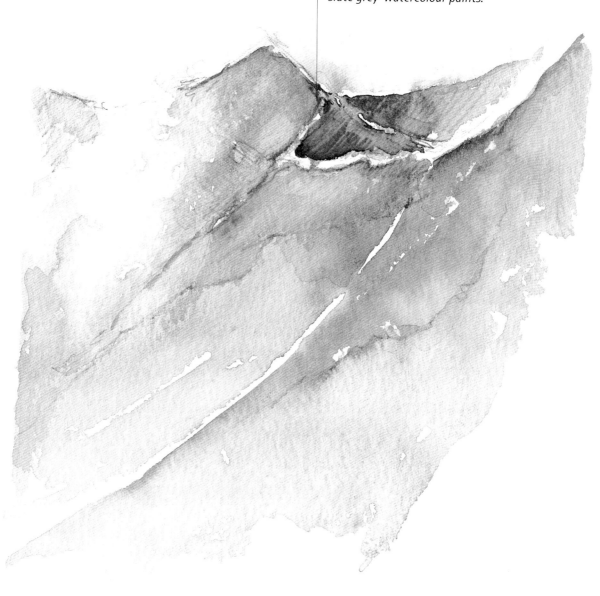

This preliminary study relied on the tonal qualities of water-soluble graphite pencil which would, eventually, have to be translated into 'slate grey' watercolour paints.

ASSESSING THE SCENE
The contrast between the dark rock face and the light mist is one specific area of interest – always look for these contrasts when making sketches.

APPROACHING STORM

It can be truly awe-inspiring, and even frightening, to witness the approach of a storm in mountainous country. The rolling clouds, the darkening sky and the way in which the storm starts to dominate the landscape, are all ominous indicators of trouble ahead. But for those brave enough to stay put and sketch the approaching weather, the rewards are great indeed.

I used a limited palette of colours to link the land and sky, blending wet-into-wet to achieve gradations from light to dark.

MATERIALS

- 500 gsm (250 lb) watercolour paper

- Brushes – 1 large (size 12),
 1 medium (size 8),
 1 small (size 2)

- Watercolour pan paints – raw sienna, Prussian blue, burnt umber, ultramarine, Payne's grey, sap green

- Water container

- Kitchen paper

1 *To establish the rain-laden clouds, I dampened the sky above the mountains. I applied a light wash of raw sienna with the large brush, following the mountain slope. INSET: I applied a dark green mixed from Prussian blue and burnt umber, to dry paper at the top of the sky. I allowed it to blend into the raw sienna. With a damp brush, I moved the paint to create different textures.*

2 *I added a touch of ultramarine into the green on the right with a damp brush. The colours blend to give dark greys and blues that give form to the underside of the towering storm clouds. Using the large brush, I brought the colour down over the mountain top to suggest the clouds rolling over the ridge.*

3 Next, I continued to build the shape of the clouds using a dark mix of Payne's grey, ultramarine and a touch of burnt umber. I dotted this colour with a very damp medium brush on to the clouds and allowed the colour to seep and feather into the green.

4 I varied the intensity of the wash from Step 3 and added it along the top of the sky, tipping the paper to allow the colours to run and blend accidentally. The sky area was now nearly complete and I began to work on the distant hills.

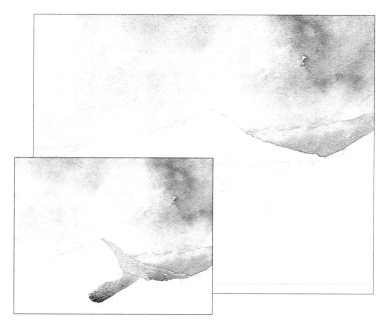

5 I added the distant hills with a cool mix of the sky colour together with a touch of sap green and raw sienna, leaving flashes of white paper to suggest light bouncing off the rocks. I deepened the mix with raw sienna to give a sense of distance and left the paint to form a puddle to give a denser colour. INSET: Using the same blends to vary tones and give depth, I created pockets and shapes of colour with broken strokes to suggest the craggy mountainside.

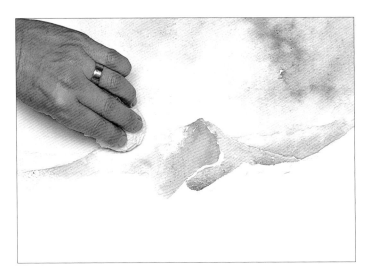

6 Working with the large brush, I used a darker green-blue mix for the side of the mountain, encouraging the paint to bleed. I added more water to the wash to vary the tone of the mountain in the middle ground, allowing the paint to move freely. I blotted off any excess wash with kitchen paper.

7 At this stage, I assessed the overall painting. The sky and horizon were working well where the different tones and blends had created a feeling of depth and form. The soft edges to the clouds give the impression of approaching weather and blur the division between sky and mountain along the horizon.

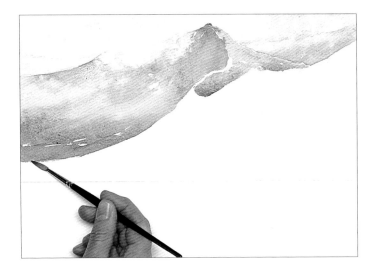

8 I applied a light green to the middle ground with a dry brush. Using a darker mix of ultramarine, burnt umber and a touch of raw sienna, I applied long strokes to follow the sweep of the mountainside. To break the smoothness, I overlaid short strokes of colour leaving a few areas white to represent patches of snow.

9 Next, I started to work on the foreground. Using a mix of raw sienna and ultramarine, I followed the sweep of the moutainside with the large brush, using rapid brushstrokes and grading the tones from light to dark to give a sense of recession. While the paint was still damp, I used the medium brush to reinforce the detail of the underside of the rock outcrops.

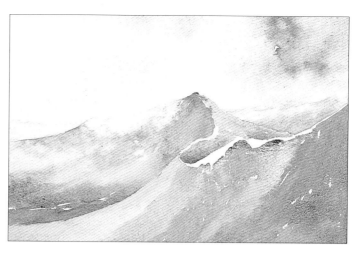

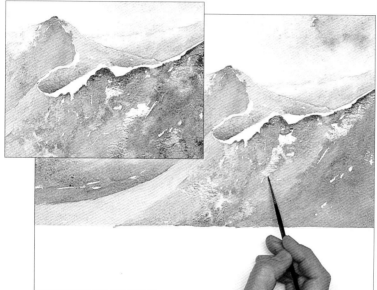

10 I used a small brush with touches of the darker mix from Step 9 to drop paint and water onto the hillside to break the broad bands of colour, leaving the paint to feather and blend freely. *INSET:* I added more intense colour to the foreground area, using a damp brush to blend the colours and give the effect of dappled light.

11 In the final stage, I allowed the paint to dry slightly, then reworked some areas layering wet paint to follow the pattern of the dry paint beneath to give the impression of pockets of mist. Using a small brush, I ran a dark brown mix of ultramarine and dark umber into the paint.

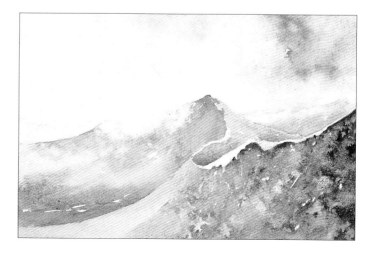

Graded Tone

The limited palette used in this painting has been extended to achieve a remarkable range of tones for both the sky and the mountainside. The progression from light to dark across the mountainside gives the impression of a vast landscape. The layering of colours in the sky has resulted in a subtle suggestion of towering rain clouds rolling across the mountain tops.

The varied tones give the suggestion of light coming through the clouds.

The light wash brought over the moutain ridge suggests rolling clouds of mist.

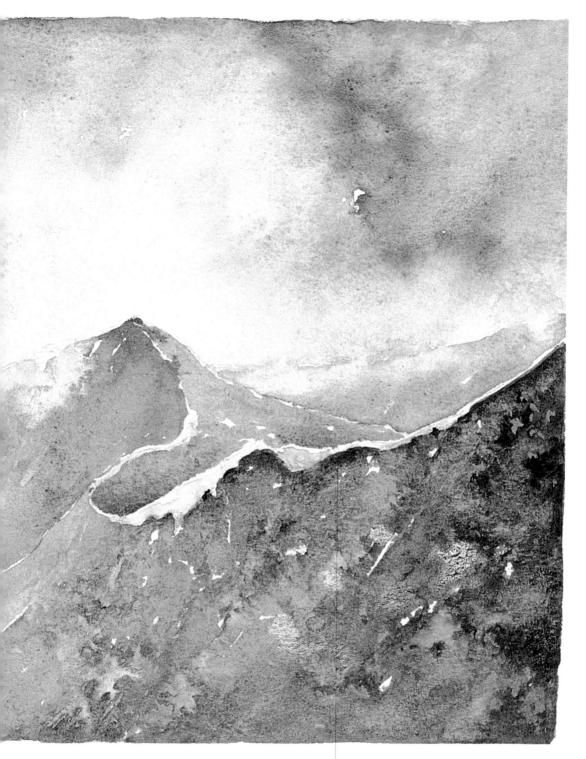

I knocked back the harsh white of the ridge with a light wash of sap green with a touch of raw sienna.

Rock and Boulder Path

Whilst the actual path only takes up a very thin part of this composition in terms of space used, it is in fact central to the success of the whole picture as it provides a means of visual access to the mountains in the distance. Our eyes are naturally drawn to such linear facets rather than the flatter areas of mountain meadow surrounding the path and this, as a consequence, provides the area of central interest or focus within the picture frame.

It was, therefore, important not to get carried away with the actual number of boulders or stones that were present in the path as this could make it dominate the scene if it contained too much detail. A simple suggestion of their shapes, therefore, suddenly became very important.

As in the study of rocks and boulders, it is not really possible or desirable to include every pebble, rock, stone or chip that you see. Instead, focus on a few prominent rocks or stones – these need not necessarily be the largest, in fact a spread of sizes is particularly desirable. The most effective method of suggesting such objects is spacing – make sure that you space your 'drawn' rocks unevenly without any discernible pattern. This makes them all the more interesting to look at.

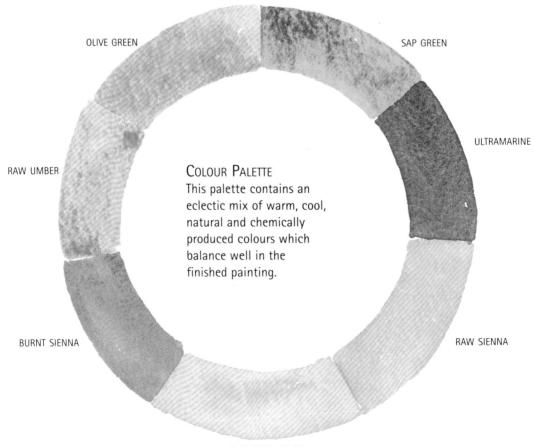

OLIVE GREEN

SAP GREEN

ULTRAMARINE

RAW UMBER

Colour Palette
This palette contains an eclectic mix of warm, cool, natural and chemically produced colours which balance well in the finished painting.

RAW SIENNA

BURNT SIENNA

CADMIUM YELLOW

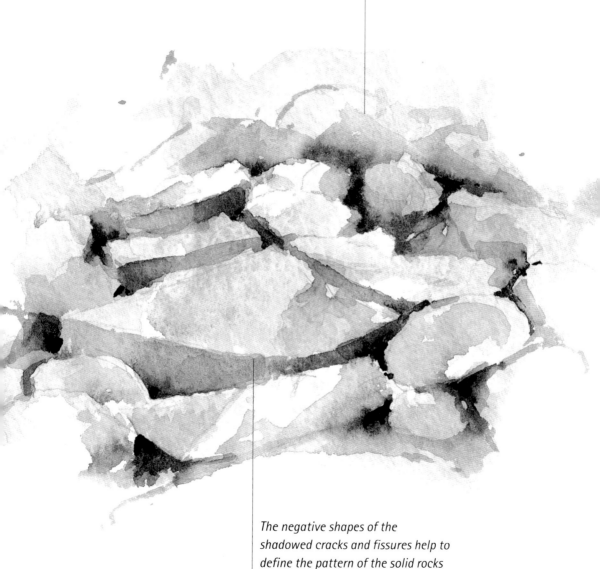

SPACES IN BETWEEN
'Negative' shapes can make even more interesting shapes than the 'positive' rocks and boulders.

A watery underwash onto dry paper will dry unevenly leaving watermarks which can be turned into rocks and boulders by making a few appropriate marks around them.

The negative shapes of the shadowed cracks and fissures help to define the pattern of the solid rocks and boulders that make up the path.

ROCKY PATH

This project involved following the sweeping line of a rocky path through lush green lowlands to mountains rising in the far distance.

The path was the centre of focus throughout the painting process and needed special attention towards the end – exactly how much detail to paint in and just how much to suggest was the key question.

MATERIALS

- 425 gsm (200 lb) watercolour paper

- Brushes – 1 large (size 12), 1 medium (size 8), 1 small (size 2)

- Watercolour pan paints – sap green, ultramarine, Payne's grey, raw sienna, olive green, cadmium yellow, burnt sienna, raw umber

1 *The scene was sketched out including some of the details on the path and then a wash of ultramarine was applied to the sky.*

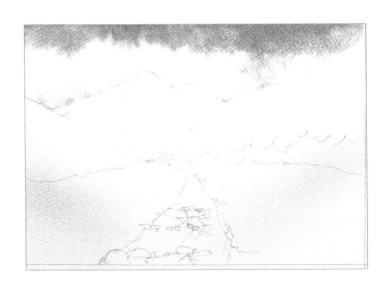

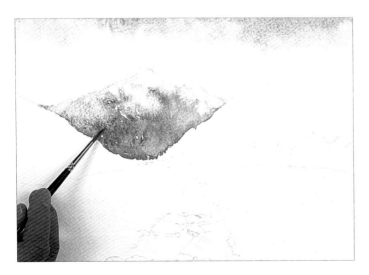

2 *Then, to establish the basic colour for the distant mountains, working onto damp paper, sap green, ultramarine and Payne's grey were painted at the base. The damp paper encouraged the colours to merge to create a mist around the peak. As this dried, a wash of raw sienna was applied to the mountain meadows, working onto dry paper with a dry brush.*

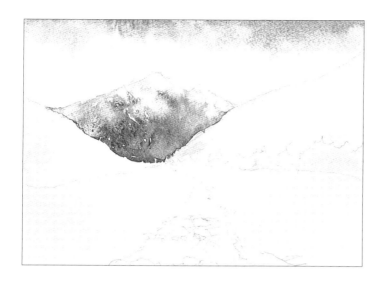

3 Once this had dried a medium size brush was used to drag a wash of olive green and raw sienna across the meadows, leaving flashes of the underwash showing through.

4 The row of trees on the right could now be established. The season required the use of autumnal colours – raw sienna, burnt sienna, cadmium yellow and some sap green. These colours were painted onto dry paper to create shapes in the trees.

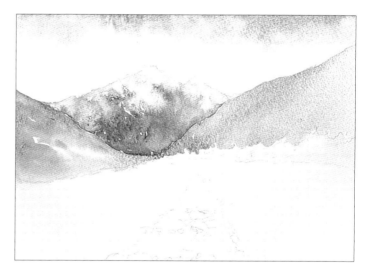

5 To make them stand out in the landscape, a small brush was used to paint a very dark mix of sap green and ultramarine along the bottom of the trees, creating shaded areas and 'anchoring' them to the ground.

6 Next, I started to work on the immediate foreground. Once again, I applied a wash of the warm raw sienna with a large brush, working onto dry paper to achieve a patchy appearance.

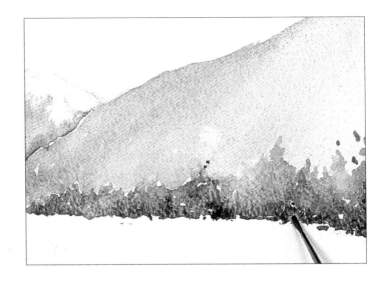

7 While the underwash was drying, I mixed some raw sienna with sap green and a touch of burnt umber to give the colour a little more visual 'weight'. Starting at the bottom of the paper, I pulled the paint upwards towards the horizon, allowing the underwash to break through in parts.

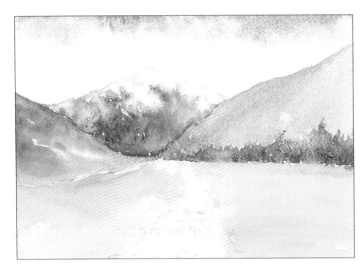

8 It was now time to look closely at the path. I had sketched a few of the boulders already and intended to use paint to suggest others. A raw umber wash was dragged along the length of the path using broken brushstrokes.

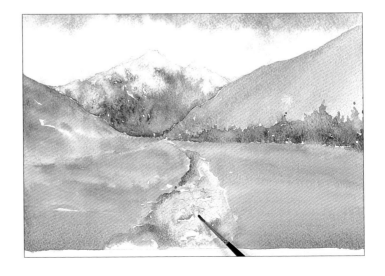

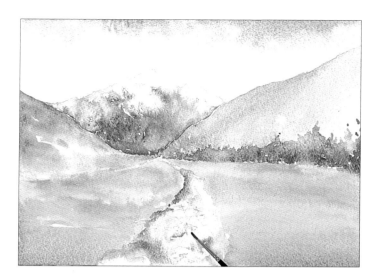

9 As this was drying, I mixed a combination of raw umber, burnt umber and Payne's grey and, using a small brush, began to pick out a few areas of dark and shade. The paint bled on the damp paper and dried with a watermark.

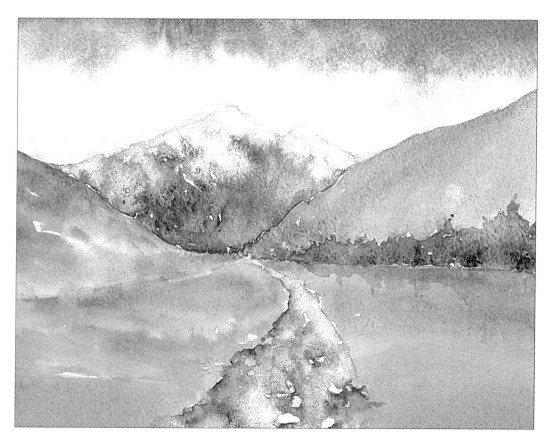

10 The final stage of this painting was to use a small brush to 'draw' some of the rocks and boulders in the immediate foreground.

SUBTLE DETAILS

Suggestion, rather than excessive detail, was the key to this painting. Shadows and shading are suggested on the row of trees in the middle ground. The rocks and boulders in the foreground are not all painted as positive shapes – many are the result of negative shapes that have occurred as watery paint has dried onto a dry paper surface.

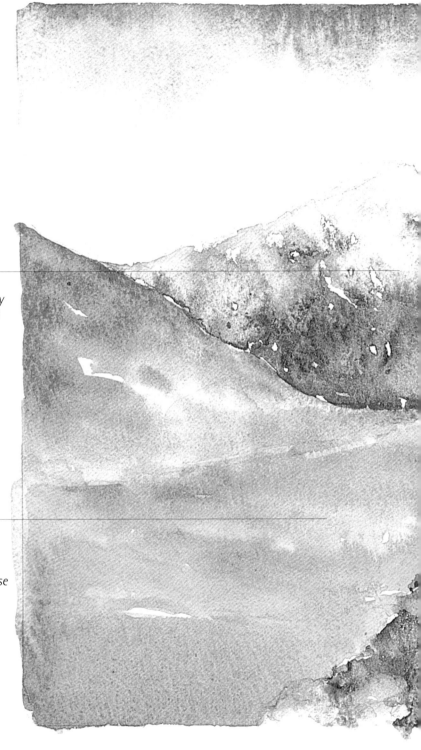

The misty effect on top of the mountain was created by allowing the colours applied to the rock face at the bottom to bleed upwards into damp paper with no other intervention.

The raw sienna underwash can be seen through the broken brush marks, acting as highlights on an otherwise flat surface.

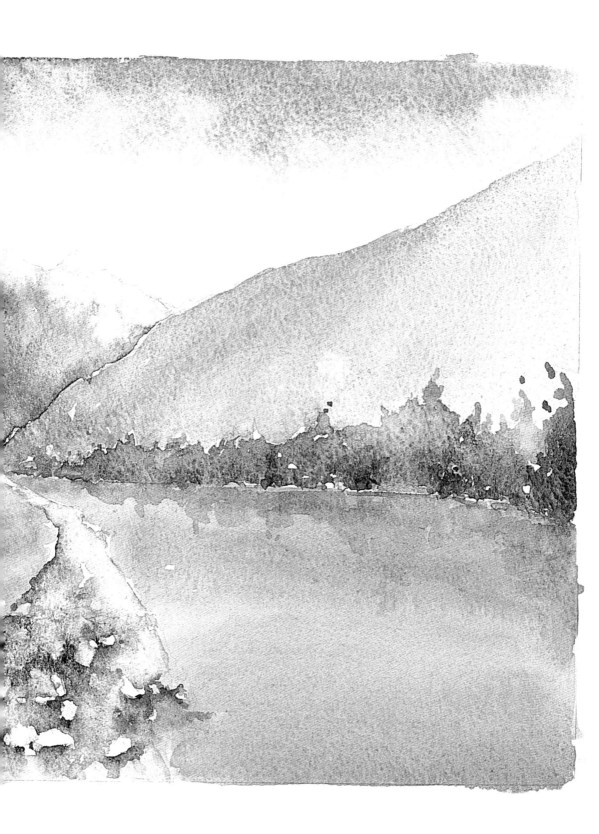

Snow-Covered Peaks

One of the main problems with painting snow is exactly how do you paint white snow onto white watercolour paper. The answer is two-fold. First, much of the snow will paint itself – pure, untouched white watercolour paper will produce the sharpest, clearest white you will find which certainly is the equal of the glare given off by most snow fields. Second, many areas of snow will not actually look white as they will be in the shadow of overhanging ledges, rocks, or even large boulders. These areas need to be painted with a mixture of soft blues and violets. These natural blue-grey tones are clearly reflected in my choice of colours for this particular project: one warm blue (ultramarine), one cool blue (cerulean) and Payne's grey, which is a chemically-manufactured paint using a combination of blue and black.

Personally, I never use pure black in watercolour paintings as it has the effect of visually 'flattening' anything that it comes into contact with. To create a really dark tone that will do a similar job, I recommend a strong mixture of burnt umber and ultramarine – the resulting colour is rich with a much better visual depth.

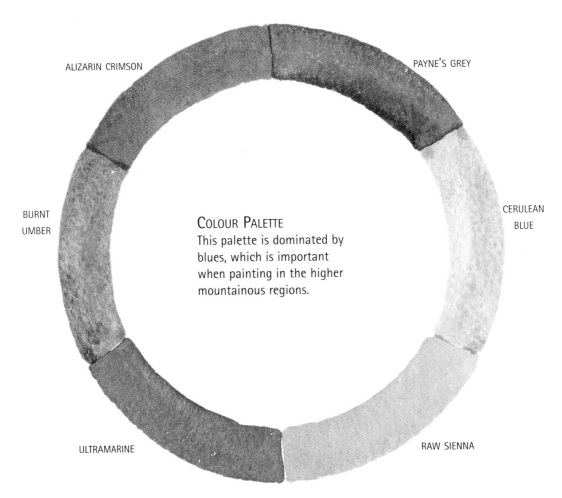

ALIZARIN CRIMSON

PAYNE'S GREY

BURNT
UMBER

CERULEAN
BLUE

COLOUR PALETTE
This palette is dominated by
blues, which is important
when painting in the higher
mountainous regions.

ULTRAMARINE

RAW SIENNA

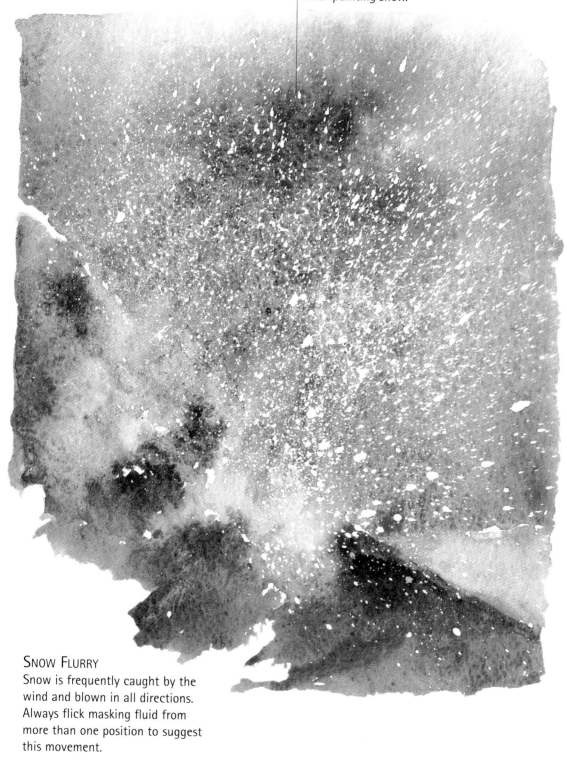

Use as many tonal mixtures of blues and violets as you can possibly mix to achieve a sense of depth and recession when painting snow.

SNOW FLURRY
Snow is frequently caught by the wind and blown in all directions. Always flick masking fluid from more than one position to suggest this movement.

FALLEN SNOW

This particular painting relied heavily on the interplay of light between the sky and the snow-clad mountainside – both served to reflect each other.

As snow holds no real colour of its own, it is our job as artists to look for the colours that are reflected and to turn those into the correct mixture of paints.

This project also relied heavily on the use of pure white – the purity of the paper being preferable to any white paint.

MATERIALS

- 425 gsm (200 lb) watercolour paper
- Brushes – 1 large (size 12), 1 medium (size 8), 1 small (size 2)
- Watercolour pan paints - cerulean blue, ultramarine, alizarin crimson, raw sienna, burnt umber, Payne's grey

1 The sky was dampened and a wash of cerulean blue was run along the mountain tops and pulled upwards. Before this could dry, a wash of ultramarine was run along the top of the paper and pulled downwards, creating a graduated wash.

2 While the paper and surface paint were still damp, I introduced a soft violet colour into the sky, mixed from ultramarine and alizarin crimson, washing it down from the top with a large brush.

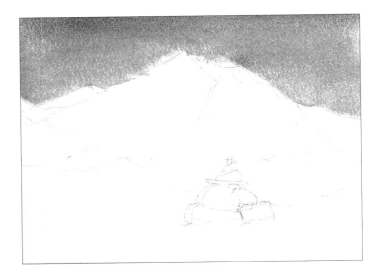

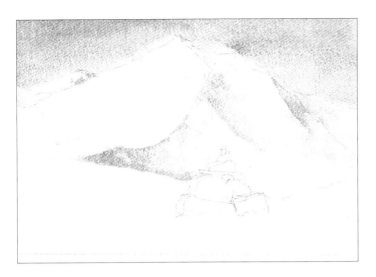

3 *The soft violet used in the sky was also used to 'block in' the main areas of shadow on the mountainside, working with a medium size brush onto dry paper.*

4 *The rock underneath the snow line was painted next, using a small brush with a mixture of raw sienna and Payne's grey. I pulled the paint upwards to meet the snow where it was left to dry with a hard line.*

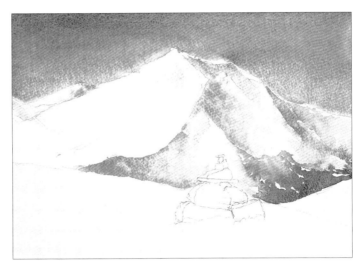

5 *I then mixed a stronger version of the soft violet by increasing the amount of ultramarine, and began to reinforce the darkest shaded sections by painting them with a small brush.*

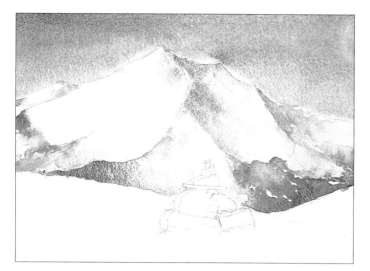

6 *Having established the very light tones of shadows and the deepest, darkest areas of shade, I was able to judge exactly how light or dark the 'middle' tones should be. These were mixed with a little raw sienna and the original soft violet, and painted onto outcrops across the mountain.*

7 *It was now time to concentrate on the immediate foreground by painting in the shadows cast by the dips and protrusions in the snowfield, highlighting the stone cairn as a negative shape.*

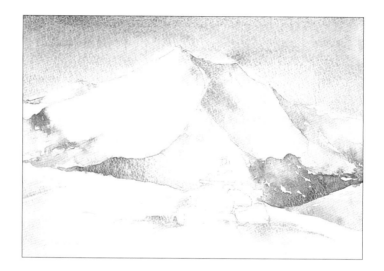

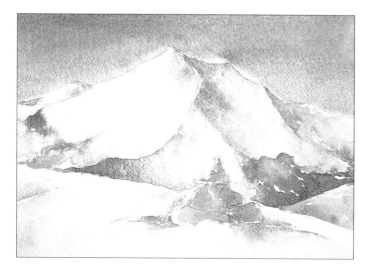

8 *The cairn was then painted with a raw sienna underwash, working onto dry paper with broken brushstrokes. A little Payne's grey was applied to the right-hand side as it dried to begin to suggest light and shade.*

9 *When this had dried, the cracks between the boulders and the shadows were 'drawn' using a small brush and a mixture of raw sienna, burnt umber and Payne's grey.*

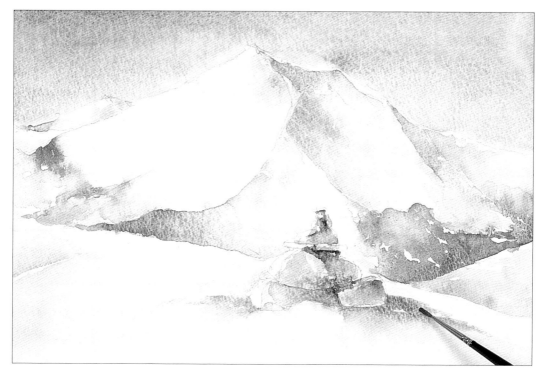

10 *The final stage was to strengthen the shadow cast by the cairn using the dark violet mix from Step 5. This was painted onto dry paper at first, but the edges were 'washed out' using clean water to soften the final appearance.*

Snow Colours

The variety of tones of violet in the sky, the snow and on the shading on the rocky outcrops proved to be a major feature of this painting – sometimes applied to dry paper and left to dry with a hard line, and at other times washed onto damp paper to provide a softer edge. Even the pile of stone cairns in the immediate foreground contained an element of violet – reflected from both the sky and the surrounding snow.

Darker blues and violets are used to give the impression of deep, cold shadows and to draw areas of snow into the visual foreground.

Soft blues and violets are used to create the illusion of distance over large areas – especially in mountainous regions.

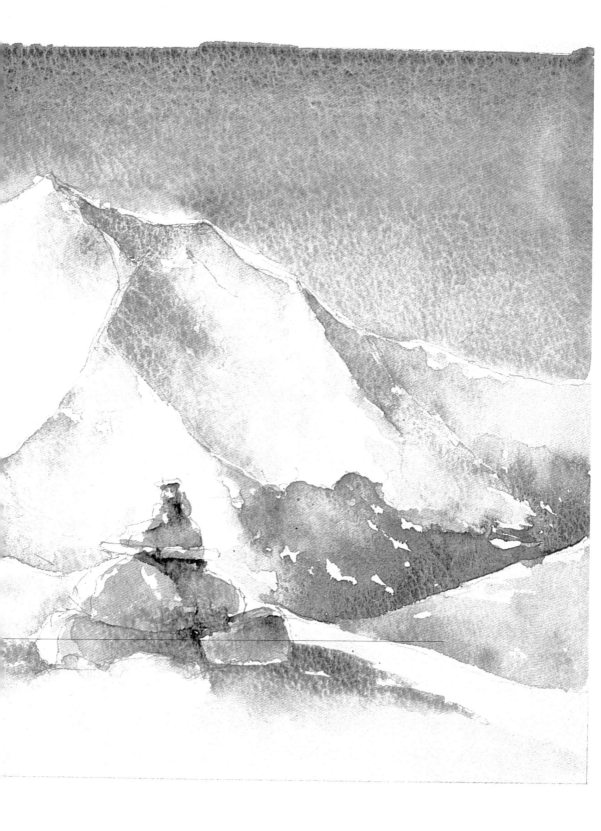

Skies and Clouds

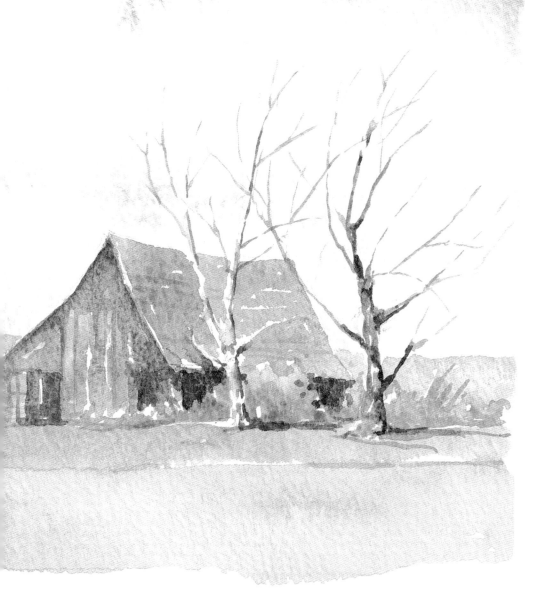

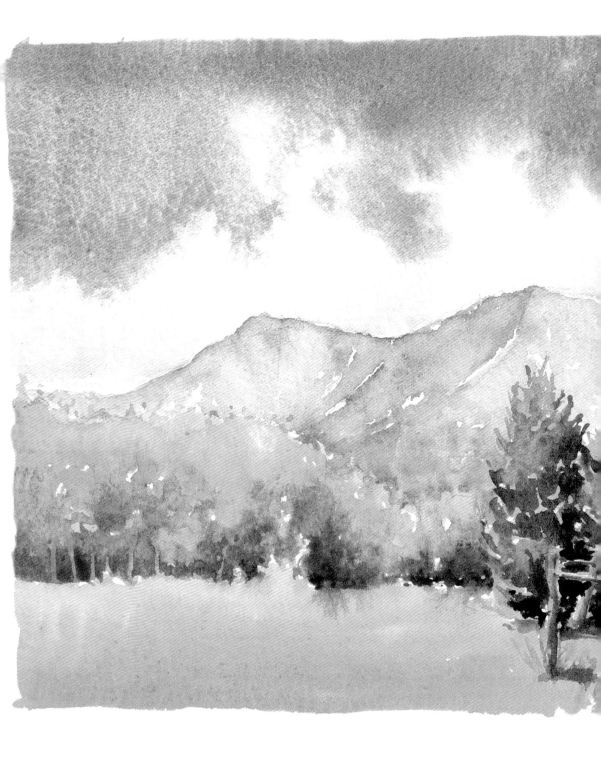

FINE WEATHER

Few painters would disagree with the notion of fine weather painting. Sitting under an ultramarine sky with large, soft, white clouds building on the horizon and only a gentle breeze to rustle the foreground trees, is certainly a wonderful feeling to experience. For the watercolour painter this is an ideal time to set out on a painting trip to record the colours and calm of the peaceful scene.

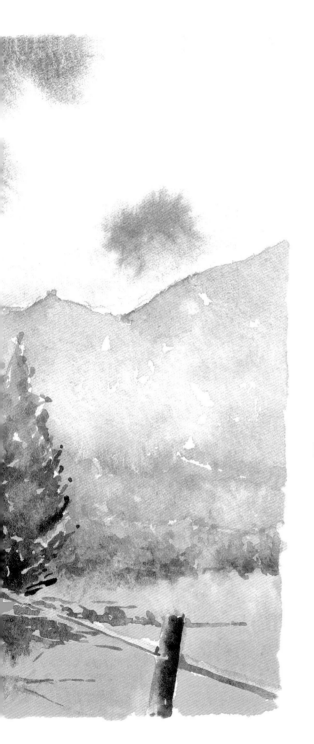

DIRECTIONAL WASH

Even on fine, fair-weather days, you can find some degree of movement in the sky. This need not be due to gusting winds, but general air pressure and light breezes.

These skies are best painted by first applying an underwash of the key sky colour – on a fine day this will usually be a combination of ultramarine and cerulean blue. This paint mix should be applied as a graduated wash to wet paper and allowed to dry (see page 12). Once the whole sky is dry, the clouds can be painted on top of the

USING COLOURS
Colour can be used to suggest movement. Whilst too many colours in any one sky may be confusing, a number of tones of different colours can help to suggest high, thin clouds.

The strong ground colours are echoed by the deep colours and diagonal brushstrokes in the sky.

DIAGONAL MOVEMENT
A sense of movement can be created in skies by employing a diagonal, sweeping brush-stroke, easing off the pressure towards the end of the motion to gently release any paint remaining on the brush.

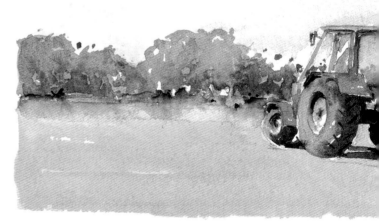

sky colours, using a watery wash of the cloud colour (Payne's grey and alizarin crimson in this picture), pulled in a diagonal direction from bottom left to top right. If you don't reload you brush with paint too frequently, you will be able to create some 'broken' brush marks which will allow the sky underwash to show through.

Finally, you can lighten certain areas by blotting with a piece of kitchen paper. This method suits the high wispy clouds, or mare's tails, of a summer's day.

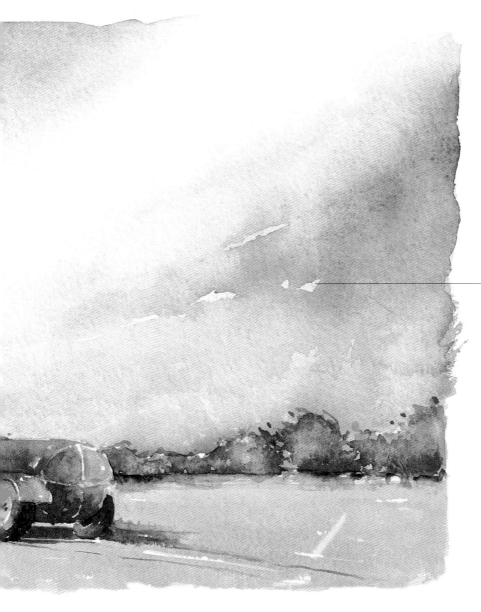

Where the clouds are painted over the underwash, it is particularly important to create a few breaks in the cloud to allow the underwash to show through, to add a sense of depth to the sky.

USING YELLOWS

The idea of 'atmospheric' skies is not something to necessarily associate with impending storms – fair weather days are equally capable of producing skies and clouds awash with appealing colours.

These skies can be painted considerably more effectively by introducing yellows into your palette. Whilst many yellows are suitable, the most useful is raw sienna – this is a 'natural earth' colour which has its origins in the foothills of the European Alps. Raw sienna can be used in two particular ways. First, as a soft wash on the far horizon. This needs to be applied to the sky immediately after the paper has been dampened, allowing the paint to bleed and dilute, softening its appearance. The second way to use raw sienna is as an underwash for clouds (see below). A second watery raw sienna wash applied to damp paper can be painted on top, allowing warm cloud tones to blend and soften while allowing the first sienna underwash to show through.

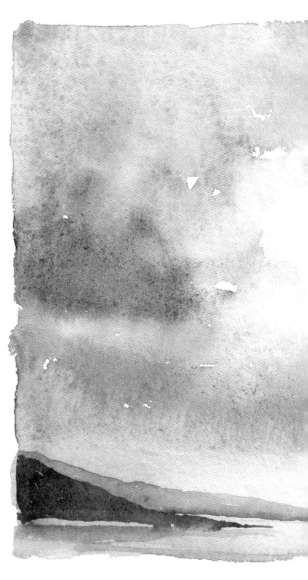

A soft wash of raw sienna, painted onto damp paper is very effective in creating a sense of far distance in skies.

YELLOWS TO SUGGEST DISTANCE
Clouds hold subtle mixes of colour – always use plenty of water when painting studies such as this to allow the paints to run and bleed freely.

YELLOWS TO CREATE ATMOSPHERE

A sense of 'atmosphere' can be created by dropping a little yellow (quinacridone gold) onto damp clouds and allowing it to bleed and dry without interference.

The riot of colour in this sky could not have been ignored – yellows, golds, cool blues, warm blues and violets all sit easily together – this is the result of careful use of wet and damp paper.

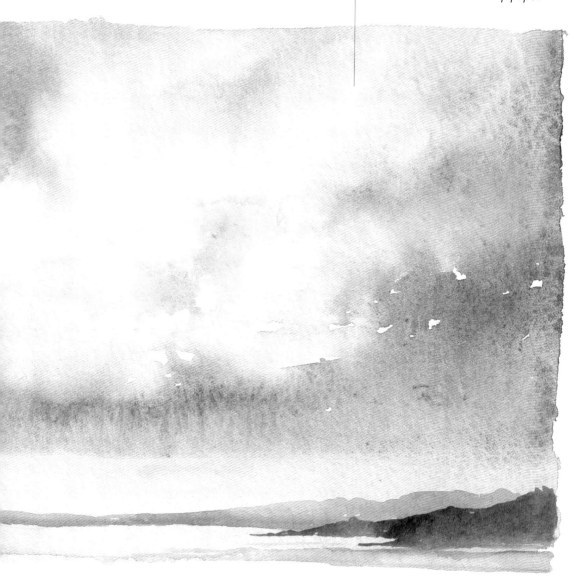

PAYNE'S GREY

CERULEAN
BLUE

ULTRAMARINE

ALIZARIN
CRIMSON

RAW SIENNA

QUINACRIDONE
GOLD

Fine Weather Clouds

Fine weather, cumulus clouds are a wonderful feature of gentle, warm summer days and are highly conducive to recording in watercolour.

The first stage is to establish the approximate shape and size of the cloud. The best way to do this is to 'draw' around the shape of the cloud with a large water-laden brush, pulling the water out towards the edge of the composition. Then, before the paper has time to dry, apply a watery wash of ultramarine and allow this to flow freely on the damp paper.

Watercolour paint will not bleed freely onto dry paper so the cloud area will remain untouched and plain white. The next stage is to mix a watery wash of raw sienna and, using the edge of a large paint brush, paint this over the centre of the cloud. Should the paint around the edge of the cloud still be damp, then the paint will bleed a little – this will look quite natural.

The final stage is to quickly mix a little alizarin crimson with some ultramarine to create a soft violet and, again, using the edge of a large brush, wash this paint along the base of the cloud while the raw sienna is still damp. This will gently bleed, creating a little 'weight' at the base of the cloud, completing the process.

ULTRAMARINE

Stage 1
Establish the basic sky colour first with a watery ultramarine wash.

ULTRAMARINE RAW SIENNA

STAGE 2
Add a wash of raw sienna before the sky has time to dry fully to allow soft edges to occur.

STAGE 3
Add a final wash of alizarin crimson along the base of the cloud and allow it to bleed softly.

ULTRAMARINE RAW SIENNA ALIZARIN
 CRIMSON

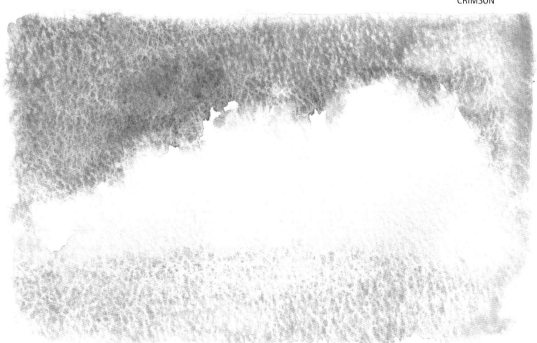

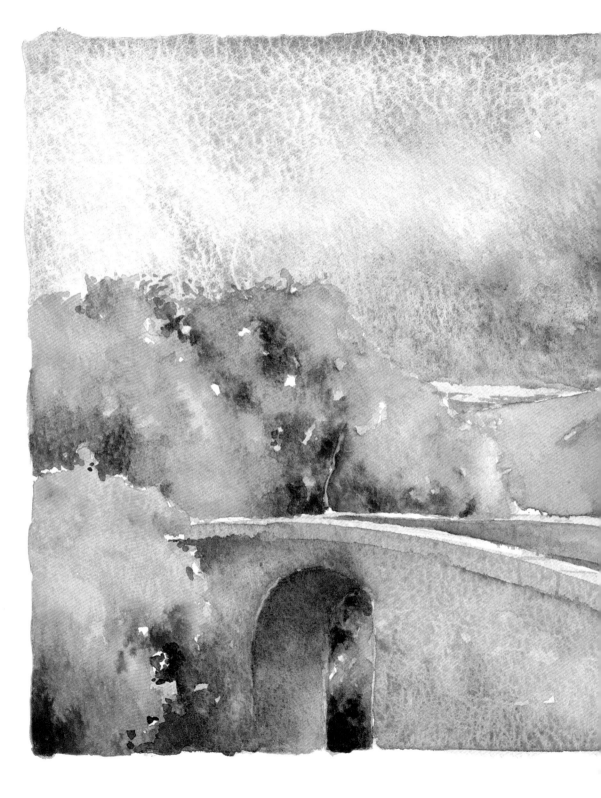

STORMY SKIES

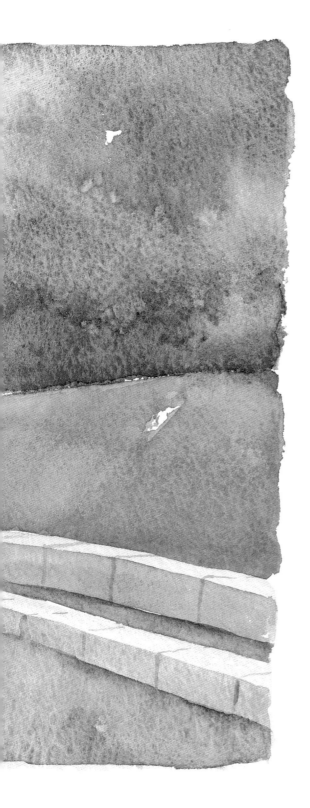

The gathering of storm clouds on the horizon would normally send most people in search of shelter. For the painter, this is the very first sign of dynamic skies, clouds and compositions to come.

Painting stormy skies often enforces a sense of speed as the final outcome could mean getting wet – vigorous brushstrokes and wet-into-wet techniques with strong colours, will help to capture the drama of the approaching sky.

Vigorous Movement

Clouds moving rapidly from the far horizon to a much closer position to your painting site are certainly a reason for speeding up the painting process.

Using a large brush, mix a suitably dark cloud colour (burnt umber, ultramarine, Payne's grey and alizarin crimson). Ensuring that you have a lot of strong, wet paint, dip your brush into water, then into the mixture and apply it to dry paper, starting near the horizon. Pull the paint in a diagonal sweep across the sky. While the paint is still wet, apply some sky colour to the top of the composition and allow this to bleed into the cloud colour.

Once the cloud colour has dried, smaller clouds can be painted onto the paper using the edge of a medium size brush – should these dry with too hard an outline, they can be 'washed' in to the sky using just plain water, then blotting the edges to soften them more with kitchen paper.

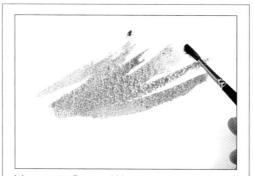

Vigorous Brush Work
To create a sense of drastic movement in skies, it is sometimes necessary to employ rapid backward and forward brushstrokes to represent clouds in rapid succession. These brush strokes will blend if worked onto damp paper whilst still maintaining their vigour.

Composition
Pulling a strong wash of paint, using sweeping brushstrokes moving rapidly across the paper, is a good compositional technique.

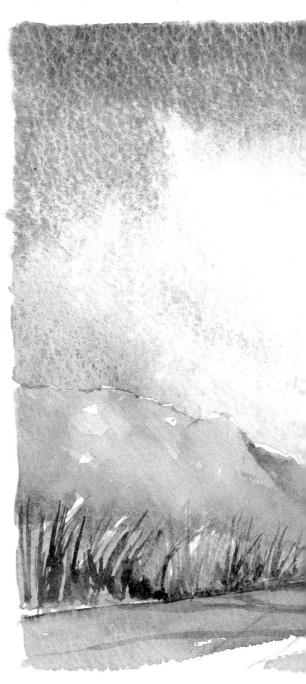

With a wind gusting across the landscape, clear and vigorous movement could be seen in the sky as the storm cloud on the horizon blew rapidly into the foreground of this composition.

Using 'broken' brushstrokes to paint skies and clouds can leave a few 'flecks' of white paper showing through. These can be particularly useful in creating highlights, visually 'punctuating' the tops of clouds.

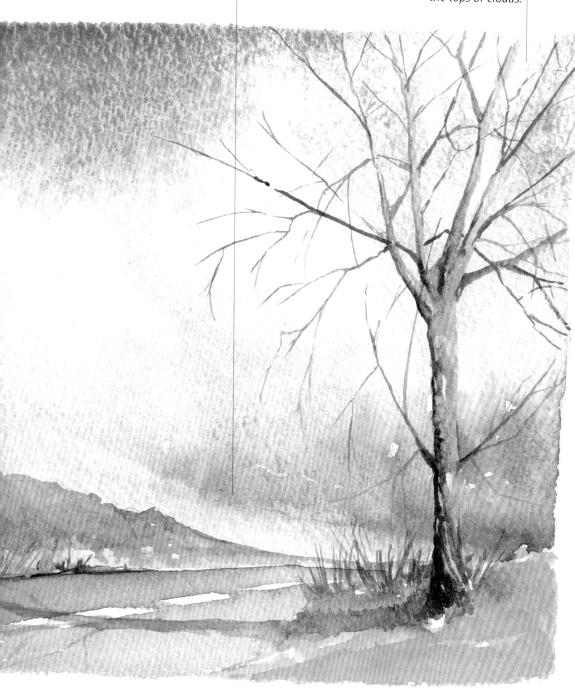

Storm Clouds

Storm clouds are best painted using a cocktail of colours and plenty of water, allowing them to run, bleed and blend freely. The one most important consideration is to use greys mixed with colour and not pure black as this would have the effect of 'flattening' any scene.

First, wet the area of paper directly around the cloud shape. Before this dries, create a mixture of ultramarine with a touch of burnt umber and apply it freely. As this is drying, mix a watery wash of raw sienna and apply this to damp paper and let it run upwards towards the sky colour. Allow a few flashes of white paper to act as visual 'punctuation' marks or highlights at the top of the clouds.

Next, mix some alizarin crimson with Payne's grey and run this along the base of the cloud, encouraging the colour to run upwards into the still damp cloud by using the edge of the paint brush to 'pull' the paint in the right direction.

The final stage is to re-dampen the cloud and to apply assorted colour mixtures to this area. Using the tip of the brush will allow you to achieve intense areas of colour, with bleeds around the edges, suggesting the shadows that are to be found in cloud shapes.

ULTRAMARINE BURNT UMBER RAW SIENNA

Stage 1
Establish the sky colour and apply a watery wash of raw sienna to the cloud area.

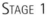

ULTRAMARINE BURNT
 UMBER

RAW
SIENNA

PAYNE'S
GREY

ALIZARIN
CRIMSON

STAGE 2
Before the raw sienna underwash dries, apply the other colour mixes using a lot of water.

STAGE 3
Increase the depth of tone by using the same colours as Stage 2, but increasing their strength in key areas.

Mixing Greys

The greys likely to be witnessed in skies and clouds need to be mixed without the use of black and white. Black will 'flatten' a colour and prevent any depth being created in the sky. White will simply form a layer over the white of the paper, diffusing its 'sparkle'.

Ultramarine is a good base colour when mixing greys to use on skies and clouds. Adding a range of colours to this 'universal'

blue will produce countless greys, all of which can be diluted to further create an even wider variety of tones.

Burnt umber, for example, will produce a 'mid grey' which can be used in most skies and clouds. The addition of alizarin crimson will 'warm up' this mixture considerably as well as producing a grey with more 'depth' of tone. Raw sienna, when added to

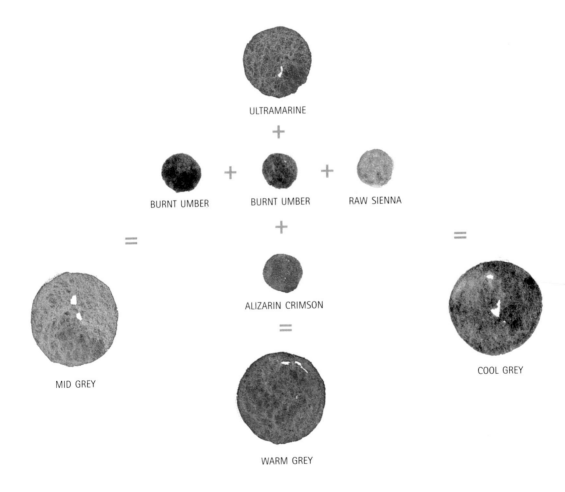

ULTRAMARINE

+

BURNT UMBER + BURNT UMBER + RAW SIENNA

+

ALIZARIN CRIMSON

=

= =

MID GREY

WARM GREY

COOL GREY

ultramarine, however, creates a particularly 'cool' grey.

Payne's grey is a manufactured colour which produces a 'thin' blue-grey paint which dries to a very disappointing hue – it looks strong when wet, but dries to a considerably lighter tone. Payne's grey is rarely used in skies and clouds on its own. It is very useful, however, as a 'mixer' and can be used to create a range of blue-greys and brown-greys.

Whilst the colour mixes illustrated here are, probably, the most useful for painting skies and clouds, they are by no means exclusive. I strongly recommend that you experiment a little and try your own grey mixes. Try to create some different colour 'temperatures', some warm and some cool.

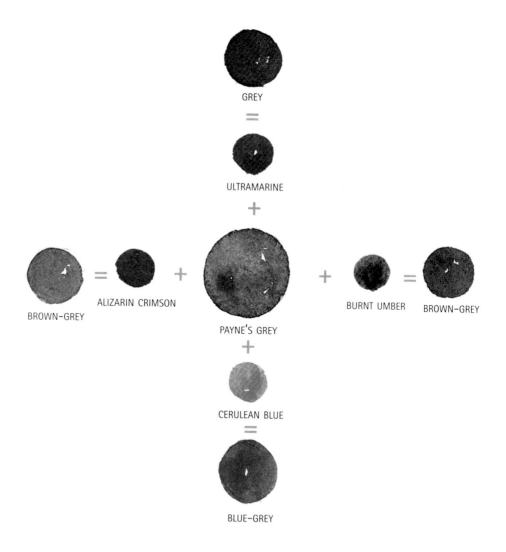

GREY

=

ULTRAMARINE

+

BROWN-GREY = ALIZARIN CRIMSON + PAYNE'S GREY + BURNT UMBER = BROWN-GREY

+

CERULEAN BLUE

=

BLUE-GREY

MASKING FLUID

The first signs of an early winter's snow are always to be found in the sky. Darkening skies with tobacco-tinged clouds often herald the fall of the first white snowflakes.

These can be recorded very effectively by the application of masking fluid – a water repellent rubbery solution. It contains an element of ammonia and dries rapidly – only use old brushes or toothbrushes to apply it to your paper.

To create the effects of snowflakes, use an old toothbrush to flick the masking fluid

USING MASKING FLUID

1 First, dip an old toothbrush into masking fluid, angle the head, and flick the rubbery solution across your paper.

2 When the masking fluid has dried, gently wash your first coat of paint across the paper – taking care not to dislodge any dried spots of masking fluid. You can now apply as many colours as you wish as the paper under the masking fluid is fully protected.

Applying very wet, watery paint to paper awash with surface water will create bleeds as the paints dry, suggesting moisture in the clouds.

An unexpected flurry of snow brings an entirely fresh appearance to skies, imposing a new method of recording – creating numerous white flecks by the application of masking fluid.

USE OF YELLOWS
The addition of raw sienna to very wet paint will help to create a stormy atmosphere and break the potential monotony of a single tone of grey.

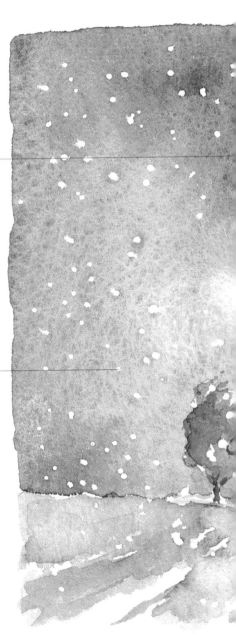

across the paper. Wait until this dries and then paint freely over the fluid, using as much water as you feel confident with as it will not penetrate the dried masking fluid.

It is imperative that you wait until the paper is completely dry before removing the masking fluid – if the fibres of the paper are even slightly damp, the rubber solution will stick to it, removing the surface of your painting. When it is fully dry, rub over the surface of your painting with a putty rubber to reveal a spattering of tiny white dots.

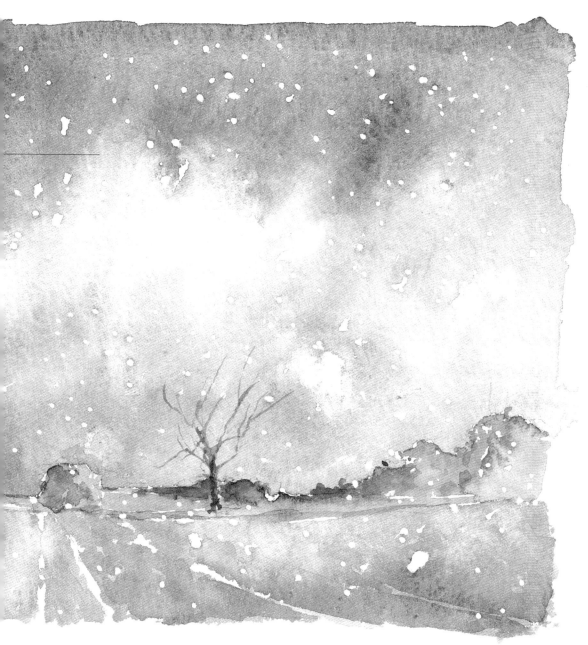

Marine Skies

The skies that we encounter over the sea can take on a number of forms, like the sea itself. But usually in the vast expanses that cover the oceans, blues will be the predominant colours.

To create the sense of depth required in a scene like this, a cool blue-grey colour needs to dominate. Indigo and Payne's grey work well to create the basic underwash for a windswept ocean sky, giving the impression of distance. Add a little ultramarine to this mixture to create a few 'warmer' patches breaking through the clouds – this complements the blue-greys particularly well, creating a slight visual contrast. The white of the clouds can be 'toned down' a little to create a more natural appearance by the addition of a very dilute wash of raw sienna. The key to using these dominant blues is to use a lot of water and allow them to mix together freely. Apply them with definite, confident brushstrokes and then sit back and allow them to dry without interfering too much with the drying process.

A few 'flashes' of pure, hard edged white paper left to represent the tops of the clouds can be particularly effective in creating 'highlights' in the sky.

INDIGO

PAYNE'S GREY

ULTRAMARINE

RAW SIENNA

Sea and Sky

In this scene, I set out to capture the sense of movement in both the sea and sky. A combination of dry brush work, wet into wet and vigorous brushstrokes was employed to complete the painting.

The most pictorially effective sails are those that catch the wind. The wind produces either a ballooning effect or a sense of stress and strain.

Ballooning sails are most successfully recorded using graduated colour – best achieved by dampening the paper and running a line of the appropriate colour along the outer edge of the sail. This will gently bleed into the damp paper, gradually becoming lighter towards the centre of the billowing sail.

To paint tighter sails make sure that you emphasize the folds of the sailcloth at both the top and the bottom of the mast – that is, the point at which where they are connected to a rope or pulley. If these lines draw your eye to the centre of the sail, the effect will be quite dramatic, producing a feeling of tension and pull.

TAUT SAILS

While ballooning sails will almost inevitably look dynamic, tighter sails can be given dramatic effect when emphasis is given to the points at which they are connected to a rope or pulley.

Once the underwash has dried, you can paint a few clearly defined marks to suggest rays of light shining from behind dark clouds using a small brush and very little paint.

The crest of the wave breaking against the dark backdrop of this windswept sky creates an area of intense white, making the horizon all the more interesting.

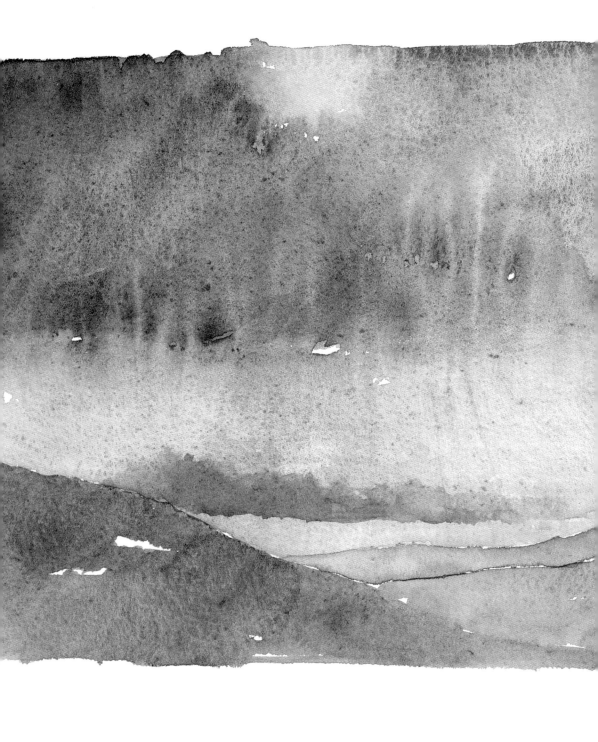

ATMOSPHERIC SKIES

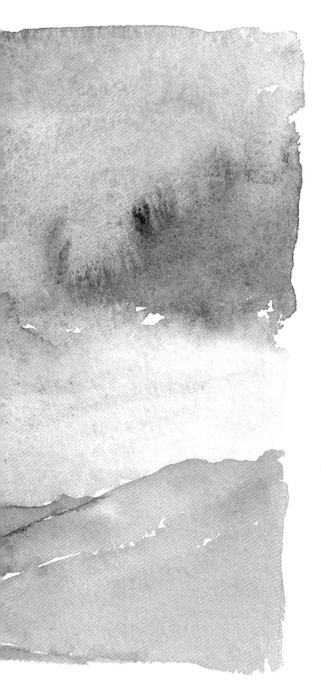

The violet cast, the sienna glow or the orange tinge in skies and clouds are all highly suggestive of changes in the weather. These changes can be quiet, gentle and passive, creating calming sunrises or sunsets. Others, however, can be violent and wild, resulting in storms breaking over the land. You will need to work quickly with a range of colours to capture these special effects.

NATURAL BLENDS

The softness of clouds and the variety of tones of colours found in 'atmospheric' skies are created by allowing, or even actively encouraging, paints to bleed, blend and mix together on paper.

Traditionally, colours are mixed in a palette and applied to the paper in their 'ready-mixed' state. This technique has its merits, but can create some rather 'pedestrian' pictures without too much depth. The most exciting way to mix colours is to simply apply paints to damp paper in their 'neat' state and watch them blend naturally. The results can be a little unpredictable – but so can the weather systems that you are painting, so maybe it is quite

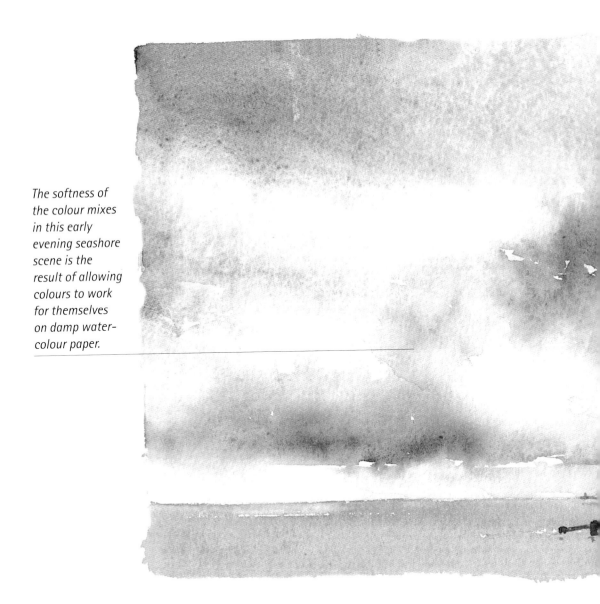

The softness of the colour mixes in this early evening seashore scene is the result of allowing colours to work for themselves on damp water-colour paper.

appropriate after all. Should, however, the bleeds not work as you had in mind, you can always blot some of the paint to halt the process, or add more water to encourage the mixes further. The resulting colours will dry with soft, blurred edges and subtle transitions of tone. The choice of how to develop this technique is yours.

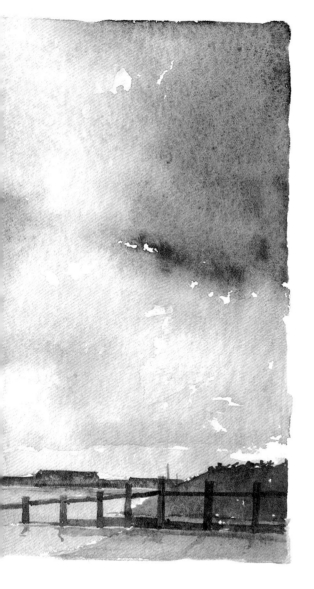

Colour Bleeding
Two wet colours placed next to each other on either wet or damp paper will bleed together, naturally finding their own level of mixture and individual drying rates.

Water Bleeds
Sometimes, often by accident, water will bleed outwards into a damp colour – this can create a soft, moist effect which is very welcome in an 'atmospheric' sky.

ULTRAMARINE PAYNE'S GREY

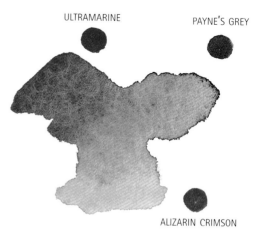

ALIZARIN CRIMSON

SUNRISE

In many parts of the world, little difference exists visually between sunrises and sunsets – both are capable of creating a feeling of great calm as the colours of the sky change to a wealth of warm tones, blending and merging across the horizon.

Sunrises, however, can sometimes be distinguished by the softness of the tones. This is often due to the early morning mists that create a diffusing atmosphere through which the sun's rays must travel before being caught by your eyes.

The soft blending of colours is certainly best achieved by personal organisation of your painting equipment. Choose the colours that you feel you will wish to use and ensure that they are all wet and ready to go. Then, wet the paper evenly with plain water using a large brush, and quickly begin to apply the paints, using a graduated wash technique in the first instance. Then, before the paper has time to begin to dry, introduce the violets, pinks, oranges and other tones by applying those to the wash, using exactly the same technique. If you paint them and leave them, they may dry with a hard line. If, however, you use your brush to really mix the colours in with the initial graduated wash, then they will dry as part of it, creating a range of warm, soft tones, with no perceptible start or end.

ROSE MADDER RAW SIENNA CERULEAN BLUE

ALIZARIN CRIMSON PAYNE'S GREY

Sometimes it can be useful to leave a thin, light line along the horizon to emphasise the difference between the sea and sky – especially where the tones of both are almost identical.

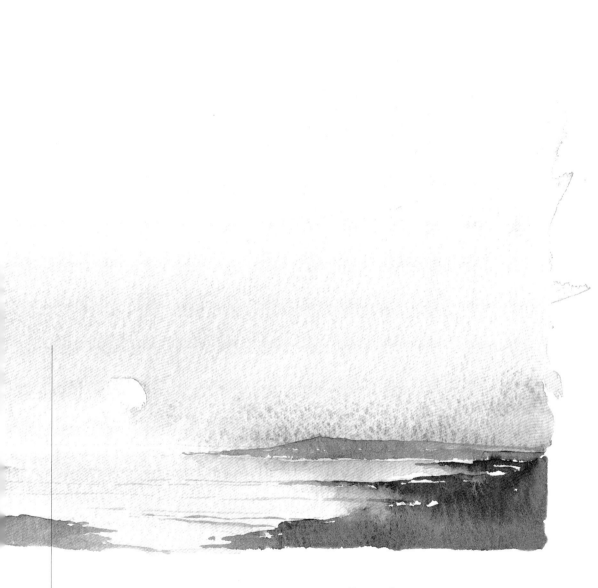

The pastel, chalky tones of the sky in this composition were painted with a lot of water and physical blending with a large brush.

PASTEL SHADES
Pastel shades are best created by applying watery washes of colour onto damp paper and using your brush to work them together on the paper surface.

Early Morning Sun

Staring at the sun is certainly not to be recommended, even when it is soft and diffused by the prevailing atmospheric conditions. When painting sunrises or sunsets, however, you will have to make a decision, based upon a quick impression, as to how you wish to paint the sun – leaving it lighter or painting it darker than the surrounding sky.

As sunrises don't usually allow the sun to fully develop its raging, colourful glare, it is probably best to leave it unpainted, concentrating on the colours in the sky.

The soft, warm grey mist of the early morning sunrise can turn all shapes into simple blocks or grey silhouettes, and is best painted onto an underwash of lemon yellow. As this is drying, apply a wash of alizarin crimson and Payne's grey over the top, ensuring an even coating to achieve the full, misty effect.

To create less murky morning mists, apply a wash of cerulean blue to damp paper. As this begins to dry (that is, when the paper is damp, not wet) paint a wash of alizarin crimson along the horizon and pull it up, using the edge of your paint brush, to meet the cerulean blue. The two colours will blend softly without completely mixing.

Sometimes, the sun will rise, casting a golden glow across the landscape – this is usually short-lived so needs to be captured quickly! To avoid a harsh orange, apply an underwash of raw sienna to damp paper. As this begins to dry, wash a watery mixture of quinacridone gold along the horizon and allow the two strong colours to merge together, creating a soft, warm glow.

Misty Skies
Misty, murky skies often allow a
light sun to shine through.

LEMON YELLOW ALIZARIN CRIMSON PAYNE'S GREY

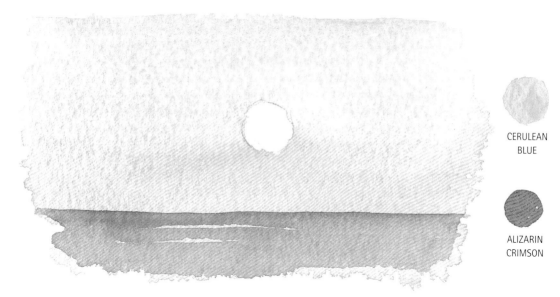

CERULEAN
BLUE

ALIZARIN
CRIMSON

PASTEL TONES
The softness of the surrounding colours allows
the sun to glow with a brilliance of pure white.

RAW SIENNA

QUINACRIDONE GOLD

GOLDEN TONES
The warmth of the golden glow is
picked up by a softening sun.

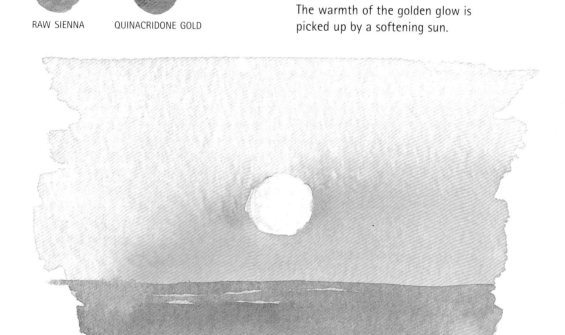

Sunset

The fiery colours of a sunset need a slightly different approach to the soft pastel shades of the calmer, less intense sunrise.

Whilst the starting point of a graduated wash is still important, the other techniques need to be more dramatic to create the intense colours of the sky.

Unusually, in this picture the graduated wash was started with cadmium orange at the bottom along the line of the horizon, and alizarin crimson at the top of the paper, and the two colours were gradually worked together in the centre. As they were beginning to dry, a mixture of cadmium orange and cadmium red was worked into the middle of the sky, just above the sun, suggesting the strength of its glow as the evening drew to a close.

As these colours began to dry, I mixed the cloud colour of Payne's grey, alizarin crimson and a touch of cadmium red in the palette and applied this using the edge of the paint brush in a sweeping motion across the sky. As the paper was barely damp, only a minimum amount of bleeding took place, allowing the clouds to exist in their own right.

To avoid your sun looking as if it has been cut out and stuck on, apply the paint and then, with a small brush, drop a little water into the centre – this will push the paint outwards, creating a curved effect.

Creating Clouds

When a watercolour painting is thoroughly dry (feel the back of the paper just to make sure) you can create some light, small clouds by rubbing over the dried paint in a diagonal direction with a putty rubber – this removes some of the surface paint.

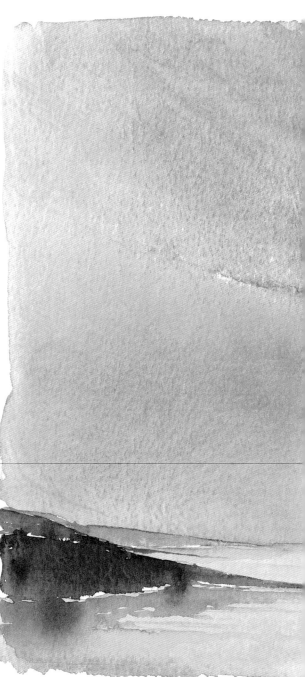

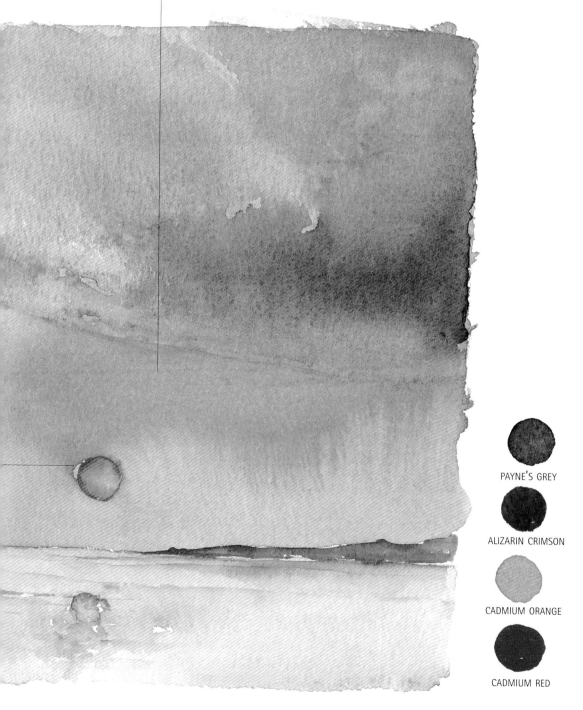

The sky appeared to be on fire when this sunset was painted, with the overall impression being aided considerably by the depth of colour on the underside of the light, late evening clouds.

PAYNE'S GREY

ALIZARIN CRIMSON

CADMIUM ORANGE

CADMIUM RED

LATE EVENING SUN

A colourful sun amidst the glow of a sunset can add an element of visual 'weight' to a composition, intensifying the effect of evening light.

An orange sun is best surrounded by an orange and gold-tinged sky – but remember that the sun is the focal point, so don't make the sky colours too strong. Apply a graduated wash of cadmium orange and quinacridone gold to the sky, then introduce a little alizarin crimson to suggest approaching cloud. Only when the sky colours have dried, paint the sun with a strong mix of cadmium orange, blended with the quinacridone gold on the palette.

A slightly less intense sun can be created using exactly the same background of sky colours, only this time add a little raw sienna to the tones in the sky – this will not look out of place amongst the intensity of the orange and gold paints, rather it will have the effect of 'calming' the tone a little, suggesting a less sharp and clear sky through which your sun is seen. Summer evenings are often hazy with heat.

The intensity and brilliance of a bright red sun is best created by careful mixing of cadmium red and alizarin crimson. It is important that the red is allowed to dominate, so only use a touch of the crimson paint – this will prevent the red from looking unnaturally bright by toning it down a little, but not removing the brilliance of its colour.

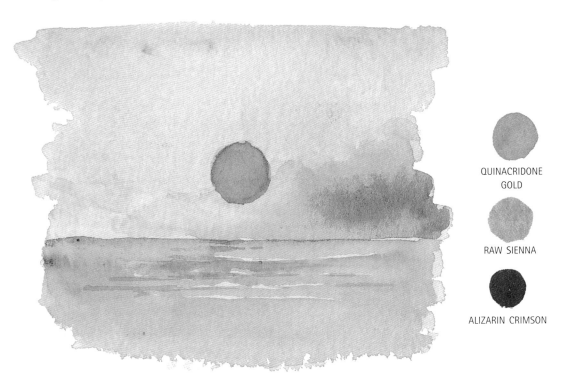

QUINACRIDONE
GOLD

RAW SIENNA

ALIZARIN CRIMSON

DIFFUSED SUN
Atmospheric conditions and mists can easily rob a sun of its strength.

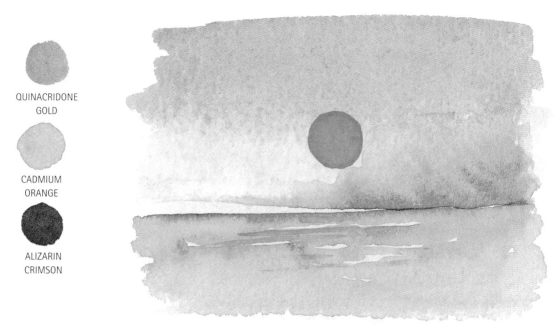

QUINACRIDONE
GOLD

CADMIUM
ORANGE

ALIZARIN
CRIMSON

Orange Sun

The intensity of this coloured sun is subdued a
little by the surrounding colours.

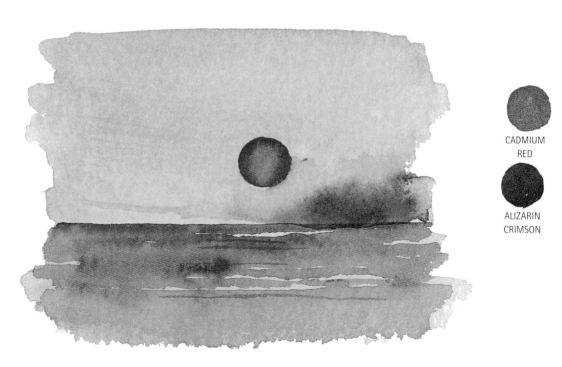

CADMIUM
RED

ALIZARIN
CRIMSON

Bright Red Sun

Sometimes a full-bodied bright red sun burns
away all cloud to glow like a fireball.

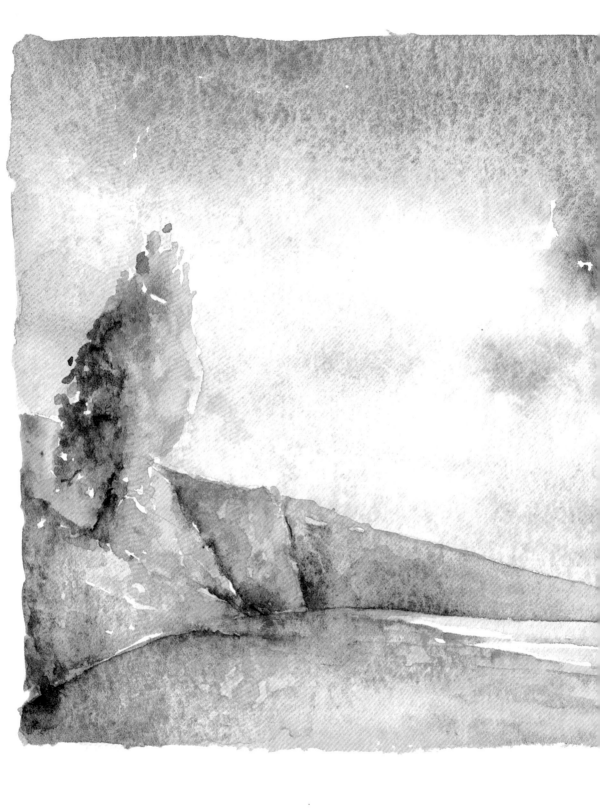

COLOURS

The main tool that any painter has to work with is colour, and understanding how colours work together, with water and on paper, is an essential part of the watercolour painting process. Whilst colours have no physical temperature they are evocative and can be used to suggest both warm and cold environments throughout the seasons.

Cool Neutrals

Grey is a cool, neutral hue – it is not really a 'colour', more of a tone – that can be found in many skies, clouds and cast shadows. It is a useful addition to your palette either as a mixer, or mixed from blues and browns.

The chemically-manufactured Payne's grey is very useful as a 'mixer', creating a base tone to which a vast array of colours can be added to produce a useable, neutral colour for cold-looking skies and clouds.

It is worth experimenting with the application of Payne's grey onto paper before you start to try different colour mixes, to get the feel of the way in which it reacts. Unlike most of the coloured paints featured

STUDY 2
Working onto dry paper, Payne's grey dries very evenly.

STUDY 1
Apply pure Payne's grey onto damp paper – watermarks occur very quickly.

PAYNE'S GREY

PAYNE'S GREY

COBALT BLUE

STUDY 4
Using lots of water mix Payne's grey and cobalt blue together on damp paper. The effect is of rain-laden clouds.

in this book, Payne's grey is a 'dye' based paint and will, therefore, stain paper very quickly. So, on a scrap piece of your normal watercolour paper, try painting Payne's grey onto damp, dry and wet paper to assess for yourself the best way to utilize the physical paint effects created by the varied paper conditions.

Once you are happy that you can predict how the paint will react, experiment with different colour mixes, applying blues and browns to Payne's grey and making some visual notes to remind yourself of the final mixes. Then, move on to mix combinations of blues and browns to see just how many different 'greys' it is possible to achieve.

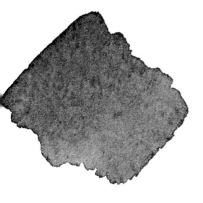

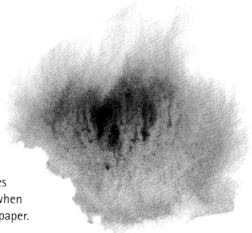

STUDY 3
Payne's grey becomes very unpredictable when applied to very wet paper.

INDIGO

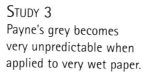

INDIGO

BURNT UMBER

STUDY 5
Payne's grey and indigo have a 'flattening' effect together, suggesting a solid bank of rain clouds.

STUDY 6
Indigo and burnt umber produce a strong 'tobacco' tone, good for stormy skies.

Winter Sky

The cold, blue-grey tones of a winter sky are probably best recorded using a lot of water and a carefully chosen selection of blues, browns and a touch of Payne's grey. This combination can, however, take on a slightly 'flattened' appearance, denying your painting the depth it deserves. This can be counteracted by leaving a small gap along the distant horizon and applying a watery wash of raw sienna to create a distant glow. This effect can be enhanced even more by painting a thin line of alizarin crimson between the raw sienna and the grey cloud colour. If you judge this correctly and apply it when both colours are damp, it will bleed evenly upwards and downwards, creating a soft area of tone connecting the sky and cloud.

When you come to paint the foreground in scenes such as this, it is often a good idea to use the grey used in the clouds for the shadows of objects such as trees and brick walls, as this has a strongly unifying effect on the composition.

Amidst the dull colours in the winter sky it is easy to miss the lighter colours, often to be found on the distant horizon, which can make compositions such as this come alive.

Even on a cold, late winter's afternoon, raw sienna can still be used to good effect to create a distant glow on the horizon, acting as a 'visual foil' to the lowering grey clouds.

SIILHOUETTES

The steely winter light and deep, dark grey clouds throw foreground shapes into little more than silhouettes, without detail, viewed against the cold slate skies.

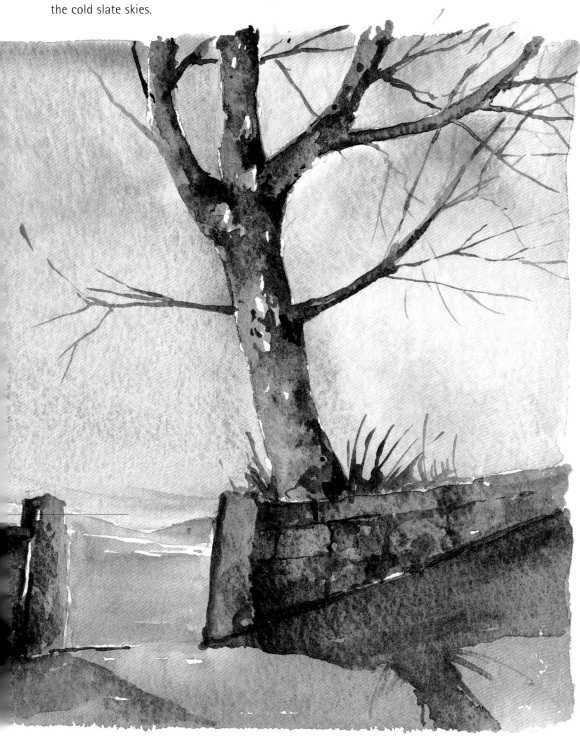

Warm Blues

The idea of 'sky blue' can be as confusing as the concept of grey for painters. With so many blues in art stores to choose from, exactly which ones do you use?

My personal preference for creating a natural, warm blue in skies and clouds is ultramarine. This is a very 'warm' colour, as well as an ideal mixer. Whilst it is a fairly predictable paint, it is always a good idea to try applying it to your normal watercolour paper in various states of wetness to see exactly how it will react.

Most warm summer days will hold more than one tone of blue in the sky, especially if your view covers a vast distance. To paint these scenes, create a graduated wash with ultramarine being the dominant colour washed onto the top of the paper and

Study 1
Apply ultramarine to damp paper and see how long it takes for the watermark to occur without any blending on your part.

Study 2
Painted onto dry paper, ultramarine dries to a smooth finish.

CERULEAN
BLUE

ULTRAMARINE

ULTRAMARINE

Study 4
Use ultramarine for the 'weight' at the top of the sky and cerulean blue to create the distance on the horizon.

pulled downwards to blend with the slightly cooler and 'thinner' cerulean blue along the horizon.

It is perfectly acceptable to use ultramarine by itself – this can produce a very strong sky colour, and is also a good base for fair weather clouds over a lake or sea.

The warmest mixture, however, can be created by the addition of a touch of alizarin crimson, pre-mixed in the palette (alizarin crimson also has staining qualities and will not always mix freely with ultramarine on damp paper). A sky wash of ultramarine with just a hint of alizarin crimson works particularly well. To add visual weight to the blaze of clouds, add a little more alizarin crimson and allow it to bleed up into the cloud shape.

Study 3
Ultramarine does not react so very differently to wet paper as it does to damp paper – it tends to dry to a 'softer' finish without blending.

ULTRAMARINE

ALIZARIN CRIMSON

Study 5
See how far you can take pure ultramarine in terms of tone and strength of colour.

Study 6
The introduction of alizarin crimson creates a gentle, warming effect.

SUMMER SKY

It is a particularly good idea to visit the same site several times during the course of a year to witness the different effect that each individual season has on the surrounding landscape.

The summer skies that hold the warmest of blues are best created by allowing ultramarine to dominate the scene, ensuring that the bulk of the colour appears at the top of the sky. Often, faint wispy clouds will appear in such skies – they are best recorded by pulling the paint in long, sweeping movements from the horizon, diagonally, up towards the corner of the page, ensuring that you leave some white paper showing through to represent the clouds. If too much paint runs into these areas you can always drag a piece of kitchen paper along the line of the clouds and this will remove the unwanted paint, creating a sense of movement in the sky at the same time.

Finally, a little raw sienna can always be added to damp cloud areas to give them a little 'bulk' if the wispy cloud areas look too gentle for your liking.

The use of the light cerulean blue along the horizon helps to create a sense of perspective in the sky, enhancing the effect of distance in the composition.

VISUAL WEIGHT
It is possible to create a feeling that the top of the sky area is 'pushing' down on the composition, sandwiching the soft summer clouds, by using a particularly strong colour.

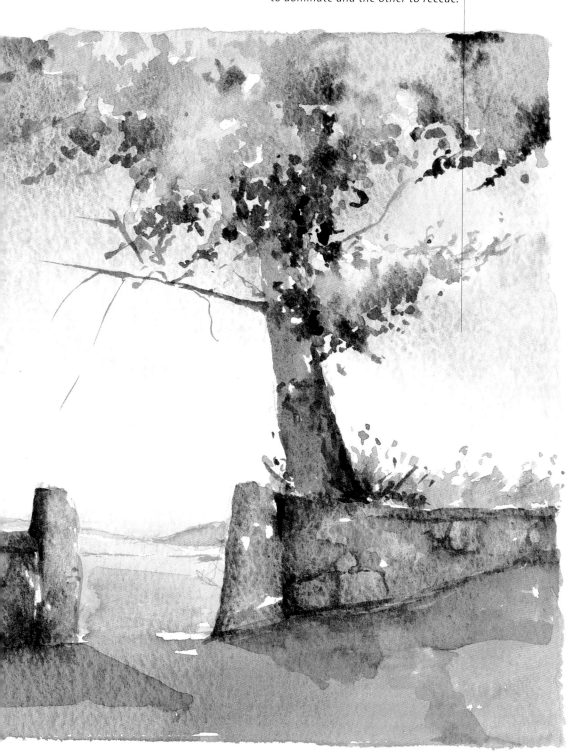

The warmth generated by the summer sky in this landscape is the result of careful use of ultramarine and cerulean blue – allowing one to dominate and the other to recede.

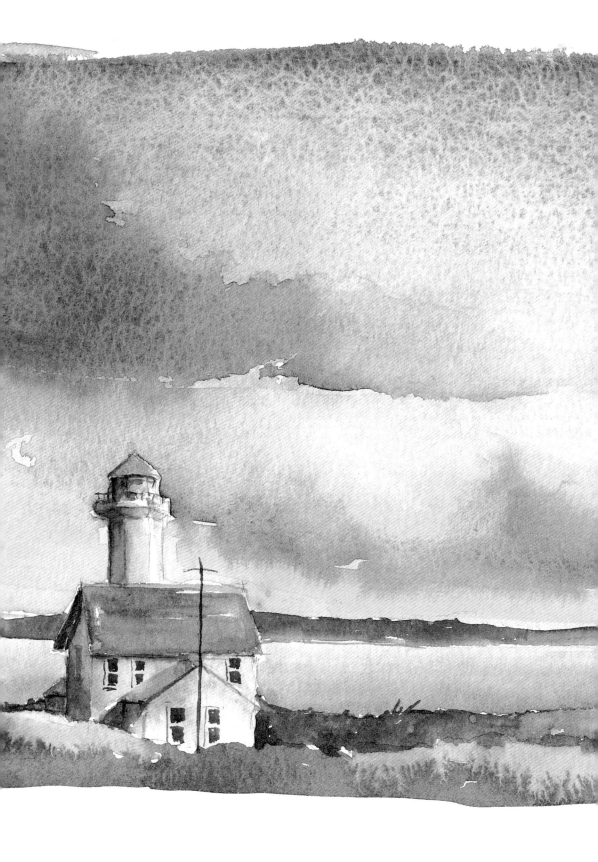

PRACTISE YOUR SKILLS

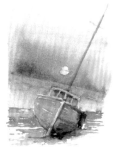

Different seasons, weather
conditions and locations all
provide individual skies for
you, the artist, to record.
The projects that feature in this
section are designed to take you
step-by-step through the processes
that I use to create a 'finished'
painting, using a variety of
different techniques.

FINE WEATHER

Although fine weather clouds, blue skies and green woodlands may, in terms of colour similarities, seem to be poles apart, it is important when painting to find some unifying tone – in this particular project it was the warmth of the natural earth colour, raw sienna. Watercolour paints are translucent – any colour placed on top of another will be influenced by the first wash to a greater or lesser extent. So, when used as an underwash, raw sienna underpins any colours placed on top.

The use of pure ultramarine in the sky is always a good indicator of fine, balmy days when you can afford to take your time over a painting in the knowledge that you will rarely be interrupted by approaching storms. Ultramarine is also known as a particularly warm blue and can always be used to suggest higher temperatures.

The key theme running through this painting is that it is advisable to become as familiar as possible with the 'colour temperature' of the paints in your box: which colours do you need to create warmth, and alternatively, which colours will help to cool things down a little. A predominantly warm palette will set the overall scene.

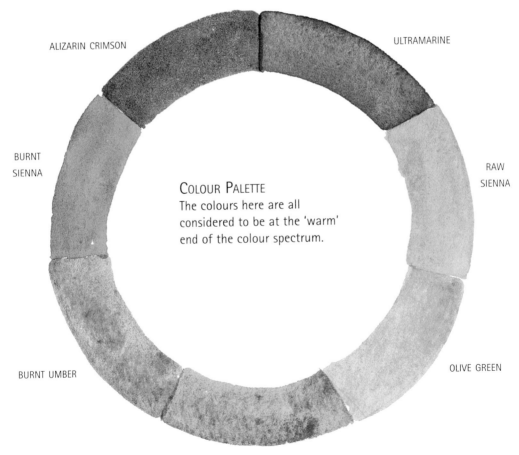

ALIZARIN CRIMSON

ULTRAMARINE

BURNT
SIENNA

RAW
SIENNA

COLOUR PALETTE
The colours here are all considered to be at the 'warm' end of the colour spectrum.

BURNT UMBER

OLIVE GREEN

SAP GREEN

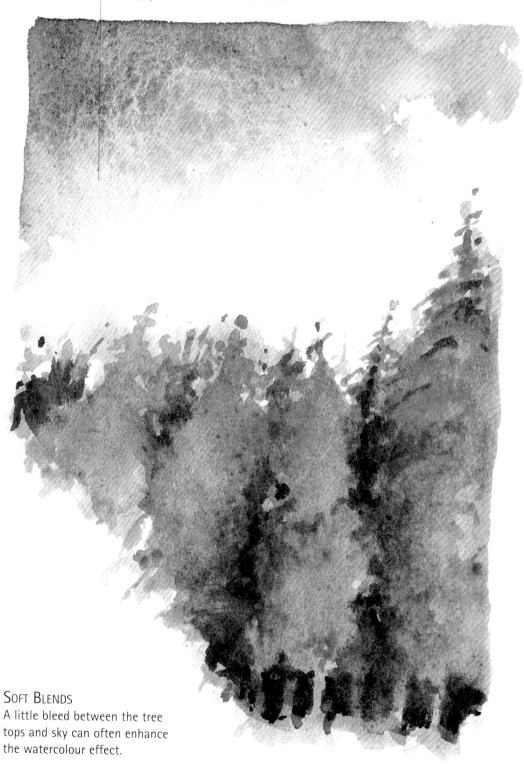

The use of a touch of violet can work particularly well in 'warming up' a sky, although ultramarine usually speaks for itself in this area.

SOFT BLENDS
A little bleed between the tree tops and sky can often enhance the watercolour effect.

CALM SUMMER SKY

The peace and tranquillity of the 'back-wood' scene in this project was as much due to the soft tones of the sky as the gentle stillness of the trees and the calmness of the foreground.

It was important that the sky and foreground shared a major unifying factor. To link the two areas, raw sienna featured in the clouds and also as the underwash for the trees and hillocks in the foreground.

MATERIALS

- 425 gsm (200 lb) watercolour paper

- Brushes – 1 large (size 12), 1 medium (size 8), 1 small (size 2)

- Watercolour pan paints – ultramarine, raw sienna, olive green, cadmium yellow, sap green, burnt umber, burnt sienna, alizarin crimson

1 *The first stage of this painting was to dampen the paper (not flooding it) to allow the first wash of ultramarine to bleed gently down into the sky area, creating very soft edges in the process.*

2 *Before this could dry fully, I added a very thin wash of raw sienna to the base of the clouds and allowed this to bleed upwards to add a little 'weight' and warmth.*

3 *Next, I applied a stronger wash of raw sienna to the line of trees in the middle ground. This bled a little into the sky – but this was quite welcome as it softened the tops of some of the trees, which was in keeping with the atmosphere of the day.*

4 *To start to develop the colours in the trees, I applied a wash of olive green – a soft, thin colour – onto the damp underwash, allowing the paint to create some shapes in the foliage for me.*

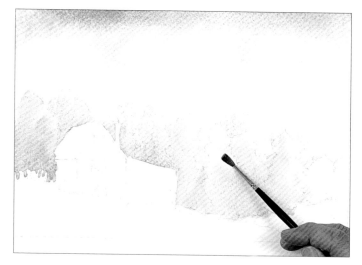

5 *Again, working quickly onto damp paper, I used a small brush to drop some cadmium yellow onto the tops of the trees, reinforcing the light from the summer sky catching the highest points of their boughs.*

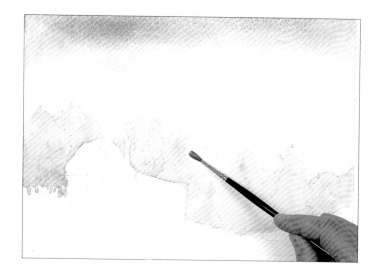

6 *With the main 'underwash' now complete, I could start to develop the deepest tones to push the lighter ones forward. Using a small brush and a mixture of sap green and ultramarine, I worked along the base of the trees where the deepest shadows would be.* INSET: *I used the shadow wash to define the shapes of the trees.*

7 *With the middle ground now complete, I needed to establish an underwash for the foreground. A raw sienna wash was applied to damp paper, then, using a graduated wash technique, olive green was pulled upwards from the base of the paper and allowed to dry.*

8 *The two hillocks had to be defined using the darker green mixture (sap green and ultramarine) to paint the furthest one. This was one of the few times in this picture when hard lines were encouraged.*

9 With the foreground dry, careful attention could be given to the shadows cast by the warm summer sky. These were mixed with ultramarine and alizarin crimson and painted across the cabin and the foreground.

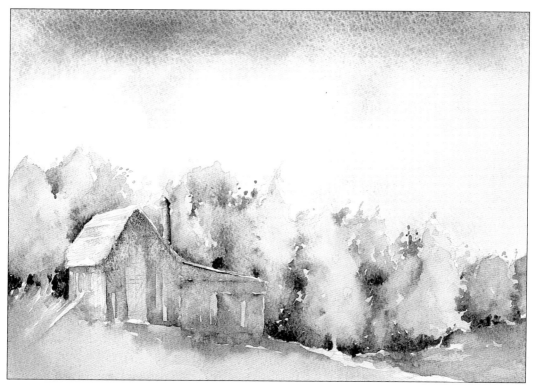

10 The final stage was to complete the detail on the cabin using a mixture of ultramarine, burnt umber and burnt sienna, reinforcing the ultramarine and alizarin crimson in the process.

A STILL DAY

The softness and warmth of both sky and ground was achieved by choosing the right colours for the job – ultramarine for the main sky colour, and an underwash of raw sienna. The lack of movement in the sky, suggesting a calm, windless day, was created by allowing the paint in the sky to find its own way on damp paper and by not introducing any directional brushstrokes.

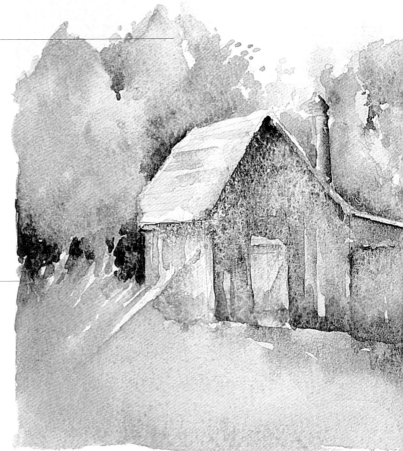

Bleeds from the foliage into the sky areas were not blotted out, allowing a 'hazy' edge to the tops of the trees, reinforcing the 'summery' feel of the scene.

The shadow colours were mixed using the main sky colour (ultramarine) to cement the sense of visual unity.

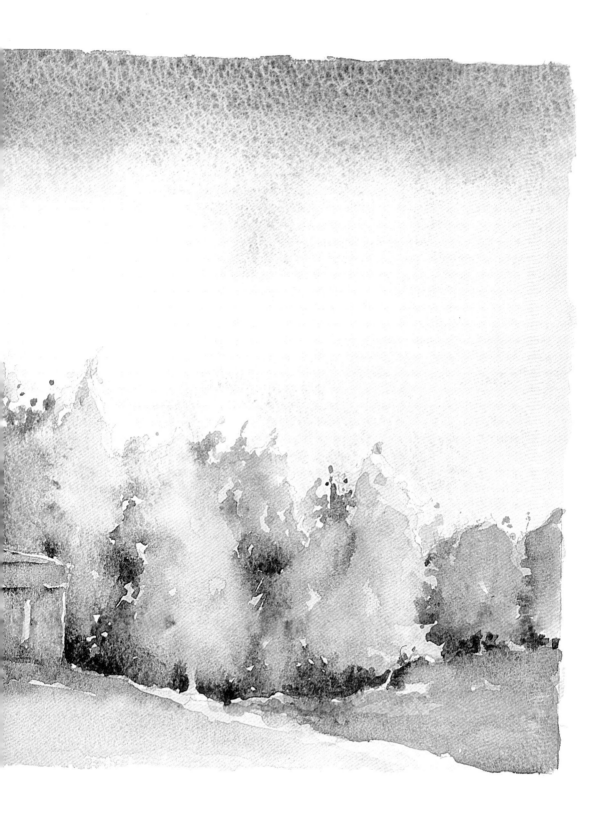

Moving Clouds

One of the most amazing aspects of painting is the way in which the extended use of colour can actually create the impression of physical movement – as is the case in this particular project.

By choosing the correct colours, and placing them with some space in between, it is possible to suggest that the space is being visually squeezed. Two identical colours will not have the same effect in creating that sense of pressure. So, choose a warm, dark blue, such as ultramarine, along the top of your sky area; a light, cool blue, such as cerulean, along the horizon line; and the area in between can be transformed into the suggestion of a moving cloud.

The transformation does involve using specific brushstrokes to indicate the direction of the clouds – a diagonal brushstroke is usually highly effective. If this is done on damp paper you will be able to create a soft, hazy cloud movement. If you choose to wait until the sky is dry, your clouds will take on a very clear shape as they will probably dry with a hard line. The final option is to use a piece of kitchen paper and drag this diagonally across your damp sky to create white cloud shapes.

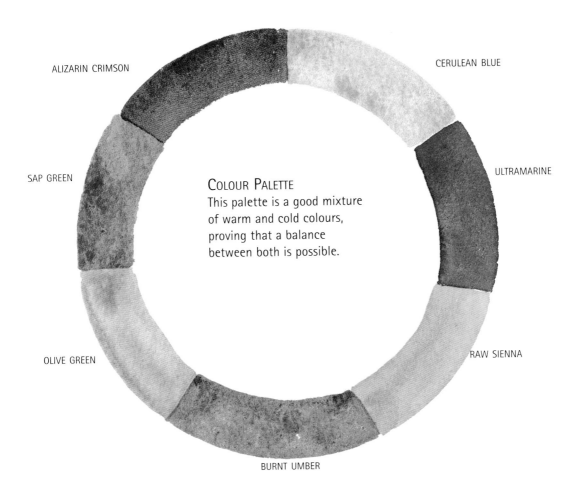

ALIZARIN CRIMSON

CERULEAN BLUE

SAP GREEN

ULTRAMARINE

COLOUR PALETTE
This palette is a good mixture
of warm and cold colours,
proving that a balance
between both is possible.

OLIVE GREEN

RAW SIENNA

BURNT UMBER

LIGHT ON DARK
Negative shapes can be
particularly effective in
creating movement if kept
thin and 'wispy'.

*The more colours that you can blend
into your sky, the better the final
result will be and the greater the
sense of 'space' in the atmosphere.*

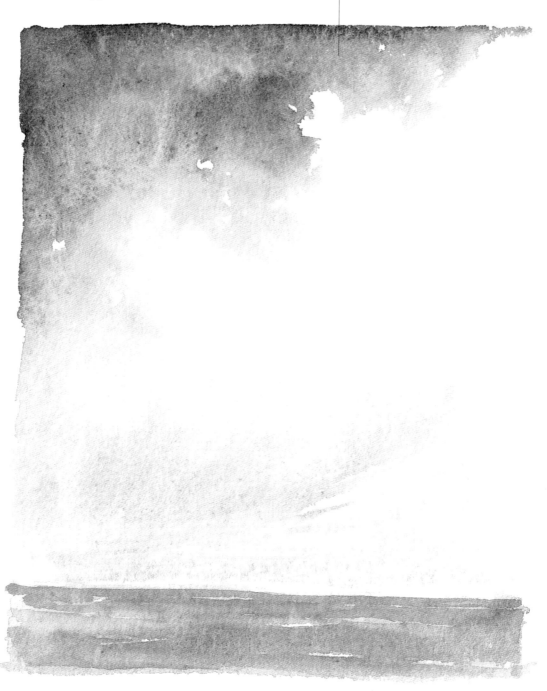

WINDSWEPT SKY

Creating a sense of movement in skies does involve an element of movement on the part of the painter. I found that it was necessary to pull paint across the paper, blot sections, and generally be a little more agile than when painting the more gentle, still summer skies.

This picture also used more colours in the creation of the sky, suggesting a level of atmospheric activity by the extended use of paint.

MATERIALS

- 425 gsm (200 lb) watercolour paper

- Brushes – 1 large (size 12), 1 medium (size 8), 1 small (size 2)

- Watercolour pan paints – cerulean blue, ultramarine, raw sienna, burnt umber, olive green, sap green. alizarin crimson

- Kitchen paper

1 *The first stage in this painting was to dampen the paper across the sky area and to run a 'line' of cerulean blue along the horizon with a large brush, raising the brush a little towards the end of the wash, creating some 'wispy' areas of cloud.*

2 *Quickly, a wash of ultramarine was run along the top of the paper and allowed to bleed downwards, 'sandwiching' the main bulk of the cloud area in between.*

3 Before the paper had dried, I took a piece of 'scrunched up' kitchen paper and blotted the top of the emerging cloud area, creating a sharp white edge to clearly define the cloud shape and size.

4 To reinforce these highlights even more, I used a watery mix of ultramarine and alizarin crimson to gently wash around the highlight and, using the edge of the medium paint brush, pulled this down onto the still damp middle cloud area.

5 The sky was now starting to look as if some activity was occurring, but the clouds still needed 'bulking out' a little to increase their visual 'weight'.

6 *To achieve this, I took a watery mixture of raw sienna and painted this along the cloud base, pulling the paint upwards, following the first cloud shapes created by the cerulean blue, reinforcing the sense of movement along the horizon.*

7 *Having fully established the form and tone of the sky, the foreground now needed to be developed. The sea was painted using the same colours as in the sky and the foreground was given a watery underwash of raw sienna.*

8 *The detail and shading on the curved lighthouse was painted with a small brush, using the same ultramarine and alizarin crimson mix used in the sky, creating a sense of visual unity.*

9 *A wash of olive green and sap green was applied on top of the foreground underwash, using broken brushstrokes to allow the raw sienna to show through in parts. The cliff face was painted using mixtures of ultramarine and burnt umber.*

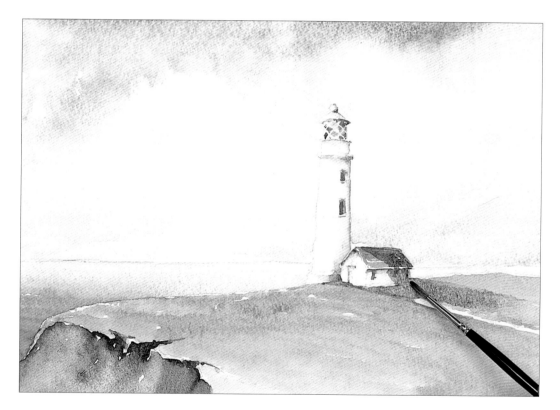

10 *The final stage was to paint the shadows cast onto the ground by the active sky. This, again, was done using a small brush for accuracy and a mixture of ultramarine and alizarin crimson.*

Controlled Colour

The key to this picture was the controlled use of a variety of colour in the sky, but also not being afraid to have many large sections of white. The contrast between the soft areas of cloud at the top and the more clearly defined brush marks along the horizon help to create the sense of direction and movement in this summer sky.

Raw sienna is best used at the base of the cloud to create a sense of weight in summer skies – too much grey or violet can make them look stormy.

The thin line of cerulean blue visually pushes the clouds forward in the composition increasing the effect of distance across this vast vista.

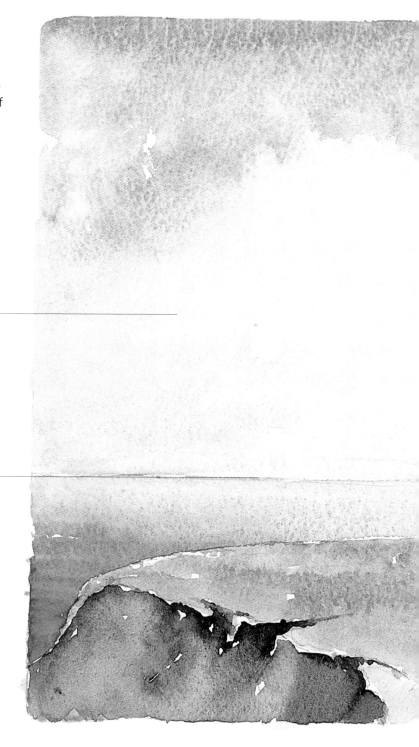

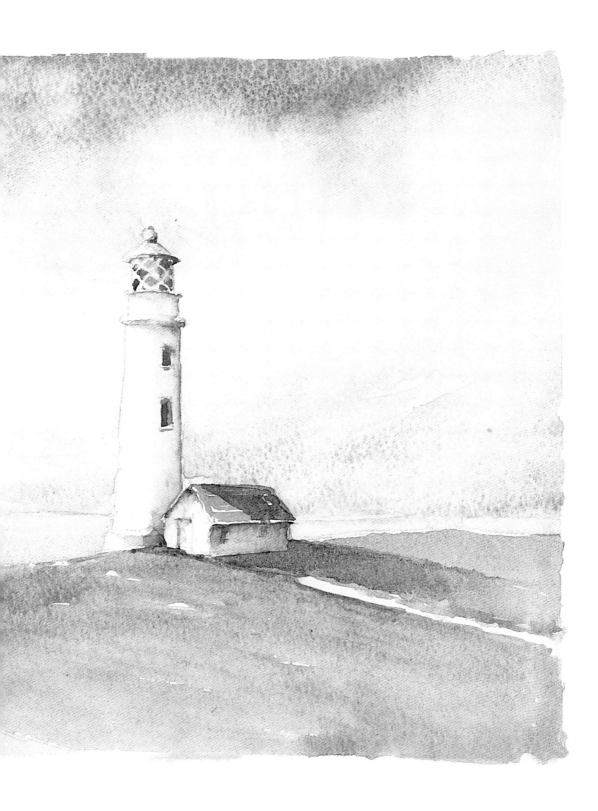

SUNRISE OVER WATER

As the sun rises over water, burning away the early morning mists, magnificent things can occur above the horizon. Oranges blend with purples and violets, catching the tops of clouds and creating fiery glows and pastel shades side-by-side.

Sunrises are usually different to sunsets - they are often softer, calmer and considerably more relaxing. The colours tend to be more localized, rarely flooding the sky with violent hues – more bathing them in an early morning glow.

To create these colours it is advisable to add very strong colours to very wet paper – this has a two-pronged effect. First, it will dilute the colours quickly so they will take on the softer appearance of an early morning sunrise. Second, they will bleed and blend quickly, creating a range of tones that you probably would not think of mixing on your palette. These too will dilute and dry to some delicate pastel shades, but without the hard edge you would find if you tried to mix them yourself and paint them onto dry paper.

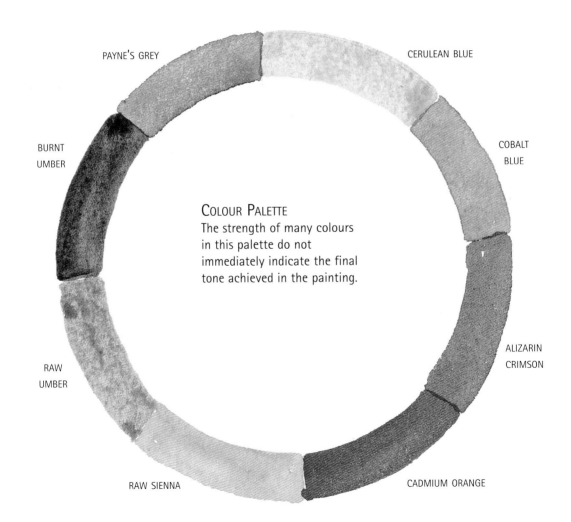

PAYNE'S GREY

CERULEAN BLUE

BURNT
UMBER

COBALT
BLUE

COLOUR PALETTE
The strength of many colours
in this palette do not
immediately indicate the final
tone achieved in the painting.

ALIZARIN
CRIMSON

RAW
UMBER

RAW SIENNA

CADMIUM ORANGE

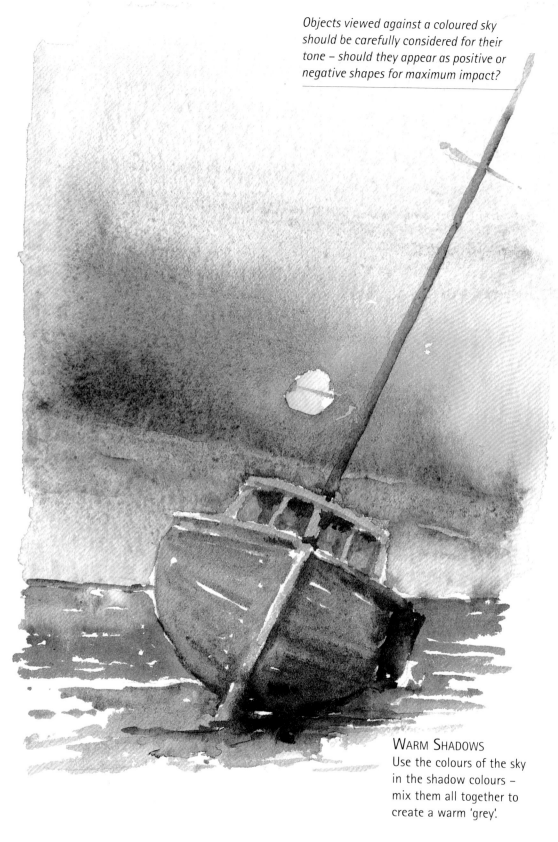

Objects viewed against a coloured sky should be carefully considered for their tone – should they appear as positive or negative shapes for maximum impact?

WARM SHADOWS
Use the colours of the sky in the shadow colours – mix them all together to create a warm 'grey'.

ESTUARY SUNRISE

The speed with which the sun rises over the horizon can be alarmingly quick for painters – the colours left in its wake, however, remain for longer, allowing us a little more time to consider how best to record them.

Although the weather was clement, I relied heavily on the colours at the 'cool' end of the spectrum to paint this passive estuary sunrise.

MATERIALS

- 425 gsm (200 lb) watercolour paper

- Brushes – 1 wash brush, 1 large (size 12), 1 medium (size 8), 1 small (size 2)

- Watercolour pan paints – cerulean blue, cobalt blue, alizarin crimson, cadmium orange, raw sienna, raw umber, burnt umber, Payne's grey

- Masking fluid in applicator

1 Having masked out the sun and boat mast which crossed the main sky area, I washed water onto the paper using a wash brush and ran a wash of the cool cerulean blue along the top of the page and pulled it downwards to the horizon.

2 While this was still wet, I mixed some alizarin crimson with a touch of the cooler cobalt blue and pulled this paint in two lines across the centre of the sky, 'sandwiching' a space in between.

3 Working quickly now, I mixed up a little cadmium orange and painted this onto the damp paper between the two violet-purple lines, creating an orange glow, suggesting the bright light emitted by the rising sun.

4 Before the sky was finally allowed to dry, I returned to the violet and ran the specific shape of a light, early morning cloud directly under the sun – take care not to paint clouds behind the sun, that's not possible! Once the wash had dried, I gently removed the masking fluid with a putty rubber.

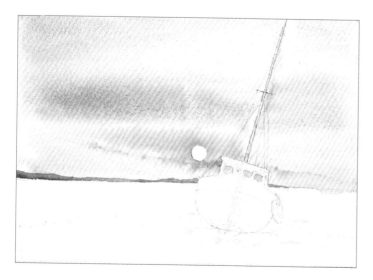

5 The bank on the far side of the estuary was painted next using a touch of Payne's grey and the orange and violet that were now sitting in the palette, creating a warm grey.

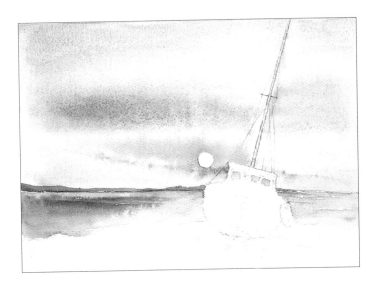

6 The water was painted in a similar way to the sky – the paper was dampened and the sky colours were pulled downwards across it, starting with cerulean blue and adding the violets closer to the foreground.

7 The wood of the boat was created by mixing raw sienna with a touch of burnt umber and a little of the 'palette violet'. Using a small brush, I picked out a few wooden planks to suggest the fabric of the hull.

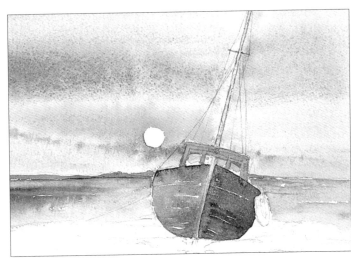

8 To reinforce the nature of the early light, I added some shadows to the hull of the boat using Payne's grey and violet, darkening the side and bottom.

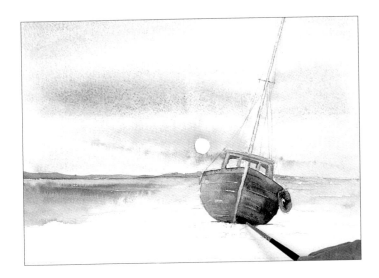

9 *The sand was painted using a watery mix of raw umber. This was painted onto dry paper at first, to allow the rivulets of water that gently lapped the shore to develop.*

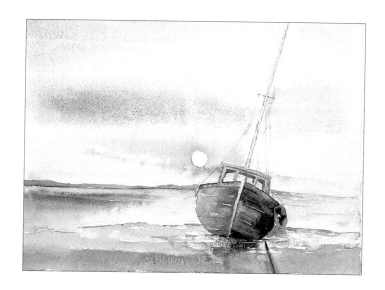

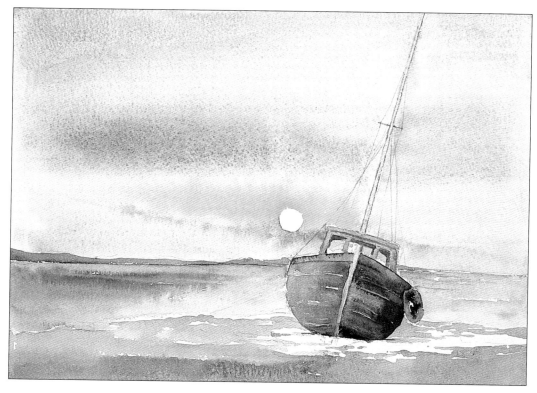

10 *The final stage of this project was to paint the reflection from the boat and sky in the foreground puddles, using watery versions of all the colours used in the entire picture. I also added a very watery wash of cadmium orange and raw sienna to the sun and gave some definition to the mast with a thin wash of burnt umber.*

SUBTLE LIGHT

The use of Payne's grey, mixed with oranges, blues and violets, contributed greatly to the success of this picture. It is best only used when the lighting produces slightly flat images, such as sunrises or sunsets.

Masking fluid also proved to be useful as it allowed the sky to be created freely without having to work around the mast, or darken it by painting over it – it now maintains its light tone, contributing to, rather than dominating, the composition.

Having removed the masking fluid from the sun, a little soft toning was applied to prevent the glare appearing too strong.

Even the reflections from the boat are created using all of the colours used in painting the sky.

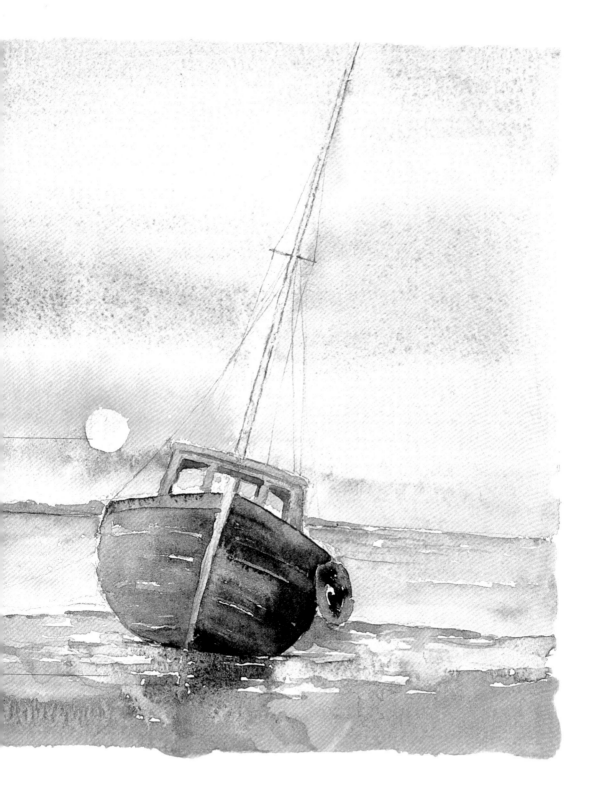

Mountain Storm

Whilst it would not be everyone's choice to be caught in the maelstrom of a raging mountain storm, it can be the most awe-inspiring, memorable experience.

The reality is that few people would stop in such a situation, take out a sketch pad and watercolours, and begin to paint. This is where visual memory becomes important. Artists develop a critical eye for the world around them, with the ability to recall shapes and colours. This is what you need to do when beginning a project involving extreme weather that you have experienced at first hand – recall the colours and apply them to the scene you wish to paint.

Hail, rain or snow can be created by the use of masking fluid, but the final result of thousands of specks of white paper will only work effectively if you ensure that the colours you apply to the sky are really strong. As they will need to blend naturally onto wet paper which will have the effect of diluting your chosen colours, you will have to ensure that the colours you apply are considerably darker than your anticipated end result.

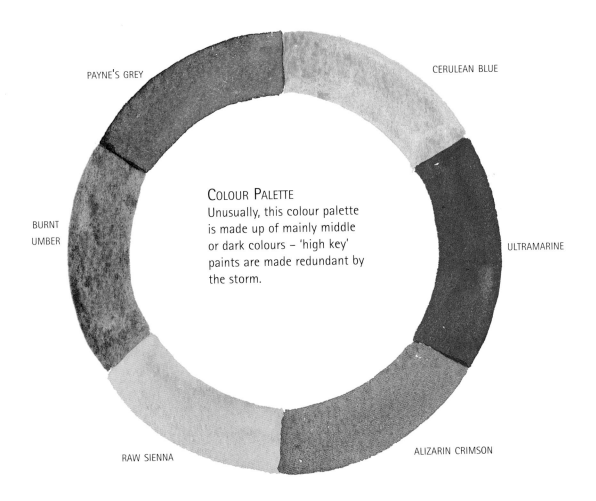

PAYNE'S GREY

CERULEAN BLUE

BURNT UMBER

ULTRAMARINE

Colour Palette
Unusually, this colour palette is made up of mainly middle or dark colours – 'high key' paints are made redundant by the storm.

RAW SIENNA

ALIZARIN CRIMSON

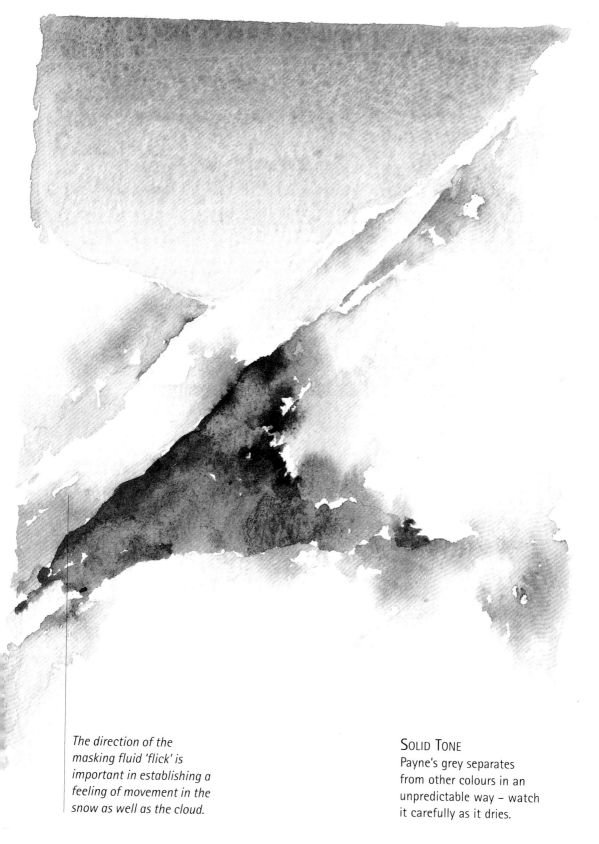

The direction of the masking fluid 'flick' is important in establishing a feeling of movement in the snow as well as the cloud.

SOLID TONE
Payne's grey separates from other colours in an unpredictable way – watch it carefully as it dries.

SWIRLING SNOW

The high mountain passes are inspiring places to walk, even in the face of a raging storm. This project relies heavily on capturing the image of swirling clouds and driving snow on watercolour paper.

The colours chosen for use in the sky are the result of impressions gained from the experience – not from studied observations that would have been impractical in the circumstances.

MATERIALS

- 425 gsm (200 lb) watercolour paper
- Brushes – 1 wash brush, 1 large (size 12), 1 medium (size 8), 1 small (size 2)
- Old toothbrush
- Masking fluid
- Watercolour pan paints – Payne's grey, burnt umber, cerulean blue, raw sienna, ultramarine, alizarin crimson
- Kitchen paper

1 *The first stage of this painting was to load an old toothbrush with masking fluid and flick this vigorously across the paper. I did this several times to create a variety of marks – small specks and larger droplets. This was left to dry.*

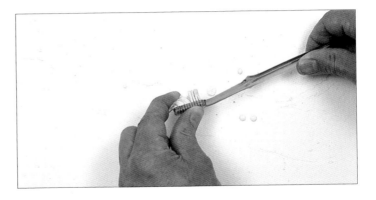

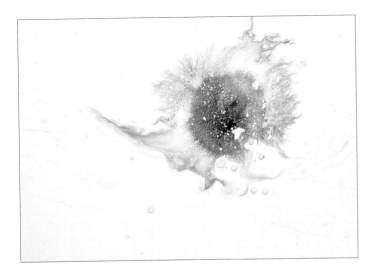

2 *Next, I flooded the sky area of the paper with water using a large wash brush and applied a very watery mix of Payne's grey. This instantly spread out across the paper and around the masking fluid.*

3 Before the paper could dry, I applied some watery burnt umber to the top of the composition and watched as the colours ran into each other, creating a variety of stormy and subtle tonal mixes.

4 The final step in creating the sky was to apply some watery raw sienna and allow that to mix with the other paints, creating more colours and tones than I could ever have achieved in my palette.

5 As the very watery paint was beginning to dry onto dry paper, the creation of a hard line was likely, so I blotted the outer edge with a piece of kitchen paper to soften the effect, reinforcing the 'misty' feel of the foreground.

6 With the sky area drying, I could now begin to concentrate on developing the foreground. Using a small brush and a pale mix of ultramarine and Payne's grey, I painted the rock under the snow in the middle ground.

7 The middle ground was completed by developing the rock and snow on the right-hand side. This was done by dampening the snow area and applying a mix of burnt umber and Payne's grey underneath – the colour bled up into the snow, softening the edges.

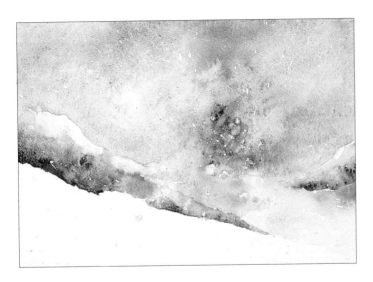

8 The foreground rocks were painted in the same way, using a medium size brush to avoid a set of 'fussy' brushstrokes. To create the effect of shading on the snow, a light violet was mixed from cerulean blue and alizarin crimson and washed onto some of the snow.

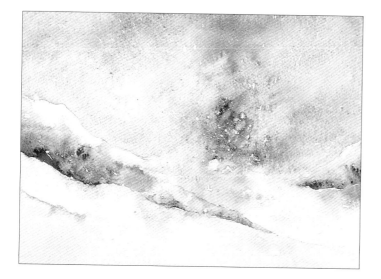

9 The light violet was used to add definition to the snow field in the immediate foreground. The piles of snow that had been created by the wind cast slight shadows – these were painted onto damp paper.

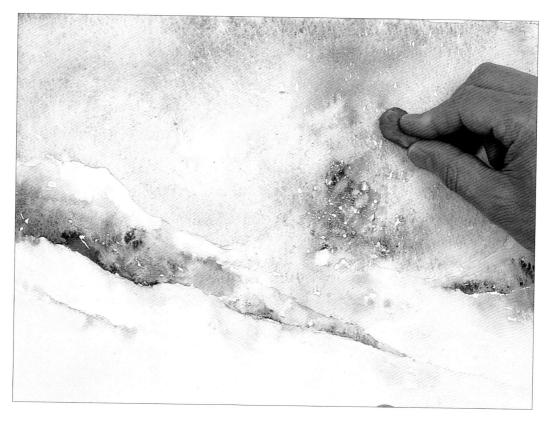

10 The final stage of this painting was to check that the paper was completely dry and then to remove the masking fluid by working gently over the surface of the picture with a putty rubber.

ABSTRACT SHAPES

The final picture holds some near-abstract qualities in the sky – but this is held firmly in check by the rocks and cliffs in the middle and foreground.

The white specks of paper representing snow are the direct result of extensive use of masking fluid. The effect works because the sky colours are dark enough to make them stand out. A pale, watery sky would not be so successful.

The variety of white flecks adds a sense of perspective and distance to the scene – these will occur naturally as you flick the masking fluid.

The soft violet tint to the foreground snow also allows the masking fluid to work effectively – when removed, the white still shows even against such gentle toning.

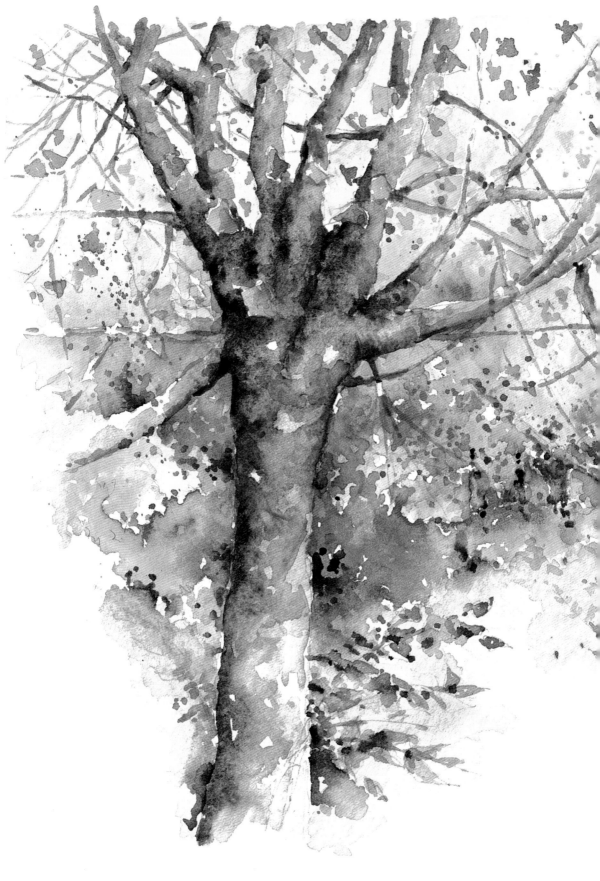

Forests and Woodlands

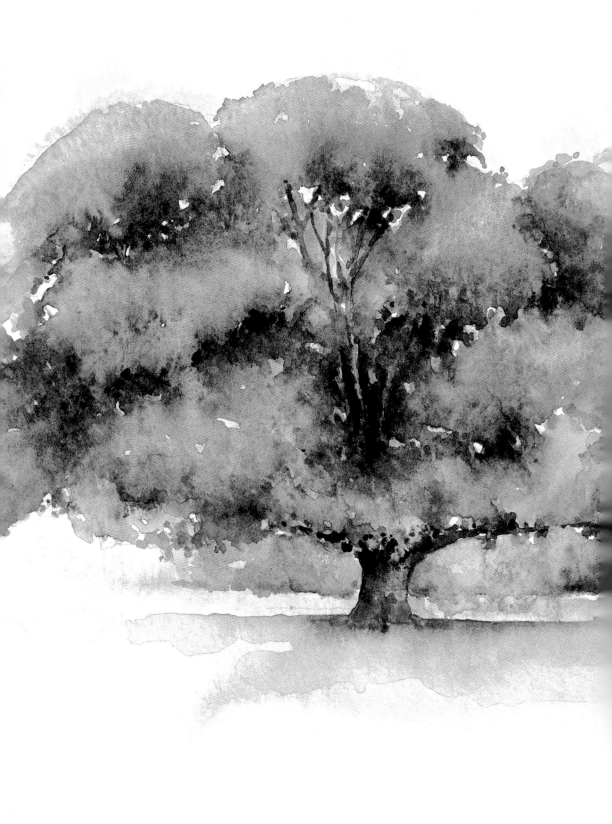

TREE AND LEAF SHAPES

Most objects can be reduced to a basic geometric shape – and trees, although irregular in shape, are particularly suited to this technique. While some trees defy simplification, most can be categorized into four main shapes: round-topped trees, tall thin trees, conical trees (conifers) and flat-topped trees. This creates a framework within which you can develop the more specific shape of the tree that you are painting.

ROUND-TOPPED TREES

One of the key characteristics of round-topped trees is that the branches and foliage usually take up approximately two-thirds of the height of the tree, leaving only a small trunk showing. Oaks, walnuts and horse chestnuts all fall into this category.

If you are painting round-topped trees in spring or winter, load a small brush with paint and begin at the main branch. Then pull the brush outwards, easing off the pressure until only the tip of the brush is touching the paper as the branches taper outwards, ending with a mass of fine, pointed twigs. During the summer months, however, the foliage covers the branches in a heavy dome, creating areas of shadow in the central sections as well as at the bottom of the tree. These sections are best painted when the initial underwash (usually a mixture of raw sienna and sap green) is still damp: mix and 'touch in' the darker tones once the surface water has evaporated.

Although you may not be able to see the branches when the trees are fully covered with masses of leaves, try to imagine where the main boughs and branches are. The branches support the leaves, and knowing where they are will help you to work out the main areas of light and shade – light above the branches, shadow below them.

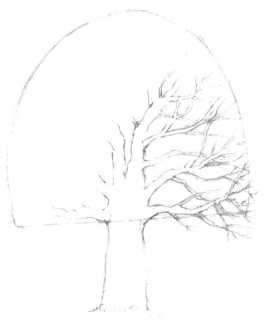

BASIC STRUCTURE
Most round-topped trees fit into a dome-type shape. One of the key characteristics of this kind of tree is that in summer the foliage takes up more than half the height of the tree, so make sure that you do not draw the straight base line high up the trunk.

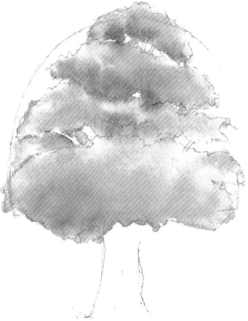

FIRST WASHES
As soon as the first wash of paint has been applied to the mass of foliage on the tree, mix a darker version of the chosen green by adding blues and browns to the first wash. Touch this into the damp paper to visually divide the bulk of the foliage.

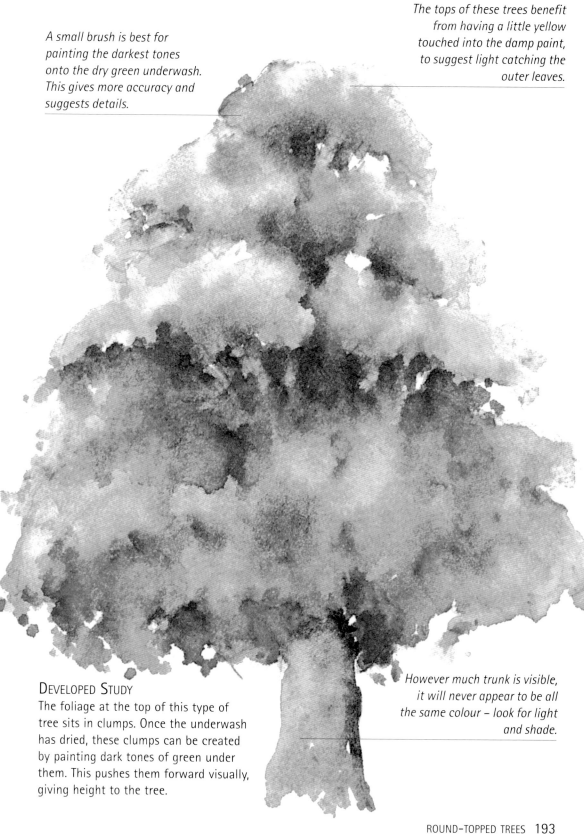

A small brush is best for painting the darkest tones onto the dry green underwash. This gives more accuracy and suggests details.

The tops of these trees benefit from having a little yellow touched into the damp paint, to suggest light catching the outer leaves.

DEVELOPED STUDY

The foliage at the top of this type of tree sits in clumps. Once the underwash has dried, these clumps can be created by painting dark tones of green under them. This pushes them forward visually, giving height to the tree.

However much trunk is visible, it will never appear to be all the same colour – look for light and shade.

When painting round-topped trees, it is best to start applying paint at the top and work towards the bottom. If you angle your paper downwards a little, the paint will run gently (if applied to damp paper), leaving the highlights at the top of the tree and the bulk of the heavy toning closer to the wider bottoms.

The stronger your basic mix, the darker the shading at the base of the tree will be. Judge the mood of the day and the lighting that falls on the tree which you are painting before committing to paper. If, however, your paint does begin to dry too dark, you can always blot some out with a piece of kitchen roll.

A Classic Example

Over the years this grand old oak tree had grown into a nearly perfect dome shape, making it very easy for me to define and start painting it.

Letting Paint Bleed

Round-topped trees are best painted onto damp paper, applying the darkest paint to the shaded areas and allowing it to bleed slightly. This is a different technique to 'wet-into-wet' (see page 30), as the paper only needs to be dampened. One medium brush is used to wash the colours on, and one small brush to apply the shadows.

1 Wash the undercoat or base colour across the tree in a sweeping, even motion.

2 As this begins to dry, apply small touches of the shadow tone using a small brush.

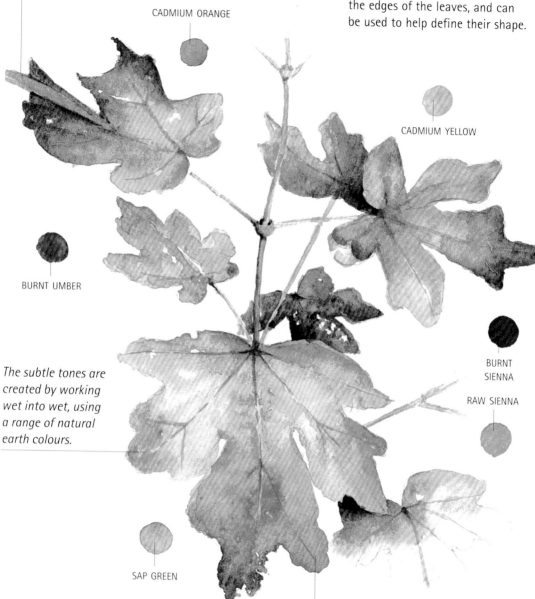

Sometimes the darkest colours are at the outer edges of leaves. Work onto damp paper and allow these colours to blend into the centre.

CADMIUM ORANGE

SHAPE AND COLOUR

Oak leaves are usually at their most visually interesting at the beginning of the autumn, just as the greens start to turn yellow, then finally to brown. The most dramatic colour changes occur at the edges of the leaves, and can be used to help define their shape.

CADMIUM YELLOW

BURNT UMBER

The subtle tones are created by working wet into wet, using a range of natural earth colours.

BURNT SIENNA

RAW SIENNA

SAP GREEN

Look carefully at the veins in a leaf. Do they appear darker or lighter than the leaf itself? Always check.

TALL THIN TREES

Trees that fit into this category include poplars, birches and plane trees. These are best constructed by drawing a long, tall and thin oval shape with a small area of trunk at the base (this will often be less than the trunk of round-topped trees). The length of these trees usually allows the clumps of foliage to be a little more spaced out, with more trunk and branches visible.

Because the boughs and branches are shorter and stronger than those of round-topped trees, the weight of the leaves, particularly in the summer, does not put so much pressure on the boughs at their outer extremities. For the painter, this means that you can find less extremes of light and shade, and more dominant middle tones – usually the colours of the underwash – on the outer edges of the bulk of the tree.

Tall thin trees often have gaps between the clumps of leaves, with either sky or other trees being visible through the spaces. The best way to create these gaps is to 'draw' around several blank areas of paper when applying the initial wash of water to dampen the paper, rather than soaking the entire bulk of the tree: water does not flow onto dry paper readily, so when you apply the underwash, the undampened areas will remain free of paint.

BASIC STRUCTURE
A wide variety of tree types fall into the 'tall thin' category, but they are all best recorded within an upright oval shape, as in this sketch. The foliage usually takes up at least two-thirds of the height of the tree.

FIRST WASHES
It is easy to observe the layers of foliage in these tall thin trees, and to see that they are visually divided by tone. Wait until the basic colour wash is barely damp, then touch in the shadow colour – this will bleed a little, producing some natural blends.

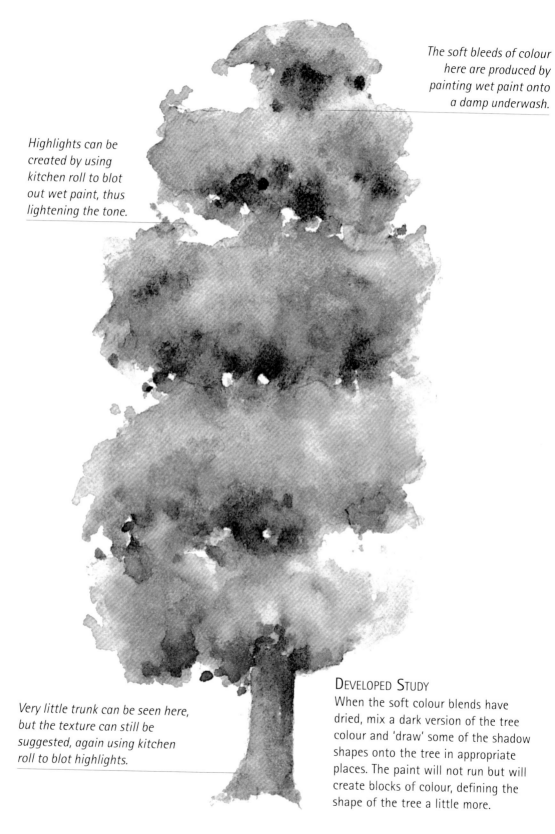

The soft bleeds of colour here are produced by painting wet paint onto a damp underwash.

Highlights can be created by using kitchen roll to blot out wet paint, thus lightening the tone.

Very little trunk can be seen here, but the texture can still be suggested, again using kitchen roll to blot highlights.

DEVELOPED STUDY

When the soft colour blends have dried, mix a dark version of the tree colour and 'draw' some of the shadow shapes onto the tree in appropriate places. The paint will not run but will create blocks of colour, defining the shape of the tree a little more.

The clumps of foliage of tall trees such as planes are divided by both space and tone. Gaps are often clearly visible between the layers of foliage, while the less subtle divisions between leaf colours can be emphasized by adding a darker tone.

To create this effect, add a darker version of the basic tree mix (sap green, raw sienna and burnt umber were used on the picture to the left) to the base of the layers of foliage while they are still damp, enabling the paint to spread and dry without a visible water mark. Next, add the branches using a small brush and a mixture of burnt umber and ultramarine.

The grace and elegance of these tall trees can be created by this use of dark and light, but particularly by close observation of the spaces in between the sharply angled branches and the foliage that they support.

PLANE TREE

The foliage on this tree was established by painting the different coloured sections individually, then allowing them to bleed together in certain parts.

LIGHT VEINS ON DARKER LEAVES

Rendering veins in leaves involves creating an overall underwash: first by painting the basic colour onto wet paper using a large or medium brush, then adding more colour onto dry paper using a medium or small brush. The final stage is drawing onto the leaf with very little paint.

1 *First wash the basic colour onto wet paper. The colour formed as it dries will form the basic colour of the vein.*

2 *When dry, use a medium brush to paint around the lines of the veins, leaving a web of negative shapes.*

3 *Use a small brush to paint a dark line of the basic leaf mix along the vein edges – the paint bleeds away from the veins.*

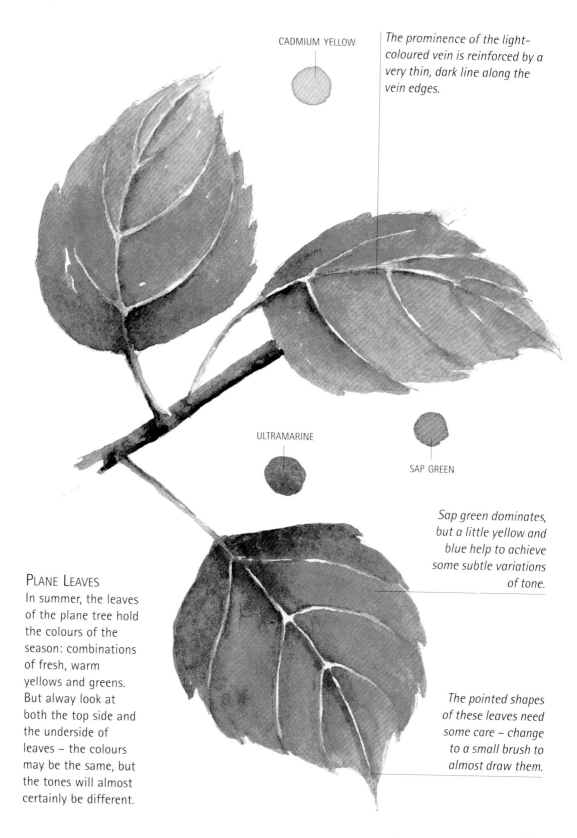

CADMIUM YELLOW

The prominence of the light-coloured vein is reinforced by a very thin, dark line along the vein edges.

ULTRAMARINE

SAP GREEN

Sap green dominates, but a little yellow and blue help to achieve some subtle variations of tone.

PLANE LEAVES

In summer, the leaves of the plane tree hold the colours of the season: combinations of fresh, warm yellows and greens. But alway look at both the top side and the underside of leaves – the colours may be the same, but the tones will almost certainly be different.

The pointed shapes of these leaves need some care – change to a small brush to almost draw them.

Conical Trees

Most conifer trees can be drawn to fit into a tall conical shape, leaving only a small amount of trunk showing at the base of the tree. Conifers are usually very 'full' trees that have few gaps showing between the branches (although the taller spruce members of the family are wider spread), so a lot of tonal variations are required in order to break up the mass of deep green foliage and avoid ending up with a solid mass.

A combination of three brushes is best for painting conifers – a large wash brush, a flat-headed or chisel brush, and a small detail brush. The large wash brush is invaluable for dampening paper prior to applying the first wash of paint. The flat-headed or chisel brush is used for applying the paint and exercising some control over its direction, using a sweeping motion to follow the shapes created by conifer branches and foliage. Finally, the small detail brush is best for finishing off areas of shadow, applying the paint with care to the darkest sections of the tree.

Conifers are ideal trees for exercising control over your painting as they hold many small areas of shaded detail.

Basic Structure
Most conifers, such as fir trees and the many varieties of pine trees, can be fitted into a conical shape in a preliminary sketch. Compared with the other basic tree shapes, conifers have very little of their trunk showing at the base.

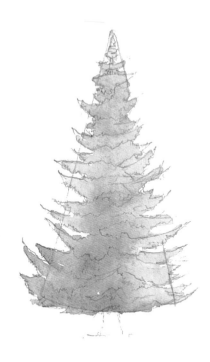

First Washes
Use a flat-headed or chisel brush to wash the base colour onto the conical shape, and paint using a sweeping, side-to-side action. The sharp, flat edge allows you to 'pull' the paint outwards, recreating the sharp edges of the tree.

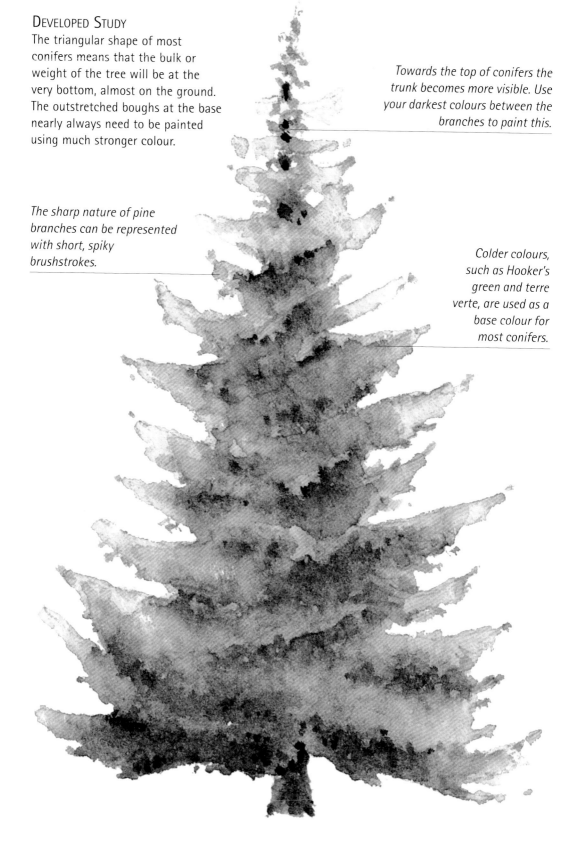

DEVELOPED STUDY
The triangular shape of most conifers means that the bulk or weight of the tree will be at the very bottom, almost on the ground. The outstretched boughs at the base nearly always need to be painted using much stronger colour.

Towards the top of conifers the trunk becomes more visible. Use your darkest colours between the branches to paint this.

The sharp nature of pine branches can be represented with short, spiky brushstrokes.

Colder colours, such as Hooker's green and terre verte, are used as a base colour for most conifers.

One common feature of some types of conifer tree is that you can often see much of the tree trunk – even in summer. This is particularly true of tall spruce trees. Although the foliage still fits into a triangular or conical shape, this shape often begins at least halfway up the tree rather than at the base, which is the case with other conifers.

Conifers vary from other trees in that they do not have 'leaves' in the way that we traditionally understand the term. The pine cones and needles on the branches and boughs need a different type of treatment altogether. Instead of allowing the colours to blend and bleed naturally, the needles have to be painted in a more 'graphic' style. To create single needles, flick a small brush outwards, creating thin lines, and use a wide variety of greens to prevent the study from looking like a flat block of colour.

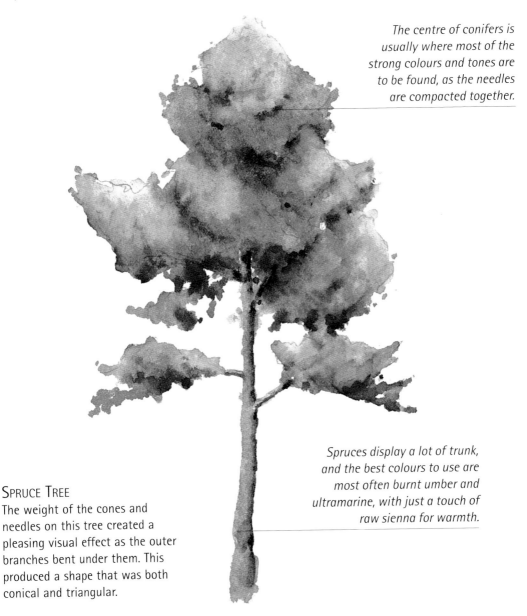

The centre of conifers is usually where most of the strong colours and tones are to be found, as the needles are compacted together.

Spruces display a lot of trunk, and the best colours to use are most often burnt umber and ultramarine, with just a touch of raw sienna for warmth.

SPRUCE TREE
The weight of the cones and needles on this tree created a pleasing visual effect as the outer branches bent under them. This produced a shape that was both conical and triangular.

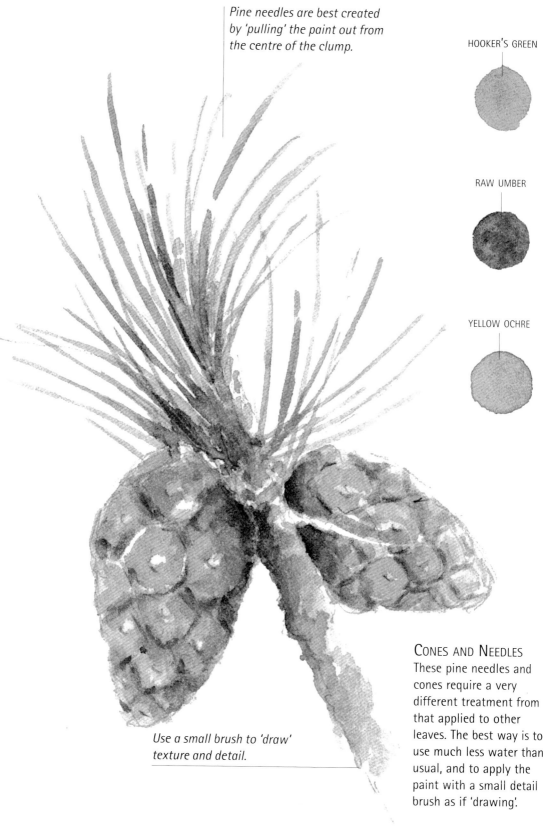

Pine needles are best created by 'pulling' the paint out from the centre of the clump.

HOOKER'S GREEN

RAW UMBER

YELLOW OCHRE

Use a small brush to 'draw' texture and detail.

CONES AND NEEDLES

These pine needles and cones require a very different treatment from that applied to other leaves. The best way is to use much less water than usual, and to apply the paint with a small detail brush as if 'drawing'.

FLAT-TOPPED TREES

Unlike the more regular round-topped trees or conifers, the *Acer* (maple) family of trees and Scots pines tend to have an uneven distribution of branches and leaves, with predominantly 'flat' tops (as opposed to domes, cones or points). These trees are best painted with a flat-headed or chisel brush, which allows you to pull the paint across the paper along the line of the foliage, maintaining a flat-topped or flat-bottomed line of paint, depending on the species and particular tree that you are painting.

In many cases, years of exposure to strong prevailing winds results in the vast majority of a tree's growth being on one side only, and the initial appearance is of

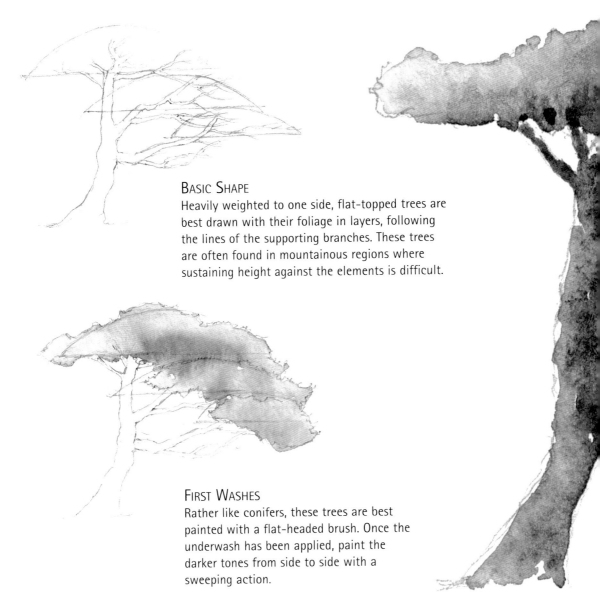

BASIC SHAPE
Heavily weighted to one side, flat-topped trees are best drawn with their foliage in layers, following the lines of the supporting branches. These trees are often found in mountainous regions where sustaining height against the elements is difficult.

FIRST WASHES
Rather like conifers, these trees are best painted with a flat-headed brush. Once the underwash has been applied, paint the darker tones from side to side with a sweeping action.

imbalance. In this situation, a useful technique is to apply plain water to dampen the paper on the side where the bulk of the foliage is to be found.

Subsequent applications of paint will then flow towards this section, accumulate there, and finally dry to a darker (but less solid) tone. This is one of the effects of placing wet paint onto already damp paper: the paint dries to a dark but graduated tone, rather than a solid, even shadow.

A flat-head or chisel brush can be used to shape both the tops and the bottoms of these trees in very much the same way as for creating the shapes of conical trees (see page 20).

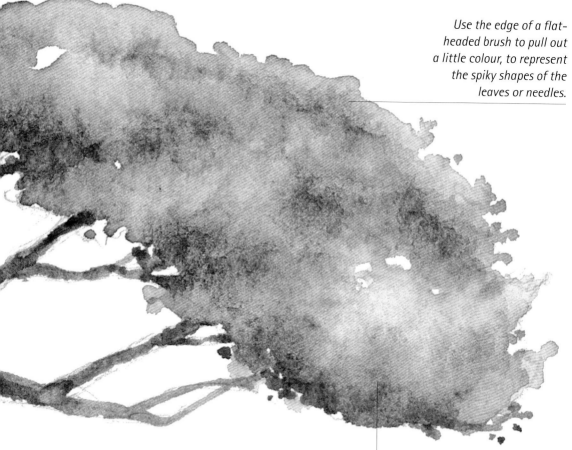

Use the edge of a flat-headed brush to pull out a little colour, to represent the spiky shapes of the leaves or needles.

DEVELOPED STUDY

Flat-topped trees differ from others in that they require some directional painting from the outset. The first wash established the shape of the top edge of the tree, and subsequent applications of paint are then 'pulled' across the shape of the tree.

Try to make sure that the branches you paint serve some purpose. Here, the bottom branches appear to be supporting the weight of foliage on the laden right-hand side of the tree.

One of the chief characteristics of *Acer* leaves is their sharp, distinctive points. Most trees hold so many leaves that it is not really possible to record individual leaves within the bulk of the tree. The smaller *Acer* trees, however, have particularly large leaves, and the scale of the tree can be suggested by including several of them in the preliminary drawing. You can then highlight these leaves by covering them with a basic wash of raw sienna and sap green, and then painting around them to visually push the individual leaves forward (see page 32).

If the areas behind these leaf shapes are painted using a flat-head brush, the sharpness of the brushstrokes reinforces the actual leaf shape. A flat-head brush also helps to determine the shape of the tree even further by allowing you to manipulate the paint and to create a sharply defined edge.

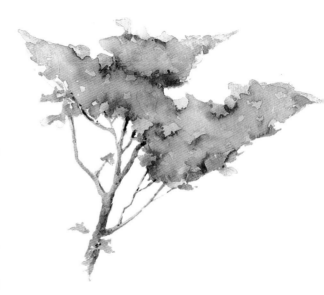

INCLUDING DETAIL

The size of the leaves on this tree allowed several to be picked out among the mass of foliage. Their sharp points are clearly perceptible and provide a visual counterpoint to the rest of the mass, and a link to the individual leaves below.

USING A FLAT-HEAD OR CHISEL BRUSH

Painting flat-topped trees requires a flat-head or chisel brush. These brushes feel different to the more commonly used round-headed brushes as they move less freely given their angular shape. However, you will discover just how quickly you can obtain sharp-edged directional brush marks.

1 First wash the undercoat colour in a sweeping side-to-side movement.

2 Mix the shadow colour and paint onto damp paper using the same sideways motion.

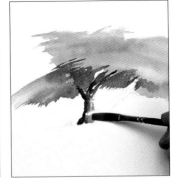

3 Create shadows on the trunk by 'pulling' the paint around the shape of the trunk.

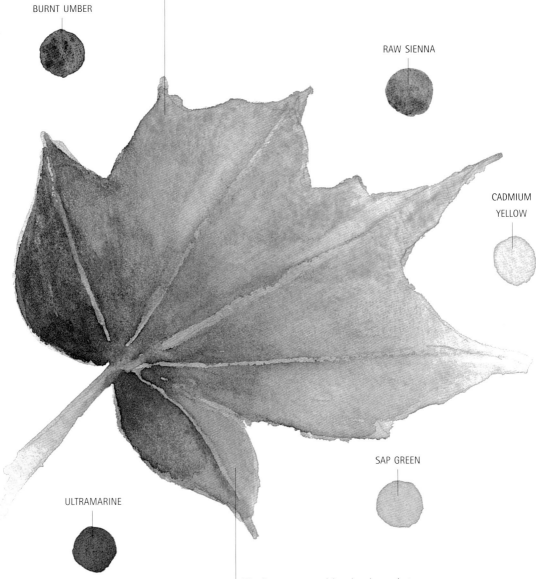

The range of colours used to paint this leaf is a mixture of natural earth colours and manufactured colours.

BURNT UMBER

RAW SIENNA

CADMIUM YELLOW

SAP GREEN

ULTRAMARINE

MAPLE LEAF
The key features of most leaves of the *Acer* family – Japanese maple, for example – are their highly decorative sharp points. This distinctive shape allows the direction of the veins to be clearly seen.

The best way to blend colours is to add paint to paper that has been washed with water – let the water on the paper do the work for you.

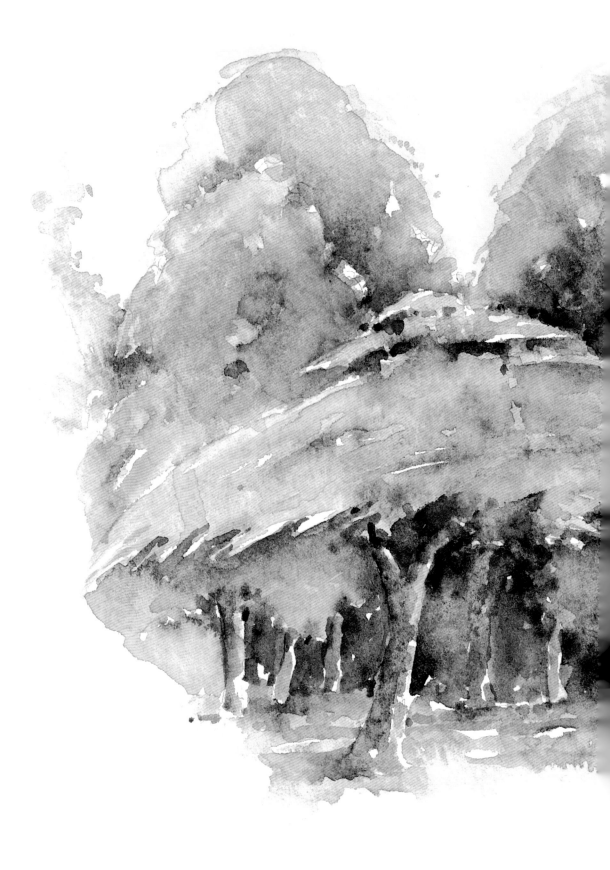

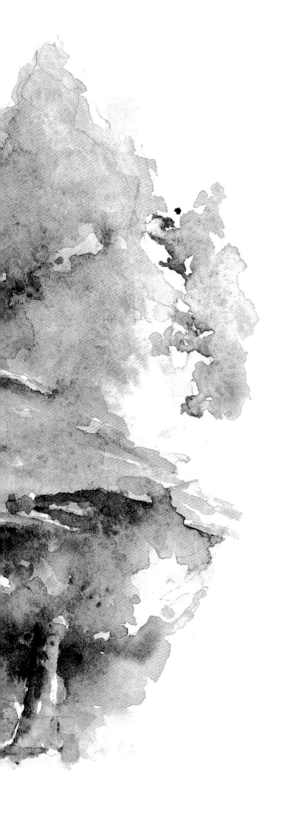

GROUPS OF TREES

Forests and woodlands, by their very nature, contain a wealth of different types and shapes of trees, usually growing in naturally random positions – and here lies the first challenge for the artist. How do you decide exactly which particular section of the forest or group of trees to paint? The main areas to consider are how attractive and visually appealing the group of trees you are looking at is, and just where the light is coming from.

Shapes and Tones

Although it is important to know how to construct the shapes of a variety of individual trees, it is very unusual to see single trees in total isolation in a forest or woodland setting.

However, the sight of a whole mass or tangle of trees, separated only by differing colour and tone, can be intimidating, so it is best to build up to whole forest scenes by focusing upon a small clump or group of trees – preferably a group of three or four trees that will require different construction shapes, and with differing tones or colours.

To help you focus in on a group of trees, it can be useful to carry a 35mm transparency mount to use as a viewfinder. Simply hold it at arm's length and move it about in your line of vision until you see the composition that you wish to paint contained within the rectangular frame of the viewfinder.

In the same way that photographers take a Polaroid snap to help them compose

Blocking In
With the basic shapes of this group of trees established, the next stage is to make some basic indications of the tonal values for each element. At this stage, there is no attempt at grading the tones.

a photograph, artists often make a small monochrome sketch before working on a composition. The illustrations on these pages show the various stages of constructing one particular group of trees. Once you have established the basic outline shapes, you can fill in and add detail to these shapes.

Wet into Wet
This is one of the most creative and expressive watercolour techniques. It involves applying wet paint from the palette to wet paint (or water) on the paper – when the two meet, the paints run and bleed into one another, finding their own way across the paper. The resulting paint then dries to a variety of tones.

1 *Apply a watery paint to wet paper. The paint flows away from the brush and settles.*

2 *Add another watery colour. As this flows away and blends, it creates new tones and colours.*

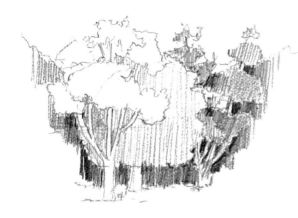

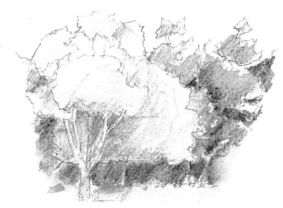

USING TONE

A monochrome tonal study can help you to see more of the shape and position of individual trees or groups by observing the positions of the lightest and darkest sections.

ADDING COLOUR

You can use water-soluble coloured pencils to make a colour sketch before moving on to a full-scale watercolour painting. Again, the lightest and darkest tones are blocked in.

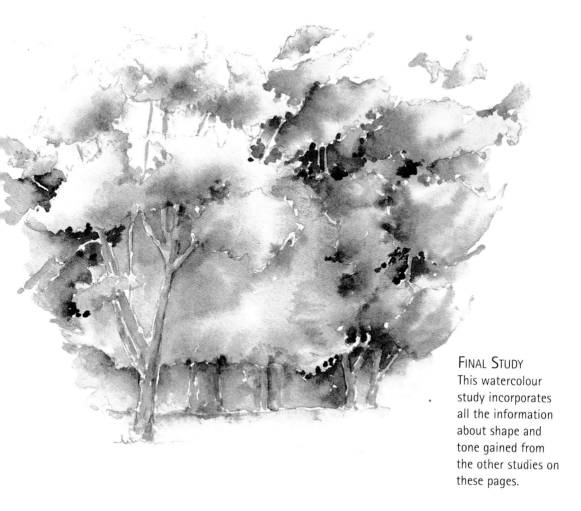

FINAL STUDY

This watercolour study incorporates all the information about shape and tone gained from the other studies on these pages.

NEGATIVE SHAPES

Negative shapes are often to be seen in forests. These occur when the main subject of your painting is light in tone and stands out against a dark background – as in this example of a pale brown sycamore trunk. Normally in watercolour painting you work from light to dark – but it is tricky to paint a dark background around a light subject in a scene that contains many complex and irregular shapes.

To overcome this, incorporate the negative shapes right from the start. Sketch the selected shape lightly in pencil and then work around it when wetting the paper, leaving the shape dry. As wet paint does not readily run into dry paper, the dry areas will remain free of paint when the first wash of dark background colour is applied.

The next stage involves working on top of the underwash once it is dry. Paint a watery wash over the lighter-toned main subject, using broken brushstrokes so that some areas are left completely free of paint.

This technique can be developed to build up different layers of paint with several respective sets of negative shapes showing through from the previous underwash. It is also a useful way of suggesting generalized leaf shapes without endeavouring to paint every single leaf.

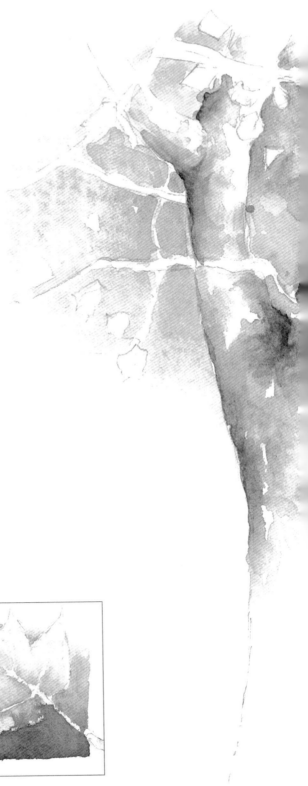

LIGHT AGAINST DARK
Sometimes it is not enough to just leave a negative shape as white paper, or with only an underwash showing. This leaf is an example of a shape that required painting but still maintained a lighter tone than the background.

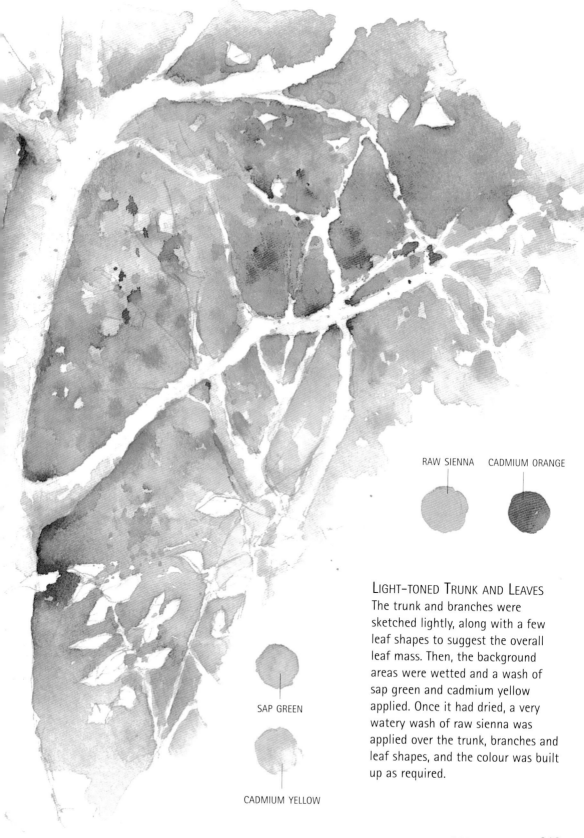

RAW SIENNA CADMIUM ORANGE

SAP GREEN

CADMIUM YELLOW

LIGHT-TONED TRUNK AND LEAVES

The trunk and branches were sketched lightly, along with a few leaf shapes to suggest the overall leaf mass. Then, the background areas were wetted and a wash of sap green and cadmium yellow applied. Once it had dried, a very watery wash of raw sienna was applied over the trunk, branches and leaf shapes, and the colour was built up as required.

POSITIVE SHAPES

Positive shapes occur when an object is darker than the background against which it is placed. This sketch, looking deep into the forest leaves and undergrowth, owes its strength to the positive shapes of the leaves that can be seen in both the foreground and the background.

The underwash – a wet-into-wet wash of raw sienna, cadmium orange and cadmium red – was applied and then left to dry. The leaves in the background were created by flicking small quantities of paint – burnt sienna and cadmium red – carefully onto the dried underwash. This is a technique that requires a little practice to ensure that you can control the direction of the paint and the quantity applied, but it does produce a spontaneous and random effect which will always help to create distant detail where no specific shape is required – only suggestion.

The leaves in the foreground were given a more considered treatment. These were painted using the same colours as the background leaves, only this time specific brushstrokes were used to create several individual shapes. While botanical accuracy is not required for this type of sketch, it does help to illustrate that different types of leaves are found in different areas of the forest.

If you do not visually attach positive leaves to a particular branch or stalk they can appear to float, enhancing the feeling of movement within your picture.

DARK AGAINST LIGHT
The leaf stands out clearly against the background. The background wash is a very dilute version of the colours that were used in the leaf – they were, after all, in the same scene.

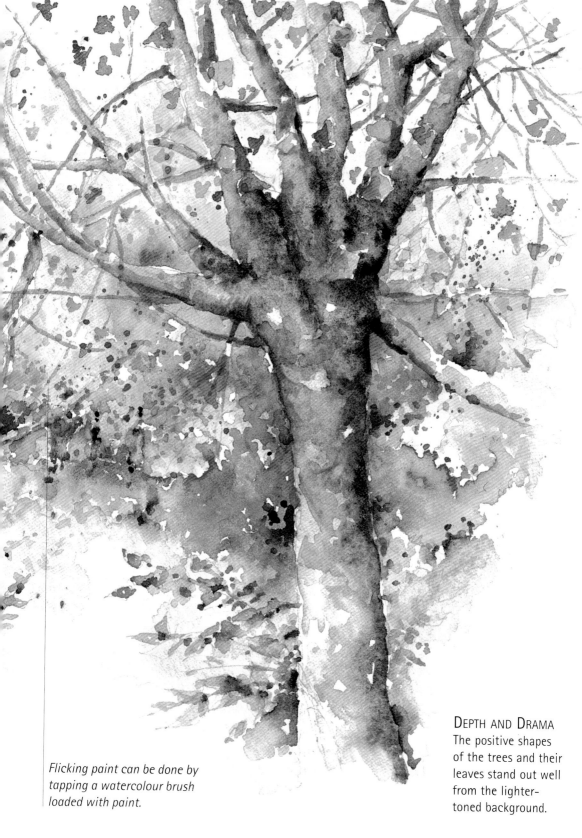

Flicking paint can be done by tapping a watercolour brush loaded with paint.

DEPTH AND DRAMA
The positive shapes of the trees and their leaves stand out well from the lighter-toned background.

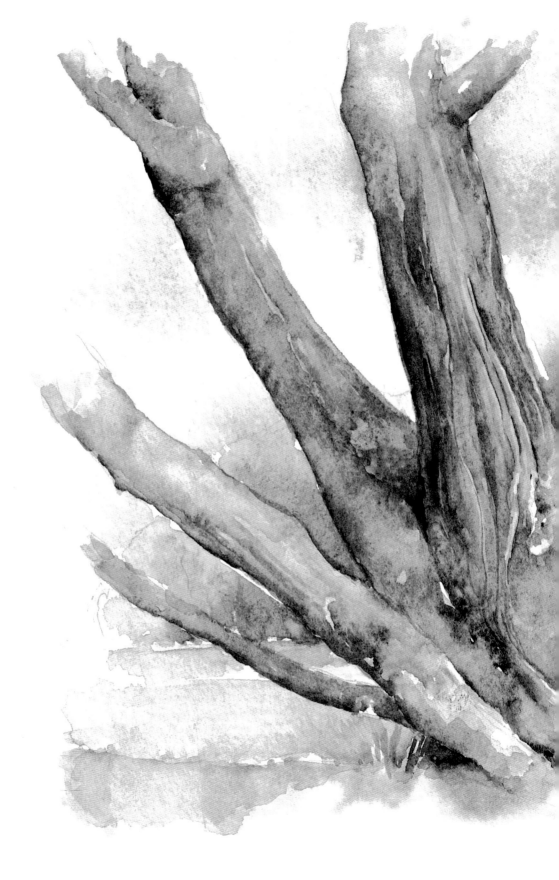

WOODLAND COLOURS

The variations in colour and tone in woodlands and forests are endless. Each season presents a new challenge, as not only the light and the weather, but also the very fabric of the forest adapt to the natural changes. The search for the right colours is never-ending, so it is a good idea to take time to establish the set of colours that best suits your requirements and personal style.

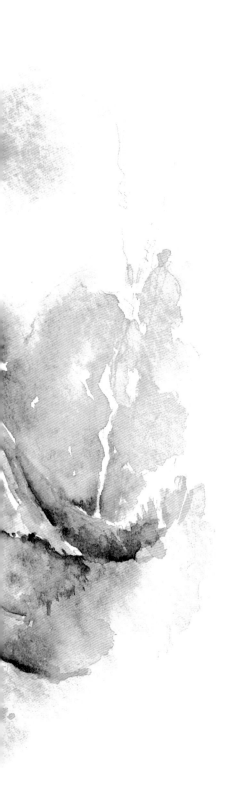

GREENS

Many people might think that the colours to choose for painting woodland scenes are obvious: greens and browns. How wrong they would be! First, the choice of colours is certainly not simple: the cool blues of spring, the violet shadows of summer, and the oranges and reds of autumn each tell a very different story. Second, which greens and which browns? The colours found on art-store shelves are rarely identical with any colours to be seen in the natural world, and you will have to practise mixing your own colours. This way, you soon discover which particular commercially produced colours suit your needs.

The example on the opposite page shows the greens that I like to use, and how they are mixed. I tend to use sap green as a general, all-purpose green – this colour is a good mixer and can be used as a base for an extremely wide range of colours and tones. The key is to experiment and to make notes on the colours that you find useful, and exactly how you mixed them.

ART-STORE GREENS

Most paints today are factory-produced to maintain longevity and consistency of performance. Despite these advantages, the colours in the tubes are not the greens we find in nature, and must therefore be used primarily as 'mixers'.

| SAP GREEN | HOOKER'S GREEN | VIRIDIAN | TERRE VERTE |

BLUE AND YELLOW DON'T ALWAYS MAKE GREEN

Try experimenting with as wide a range of commercially available paints as possible, to see exactly which colours combine to make the types of greens you wish to use. Label the results and keep them away from direct light so you can have a handy reference chart.

CADMIUM YELLOW 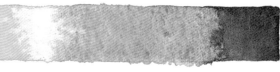 ULTRAMARINE

CADMIUM YELLOW PAYNE'S GREY

LEMON YELLOW WINSOR BLUE

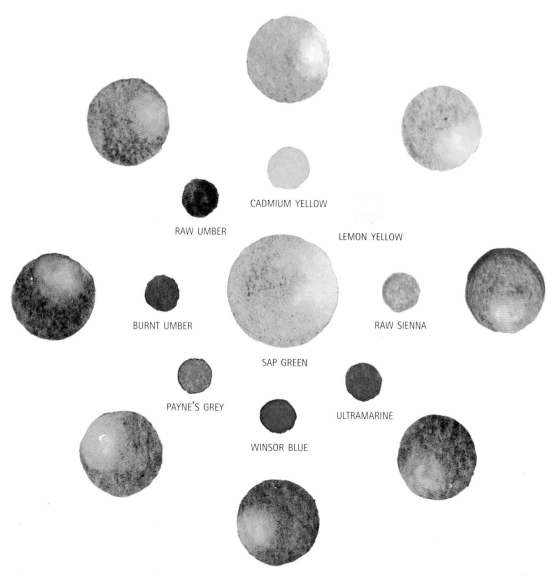

CADMIUM YELLOW

RAW UMBER

LEMON YELLOW

BURNT UMBER

SAP GREEN

RAW SIENNA

PAYNE'S GREY

ULTRAMARINE

WINSOR BLUE

Sap Green Mix

Although sap green is not a particularly useful colour for forests and woodlands on its own, you can use it as the principal ingredient in a whole range of mixtures. Even those shown here can be varied greatly by the proportions of each colour in the mix.

When mixing greens, it is not always a good idea to keep changing your water, strange as this may seem. Slightly tainted water can act as a binding medium, thus ensuring that all the colours and tones that you mix are visually related and connected.

You can mix tones by diluting paint in the palette – more water will always give you a lighter-toned paint. You can also vary tones by painting onto wet paper, which has the effect of diluting the tones even more. So don't just consider tones as varied mixtures of colour – think of the variety of tones that you can create through dilution.

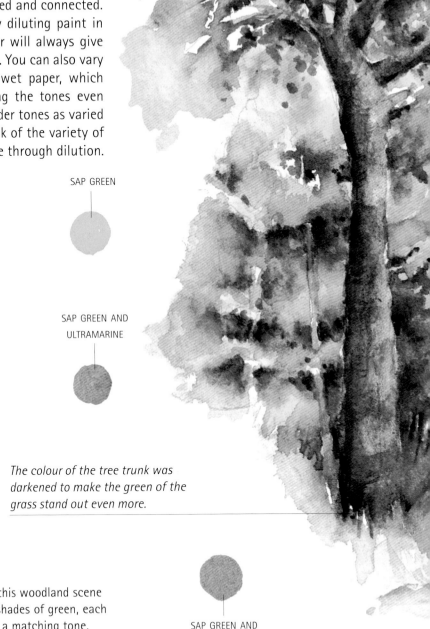

SAP GREEN

SAP GREEN AND ULTRAMARINE

The colour of the tree trunk was darkened to make the green of the grass stand out even more.

A MIXING CHALLENGE
Painted on a summer day, this woodland scene was awash with different shades of green, each of which forced me to mix a matching tone.

SAP GREEN AND BURNT UMBER

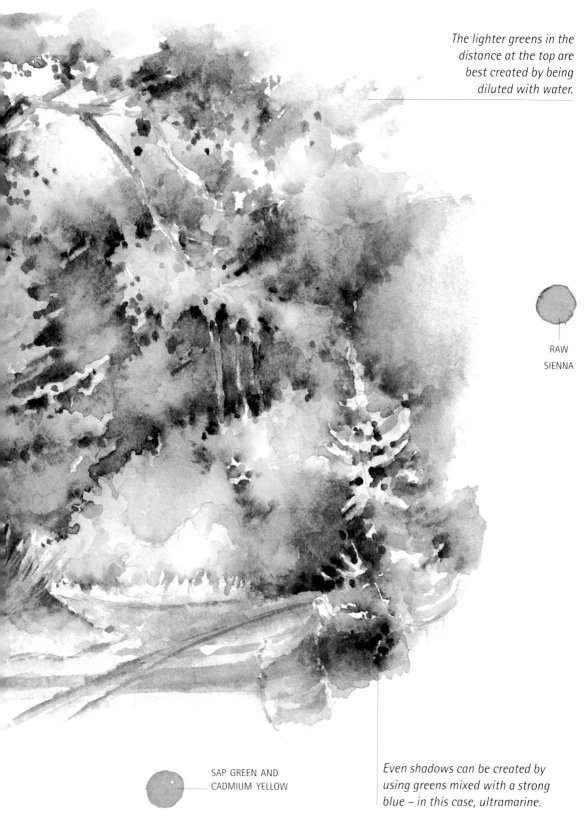

The lighter greens in the distance at the top are best created by being diluted with water.

RAW SIENNA

SAP GREEN AND CADMIUM YELLOW

Even shadows can be created by using greens mixed with a strong blue – in this case, ultramarine.

EXAMINING COLOURS

Most of us grow up believing that skies are blue, trees are brown, and leaves are green. As we become visually more sophisticated and articulate, we soon learn that for an artist, life is not quite so simple and straightforward.

It is probably true to say that most tree trunks have a 'brown' base colour, but artists need to make many decisions upon which type of brown to use. As a general rule, I use a generic 'tree-trunk brown' mixture as a starting point, and develop this according to the type of tree and the respective colours and tones that are in front of me. This basic mixture consists of burnt umber and raw sienna with a touch of ultramarine.

Many trees found in forests or woodlands, however, need to have a series of additional colours added to increase the range of colours and tones that they contain – redwoods, for example, require a considerable amount of reddish burnt sienna in the mixture. In contrast, silver birches require a totally different base colour.

ULTRAMARINE

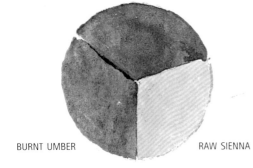

BURNT UMBER RAW SIENNA

'GENERIC' TRUNK
While the colours that are mixed are important, the method of applying them also matters – for instance, applying them wet-into-wet results in some colours 'separating' as they dry. This is great for some trees, but others require a smoother application of colour.

FINDING THE RIGHT MIX

Some tree trunks require a mix of up to six colours to record them. These colours are rarely mixed together on the palette, but are applied to damp paper and allowed to mix and blend on the paper, creating a more textured and natural look.

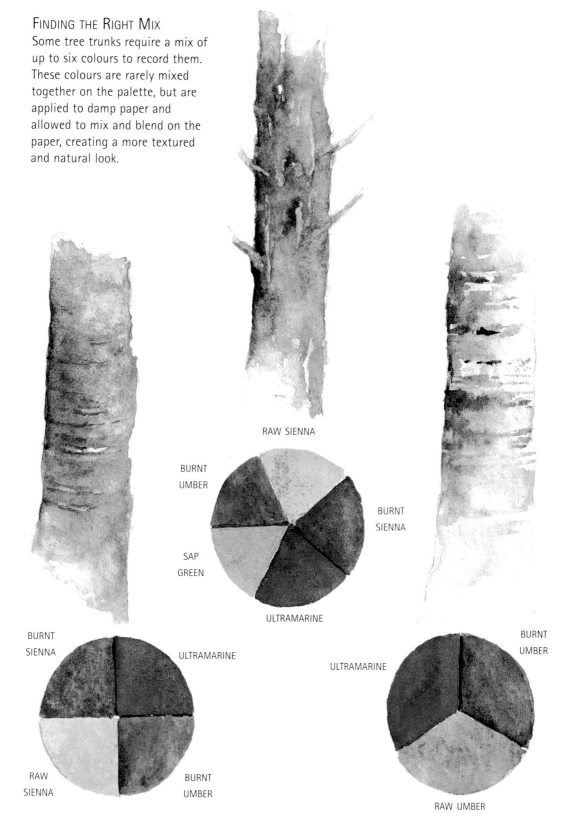

RAW SIENNA

BURNT UMBER

BURNT SIENNA

SAP GREEN

ULTRAMARINE

BURNT SIENNA

ULTRAMARINE

RAW SIENNA

BURNT UMBER

ULTRAMARINE

BURNT UMBER

RAW UMBER

Leaves are no different from tree trunks when it comes to colour mixing – a basic colour mix can be useful as a starting point, but it soon becomes limited when you examine the colours in a variety of leaves more closely.

My 'generic' leaf colour starts with sap green, to which I add a little cadmium yellow and a touch of burnt umber. The varia-tions on this mix are not only from leaf to leaf, but from season to season: in the spring, I substitute lemon yellow for cadmium yellow, and in the autumn I use cadmium orange instead of cadmium yellow.

When painting leaves it is also important to turn them over and examine the under-sides, as the colours here can be quite dif-ferent in intensity.

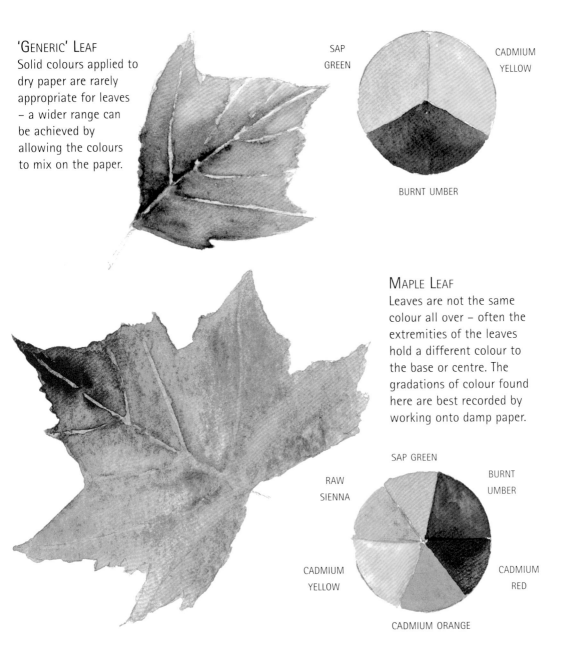

'GENERIC' LEAF
Solid colours applied to dry paper are rarely appropriate for leaves – a wider range can be achieved by allowing the colours to mix on the paper.

SAP GREEN

CADMIUM YELLOW

BURNT UMBER

MAPLE LEAF
Leaves are not the same colour all over – often the extremities of the leaves hold a different colour to the base or centre. The gradations of colour found here are best recorded by working onto damp paper.

SAP GREEN

BURNT UMBER

RAW SIENNA

CADMIUM YELLOW

CADMIUM RED

CADMIUM ORANGE

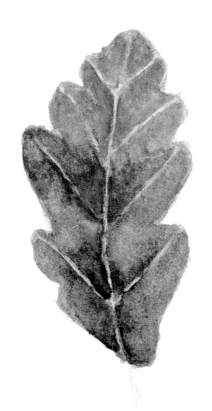

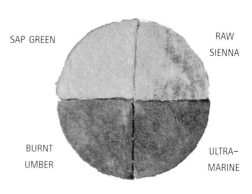

SAP GREEN

RAW
SIENNA

BURNT
UMBER

ULTRA-
MARINE

Oak Leaf

An exciting and natural-looking range
of colours can be created by allowing
paints to mix together on damp paper,
rather than mixing them on the
palette and applying them to dry
paper, which can make the colours
somewhat 'flat'.

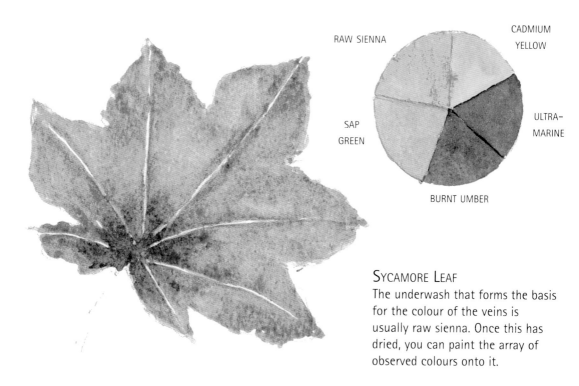

RAW SIENNA

CADMIUM
YELLOW

SAP
GREEN

ULTRA-
MARINE

BURNT UMBER

Sycamore Leaf

The underwash that forms the basis
for the colour of the veins is
usually raw sienna. Once this has
dried, you can paint the array of
observed colours onto it.

SPRING COLOURS

Spring colours tend to come from the cooler end of the colour spectrum – predominantly blues and lemon yellows.

The season's freshness can be recreated by informed choices about colour mixes. The cooler blues are cobalt blue and Winsor blue; Hooker's green has a strong blue element. Cadmium yellow can be used in spring forest scenes, but mixing in a little lemon yellow freshens the colour. The cool violets of bluebells, for example, can be mixed with Winsor or cobalt blue and a touch of permanent mauve. Although Winsor blue can be good in skies and greens, it can be rather overpowering on the ground.

Don't be concerned about mixing warm and cold colours together in a composition (such as warm greens and cool yellows) – often they work particularly well.

Using water as the medium, a wider variety of tones can be mixed on the paper.

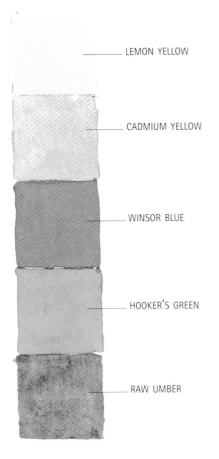

LEMON YELLOW

CADMIUM YELLOW

WINSOR BLUE

HOOKER'S GREEN

RAW UMBER

SPRING PALETTE
Few of the range of spring colours are used 'neat'. They need extensive mixing as not many of them are 'natural' colours. You can mix these paints in the palette or on the paper itself, using the surface water to carry the paint and mix it for you.

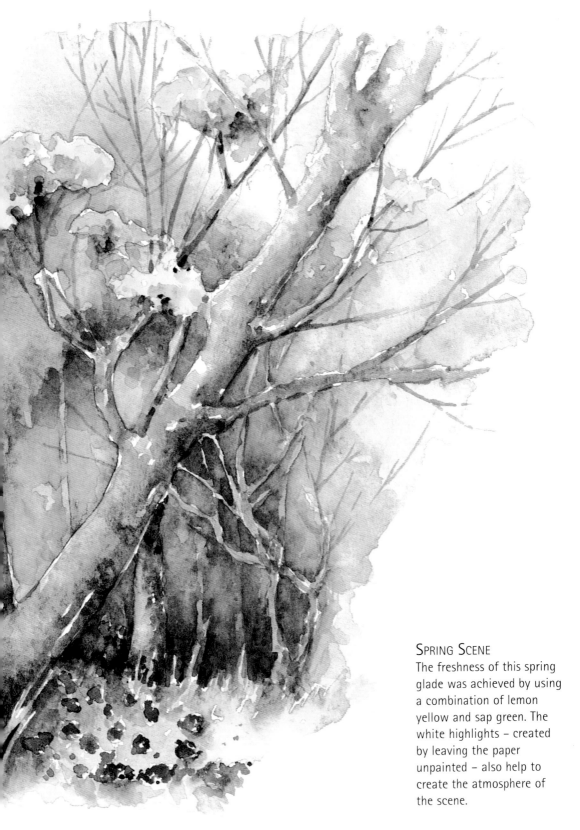

Spring Scene
The freshness of this spring glade was achieved by using a combination of lemon yellow and sap green. The white highlights – created by leaving the paper unpainted – also help to create the atmosphere of the scene.

Summer Colours

The sun-filled days of summer are best recorded using a selection of yellows and greens, reserving a little warm violet for the shadows. Sap green is a good starting point, adding the warmer cadmium yellow to develop the highlights. The more sunlight, the stronger the shadows, and these can be painted using a mixture of ultramarine with a touch of alizarin crimson or burnt umber. Both these colours have warm qualities and are ideal for turning a neutral colour or tone into summer shadows. The sharp, cold light of spring has been replaced by softer summer light, usually resulting in softer-edged shadows. To achieve this, allow the shadows to bleed into damp paper, or blot the edges.

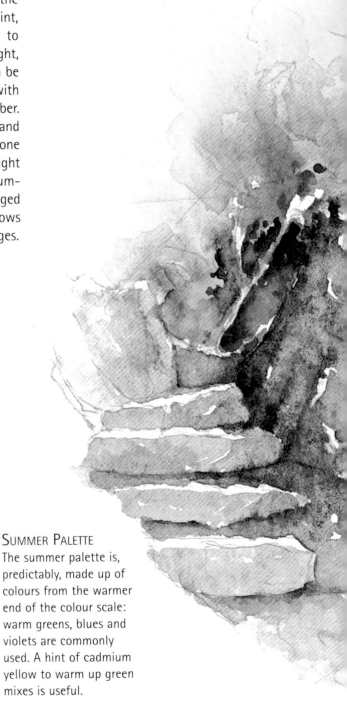

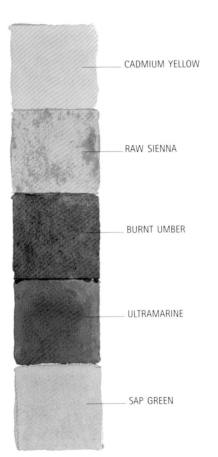

CADMIUM YELLOW

RAW SIENNA

BURNT UMBER

ULTRAMARINE

SAP GREEN

Summer Palette
The summer palette is, predictably, made up of colours from the warmer end of the colour scale: warm greens, blues and violets are commonly used. A hint of cadmium yellow to warm up green mixes is useful.

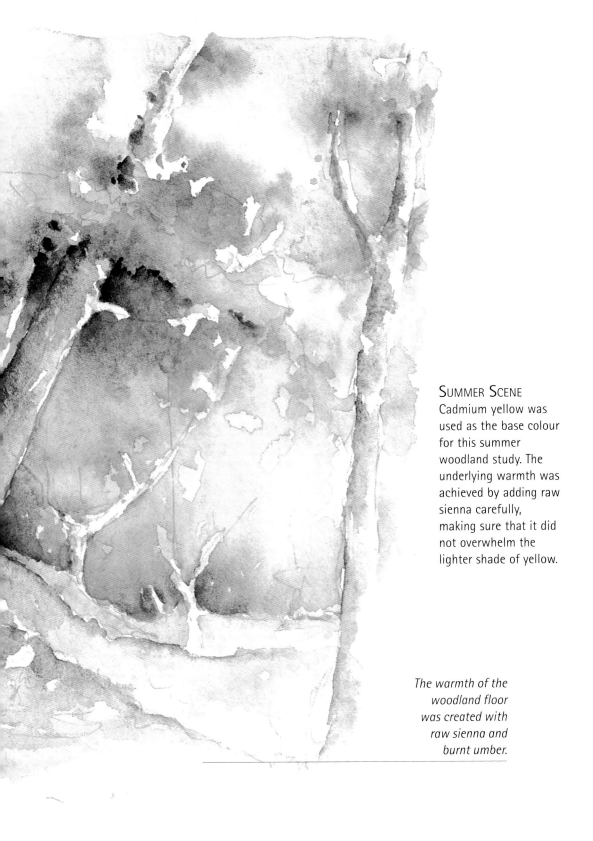

SUMMER SCENE
Cadmium yellow was used as the base colour for this summer woodland study. The underlying warmth was achieved by adding raw sienna carefully, making sure that it did not overwhelm the lighter shade of yellow.

The warmth of the woodland floor was created with raw sienna and burnt umber.

Autumn Colours

This is the season of oranges, reds, golds and browns, largely created from the natural earth colours, with the occasional addition of the cadmium family.

Raw sienna is a good catalyst for colour mixes: this warm yellow colour mixes well with siennas and umbers as well as cadmium yellow and cadmium red to aid the 'golden' feel. Burnt sienna, a reddish-brown colour, is a good base for the addition of a few splashes of colour. In small quantities, pure cadmium red can look visually stunning when mixed with raw sienna, and even more so when a few neat flecks are introduced to a scene. Burnt umber and ultramarine work well for shadows.

Even the tree trunks hold the colours of the season.

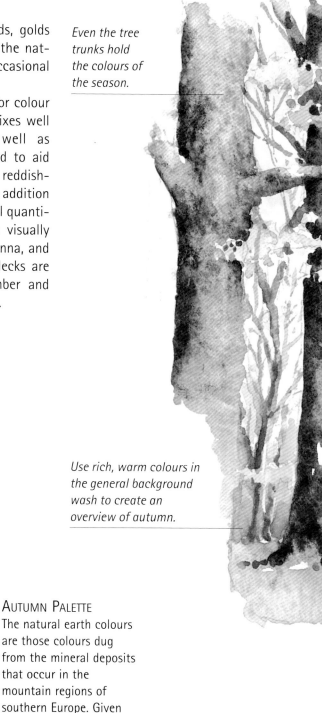

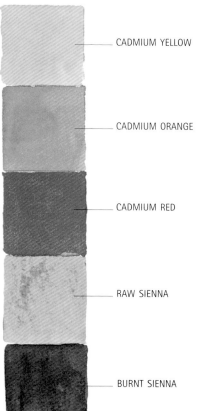

CADMIUM YELLOW

CADMIUM ORANGE

CADMIUM RED

RAW SIENNA

BURNT SIENNA

Use rich, warm colours in the general background wash to create an overview of autumn.

Autumn Palette

The natural earth colours are those colours dug from the mineral deposits that occur in the mountain regions of southern Europe. Given their organic nature, they are ideal colours for an autumnal palette.

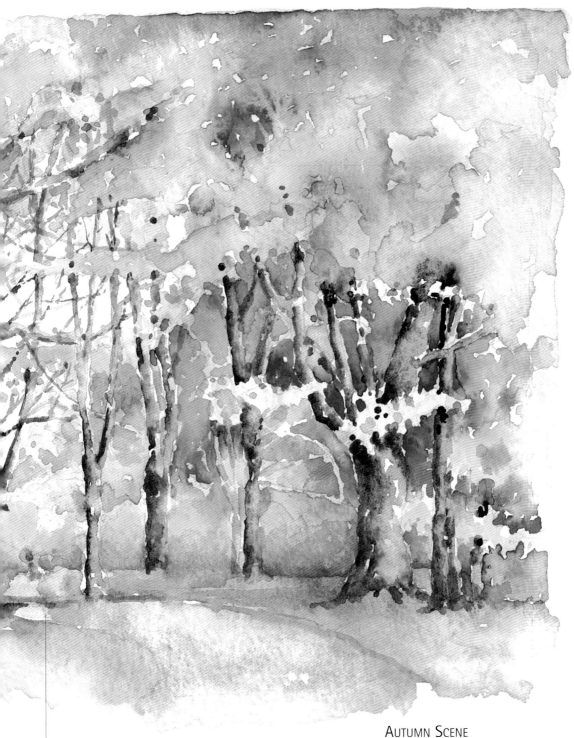

Dying leaves fall onto the forest floor; use colour mixes here as well.

AUTUMN SCENE
The rich, autumnal colours were created by cadmium red and orange with a touch of burnt sienna, all allowed to blend freely.

Winter Colours

Winter in the woods is usually a time of cold, muted colours, often tinged with grey. Use terre verte (a grey-green), and Hooker's green (a blue-green) as the base for any greenery that still remains. Raw umber is a useful colour to add to your winter palette: this cool grey-olive colour is good for toning trees, branches and general ground cover.

For snow, leave the paper white and paint around it – I don't believe that you can ever find a purer or cleaner white than your paper. Snow, however, does hold some degree of tone, depending of course on the strength of the daylight. A cool blue/violet mixed with alizarin crimson and Winsor blue is my choice for capturing the effect.

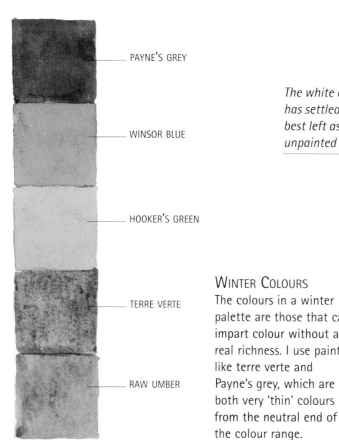

The far trees are painted with a mixture of Hooker's green and terre verte with a touch of Payne's grey.

PAYNE'S GREY

WINSOR BLUE

HOOKER'S GREEN

TERRE VERTE

RAW UMBER

The white of the snow that has settled on the trees is best left as plain, unpainted paper.

Winter Colours

The colours in a winter palette are those that can impart colour without any real richness. I use paints like terre verte and Payne's grey, which are both very 'thin' colours from the neutral end of the colour range.

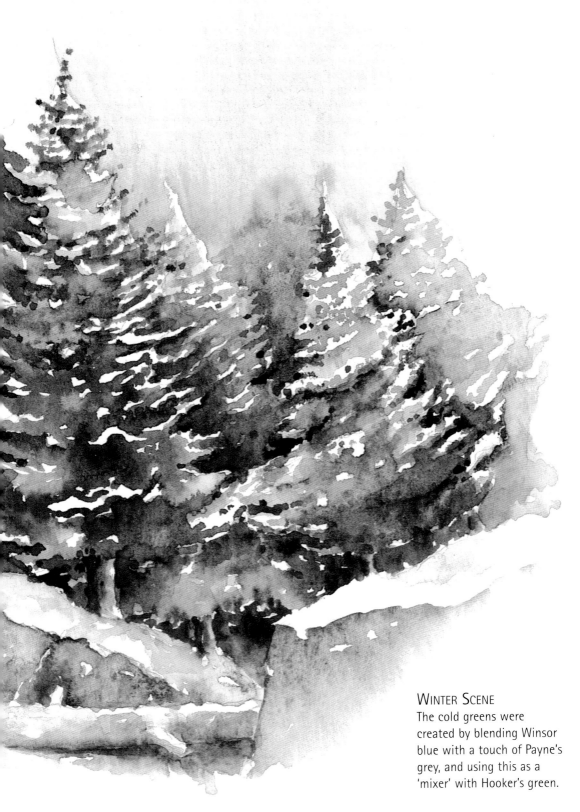

WINTER SCENE
The cold greens were
created by blending Winsor
blue with a touch of Payne's
grey, and using this as a
'mixer' with Hooker's green.

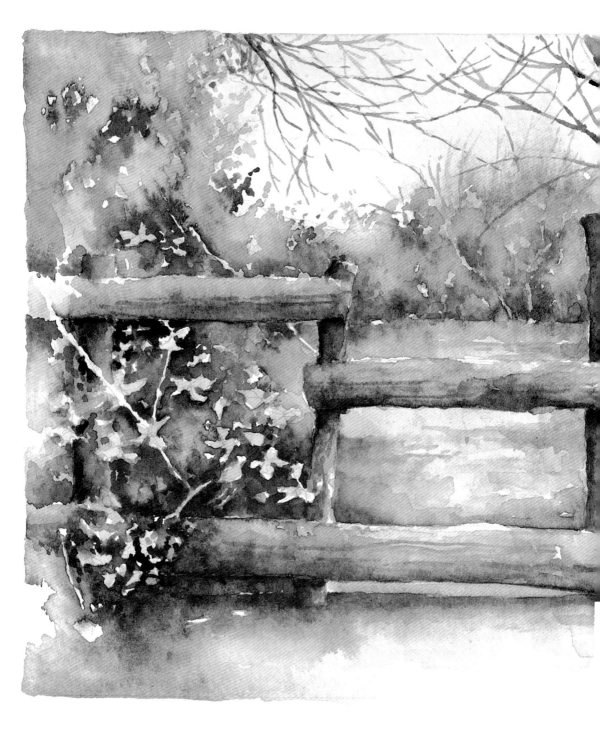

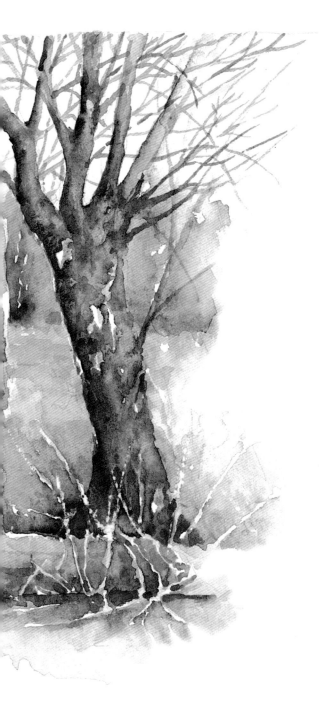

WOODLAND CLOSE-UPS

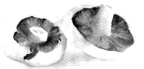

Much of the time spent amongst forests and woodland involves admiring and setting down on paper the colours of the trees, or the patterns created by shafts of light from above, and shadows on trees. But sometimes it is to the artist's advantage to look for other sources of inspiration; many of these can be found on the woodland floor, where a wealth of colour and textured objects are to be found.

WOODLAND FLOOR

Fungi, seed heads and shells, as well as berries and twigs, can appear in the most unusual and appealing shapes, colours and textures and make exciting subjects for the sketchbook studies.

It is quite easy to create these textures in watercolour, either by washing and blotting or, in the case of some fungi, splattering (see opposite).

More often than not, the colours on the forest floor come from a limited range, generally the natural earth colours (raw and burnt sienna, and raw and burnt umber).

Shape is another important factor when making close-up studies of found objects – curves, for example, can be best created by carefully blotting out the paint from the point at the top of the curve and allowing the paint to dry to a darker tone at the base of the object.

Washing and blotting is a watercolour technique that involves fairly quick action: wash watercolour paint onto a shape and then quickly blot chosen areas of the surface water with a piece of kitchen roll, thus creating a highlight.

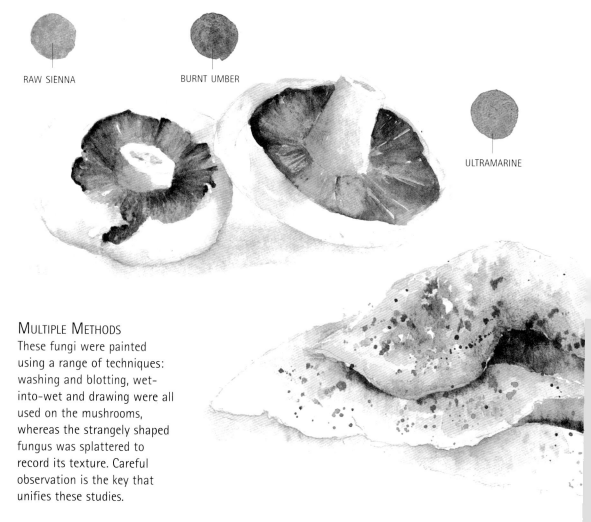

RAW SIENNA

BURNT UMBER

ULTRAMARINE

MULTIPLE METHODS
These fungi were painted using a range of techniques: washing and blotting, wet-into-wet and drawing were all used on the mushrooms, whereas the strangely shaped fungus was splattered to record its texture. Careful observation is the key that unifies these studies.

SPLATTERING

Splattering helps to achieve the effect of texture on a small, pitted or naturally speckled object – from a stone or shell to a fungus or bird's egg. To achieve the effect, you need to splatter very watery paint onto dry paint only – on damp paper the 'splats' will bleed into it, negating the effect.

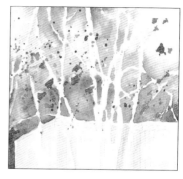

1 Dip a brush into very watery paint. Hold this over dry paint and tap the ferrule vigorously with your finger.

2 Change to another watery colour and repeat, building up a speckled layer of tones.

USING TONE

The limited colour range used in these studies means you have to experiment with tone. This is best done by working onto wet paper and ensuring that you use a lot of water in your mixtures. Apply several colours to a shape in rapid succession – as the colours dry they create a wealth of subtle tones.

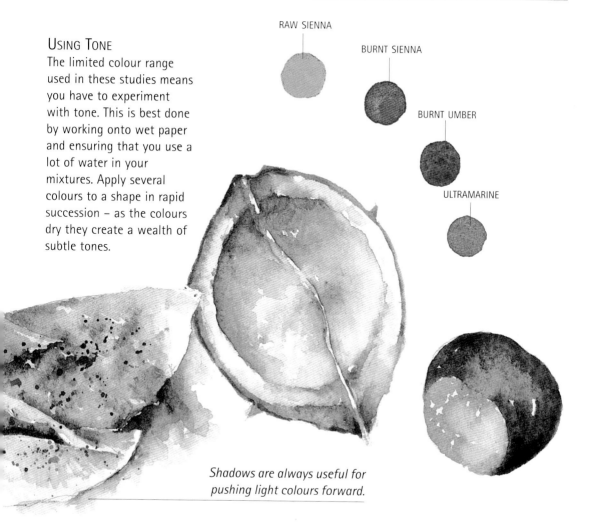

RAW SIENNA

BURNT SIENNA

BURNT UMBER

ULTRAMARINE

Shadows are always useful for pushing light colours forward.

BARK TEXTURES

Close-up studies of the different types of tree bark found in any area of woodland or forest can be very rewarding.

Three main skills are used: colour mixing – subtle blends of tones go to make up the colours found on many tree barks; washing and blotting – blotting (see page 56) is particularly useful here; and drawing – when the underlying texture has been created and the paint and paper have dried, 'draw' onto the shape to create the lines of the bark.

The varied spacing of a tree's rings creates an unusual and irregular pattern, offering the chance to practise accuracy and clarity of line. The cross-section of a log is usually best painted with a raw sienna underwash, with a touch of burnt umber dropped into the very centre and allowed to bleed outwards. When this has dried, use a small brush to 'draw' onto the dried underwash using combinations of raw sienna, burnt umber and ultramarine.

VARIATIONS IN BARK
The silver birch in the centre was painted with a flat brush pulled around the curve of the bark; the others used round brushes pulled downwards along the trunk's length.

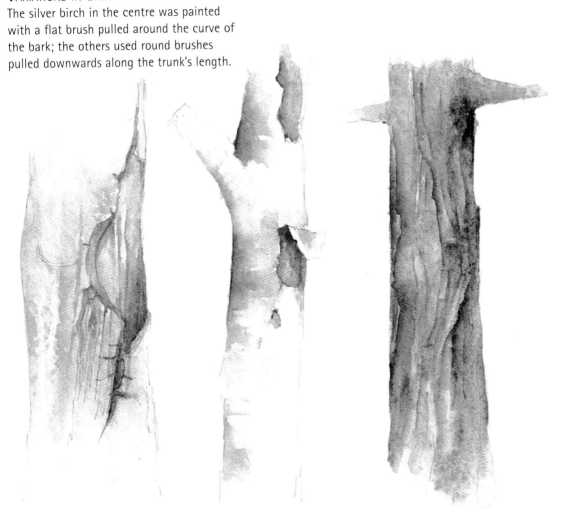

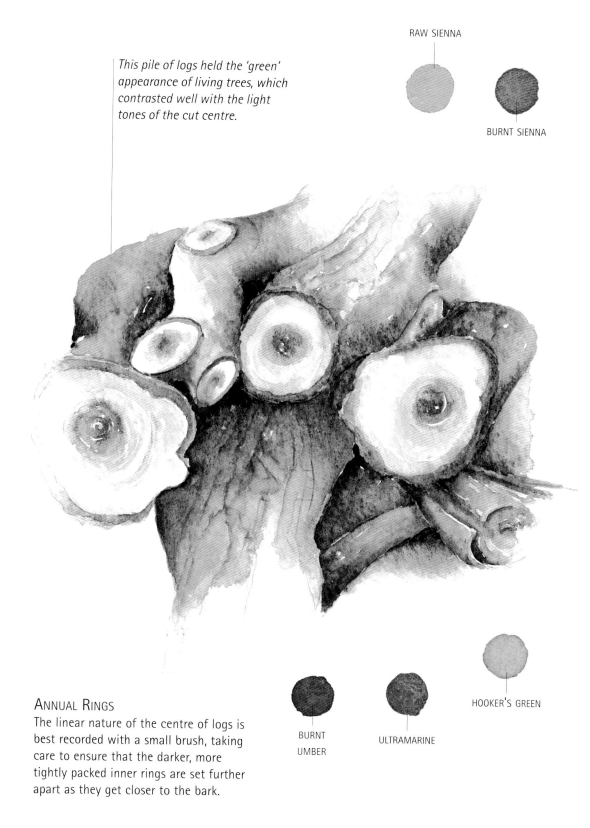

This pile of logs held the 'green' appearance of living trees, which contrasted well with the light tones of the cut centre.

RAW SIENNA

BURNT SIENNA

ANNUAL RINGS

The linear nature of the centre of logs is best recorded with a small brush, taking care to ensure that the darker, more tightly packed inner rings are set further apart as they get closer to the bark.

BURNT UMBER

ULTRAMARINE

HOOKER'S GREEN

Flowers and Leaves

The forest floor is always a good place to look for wild flowers and assorted growths. Remember that not all the leaves that you find in a forest fall from the trees – many grow from the floor upwards to meet the trees or, in the case of ivy, are seen on the trunk itself and are worthy of studies in their own right.

While wild flowers come into bloom chiefly in the spring, a wonderful range of ivies and ferns is present at all times. Give yourself the opportunities to study them and observe them exactly, so that you can feel confident in painting them when they make an appearance in a composition.

To ensure that your studies take on a more realistic look in your sketchbook, it is best to include some of their surroundings (if only a wash of pure colour) to give them a sense of existing within a particular space.

All the flower studies on these pages use the techniques of positive and negative painting (see pages 32 and 34). These methods ensure that most light colours have darker colours behind them in the shadow areas, visually thrusting them forward away from the page. To achieve this effect, I used a particularly deep green – sap green – and combined it with ultramarine and a touch of burnt umber.

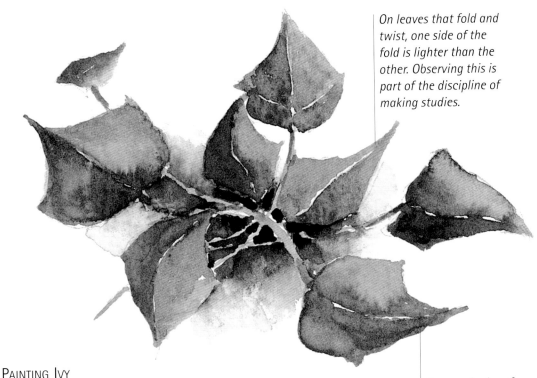

On leaves that fold and twist, one side of the fold is lighter than the other. Observing this is part of the discipline of making studies.

Painting Ivy
Many varieties of ivy grow in woods, and it is worth while making as many studies as possible of the different types. You will find, as you do this, that different colours and tones are required, even within the same genus.

Deeper shades of green are created by the addition of the most appropriate blue.

CADMIUM ORANGE

LEMON YELLOW

You may need to mix two yellows to achieve the correct colour.

Washing out background colour avoids clumsy hard edges.

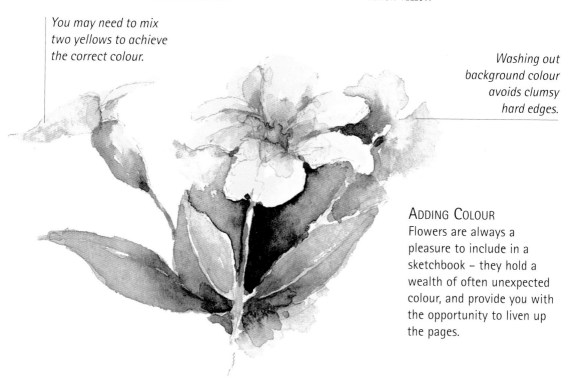

ADDING COLOUR

Flowers are always a pleasure to include in a sketchbook – they hold a wealth of often unexpected colour, and provide you with the opportunity to liven up the pages.

Use a small brush to pull colour out to the edges of leaves.

SAP GREEN

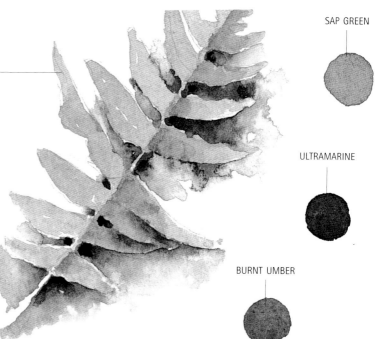

FERNS

Ferns frequently appear in the ground growth of forest compositions, and their shapes make them an attractive way to add a touch of detail and visual interest to foregrounds. A single study such as this can help you to become familiar with their shape and structure.

ULTRAMARINE

BURNT UMBER

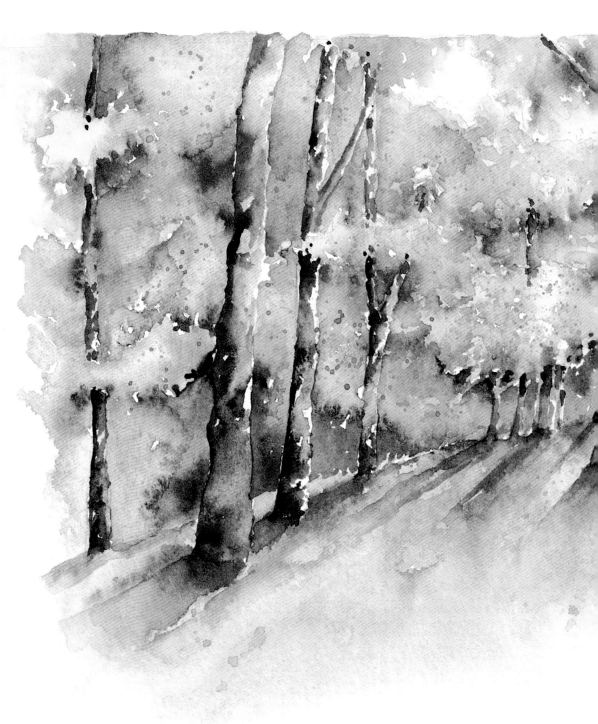

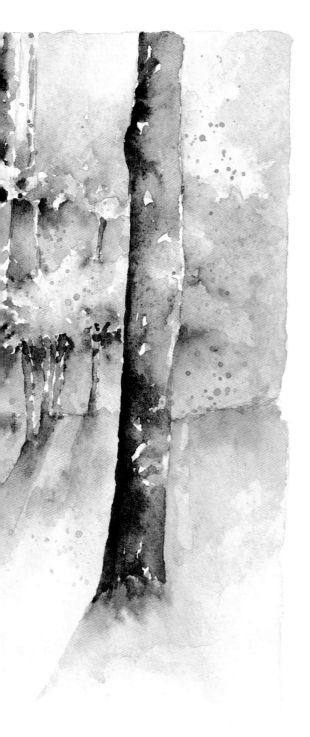

PRACTISE YOUR SKILLS

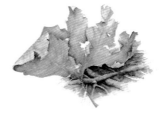

The previous sections of the book
have been devoted largely to
examining shapes, composition and
colours and tones – all of which
are invaluable practice if you
intend to work 'on-site'. Now it's
time to take a little longer over
completing full-scale paintings –
one for each season. The projects
take you step by step through the
processes that I use to create a
'finished' painting.

Spring

Spring is a time of growth, when buds and flowers burst into the natural world. The forest floors are again free of snow and frost, and the green shoots can begin to push upwards.

Perhaps more than any other season, spring is a time when the forest floor can be just as interesting as the colours and shapes that can be found in the trees above the eyeline. One of the greatest delights of walking in a cool spring forest is to stumble upon a carpet of bluebells in a small shady glade, as the blues, violets and greens are all highly conducive to being recorded in watercolour. Soft bleeds, hard edges and strong flashes of colour are both the characteristics of the season and the fundamentals of watercolour painting.

I use blues from the cooler end of the spectrum – chiefly Winsor blue and cobalt blue – as my main mixers. Both impart a 'cold' quality to any other paints to which they are added. Winsor blue, in particular, is a very powerful paint that can easily dominate even the strongest colour mixes.

My other two main colours are Hooker's green, which I use for its cold tone, finding that only a little blue is needed to produce a sharp, cold colour; and lemon yellow, which I use mainly in highlights where spring sunlight is caught by fresh, new growth, thus requiring a bright flash of colour.

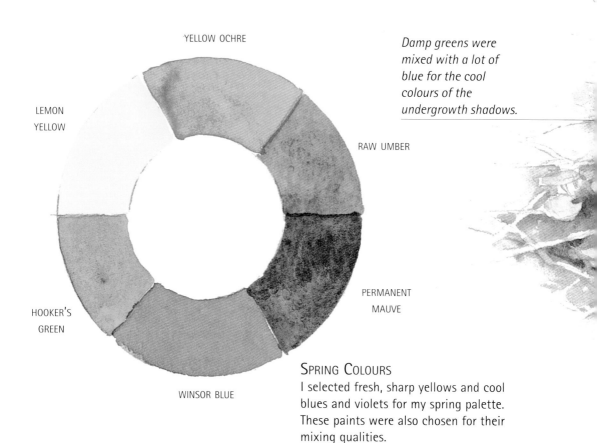

Damp greens were mixed with a lot of blue for the cool colours of the undergrowth shadows.

YELLOW OCHRE

LEMON YELLOW

RAW UMBER

HOOKER'S GREEN

PERMANENT MAUVE

WINSOR BLUE

Spring Colours
I selected fresh, sharp yellows and cool blues and violets for my spring palette. These paints were also chosen for their mixing qualities.

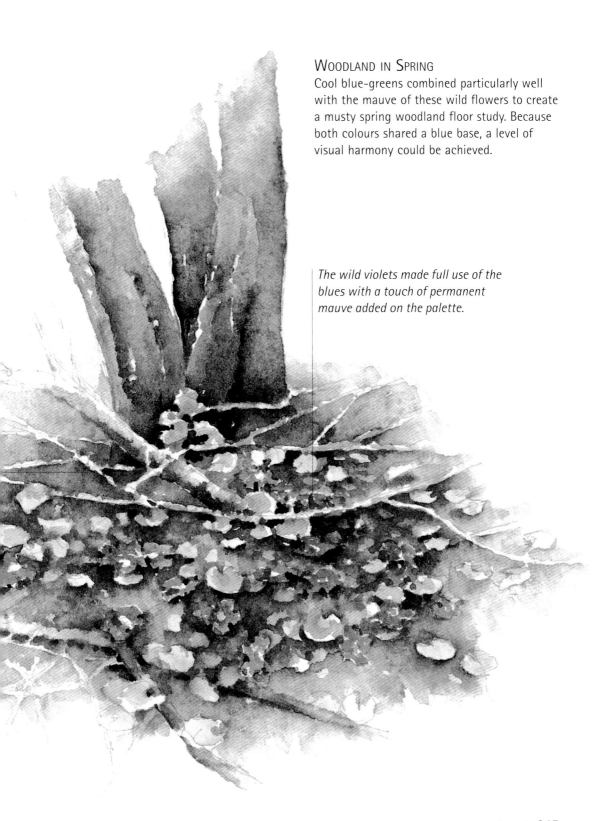

WOODLAND IN SPRING
Cool blue-greens combined particularly well with the mauve of these wild flowers to create a musty spring woodland floor study. Because both colours shared a blue base, a level of visual harmony could be achieved.

The wild violets made full use of the blues with a touch of permanent mauve added on the palette.

A CARPET OF BLUEBELLS

The intensity of colour in this spring blue-bell-carpeted woodland seemed to me to be an irresistible subject. The sharpness and clarity of the light on this cool, clear day made the violet ground cover almost jump off the ground.

The intensity of the light in this scene also meant that some degree of balance was required in the shadowed areas, and this resulted in my painting a very strong set of deep violet shadows into the fore-ground at the very last minute.

MATERIALS

• 500 gsm watercolour paper

• Brushes – 1 large (size 12), 1 medium (size 8) and 1 small (size 2)

• Watercolour pan paints – Winsor blue, Hooker's green, lemon yellow, cobalt blue, permanent mauve, raw umber, raw sienna

• Water container

1 *I dampened the sky area with water and applied watery Winsor blue with a medium-sized brush and allowed it to bleed. The area where the sky and trees met was painted with a watery mixture of Hooker's green and lemon yellow.*

2 *The areas where the foliage shows through the trees were painted in the same way, dampening the foliage sections. On the still-damp paper, I applied watery washes of cobalt blue, Hooker's green and lemon yellow, allowing them to bleed freely.*

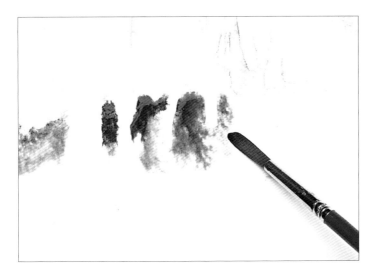

3 To create the colours for the ground cover of bluebells, I dampened the paper between the tree shapes and applied a very strong mixture of permanent mauve, mixed with a touch of the sky colour to maintain a balance between the top and bottom.

4 The initial stages of the painting were made very quickly, with a succession of washes being applied and left to bleed. Now I could start to think about the tones and colours required to develop the background.

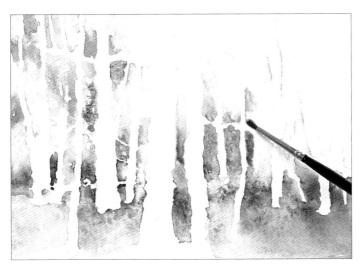

5 The colours of the new growth were created by applying washes of darker greens and yellows. Working onto dry paper with a small brush, the paint stayed where it was without too much bleeding, so it was easier to describe the shapes of the bushes and trees.

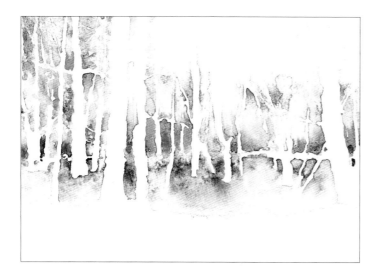

6 *I fixed the connection between the background and foreground by applying a combination of Hooker's green paint and a lot of burnt umber and cobalt blue to the 'line' where the two sections appeared to meet.*

7 *Next, I applied a mixture of raw umber and cobalt blue to the background trees with a small brush along their left-hand side, leaving a few white highlights on the opposite sides to indicate the direction of the light.*

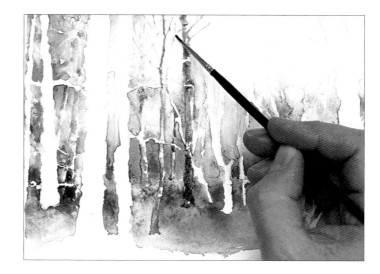

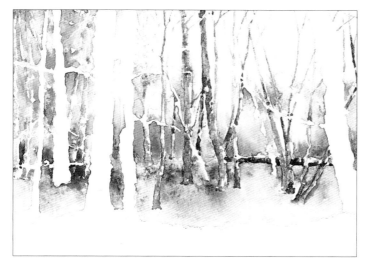

8 *As I continued across the background and middle ground, I made sure that the trees furthest away were the lightest and that the colour mixture was strengthened. I allowed some branches to remain as negative shapes, acting as highlights.*

9 *Using a flat-headed brush to paint the thicker trees in the immediate foreground enabled me to record both shape and texture, and allowed me to create a sharp line along the edge of a tree. I dragged the paint around the shape of the tree, copying the line of the bark. INSET: A few adjustments were made at this point to the trees – chiefly darkening the shaded side by applying a darker mixture of raw umber and cobalt blue, and allowing it to dry with a hard edge, emphasizing the shadow.*

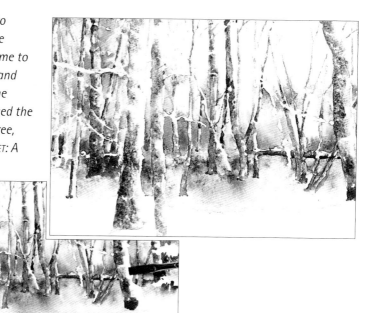

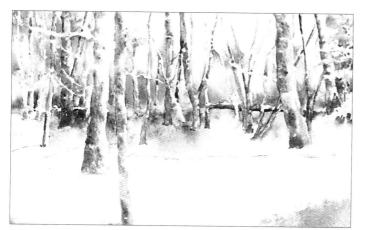

10 *On the immediate foreground I applied a wash of pure raw sienna. Next, I applied a cool mixture of Hooker's green and cobalt blue to the bottom edge of the still-damp paper. This bled gently upwards, creating a feathered, grass-like appearance .*

11 *For the shadows, I mixed together nearly all of the colours in the palette to create a blue/violet grey and then, using a medium-sized brush, pulled the paint along the line of the cast shadows, easing off the pressure towards the end of the shadow.*

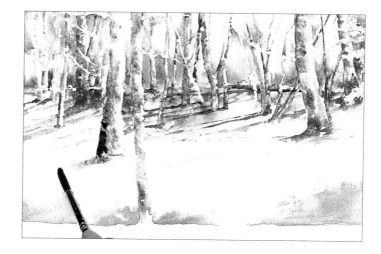

Keeping Balance

The most important element in this scene is the balance of light and shade. However, it is not a painting of simple extremes – the range of tones between the poles of light and shade maintain the balance. Don't ignore the balance between warm and cold colours, either.

The fresh lemon yellows of the background foliage are a direct result of the strength of the light.

The complex web of shadows is almost drawn onto dry ground-cover paint.

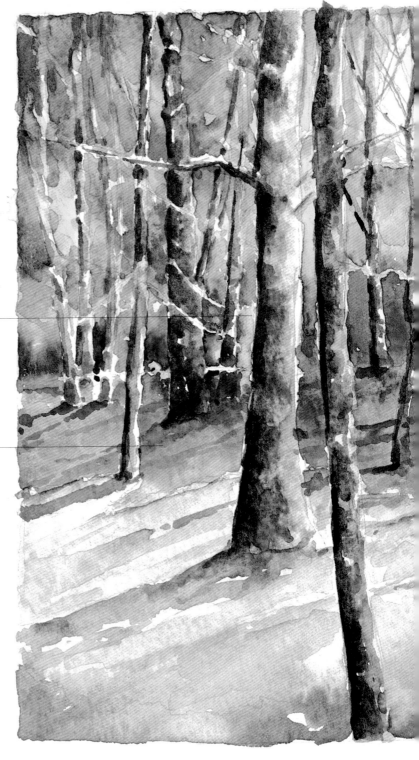

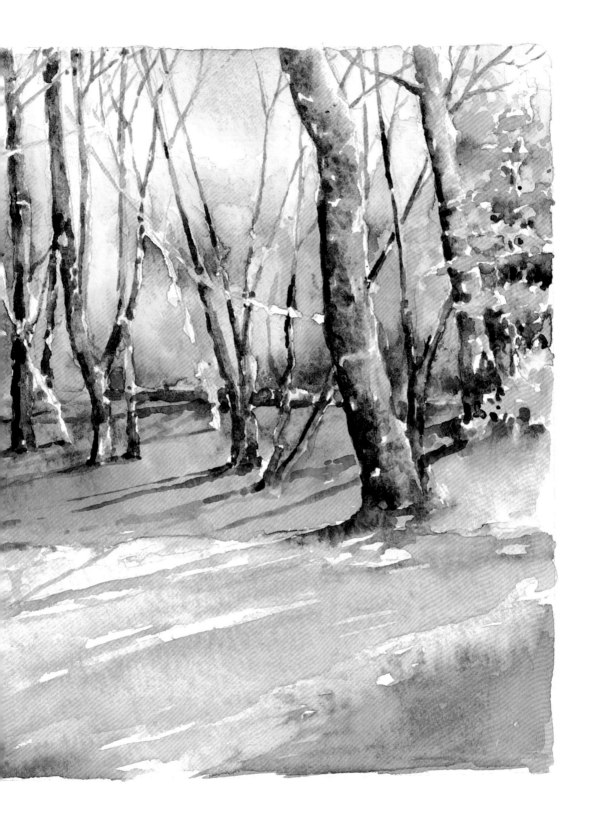

SUMMER

Summer is a peaceful and relaxing time in which to paint amid the gentle warmth of lush green forests and woodlands.

Because the weather is usually a little more predictable during the summer months, you may feel inclined to explore the greater depths of forests, where the shadows are darker and the foliage more overgrown and heavy with blue and violet shadow tones. Alternatively, you might like to climb high above the timber line, as in the following demonstration, and look down on a forest, recording the vast expanse of woodland receding into the far distance. This way, you can achieve an alternative view to traditional woodland painting.

Whichever viewpoint you choose, you will encounter many similar characteristics in summer woodlands – in particular, the colours. I tend to use much more yellow in summer, but not the cool, sharp yellow of the spring days. Cadmium yellow is a warm and powerful colour that can easily dominate any colours to which it is added – chiefly sap green – and this can be used to create a few gently rustling leaves.

At the other end of the scale are the deep shadows. I use ultramarine as my main blue, for its warmth of tone, and often add a touch of alizarin crimson to it, to create some deep damp- and heat-soaked shadows on the woodland floor.

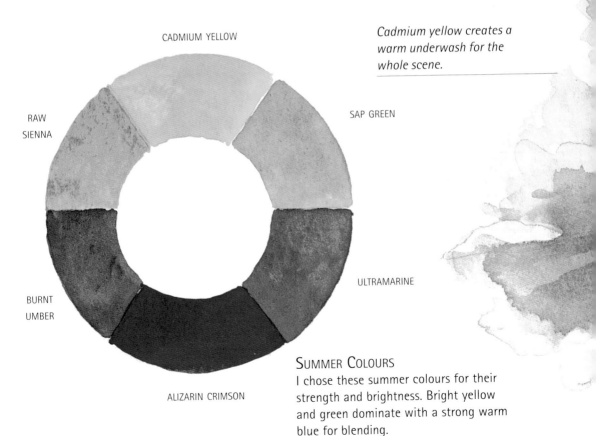

CADMIUM YELLOW

RAW SIENNA

SAP GREEN

Cadmium yellow creates a warm underwash for the whole scene.

BURNT UMBER

ULTRAMARINE

ALIZARIN CRIMSON

SUMMER COLOURS
I chose these summer colours for their strength and brightness. Bright yellow and green dominate with a strong warm blue for blending.

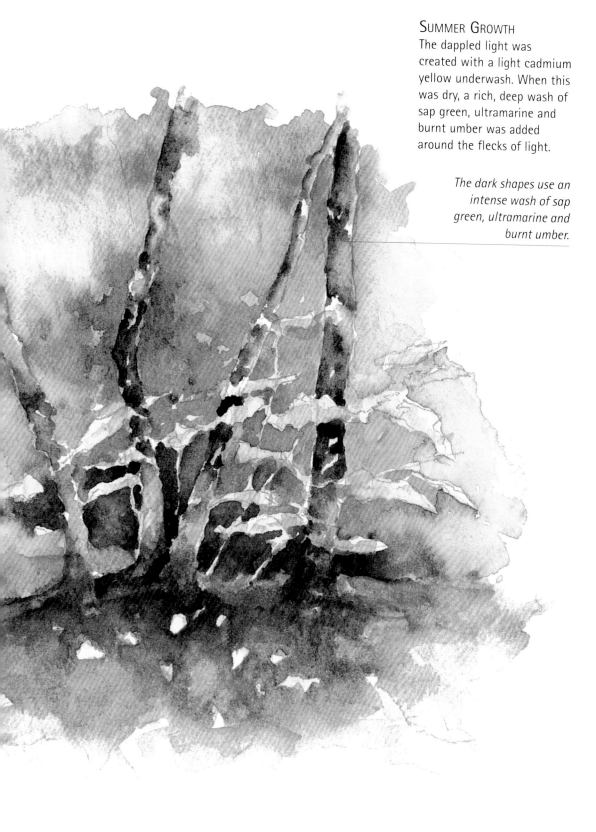

SUMMER GROWTH

The dappled light was created with a light cadmium yellow underwash. When this was dry, a rich, deep wash of sap green, ultramarine and burnt umber was added around the flecks of light.

The dark shapes use an intense wash of sap green, ultramarine and burnt umber.

Woodland Panorama

In forests and woodlands, most of your painting time involves painting the trees that you see at eye level, and looking upwards to the trees that tower above you. Sometimes, however, it is good practice to find a position above the timber line that allows you a view of tree tops from above.

This composition requires looking at trees in a different way, and developing the skills of layering as you complete the composition from the far distant background to the immediate foreground.

Materials

- 500 gsm watercolour paper
- Brushes – 1 large (size 12), 1 medium (size 8) and 1 small (size 2)
- Watercolour pan paints – sap green, ultramarine, alizarin crimson, raw sienna, cadmium yellow, burnt umber
- Water container
- Kitchen roll

1 *To establish the warm summer sky I applied ultramarine with a large wash brush onto damp paper to create an even covering. The soft, white clouds on the horizon were created by blotting out the damp paint with kitchen roll.*

2 *For the mountain in the furthest distance I mixed a lot of ultramarine with a little alizarin crimson and a hint of sap green to suggest the tree-covered mountainside. INSET: I made a darker mixture of the same colours and ran this along the base line dividing the background and the middle ground.*

3 *While the tops of the hills appeared light against the dip behind, the base was much darker. I added a little cadmium yellow to the basic ultramarine and sap green mixture.*

4 *I continued layering across the middle group, creating highlights at the top of hills and shadows in the valleys, working with a medium brush to create the bulk of the colour and a small brush to darken the tones at the base.*

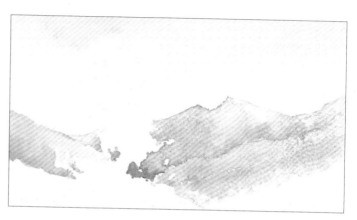

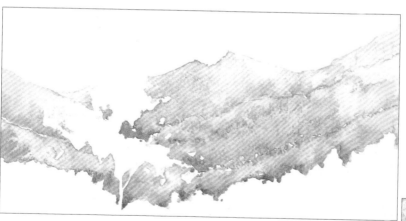

5 *To emphasize the shape of the tops of the trees, I introduced a little raw sienna, and continued the layering of the forms with some detailed painting into the valleys. INSET: As the paint dried, so the intensity of the colours faded a little – this was the time to consider the situation and to make a few decisions regarding areas that needed darkening.*

6 *I dampened the areas that needed darkening a little, and left them for a few seconds for the water to sink into the paper. Then, using a small brush, I applied a mixture of sap green, ultramarine and a touch of burnt umber.*

7 *Next, I continued this process to fill the bulk of the tree shapes that made up the middle ground. To complete this section I painted a little cadmium yellow onto the top of the trees to represent the summer highlights.*

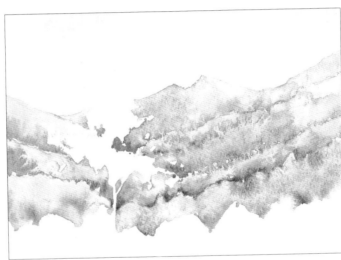

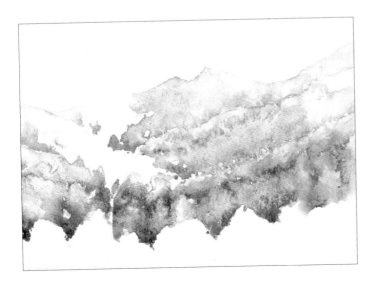

8 *Before moving on to the foreground, I established the darker tones that would 'push' the front layer of trees forward using a small brush and the mixture described in Step 6.*

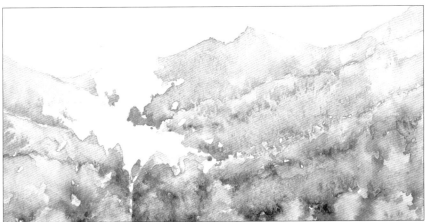

9 *Next, I dampened the paper for the foreground trees, and then painted it with the addition of a little raw sienna to the mixture, allowing the paint to bleed downwards. INSET: To make the tree shapes much more pronounced in the foreground, I then 'drew' the shadows behind the dried wash, giving each tree an individual identity.*

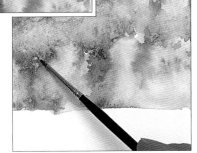

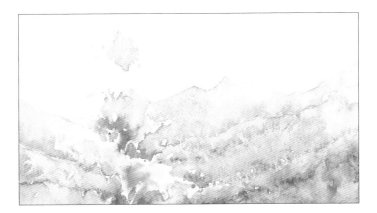

10 *The highlights on the tree in the immediate foreground had to be the lightest in the composition. I painted them by dropping onto damp paper a mixture of cadmium yellow and the slightest touch of sap green.*

11 *As the main area of focus, the foreground tree also had to have the darkest shadows (sap green, ultramarine and burnt umber). I applied these to dry paper to avoid dilutions, and allowed them to bleed into the immediate highlights to create a few 'middle' tones.*

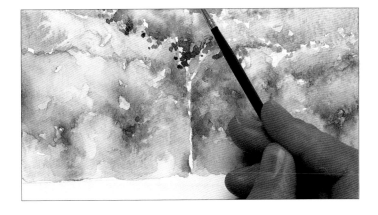

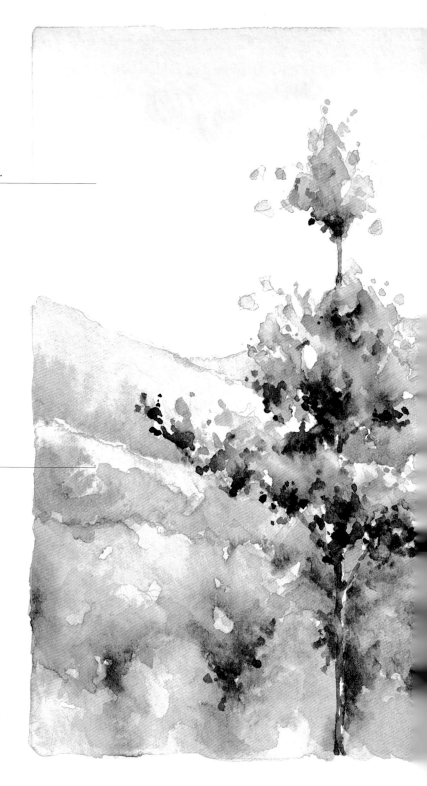

More sky is evident in this scene than is often found in woodland scenes – this was painted onto damp paper to create an even flow of paint, resulting in a smoother finish.

The layering of trees was created by using dark colours to 'push' the lighter ones forward.

TONE VS COLOUR

This summer scene relied on the creation of a wealth of tones, rather than the use of a range of colours – in fact, fewer colours may be required in a summer scene than you might expect. The violets in the background are the result of tonal mixing using only a limited palette.

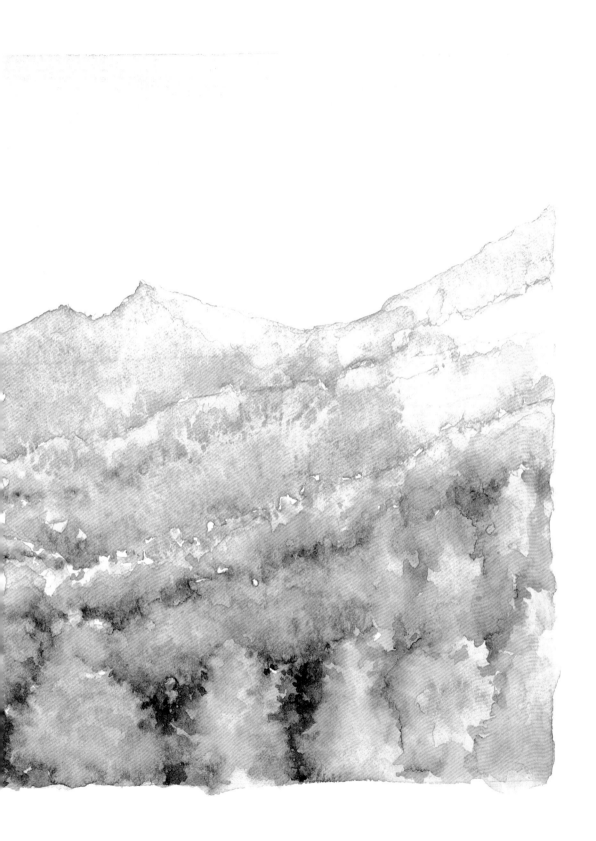

Autumn

Autumn is truly a 'golden' time to be out and about in forests and woodlands. The colours to be witnessed as the year begins to draw to a close can be remarkable. The fiery reds, mixed with scarlet lake or cadmium red and burnt sienna; the golden yellows, mixed with cadmium yellow and raw sienna; and the deep browns, mixed with burnt umber and ultramarine – these are all a pure pleasure to record.

But it isn't just the colours that are so appealing. As summer reaches its end the leaves start to fall from the trees, exposing a whole new vista. Stark, skeletal structures replace the wealth of green foliage, offering a much more linear approach to recording the scene. The technique of recording falling leaves by flicking and dotting paint is explored in this project. While not unique to the season, it is a particularly appropriate technique for recording golden forest days.

At this time of year I tend to use raw sienna as an underwash, as it maintains a warm tone when diluted. The translucent qualities of the other colours added in further layers result in the underwash dominating the scene from the start. Autumn is also a time for experimenting with colours – mixed on the palette, applied neat, or allowed to bleed into each other on damp paper, creating unexpected tones.

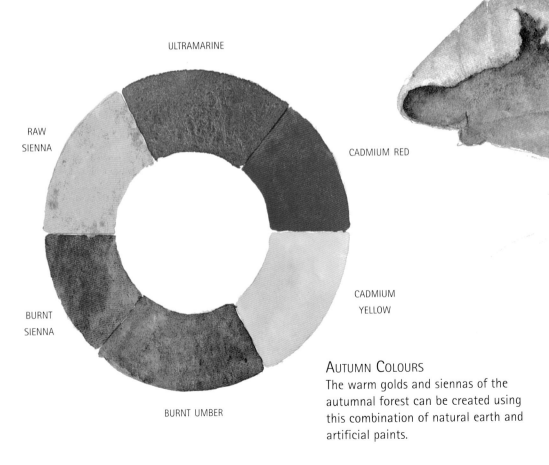

ULTRAMARINE

RAW SIENNA

CADMIUM RED

BURNT SIENNA

CADMIUM YELLOW

BURNT UMBER

Autumn Colours
The warm golds and siennas of the autumnal forest can be created using this combination of natural earth and artificial paints.

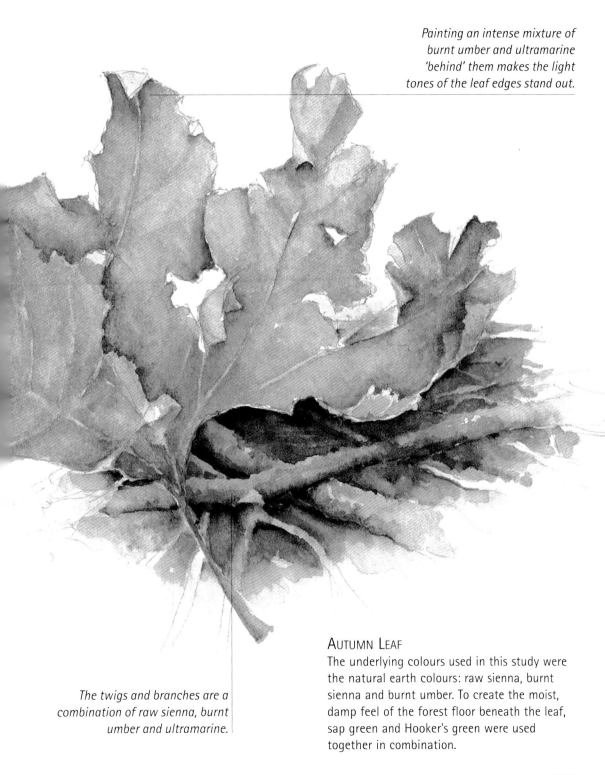

Painting an intense mixture of burnt umber and ultramarine 'behind' them makes the light tones of the leaf edges stand out.

The twigs and branches are a combination of raw sienna, burnt umber and ultramarine.

AUTUMN LEAF

The underlying colours used in this study were the natural earth colours: raw sienna, burnt sienna and burnt umber. To create the moist, damp feel of the forest floor beneath the leaf, sap green and Hooker's green were used together in combination.

FALLING LEAVES

The intensity of colours in this gentle autumn scene required more than one technique to record its atmosphere.

First, I used wet-into-wet to create a whole range of tones in the background. Next, many of the shapes of the trees and leaves were recorded as negative shapes (see page 32), where I needed to exercise full control over the application of the paint. Finally, I flicked paint onto dry paper to create the illusion of leaves rustling on a warm autumn breeze.

MATERIALS
- 500 gsm watercolour paper
- Brushes – 1 large (size 12), 1 medium (size 8) and 1 small (size 2) round-headed, plus 1 medium flat-headed
- Watercolour pan paints – raw sienna, burnt sienna, burnt umber, sap green, cadmium orange, cadmium yellow, ultramarine
- Water container

1 *Raw sienna was an obvious choice for a warm, rich golden underwash. I applied a watery mixture to areas of paper that had been previously dampened, and allowed it to bleed freely and dry to irregular patches of tone.*

2 *Before the underwash dried completely, I applied raw sienna, burnt sienna, burnt umber and a touch of cadmium yellow to it and allowed the paint to bleed, working carefully around the negative shapes of the bare branches and leaves.*

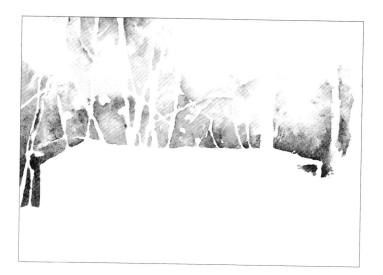

3 I continued this process, working rapidly before the damp underwash dried. Eventually, all the tree and leaf shapes were pure white shapes, with a riot of red and golden colours thrusting them into the foreground.

4 Once the background was dry, I painted the bush and scrub in the middle ground with a mixture of cadmium orange and burnt sienna. The section at the top was left light to contrast with the dark background colours. The bottoms of the bushes had a little burnt umber added to the mixture, to 'attach' them to the ground.

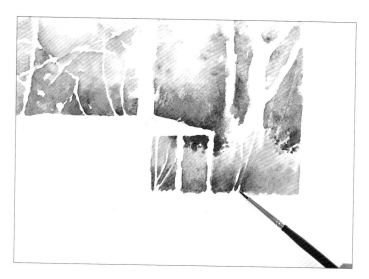

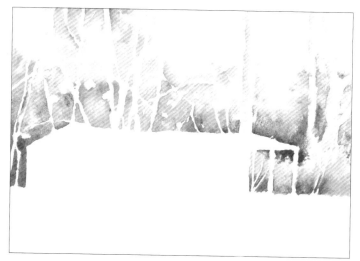

5 It was now time to develop some detail in the trees. I first treated the large tree trunks to a thin wash of raw sienna, working with a small brush on dry paper. A few strips of white paper were left unpainted to act as highlights.

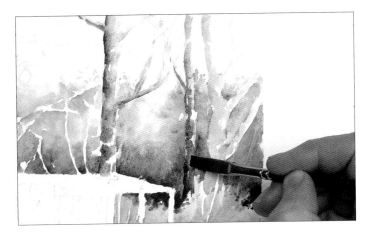

6 With the tree underwash dry, I used a flat-headed brush to run a strong mixture of burnt umber with a touch of ultramarine along the shaded side of the trees, using broken brushstrokes. I pulled this around the shapes of the tree to create curvature.

7 After loading a small brush with a strong and very wet mixture of burnt sienna and a touch of raw sienna, I held it over the painting and vigorously tapped the ferrule to splatter flecks of paint. I then painted a few specific leaf shapes.

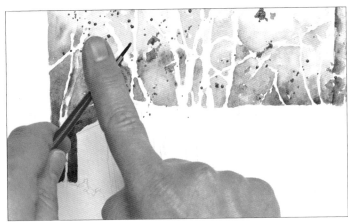

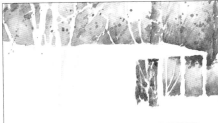

8 The next stage was to begin to paint the central part of the scene – the wooden hut. Initially, I treated this with a thin wash of raw sienna to establish the base colour, still working carefully around the negative shapes of the clump of trees in the foreground. *INSET*: Once the underwash had dried, I used a medium-sized brush to apply a mixture of burnt umber and ultramarine to the shaded side of the hut and underneath the canopy, pulling the paint in a diagonal direction to achieve a sense of direction for the shadows.

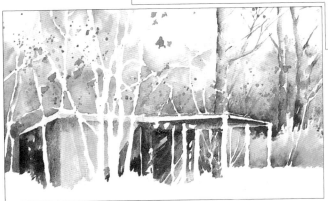

9 When the blocks of shadow had dried, I painted a few planks using a small brush and a much-diluted version of the shadow mix. This same mixture was used to emphasize the broken nature of the light by almost drawing onto the canopy supports, leaving flashes of underwash showing to suggest highlights.

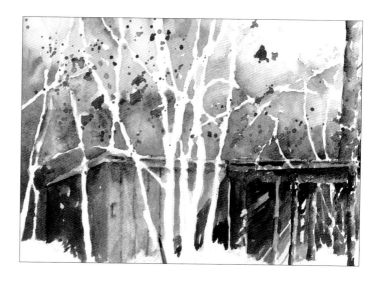

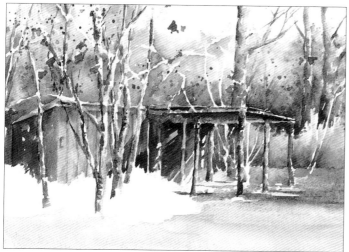

10 The foreground colour was created by adding a little raw sienna to a mixture of all the colours in the palette. Using a dry, medium brush, I dragged this across dry paper to develop a few flecks of highlighting. Before this dried I quickly pulled a little burnt umber and ultramarine across the paper to the line of the foreground shadows.

11 To finish, I painted the trees in the immediate foreground using a flat-headed brush, with the highlights on the right-hand side. For the patches of scrub grass around the base of the trees, I applied sap green and raw sienna to damp paper with a medium-sized brush.

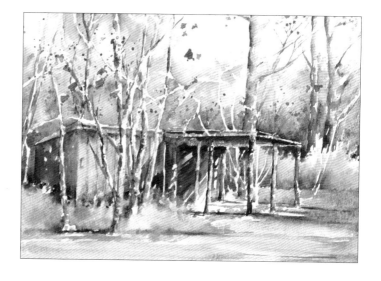

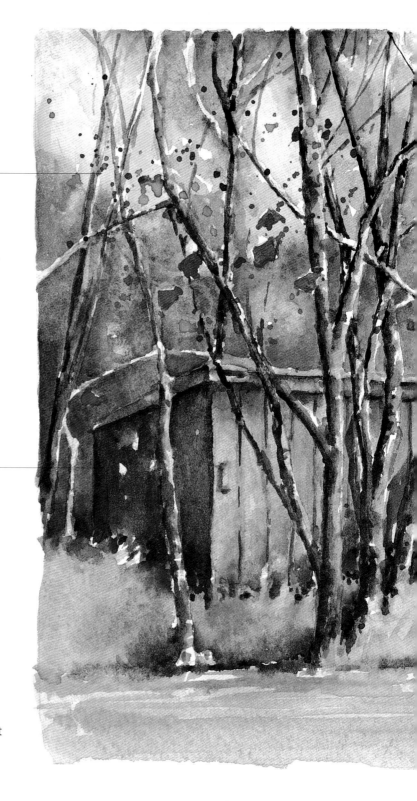

The random method of splattering paint across the upper sections is very effective for suggesting the movement of leaves.

The deep, warm tones are created by painting pure colours onto wet paint and allowing them to bleed.

MOVEMENT AND LIGHT
The interplay of the positive and negative shapes in the branches and leaves is the key to this scene. While the autumnal colours describe the scene well, it is the sense of movement in the 'floating' leaves and flashes of light on the branches that really make the picture come to life.

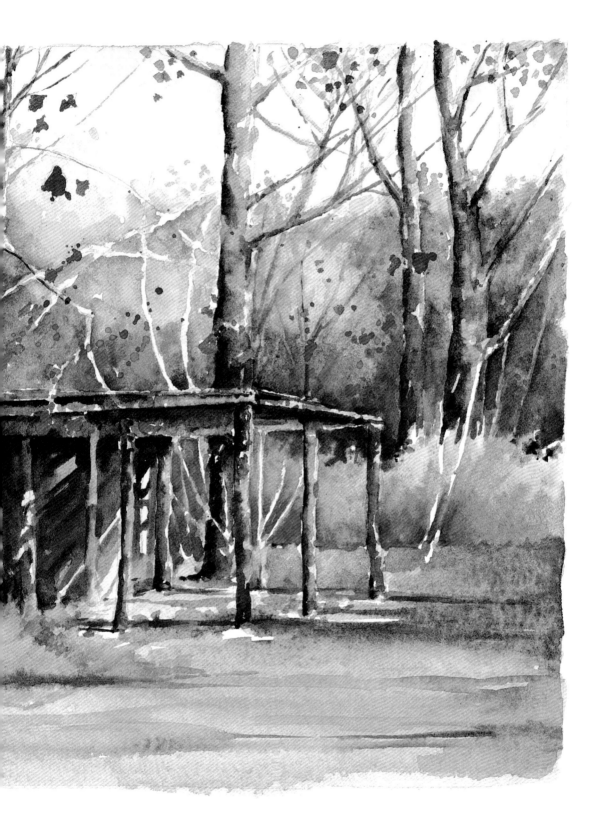

WINTER

Winter is one of the least predictable times for painting on-site in forests and woodlands – you can always expect cold, but just how cold and how quickly snow can fall are always unknown quantities. You can, however, experience some very still days in woodlands when the winter sun casts pale violet and orange-tinged shadows onto deep-piled snow, and the coldness seems to be absorbed by the beauty of the scene.

The colours I use to paint snow-laden trees and forests are taken from the more neutral range of paints – Payne's grey and terre verte, for example. Both have little value of their own, but they are very good for mixing to either tone down colours, or to underpin a cool feel in a scene.

Unlike the previous demonstrations, in this one the colours are mixed in the palette because a higher level of control needs to be maintained over their use. If overused or allowed to run unchecked into your scene, neutral colours can easily make a landscape appear flat.

Perhaps surprisingly to some people, I chose not to use masking fluid to keep the white paper free of paint. While it can be a valuable medium – and I certainly do make use of it – I came to the conclusion that spontaneity was the most important factor in this particular scene.

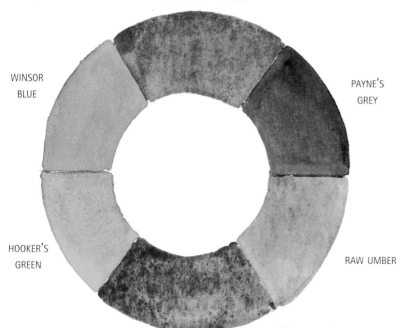

PERMANENT MAUVE

WINSOR
BLUE

PAYNE'S
GREY

HOOKER'S
GREEN

RAW UMBER

TERRE VERTE

WINTER COLOURS
The colours I selected for my winter palette are cool, more 'neutral' paints that, however they are mixed, usually produce slightly muted tones.

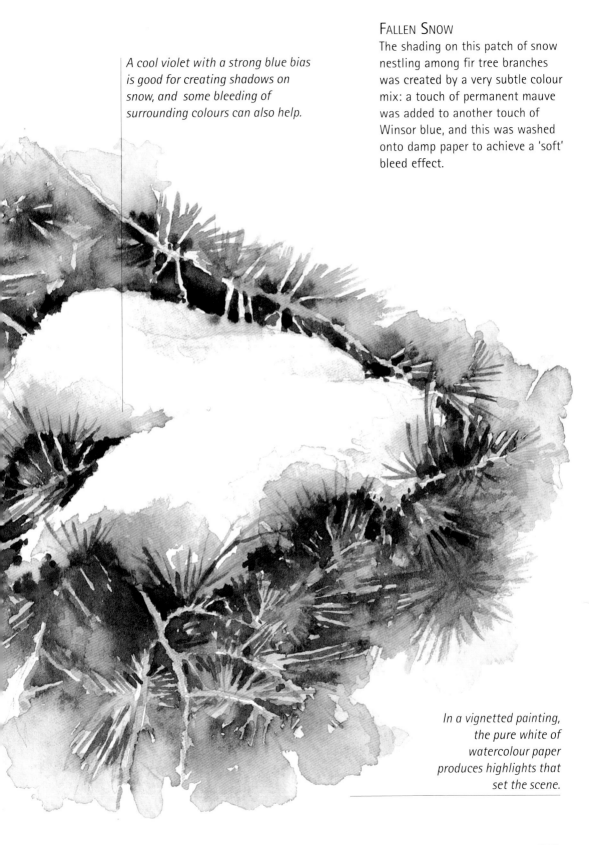

A cool violet with a strong blue bias is good for creating shadows on snow, and some bleeding of surrounding colours can also help.

FALLEN SNOW

The shading on this patch of snow nestling among fir tree branches was created by a very subtle colour mix: a touch of permanent mauve was added to another touch of Winsor blue, and this was washed onto damp paper to achieve a 'soft' bleed effect.

In a vignetted painting, the pure white of watercolour paper produces highlights that set the scene.

Snow-laden Forest

In a winter scene such as this project, although snow itself does not really have a colour, it does both hold and reflect all the colours that surround it. The colours of the shadows witnessed in forests is worth studying by any artist. Forests will always create shadows, due to the number of trees and branches – the shadows cast onto snow will often take on a cool violet tint and are best mixed with either Winsor or cobalt blue (both colours are known for their cool qualities) and a touch of alizarin crimson.

Materials

• 500 gsm watercolour paper

• Brushes – 1 large (size 12), 1 medium (size 8) and 1 small (size 2) round-headed, plus 1 medium flat-headed

• Watercolour pan paints – Winsor blue, terre verte, Hooker's green, cobalt blue, Payne's grey, raw umber, burnt umber alizarin crimson

• Water container

1 *To create a cold sky I painted Winsor blue evenly onto damp paper. Before this dried, I applied a mixture of terre verte, Hooker's green and Winsor blue onto the background trees and encouraged it to bleed a little into the sky, to suggest the soft qualities created by distance.*

2 *To create variety, I added Winsor blue and cobalt blue to the mixture, occasionally adding a little Payne's grey to ensure depth of tone. The feathering effect of applying paint onto damp paper helped to create the look of pine trees.*

3 As I continued, I left most of the white areas unpainted, or barely tinted to act as snow – especially the areas at the top of the pine needles and along the tops of the branches where the sky and trees meet.

4 To achieve the effect of snow blown onto the trunks, I ran a mixture of raw umber and cobalt blue along the edge of the bare tree trunks with a small brush and allowed it to dry.

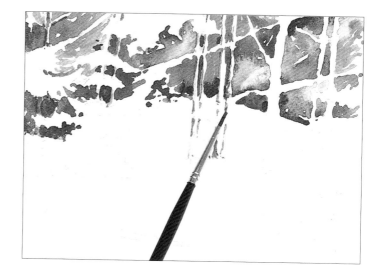

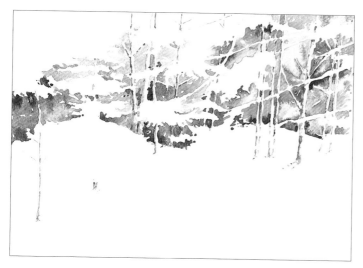

5 Now was the time to make any minor adjustments that were required to the background colours. I sharpened one or two of the tree shapes by drawing onto the darkest shapes with a small brush, with the effect of pushing the lighter trees forward.

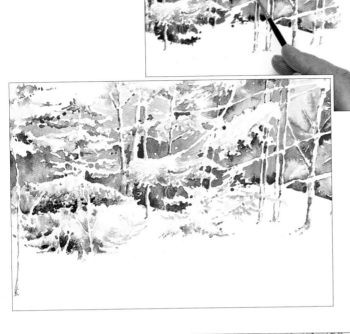

6 The tops of the branches and clusters of needles on the middle-ground trees were left pure white, and I painted the lower areas with a mixture of Hooker's green and cobalt blue and a touch of raw umber, using the point of a small brush to dot on the paint. INSET: To make the floating clumps of greenery and long branches stand out against the background, I used a strong paint mixture of terre verte, Hooker's green and burnt umber applied with a small brush to darken the colours behind them. This helped to give more shape to the trees.

7 To suggest overhanging layers and create a contrast that highlighted the snow on those overhanging layers, I painted a little of this colour mixture at the very bottom of some of the middle-ground trees. This helped to anchor the trees to the ground.

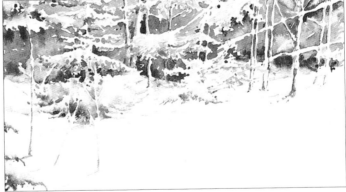

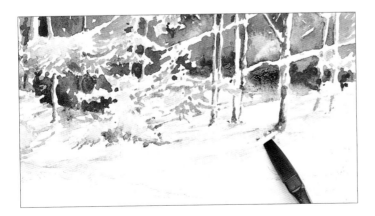

8 The shadow colour here was a very cool violet. I used a mixture of alizarin crimson and Winsor blue to create a very watery shadow colour, applying it to dry paper using a flat-headed brush, and pulling along the line of the shadow.

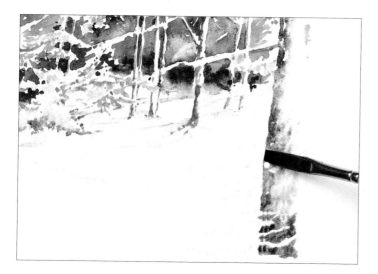

9 I painted in the bark of the large tree using the flat-headed brush, pulling raw umber, burnt umber and cobalt blue around the shape of the trees. Painting on dry paper created broken brushstrokes as the brush was dragged across the textured paper.

10 Using a dabbing or dotting technique, I painted the small conifers beside the main tree trunk. The colours (Hooker's green, burnt umber and cobalt blue) were intensified to create a tonal distinction between the middle ground and foreground.

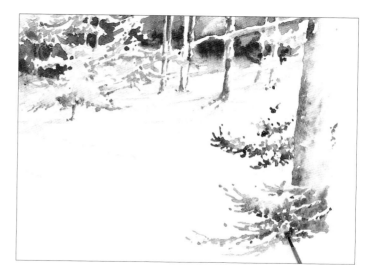

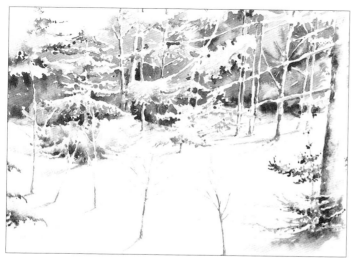

11 To finish, I made a one-stroke application for the thin twigs in the immediate foreground. I used the mixture for the main tree trunks, pulling the colour upwards from the base to the top, and lifting the small brush quickly at the end of the stroke.

CATCHING THE BALANCE

The colours used in this scene were chosen for their ability to complement the amount of white needed to represent the snow – too much subtlety could result in these tones being dominated by the highlights, while too strong colours would create too intense a feeling of light.

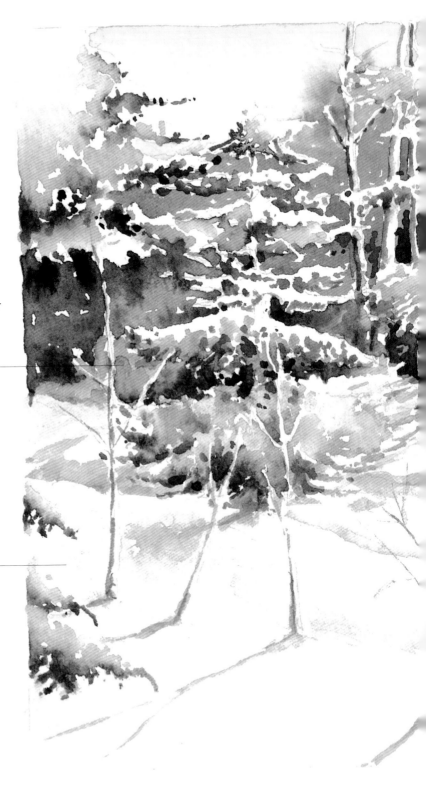

Among the many greens used in this scene, the deeper tones were used to create the feeling of depth in the background.

Broken brushstrokes allow the flashes of white snow to work for themselves.

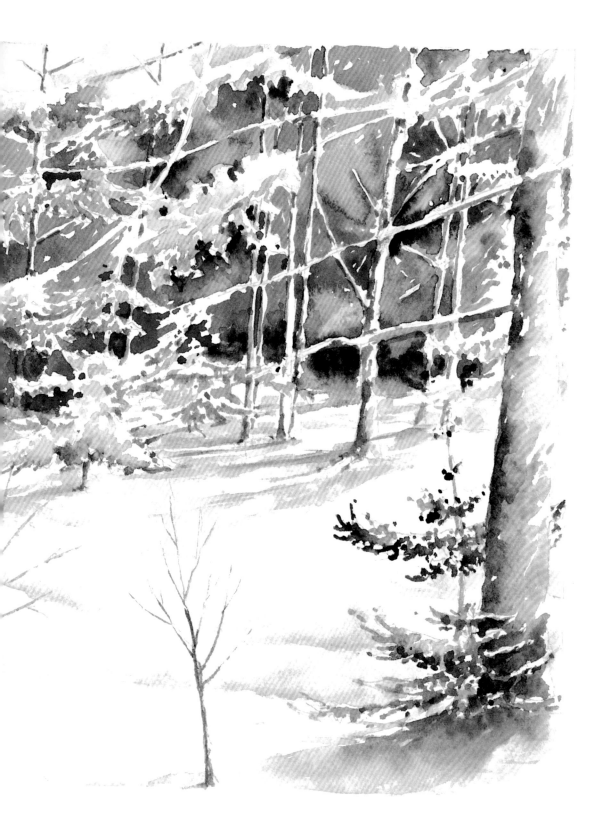

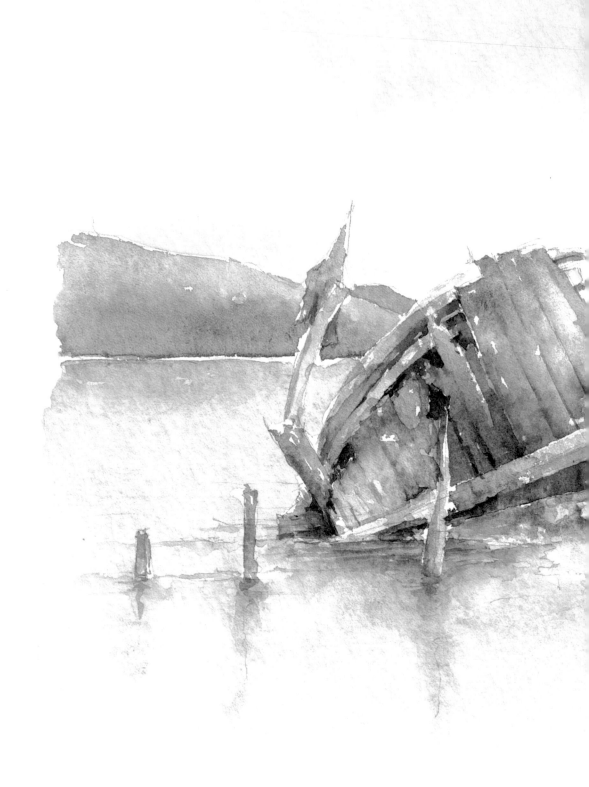

Lakes and Rivers

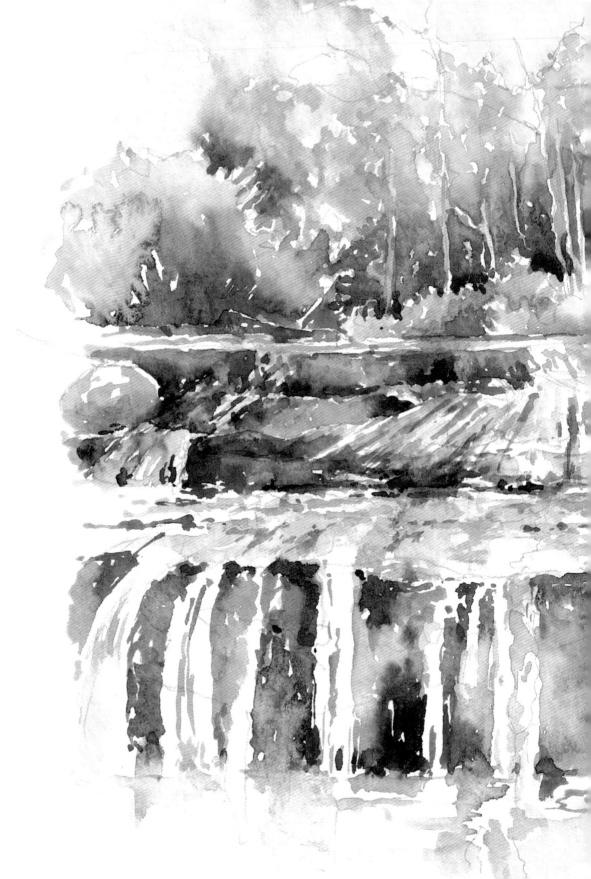

Types of Water

Wherever we find it, anywhere across the globe, the nature of water is unchanging. The way in which it flows, the ground across which it flows, and the volume of water flowing, however, are extremely variable. In fact, it is probably true to say that the natural surroundings and environmental conditions that are to be found close to lakes and rivers affect the appearance of water more than anything else in nature.

Still Water

On any reasonably large expanse of water, even the slightest breath of wind produces small ripples and a limited degree of movement on the surface – completely still water is rarely to be found in nature. There will, however, be occasions when you arrive at a lake for a painting session to find that the air is calm and barely a breath of wind has touched the water's surface.

My starting point on these days is to dampen the paper using clear water, washed evenly across the paper with a large brush to ensure an unbroken covering. I then leave the paper for a minute or two to allow the water to thoroughly soak into the fibres of the paper. As soon as the surface water has evaporated or soaked into the paper, and an even sheen can be seen on it, the next stage can begin.

It is important to make some initial judgements based upon observation: are the colours and tones reflected in the water darker or lighter than the forms that are actually being reflected, and how much do you wish to include in the composition? Having made these decisions, mix up the paints for the main bulk of the reflections and apply this quickly to the damp paper using a medium-sized brush. The paint will now bleed gently outwards, softening in tone as it becomes diluted by the damp paper. Next, use a chisel-headed brush to pull the damp paint downwards from the lake's edge to create reflections.

More colours can then be added using the same technique. The important thing to remember is not to allow the paper to dry – work quickly and decisively.

Capturing Still Water

The key to painting successful reflections in still water is to have everything that you need ready and close to hand, as you will have to work very quickly once you have applied the initial wash to the 'water area'. So mix the paints, fill your water pot and arrange your brushes.

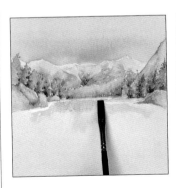

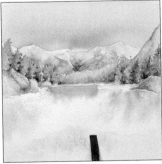

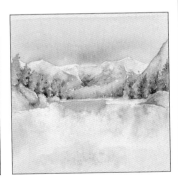

1 *Apply a line of the most prominent colour along the line of the water's edge, leaving a thin white shore line.*

2 *Pull the damp paint downwards to the bottom of the page using the flat side of a chisel-headed brush.*

3 *Add the further colours in rapid succession, and pull the paint downwards, using as few brushstrokes as possible.*

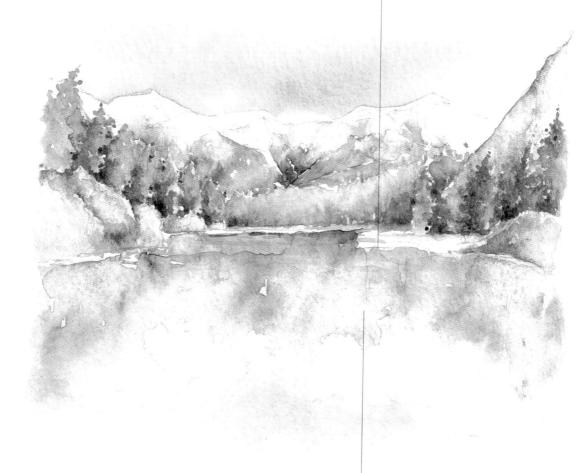

In this scene, a white line left unpainted to break the composition and separate the land and water is a useful technique.

MIRROR IMAGES

Water is rarely so still that no movement can be detected at all, so it is always a good idea to allow the reflection washes to dry and then, using a small brush, paint a ripple or two onto the immediate foreground.

The same colours used for the sky, mountains and trees were used in the lake – only the damp paper diluted them. Make sure that you pull the paint down vertically using positive and decisive brushstrokes – the fewer the better.

Broken Water

Gentle summer days, when breezes softly rustle the trees and boats sit calmly on the river, only occasionally shifting on their moorings, are ideal times for painting small areas along the river bank.

The basic principles that you should use for recording reflections are exactly the same as those described on pages 12 and 13 for painting still water: start by dampening the paper and then, working quickly, apply the appropriate colour wash, pulling the paint downwards with confident and decisive brushstrokes.

Once this first application of paint has dried completely, use a small brush and a limited set of dark paints to describe the movement on the surface of the water. Because the colours that you will see underneath overhanging branches, bridges, boats and so on, are actually the colours of the objects being reflected, this should be your starting point.

Choose the darkest of these colours, mix a little of your main water reflection mix to harmonize the colours, and paint a thin line that echoes the shape and direction of the ripple. Then, using plain water, wash the bottom edge of the brushstroke out into the paper to prevent a hard line forming and to give a much more natural look to the ripple. Repeat this process a few times, at all times ensuring that your brushstrokes follow the natural curve of the ripples and that the spaces between them expand towards the bottom of your picture.

For gently moving water, add the detail of the directional movement of the water only when the reflections are dry.

Painting Ripples

The key to painting successful ripples is to make some judgements about the depth of tone (ripples are often only moving reflections) and the spacing between them – not too many, and not evenly spaced. Always remember that ripples spread outwards in a rhythm, expanding as they go.

1 *Create the colours by mixing a diluted version of the overhanging trees.*

2 *Mix the underside of the boat with the colour of the water and draw a thin line.*

3 *Wash the underside of the line into the underlying colour to avoid a hard edge.*

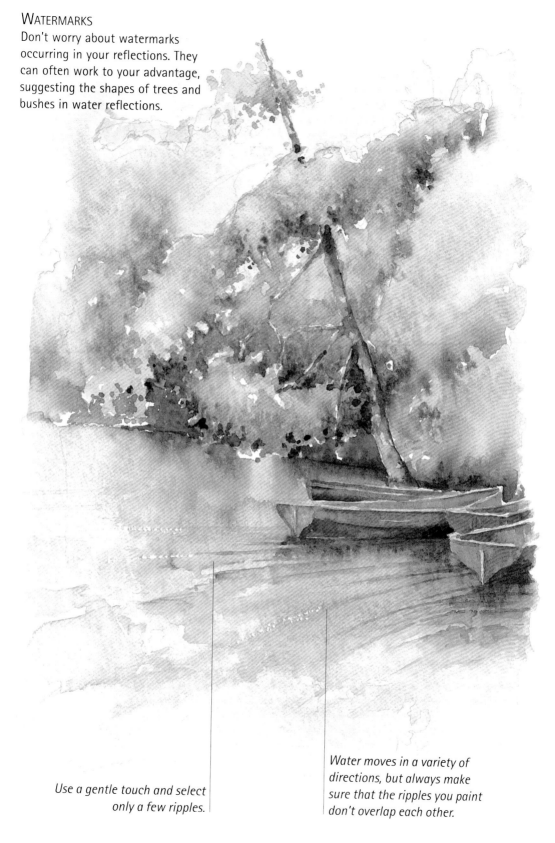

WATERMARKS
Don't worry about watermarks occurring in your reflections. They can often work to your advantage, suggesting the shapes of trees and bushes in water reflections.

Use a gentle touch and select only a few ripples.

Water moves in a variety of directions, but always make sure that the ripples you paint don't overlap each other.

MOVING WATER

As water tumbles across rocks and boulders and breaks around them, areas of white water appear – and it is these areas of white that give a convincing impression of moving water in a painting. In watercolour, the best way to convey this is to leave areas of white paper showing as you paint around rocks and boulders. The more white paper you leave, the faster the water appears to be moving.

When you make visual notes to determine the white water, hold your pencil lightly and work with short marks. You can also scratch into dry paint with a sharp blade to create the effect of sunlight sparkling on water.

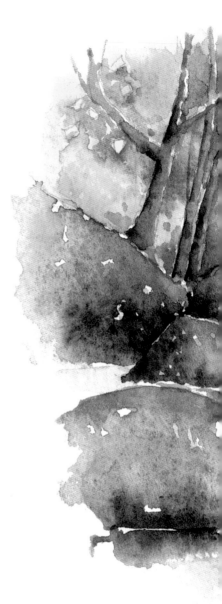

PAINTING MOVING WATER

The key to painting moving water successfully is to look at the shapes the white water makes as it breaks around rocks – it rarely, if ever, flows in a completely straight line. You may find that it helps to make a few faint pencil marks, to remind yourself which areas to leave unpainted.

1 *Fill in the background and foreground rocks and boulders, leaving the water area free of paint.*

2 *Paint the water area, leaving spaces around the boulders and several lines of water movement.*

3 *When dry, scratch off tiny flecks of paint with a sharp knife to represent light bouncing from breaking water.*

CAPTURING MOVEMENT

If you want to record moving water, try to create a 'snapshot' image of the scene in your head, and then use fluid marks to record this image on paper.

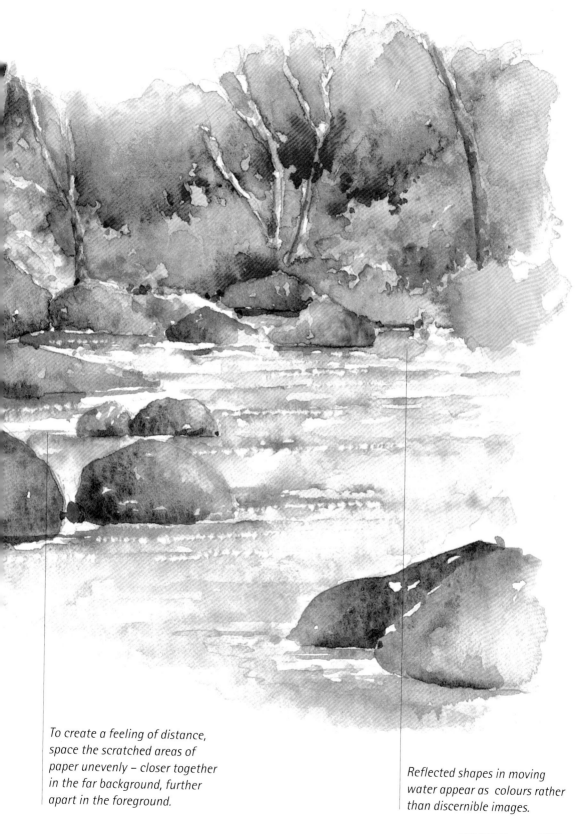

To create a feeling of distance, space the scratched areas of paper unevenly – closer together in the far background, further apart in the foreground.

Reflected shapes in moving water appear as colours rather than discernible images.

Fast-moving Water

The speed that fast-flowing water moves at does mean that a rapid response is required to capture the effect of movement, but this does not mean that more paint need be applied – in fact, it is the exact opposite. The amount of 'white water' found in fast-flowing rivers requires the selective use of paint and an equally selective amount of unpainted paper. The basic rule is, the faster the flow of the water, the more white will become visible as the water hits objects in its path and splashes, falls and tumbles across rocks, boulders and logs.

White water can also be emphasized as it hurtles over rocks, by painting the colours of the objects and leaving the white of the paper to represent the falling water. This involves observing closely the pattern of the falling water and the colours of the rocks and stones. These colours will usually be mixed with a combination of blues and browns, resulting in a stone-grey tone.

Painting Rushing Water

Rather than use masking fluid, use a few quick pencil marks to draw the shapes of falling water. This indicates the areas to which you need to apply paint. Apply a much lighter version of the reflected colours to paint this type of water, and paint the rocks with dark colours to reinforce the contrast.

1 *Isolate the white areas that you are going to surround with paint, keeping the colours light.*

2 *Enhance the direction of moving water by using specific and deliberate directional brushstrokes.*

3 *Use a small brush to paint the rocks and boulders over which the water is falling.*

WHITE WATER

Painting fast-moving water relies on leaving sections of paper unpainted. These areas of white are created by applying brushstrokes and colour around them. Moving water is best painted with smooth, flowing brushstrokes that reflect and echo the movement of the water.

The more white paper left unpainted, the faster the movement of the water will appear.

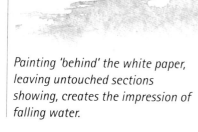

Painting 'behind' the white paper, leaving untouched sections showing, creates the impression of falling water.

Single brushstrokes following the flow of the water help to give the effect of movement.

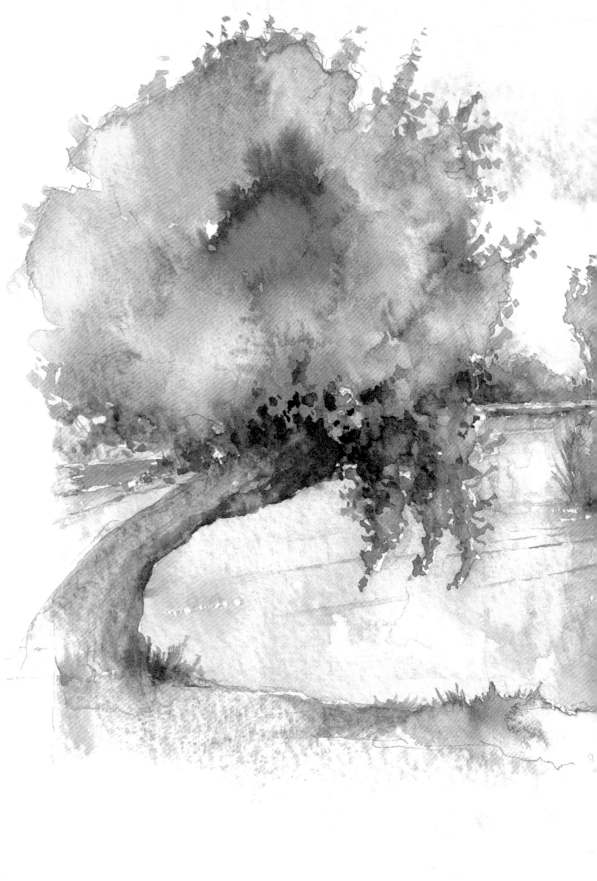

RIVERS

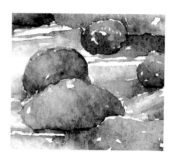

Rivers are chameleon in character.
They twist and turn as they flow
effortlessly through the landscape,
changing pace as they wish, and
taking on the colours of the day as
they go on their journeys. The
colours of the landscape, the trees,
the bridges and the river bank all
lend themselves to the ever-
changing colours of the water that
flows along the river's course.

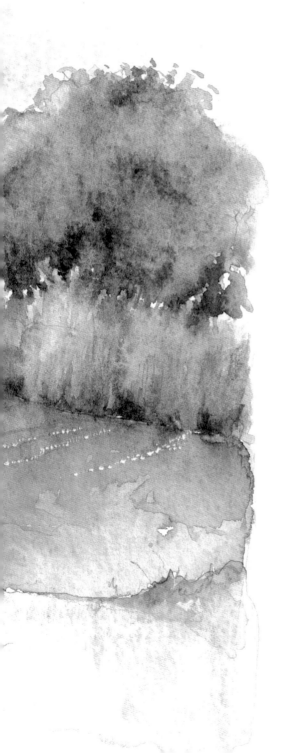

EARLY-MORNING MIST

Soft, hazy early-morning mists are often to be found sitting on the water's surface along the banks of rivers, seeming to wait for the sun to come and burn them away as the day begins.

Mist (and fog) do have physical qualities, but these are not tangible. Like clouds, they exist visually, but once inside them, they are nothing more than moisture with no apparent or discernible shape.

In the early morning mists occur above rivers and lakes as the moisture begins to rise from the water. It is, therefore, important to observe closely both the top and bottom of the bank of mist that you are about to paint. Along the base will be the water itself – the source of the moisture. There is no visible gap between the mist and the river. At the top, however, you are very unlikely to see a flat, straight line – the top of a mist bank is graduated, softly blending into the foreground colours and shapes.

Recreating this mist in watercolour requires more timing and judgement than consideration of paint and colour – success depends on how much paint you take out and exactly when, rather than how much you put on and where.

The very nature of mist lies in its soft appearance, so it is essential to avoid hard lines – carefully blot the area at the top of the mist with a piece of kitchen paper, which will partially absorb any recently applied damp paint.

The timing of this is important: if you blot very wet paper, you are left with nothing to show on the paper, but if you leave the paint for too long and the surface begins to dry, you can't remove any paint – working on barely damp paper is the key to getting this right.

Capturing Mist

Always try to blot along an even line, as mist does not peak and dip along its length. In addition, vary the pressure of the blot: softer at the top of the background paint, and harder at the bottom as the mist thickens.

Blotting

To create this atmospheric effect, gently remove the surface paint along the top of the mist with a piece of kitchen paper – use a light touch here, as you do not want to blot out the full range of colours, but simply soften the tones. Here, I painted the distant bank and the areas directly behind the mist.

1 *As soon as the paint sheen begins to disappear, gently blot the top edge of the mist, removing some paint, not all.*

2 *Working downwards, from the base of the mist, begin to paint the river underneath accordingly.*

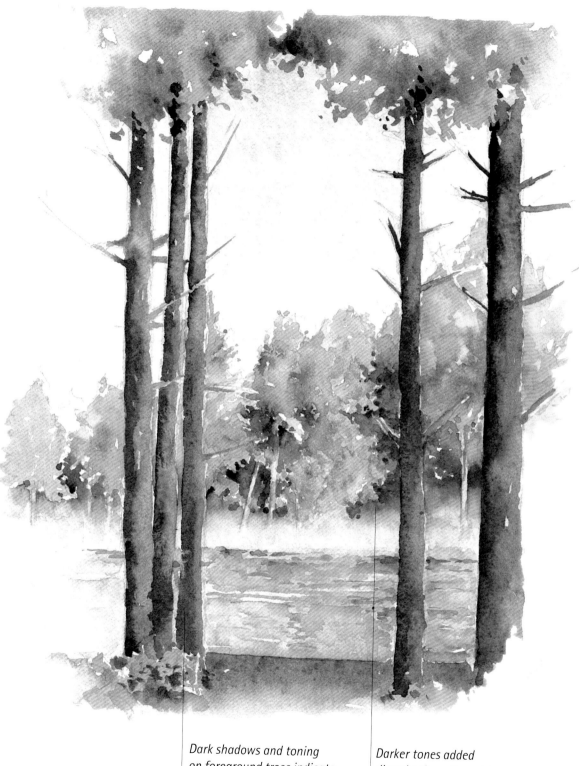

Dark shadows and toning on foreground trees indicate the hard, sharp light of the early morning.

Darker tones added directly above the mist are useful for strengthening the tonal contrast.

Stepping Stones

It can be a real pleasure to move in close to a river's edge or lakeside and observe closely the rhythmic, hypnotic movement of water running around and between stones, rocks and boulders. There are extremes of light and shade – sparkle from reflections and depths of shadows underneath large boulders – but you rarely find any extremes of colour. Paint studies of this kind thus become exercises in tonal mixing.

I mix together the cooler colours most frequently, especially cobalt blue and yellow ochre. These colours, with a little burnt umber for greater depth of tone, are an ideal base for painting wet rocks and boulders. I often dampen a rock or boulder with a watery raw sienna underwash and then apply the paint mix of cobalt blue and yellow ochre so that it flows evenly across the paper – working wet-into-wet. Before this has had time to dry, I mix a stronger version of the same colour and touch this onto the darkest part. This bleeds softly because the paper is still damp, giving a graduated appearance.

The same colours are, naturally, used for the water, although I may make several additions to allow the colours from the overhanging trees, the river bed and so on to influence the colour of the water. Observe closely the way in which the water moves and flows around the stones: the ripples that are created, and tiny pools of water that occur, can work harmoniously together as long as you don't try to put too much detail into these. Instead, suggest them by leaving just one or two highlights for ripples and a little dark paint for the reflection in the pool. What is important is to include a wide range of tones rather than illustrative or linear detail.

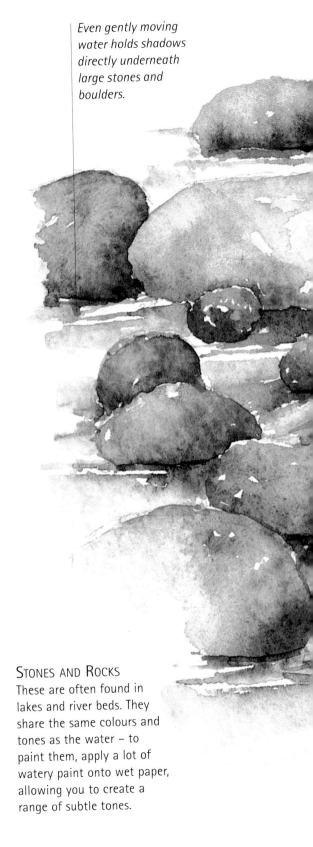

Even gently moving water holds shadows directly underneath large stones and boulders.

Stones and Rocks
These are often found in lakes and river beds. They share the same colours and tones as the water – to paint them, apply a lot of watery paint onto wet paper, allowing you to create a range of subtle tones.

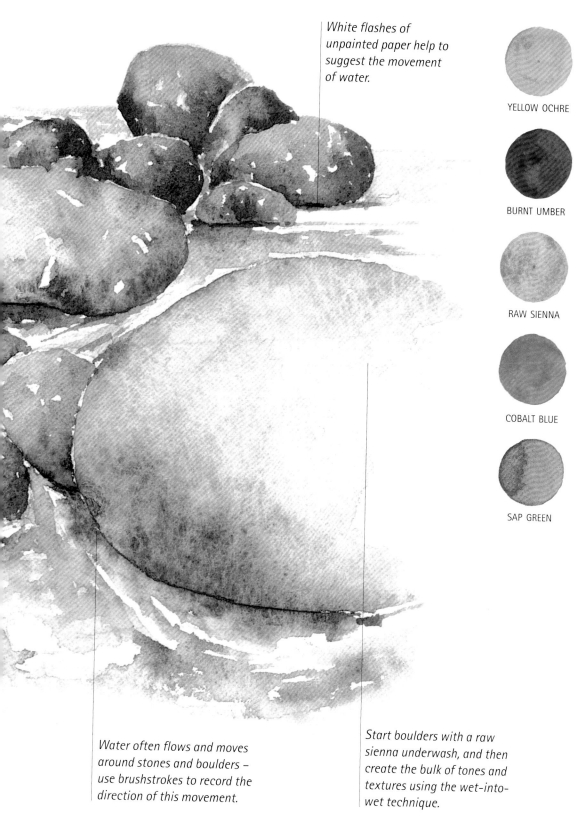

White flashes of unpainted paper help to suggest the movement of water.

YELLOW OCHRE

BURNT UMBER

RAW SIENNA

COBALT BLUE

SAP GREEN

Water often flows and moves around stones and boulders – use brushstrokes to record the direction of this movement.

Start boulders with a raw sienna underwash, and then create the bulk of tones and textures using the wet-into-wet technique.

SCALE

Water itself offers no real sense of scale. We make judgements about size, depth, distance and so on by looking at the more tangible surroundings – trees, structures, boats – and here, the human figure.

A figure allows us to make comparisons between the size of distant and immediate objects that are viewed against the person. But a figure standing in the water also allows us to gauge and suggest the speed of the moving water by painting the ripples and reflections that occur accordingly. Very fast-flowing water does not allow much reflection to occur (this usually requires fairly still water), and ripples are whiter and irregular in pattern. Slower-moving water, however, allows more linear patterns to occur and a little more colour to be observed directly underneath the figure.

Finding a figure helps you to distinguish between a fast-flowing section of river, where sharp white flashes occur, and the gentler, protected sections, where the pace of the water slows and pools and ripples accumulate – rivers do not always flow at the same pace throughout their course.

VIEWPOINTS
The scale of any scene can be altered by changing your viewpoint. This sketch was made from a very low viewpoint, with the result that the canoeist's head is above the line of the trees on the far bank. This also appears to 'compress' the water, making the distance between the shore and bank seem quite small. A higher viewpoint would 'expand' the water.

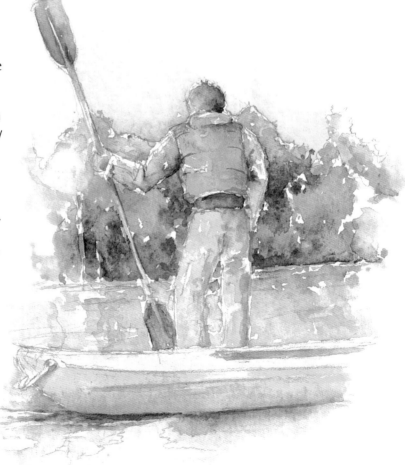

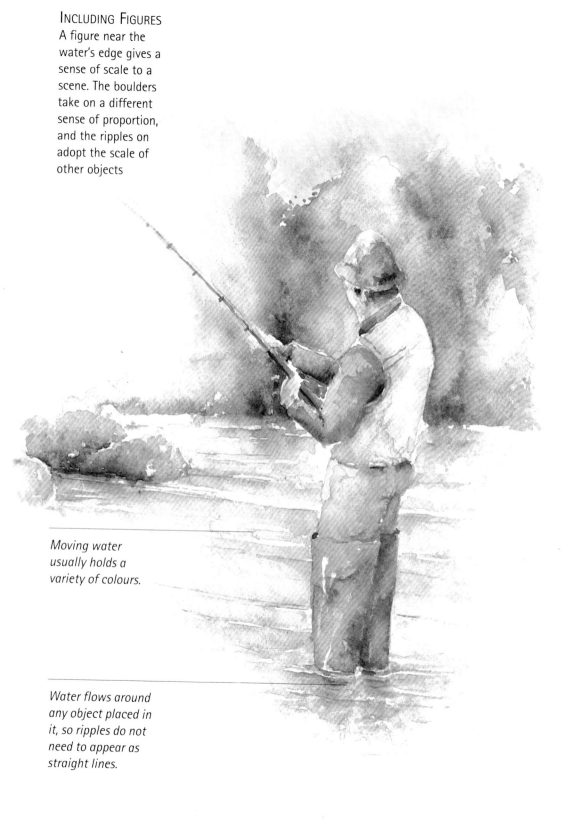

INCLUDING FIGURES

A figure near the water's edge gives a sense of scale to a scene. The boulders take on a different sense of proportion, and the ripples on adopt the scale of other objects

Moving water usually holds a variety of colours.

Water flows around any object placed in it, so ripples do not need to appear as straight lines.

BRIDGES

The visual qualities of rivers and bridges complement each other particularly well. As flowing water works on old brick and stone, so the very nature of the bridge will have changed over the years.

Apart from erosion where bricks and blocks have become misshapen due to the action of flowing water, the colours and tones of the building material will also have changed. Once-red bricks and yellow stone often have a green tinge around the water line where damp has entered the fabric and left its visual mark. Equally, rich red-brick colours and softer, weather-worn stone produce some very attractive sights when reflected in the water – especially the largely untouched undersides of bridges.

Painting these scenes involves using all of the techniques examined so far. Usually, an initial wash is applied to the river area and the reflected colours are then applied to damp paper, before being pulled downwards towards the bottom of the paper. Once this has dried, you can introduce the movement of the water, either by painting ripples on top and around the bridge, or by scratching out a few sparkle highlights to suggest movement on the water's surface.

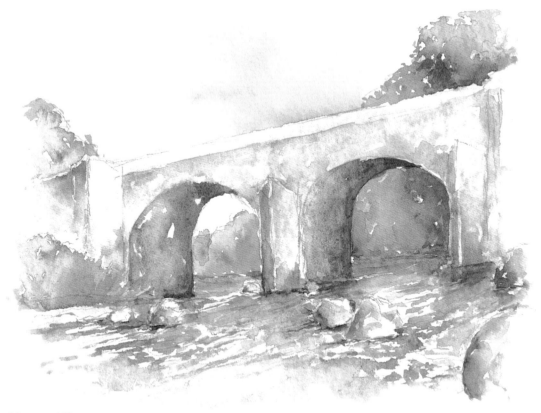

MOVING WATER
The rapid movement of water under a bridge usually holds a shadow, but does not allow much of a reflection to develop.

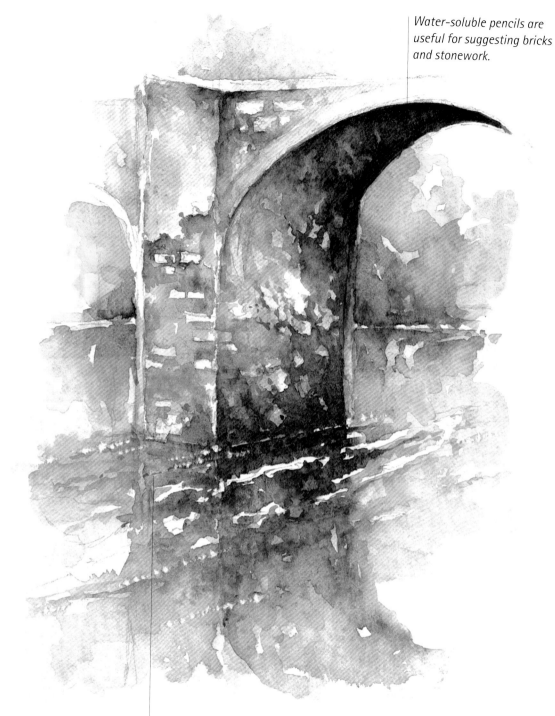

Water-soluble pencils are useful for suggesting bricks and stonework.

Bridges often cast shadows and reflections which appear darker in the water than the actual bridge.

REFLECTIONS
Look for stone and brick reflected in the water, and for light reflected up from the water onto the underside of the bridge, creating dappled shadows.

WATERFALLS

Painting a waterfall is probably one of the most daunting tasks facing any artist. So much moving water is particularly difficult to absorb visually, so I suggest that you again concentrate not so much on the water itself, but on what is happening behind it – the colours and the shapes of the rocks and boulders over which the water is tumbling.

To really emphasize the pressure of the water and the speed at which it falls, it helps to create an effective spray of water at the point where the waterfall ends – usually a pool. To create this, I use an old, clean toothbrush to spray and spatter masking fluid before applying any paint to the water area.

This gives you the freedom to wash paint freely onto the rocks behind, allowing you to create a wide range of textures as the paint bleeds, blends and dries without covering up the white paper under the fluid.

PAINTING FALLING WATER

To create the effect of splashing water, dip an old toothbrush into a saucer filled with masking fluid. Then, holding the toothbrush at the point where the spray is to be created, flick the brush head upwards – this sends tiny flecks of masking fluid splashing upwards across the paper, just as falling water does, and prevents paint coming into contact with the areas of the paper onto which it has dried. Be careful when washing paint over the paper, as over-vigorous brushwork could remove the surface of some masking fluid specks. The darker the paint, the more effective the white flecks will look in the end.

1 *Flick masking fluid upwards in the direction of the spray, using an old toothbrush.*

2 *Allow the masking fluid to dry completely, then apply the paint freely over the paper.*

3 *Let the paint dry thoroughly, then remove the masking fluid by rubbing it gently with a putty rubber.*

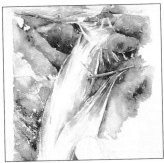

4 *The result is a very effective impression of spray, the white specks visible against the dark rocks.*

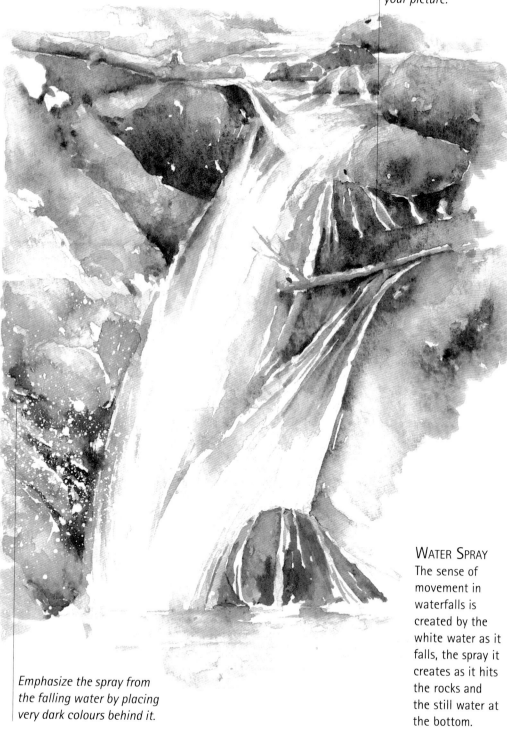

Little rivulets of water often seep out between rocks. Don't worry about finding their origins in your picture.

Emphasize the spray from the falling water by placing very dark colours behind it.

WATER SPRAY
The sense of movement in waterfalls is created by the white water as it falls, the spray it creates as it hits the rocks and the still water at the bottom.

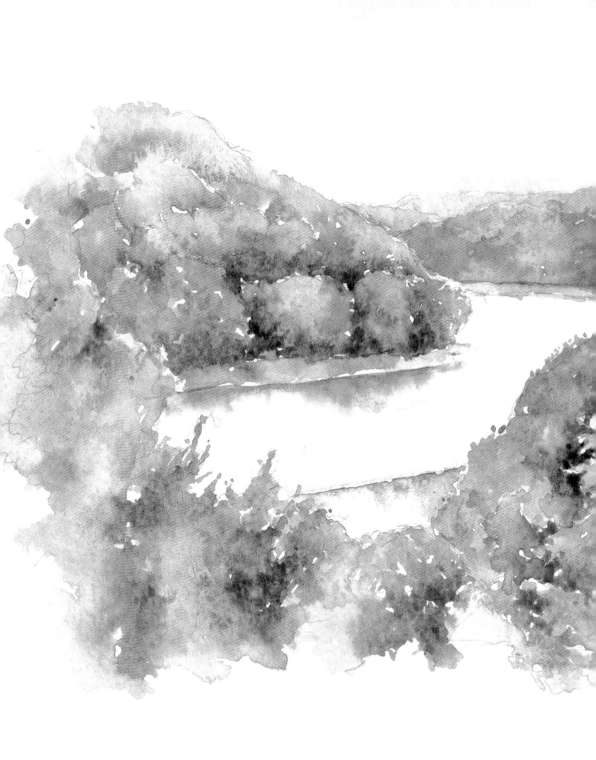

LAKES

Sometimes you need to climb to
a high vantage point to fully
appreciate the size, shape and scale
of some lakes, as their grandeur
simply can't be appreciated at the
water's edge. In this position it is
so much easier to see exactly how
the colours of the sky and the
surrounding trees are mirrored in
the waters of the lake.

Foreground Details

When you are searching for a subject around the water's edge, it can be helpful to include some foreground detail. This serves to break up the vast expanse of open space that often sits between you and the far edge of a lake or river, and gives the viewer something to focus on. Structures such as jetties and landing stages can add a great deal of visual interest to an otherwise dull shoreline.

In this instance, I positioned myself so that the poles of the landing stage led the eye into the picture. The mooring lines also cut across the foreground, creating even more interest in the scene.

As the foreground was the main area of interest, I painted the wash for the sky, water and background hills very quickly. The foreground was painted with more attention to detail – I painted carefully around the ropes, leaving negative shapes, and the wooden poles were painted with a combination of raw sienna, burnt umber, and a touch of cobalt blue.

The boats were accentuated by darkening the water directly beneath them with a strong mix of cobalt blue and burnt umber. As soon as this had dried, I scratched a few highlights into the foreground water to create a feeling of gentle movement.

Adding Interest to a Scene
In this picture, visual tension is created by the mooring lines diagonally crossing the upright poles. Using light and dark colours together also adds to the sense of tension: the dark colours of the wood contrast with the light ones of the water.

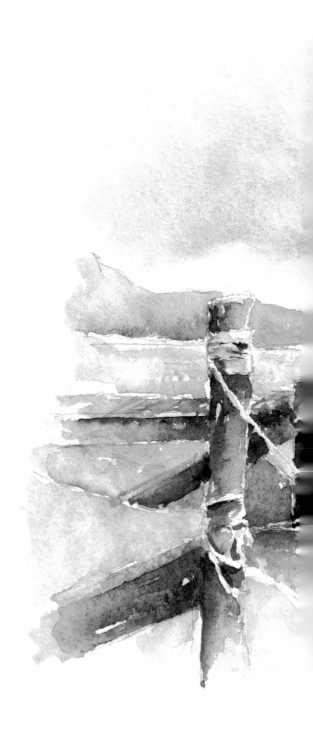

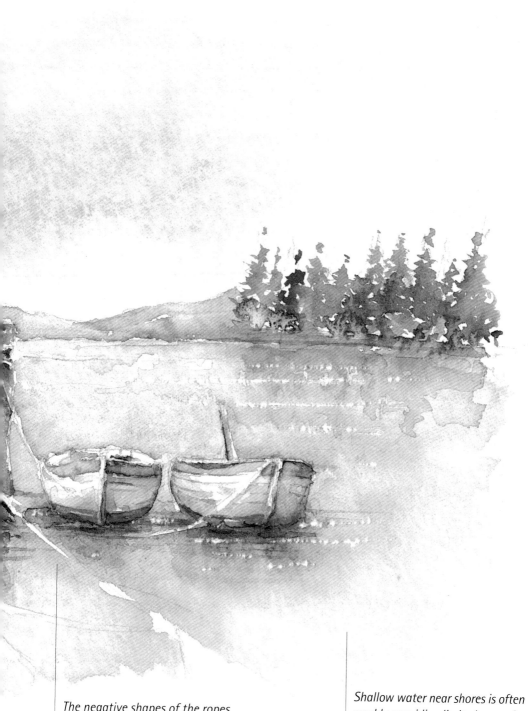

The negative shapes of the ropes were drawn with a double pencil line and then painted around.

Shallow water near shores is often muddy, providing limited scope for reflections: the granular qualities of earth and sand usually produce cloudy water.

SCALE AND DISTANCE

In townscapes and some landscapes we can establish a sense of space and distance by using linear perspective, focusing on key points in the scene to act as guides – fences, posts, cottages and so on. Large lakes, however, rarely have convenient features mapped out across their surface, thus removing the option of using linear perspective. This means that we have to use colour to create the sense of distance.

Distance and scale can be created by ensuring that the very furthest distance is painted with a much lighter tone, which should contain a blue or violet base. The lightness of tone helps to suggest distance. As our eyes are not capable of focusing over a very long distance, the background in any scene is less distinct, containing hardly any detail or colour.

Thanks to the earth's atmosphere, 'blue' light is reflected more than any other colour, giving the impression of blue hills or mountains when we look at wide open spaces. To create the feeling of sharp, cold lakeland days, use a cool blue – cerulean blue for example. For warmer days, a hint of violet (add a touch of alizarin crimson to sky blue) works well.

The final consideration is creating a graduation of tone from furthest background, through the large area of space in the middle, to any specific detail in the foreground. The middle ground of a lake may be only a rather vague part of the composition, with little specific detail upon which to focus. This is where colour and tone become very important. The middle ground should not be just the space in between the background and foreground, but a balance of tones that leads the viewer gradually through the composition.

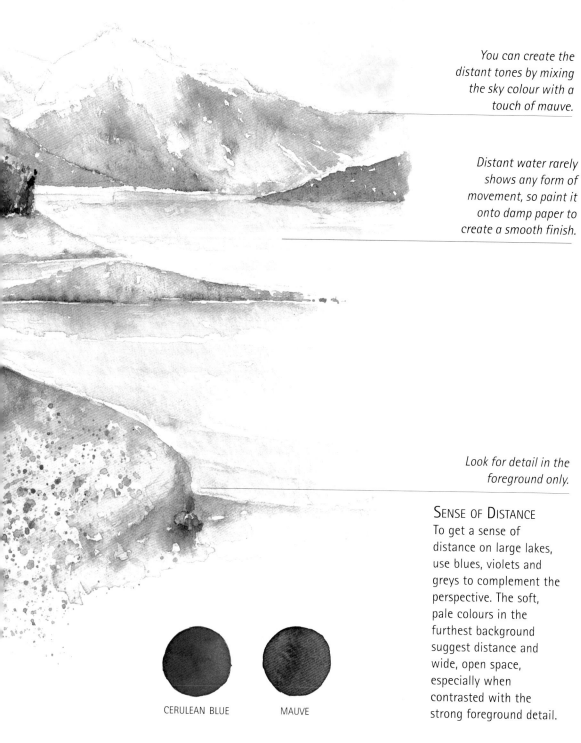

You can create the distant tones by mixing the sky colour with a touch of mauve.

Distant water rarely shows any form of movement, so paint it onto damp paper to create a smooth finish.

Look for detail in the foreground only.

SENSE OF DISTANCE

To get a sense of distance on large lakes, use blues, violets and greys to complement the perspective. The soft, pale colours in the furthest background suggest distance and wide, open space, especially when contrasted with the strong foreground detail.

CERULEAN BLUE

MAUVE

SUNSETS

Sunsets are a delight to paint, but are one of the hardest subjects to attempt. First, sunsets tend to start slowly and then gain impetus quite quickly as the sun sinks behind the clouds or the horizon. You do not normally have much more than 30 minutes painting time, so a quick sketch accompanied by a few colour studies is probably the best system to develop. Second, as the sun begins to set, the surrounding landscape loses its definition as the light fades. Shadows fall upon the distant hills, and the scene becomes flattened as the colours turn to grey.

The final disadvantage of painting sunsets is the temptation to overdo colour, creating a highly unnatural scene in both sky and water. The atmospheric conditions at the end of a day can create a wealth of colours, but don't confuse quantity with strength. A collection of soft, subtle colours seen together is stunning, but they are still individual, gentle tones and hues.

The most successful method is to set a limited range of colours and to stick to them exclusively. Use exactly the same colours on the water as for the sky's colours – while they may appear different, this is chiefly because of the background against which you are viewing them.

It is very helpful to ensure that some foreground detail is available within the composition – some reeds or twigs, for example. The strength of colour and tone that can be created in foreground details as they stand against the intense light of a setting sun creates a marked contrast against the visually flattened background. Water-soluble pencils are quite useful for this, as they create a visual punctuation mark in the immediate foreground.

WINSOR BLUE

CADMIUM ORANGE

SCARLET LAKE

BURNT UMBER

PAYNE'S GREY

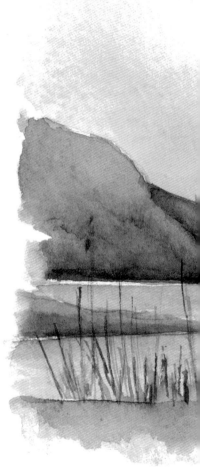

COLOUR AND TONE
It is best to paint sunsets when the sun is as near to the horizon as possible. This creates gentler tones and reflections on the water, eliminating the need to try to capture the full glare of a glorious sunset, however attractive the colours may be.

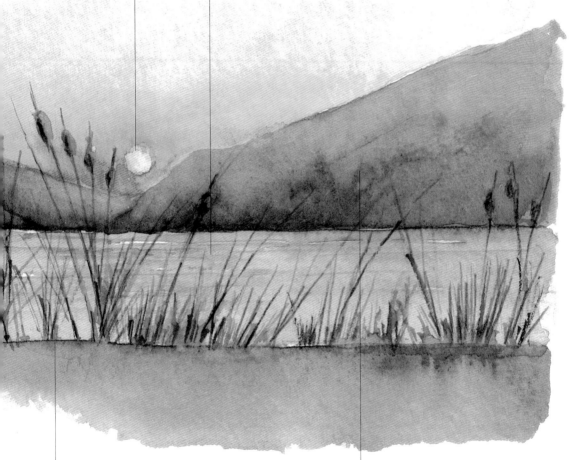

The sun is often lighter than the immediately surrounding sky.

Colours used for reflections are the same as those used in the sky. Paint these onto dry paper to avoid dilution.

Black does not really exist in nature. For the dark foreground, I use burnt umber, Winsor blue and Payne's grey, plus water-soluble pencils for the rushes.

Sunsets have the effect of visually flattening the back and middle grounds, so use neutral tones and a large brush to eliminate detail.

FORESHORES AND BEACHES

On many large or even medium-sized lakes, it is very easy to believe that the foreshore is, in fact, part of the ocean – sand, pebbles and all manner of washed-up items can all be found above the water line. The explanation for this is that while they are not tidal, lakes can still be hit by storms (or even small tornadoes), which whip up waves, creating storm damage around the edges, the evidence of which is often washed up onto the foreshore.

Making paintings that include the details from lake shores usually requires a slightly different approach to composing your scene from painting rivers. Many lake scenes include, and concentrate on, a large expanse of water, and these are often painted from at least a standing viewpoint, if not higher.

If, on the other hand, you wish to include much of the appealing detritus from the weather's effect on the lake, you may need to visually sandwich the amount of water between the sky and foreground, compressing it to allow more space for the detail on the foreshore.

I find it easier to paint the foreshore and its sun, and water-bleached objects from a seated position, as this allows you to come closer to the subjects as you adopt this lower viewpoint.

Most foreshores are peppered with all sizes and kinds of stones, set into a sand or mud surface. To recreate the colours and shapes of these tiny pebbles, I use a spattering technique similar to that used with masking fluid and waterfalls (see page 30). The first stage of this process is to freely apply a yellow ochre wash to the immediate foreshore.

Once this has dried I prepare watery mixes of raw sienna, burnt umber, and usually the same blue as I used for the sky. Then I dip a small paintbrush into one mixture at a time and, holding the bristles over the dried wash, vigorously tap the metal ferrule of the brush. This sends tiny flecks of paint spattering across the paper, thus recreating the effect of thousands of tiny stones and pebbles that are resting on the foreshore surface.

On a larger scale, a toothbrush can be used. This is a much more efficient way of creating a large expanse of pebbles, as you can build up the colours and tones very quickly. It is, however, a technique that is much harder to control, and does often result in directional flicks of paint spraying outwards from the point from where you made the flick.

A combination of small specks of paint flicked from either a paintbrush or toothbrush, plus a few selected rocks or boulders painted in with a small detail brush is often the best solution. This will provide a variety of shapes and sizes in the foreground, and will also give the painting a change of shape and tone.

CERULEAN BLUE

MAUVE

YELLOW OCHRE

RAW SIENNA

BURNT UMBER

LOG PATTERNS

Storms can easily wash up a variety of fascinating objects onto lake shores. Logs that have been in the water for a long time are particularly appealing, as they require attention to their linear qualities as well as their colours.

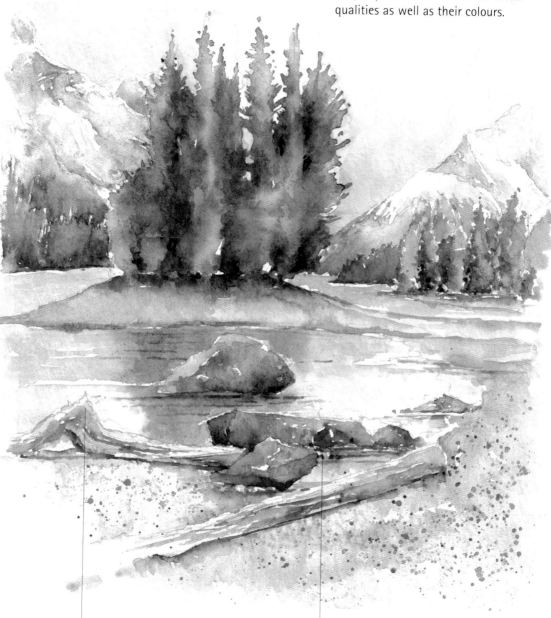

Sun-bleached logs need little colour: I used raw sienna and a touch of cerulean blue.

On calm days, the part of the foreshore where the water and the beach meet can become hard to define – a natural division between the land and water may not always exist.

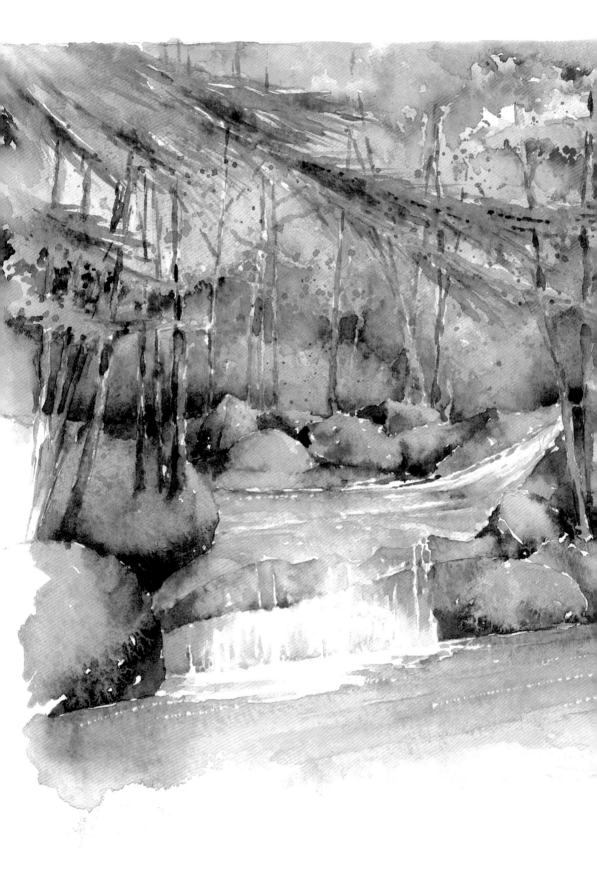

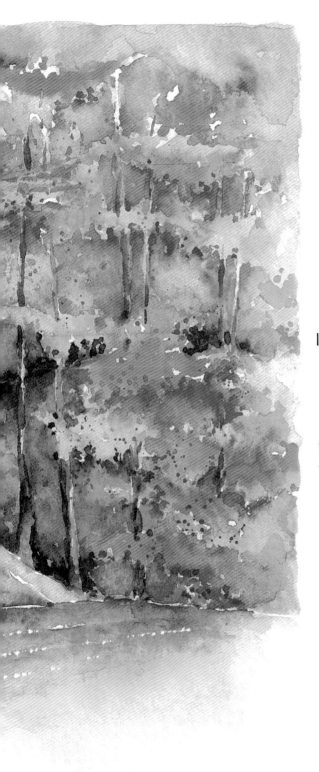

Colours

It is fair to say that most water has little colour of its own – only the colours of mud, silt and sand that are carried along downstream. The colours that we see are more likely to be the results of reflections. The sky, the river or lake bed, the surrounding trees and rocks and boulders, all play a vital role in determining the colours that we see when we view water in lakes and rivers.

BLUES

The colours we use to paint water are mixed using the colours of the immediate surroundings – especially the sky. An overcast sky does not allow a sparkling blue lake to sit beneath it. Likewise a clear, warm blue sky rarely gives rise to a dull, lifeless expanse of water.

Certain key colours are perceived to be warm or cold, suggesting that they impart such feelings of temperature to the viewer.

These characteristics can, however, easily be altered by placing them out of context (for example, using cold cobalt blue among warm violets, oranges and reds), or mixing colours from the opposite end of the colour spectrum (for example, traditionally warm ultramarine mixed with Payne's grey and raw umber).

I don't often produce neutral colours with no temperature characteristics, as I

WARM BLUES
'Warm' skies reflected in lakes or rivers are best recorded using either of these two blues. Both are usually categorized as holding a high colour temperature that imparts a strong feeling of warmth.

ULTRAMARIINE

WINSOR BLUE

WARM GREYS
To create the base colour (that is, the first colour applied to the paper) for a river bed or bank on a warm, summer day, use these three colours, making sure that the blue is the most dominant.

BURNT UMBER

RAW SIENNA

ULTRAMARINE

WARM GREY

have rarely been out painting in neutral weather. My standard base colours can be divided into two clear categories.

For still, fairly clement days I usually mix a warm grey made up of burnt umber, raw sienna and ultramarine, and this will form the basis of my colours for water. I may well add several other colours, depending on the particular site and lighting conditions, but this mix serves as the first water wash to establish the colour temperature of the day. On days when the wind blows from the north or east, and the sky is dull and lifeless, I choose a colder grey mix as a base colour for water, made up usually of raw umber, yellow ochre and Payne's grey (sometimes with a touch of cobalt blue). I may also add several colours to this mix to help determine the exact nature of the scene and the conditions of the day.

COLD BLUES

Paint cold skies using either of these two colours. A touch of Payne's grey can be useful in either colour to reduce its blueness and introduce a more stormy sky.

COBALT BLUE

CERULEAN BLUE

COLD GREYS

A fast-running, cold mountain stream or lake often has a cold grey bed or bank. Because this usually shows through the water, these colours can be particularly helpful – but don't let the Payne's grey dominate, as this can flatten reflected colour.

RAW UMBER

YELLOW OCHRE

PAYNE'S GREY

COLD GREY

COLD BLUES

The colour you choose to create a certain colour temperature is very important, as it is used for the base colour, or underwash, for most of the scene – that is, to mix the sky, the water and any surrounding hills and trees. When you are looking out at a cool, open expanse of water, search your art box for a suitable blue paint to use to paint this base colour.

In this lies one of the greatest problems that face watercolour painters – which blue to choose. Because blues are not dug from the earth in their pure state (with the exception of ultramarine, which originally came from the precious lapis lazuli, found in the foothills of the Afghanistan mountains), paint manufacturers have over the years created a wide range of blues.

While blues in general are usually considered to be in the cold end of the colour spectrum, all blue paints are individual and have their own qualities, and not every single blue necessarily imparts a cool feeling. Ultramarine, for example, is always considered to be the warmest of blue paints, whereas cobalt blue is usually perceived to be one of the coldest. Cerulean blue certainly evokes cold moods, yet it can equally be used for a fresh spring sky. Winsor blue is something of a chameleon colour and can be used effectively in either cold or warm scenes, adapting particularly well to its surrounding colours.

For this painting I used a combination of cobalt blue with a touch of Payne's grey (this colour contains black and can, therefore, easily flatten any colour) as my basic mixture and created most of the other colours using this as my starting point, ensuring continuity of atmosphere throughout the painting.

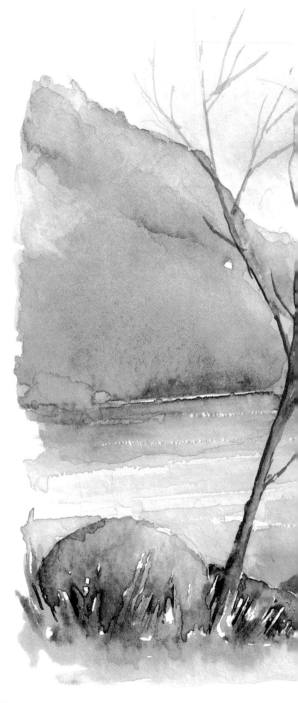

CONTINUITY OF ATMOSPHERE
To create the water, mix the sky colour with a touch of the hill colours and a little Payne's grey. Paint the water with light sections for a high level of movement which is echoed by the sky.

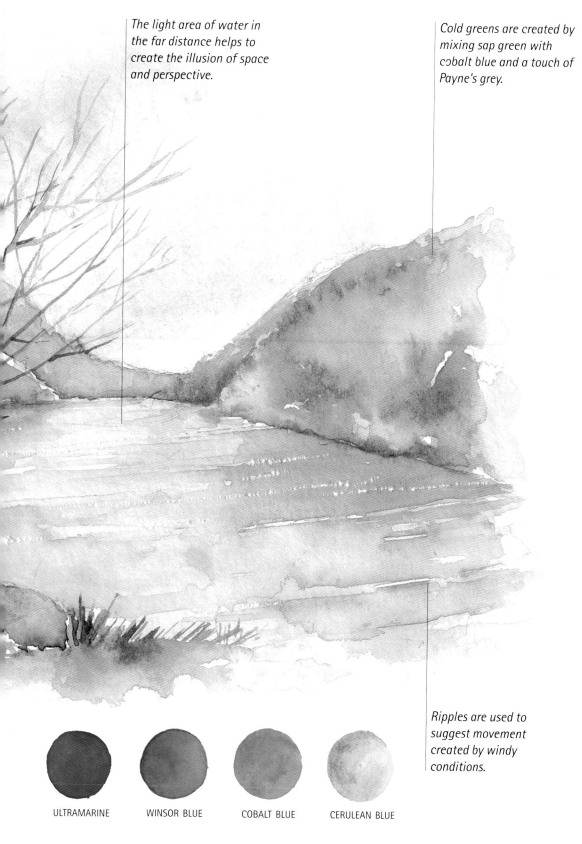

The light area of water in the far distance helps to create the illusion of space and perspective.

Cold greens are created by mixing sap green with cobalt blue and a touch of Payne's grey.

Ripples are used to suggest movement created by windy conditions.

ULTRAMARINE

WINSOR BLUE

COBALT BLUE

CERULEAN BLUE

WARM GREENS

The gentle, lazy lakes and rivers of summer are usually awash with reflections and the colours and tones of the warm, balmy days. Because these days create calm and placid water surfaces, the strength of the reflections, and the consequent colour of the water, is considerably increased.

To capture the relaxed atmosphere of these long, hot days spent painting at the water's edge, I tend to use raw sienna as my base colour. This is a natural earth colour which glows with warmth, making it ideal for any natural object or scene where this colour temperature is required. I often apply raw sienna as an underwash and then, while the paint is still damp, apply the other chosen colours to the trees and foliage, allowing them to flow and bleed, blending unevenly on the paper. Before these colours have time to dry, I pick up some of the wet paint and pull it downwards onto the water area, creating the basis for the lake or river and establishing a unity of colour. If you mix and apply your surroundings colours, then mix your reflection colours separately, the difference in colours is likely to show – but if you do the entire process in one go, the greater the natural effect.

A little cadmium yellow dropped onto the top of the trees serves to lift the colour a little, enhancing the notion of sunlight catching both trees and water. I also like to leave the sky until after I have painted the reflection. While the edge of the reflection is still barely damp, I apply the sky colour to the river or lake – the colours blend softly without a hard line. Once this underwash has dried, I paint on the shadows and ripples using a small brush.

CADMIUM YELLOW

LEMON YELLOW

RAW SIENNA

SAP GREEN

Create highlights on tops of trees by dropping cadmium yellow onto a wash of raw sienna and sap green.

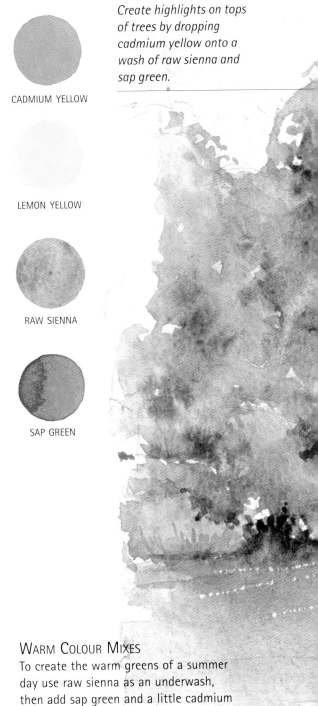

WARM COLOUR MIXES

To create the warm greens of a summer day use raw sienna as an underwash, then add sap green and a little cadmium yellow. All these colours are reflected collectively and individually in the gently moving river.

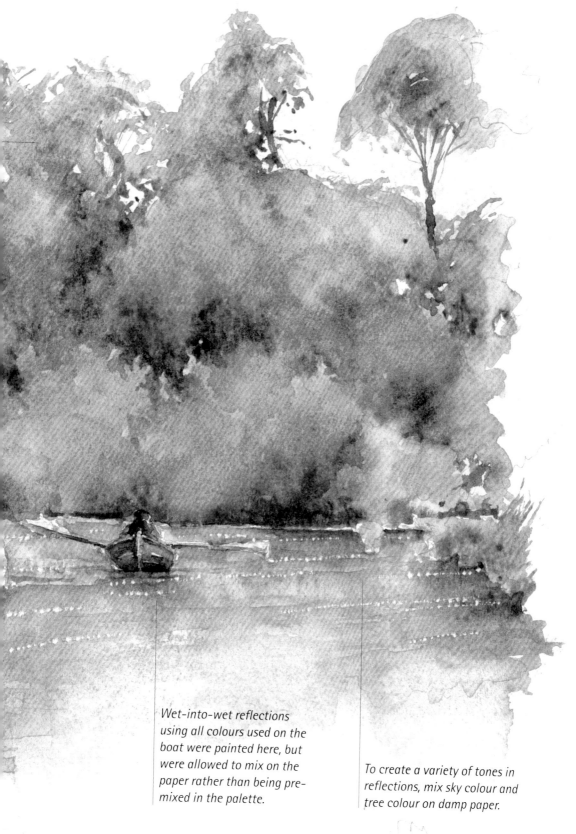

Wet-into-wet reflections using all colours used on the boat were painted here, but were allowed to mix on the paper rather than being pre-mixed in the palette.

To create a variety of tones in reflections, mix sky colour and tree colour on damp paper.

Muddy Water

Muddy water is one of the few types of water that does actually hold a number of colours of its own, and is not just, visually, a product of the immediate surroundings. Still, mud-laden water can sometimes reflect the banks and branches, but to a more limited extent.

I always choose the natural earth colours to paint anything with mud – banks, river beds and water itself. These are raw sienna, burnt sienna and burnt umber for the warmer natural elements, and yellow ochre and raw umber for the colder, less colourful features.

It may seem a bit of a contradiction to say that you must take care not to muddy your colours when painting muddy water, but there is sense in doing so. If you blend a large number of the colours in your paint box together, they will invariably end up producing a bland, neutral greyish brown which does not help to describe the scene in an effective way.

For this reason, I prefer to allow my colours to mix on the paper. In this way, they do not mix so thoroughly, thus maintaining some of their individual identity. This also allows me to paint some very dark shadows onto these tones when they are dry, creating some exciting extremes, and not just a soft, dull, flat area of muddy water.

This skill of 'drawing' onto a dried underwash is particularly valuable when painting still, muddy or stagnant water. The technique allows you to create shapes and lines in a positive way, giving the reflections an added strength.

It is important that you only draw in this manner simply and quickly, and don't give way to the temptation to overwork this final stage of any painting. The sparkle from a painting can easily be lost by the heavy-handed application of too much paint or, probably more commonly, by too many brushstrokes.

RAW SIENNA	MID-TONE MUD	BURNT UMBER

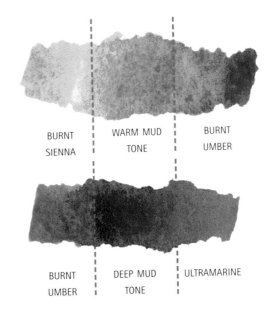

BURNT SIENNA	WARM MUD TONE	BURNT UMBER

BURNT UMBER	DEEP MUD TONE	ULTRAMARINE

Mud Colours
Choose natural earth colours to recreate muddy streams and rivers. You can create a wide variety of tones, depending on the colours you mix together.

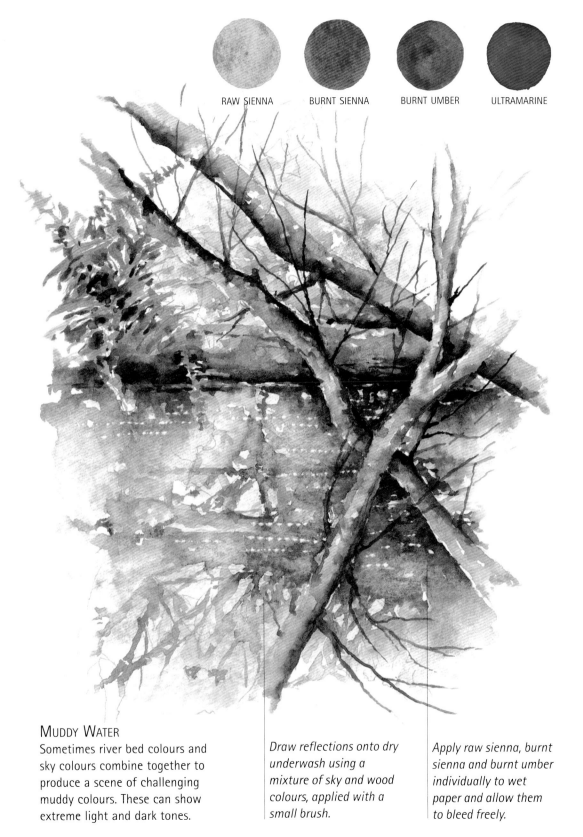

RAW SIENNA BURNT SIENNA BURNT UMBER ULTRAMARINE

Muddy Water

Sometimes river bed colours and sky colours combine together to produce a scene of challenging muddy colours. These can show extreme light and dark tones.

Draw reflections onto dry underwash using a mixture of sky and wood colours, applied with a small brush.

Apply raw sienna, burnt sienna and burnt umber individually to wet paper and allow them to bleed freely.

ICE AND SNOW

The long, cold days of winter can produce some very inhospitable climates – snow, ice and chilling winds are not usually friends to artists. But it really is worth wrapping up in warm clothing – fingerless gloves are a particularly useful aid – and braving the elements, as many inspiring treasures lay in wait along river banks and lakesides during the frozen winter days.

Snow is a particular challenge to the watercolour painter as it 'holds' no colour of its own. The pure, brilliant white of freshly fallen snow visually absorbs all the colours around it and reflects many of them – especially when viewed in strong daylight. A cool violet mixed with a strong quantity of cobalt blue is a particularly good colour for painting shadows cast onto snow. If mixed with some strength it can create the sharp, cold shadows of a sunlit, wintery day. Mixed lightly, it can be used to tint areas of paper to suggest soft shadows cast by snowdrifts, reinforcing the notion that daylight always creates shadows, however minimal, even when overcast.

It is important to allow the paper to act as highlights. Don't be afraid of white paper – there is no cleaner and sharper white, and if it is left unpainted, its texture can be seen, adding to the painting. The 'body' required to make white paint effective covers the texture, resulting in a slightly flat or 'dead' area of paper – in marked contrast to the rest of the picture.

FROZEN RIVERBANK
Use cold colours – Payne's grey, yellow ochre, raw umber and so on – to paint rocks and boulders surrounding a frozen expanse of water. Remember to leave flashes of white paper to act as the highlights of ice or snow.

Rather like watercolour paints, ice can be translucent, allowing the colours underneath to show through, but in a greatly more muted set of tones. Once again, I use a few flashes of white paper to represent the highlights.

The torrents of water that rush through snow-clad mountains pick up the colours of many of the stages they pass through. I often use yellow ochre in tumbling mountain rivers – it has a cold feel and suggests the silt carried along the river bed. For darker areas of tone, I add a small touch of Payne's grey mixed with a little raw umber, or even burnt umber for darker areas.

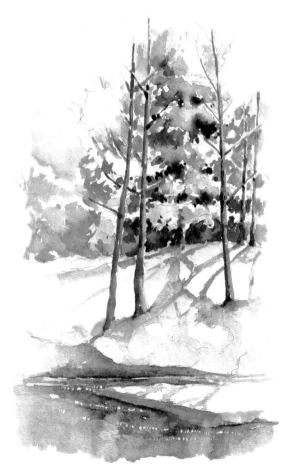

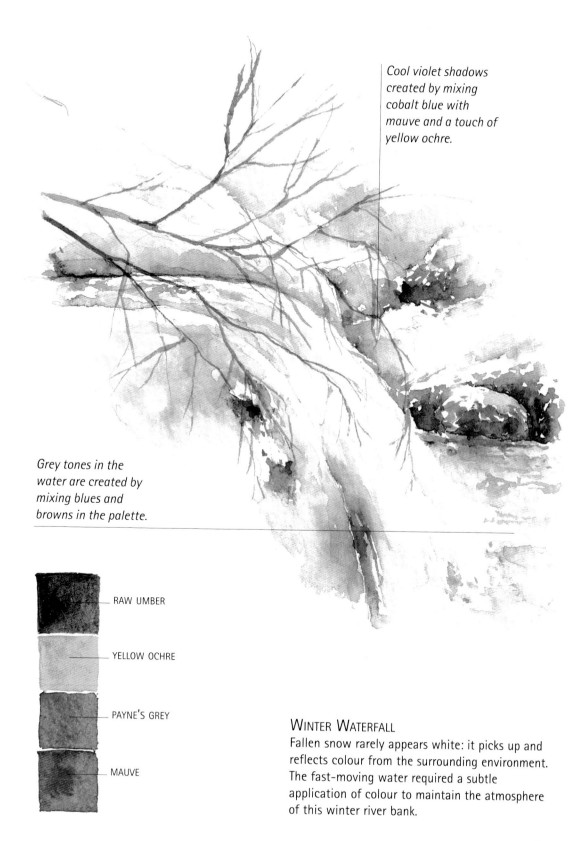

Cool violet shadows created by mixing cobalt blue with mauve and a touch of yellow ochre.

Grey tones in the water are created by mixing blues and browns in the palette.

RAW UMBER

YELLOW OCHRE

PAYNE'S GREY

MAUVE

Winter Waterfall

Fallen snow rarely appears white: it picks up and reflects colour from the surrounding environment. The fast-moving water required a subtle application of colour to maintain the atmosphere of this winter river bank.

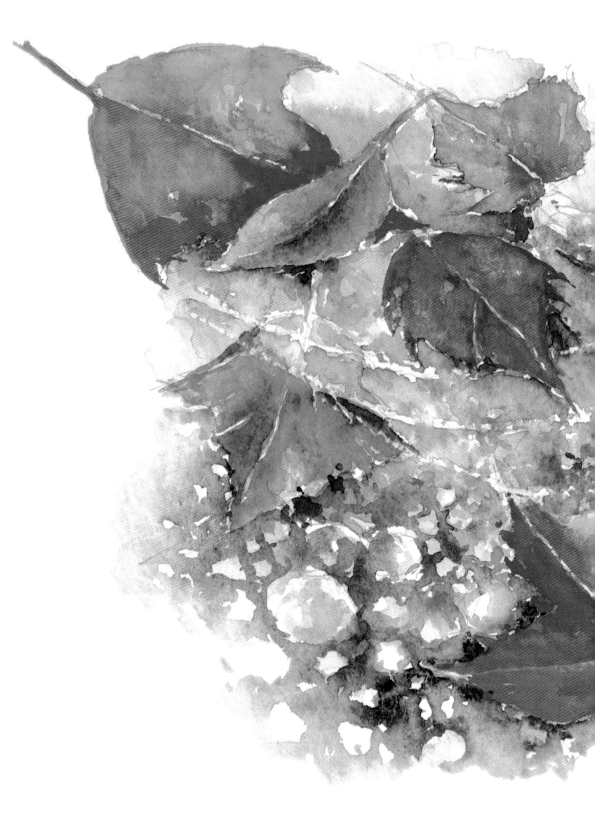

AT THE WATER'S EDGE

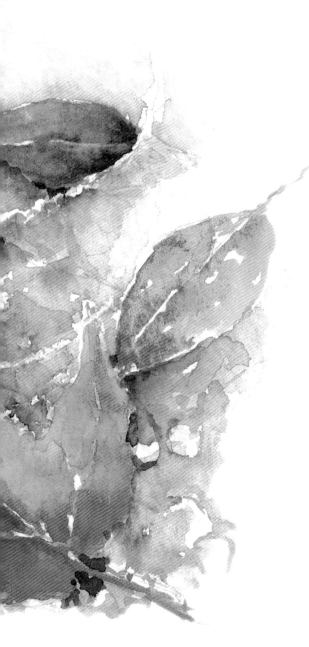

The translucent qualities of watercolour paints make them particularly well suited to recording the many subtle tones that can be seen when natural objects found along the water's edge (leaves, stones and driftwood, for example) become partially submerged. The tone of the water, the colours of the river or lake bed, and the shapes of objects embedded along the shore line can all make fascinating subjects for studies.

Rotting Boat

Not all objects found on the water's edge are there as a result of natural erosion. This old boat had been abandoned and left to rot, and in the process had become a very visually appealing subject.

The tonal balance for recording objects like this is very important to create a sense of harmony and balance. The cool cobalt blue used in the sky, for example, was also used as a base colour to mix the faded and sun-bleached pale wood tones for the boat. I used the same blue and the wood colours (burnt umber and yellow ochre) to paint the water directly beneath the boat without adding anything else.

To paint the beach and the stones, I simply used a lighter version of the wooden boat colours, again to create a sense of

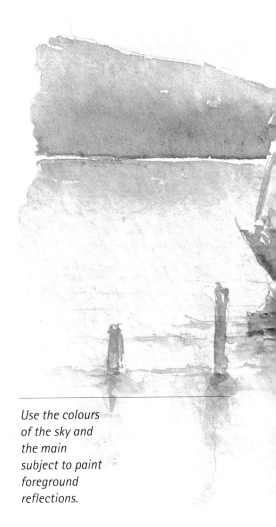

Use the colours of the sky and the main subject to paint foreground reflections.

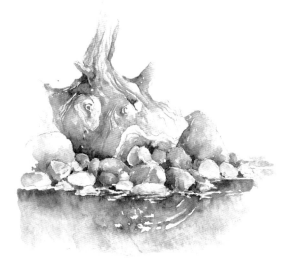

Wood
Old wood found at the water's edge often takes on a 'fossilized' appearance, making it similar in shape and tone to the rocks and boulders around it. The internal shapes may contain interesting patterns.

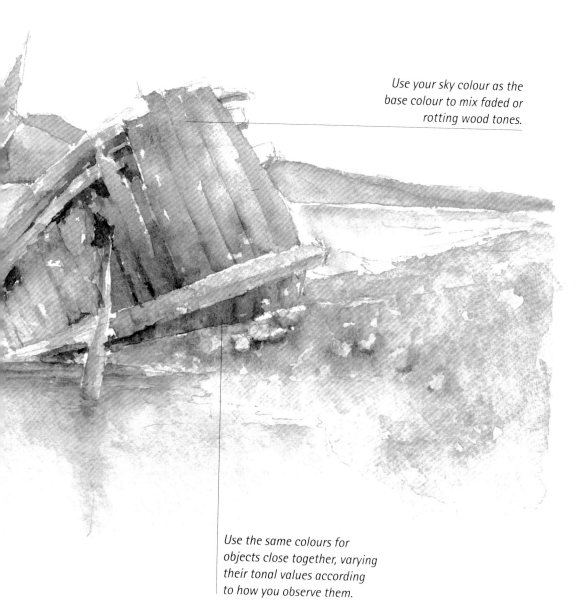

Use your sky colour as the base colour to mix faded or rotting wood tones.

Use the same colours for objects close together, varying their tonal values according to how you observe them.

Water's Edge Nest

Wildlife is particularly challenging to record in paint for several reasons – chiefly, birds' natural ability to use camouflage. Most nests can barely be seen through a web of reeds and natural protection, which means that a very limited colour palette is required, but a great deal of drawing with your paintbrush.

To record nests, create the basic tone with a wash of burnt umber and cobalt blue, working carefully around the leaves and reeds so that they appear as negative shapes in the first instance. Once this underwash has dried, darken the centre of the nest and apply a few short, sharp brushstrokes to the complex web of twigs and sticks to suggest detail.

The assorted reeds and leaves used to protect the well-hidden nest opposite were painted a much lighter tone than the nest, using sharp, directional brushstrokes along their length. The water underneath the nest was probably the least important part of this particular study and was, therefore, painted using mainly reflected tones and with very little detail.

Circular Patterns

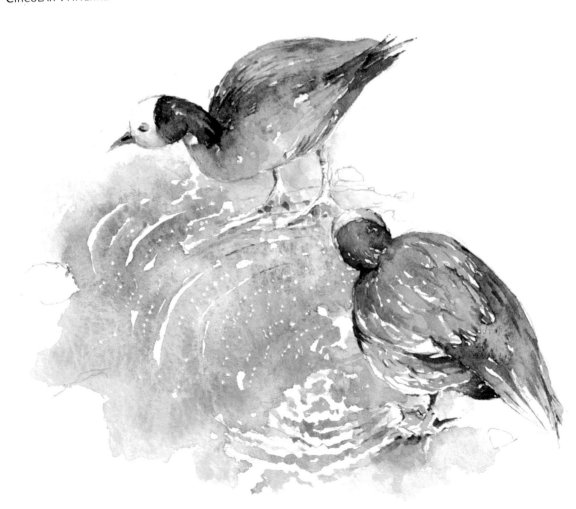

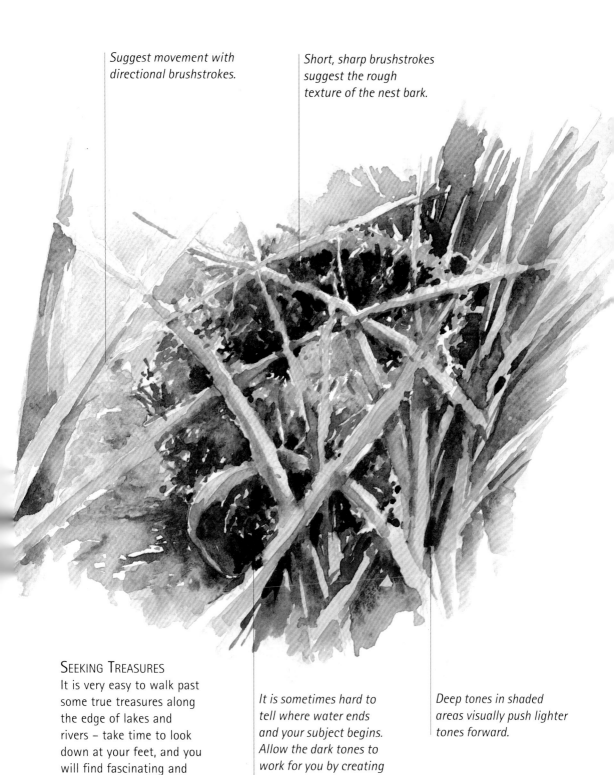

Suggest movement with directional brushstrokes.

Short, sharp brushstrokes suggest the rough texture of the nest bark.

SEEKING TREASURES

It is very easy to walk past some true treasures along the edge of lakes and rivers – take time to look down at your feet, and you will find fascinating and challenging subjects.

It is sometimes hard to tell where water ends and your subject begins. Allow the dark tones to work for you by creating undefined edges.

Deep tones in shaded areas visually push lighter tones forward.

Shallow Water

It is not usual to witness much vigorous movement in very shallow water, especially in small pools and at the very edges of lakes and rivers, but you can usually spot a few gentle ripples which visually distort the calm, mill-pond images.

Objects viewed through shallow water are subjected to two very different types of visual distortion: physical and tonal. First, the shape of an object appears to change when part is seen on top of the water and part of that object is submerged. Second, the tonal qualities seem to change, with the section underneath the water appearing to be a little lighter. Combine these two qualities to record successfully any objects in very shallow water.

It is also important to record the concentric movement of the water and ensure that the spaces between the ripples expand as they move outwards, and that they maintain a regular shape that is in keeping with their natural circular movement.

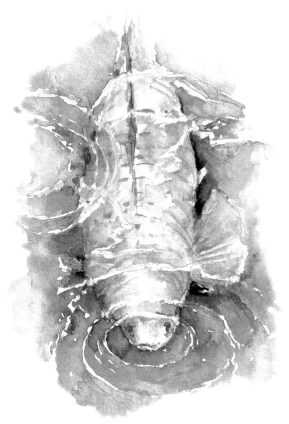

Fish in Water
Ensure that the area immediately beside the fish is painted a dark tone – this allows any colouring in the fish to be enhanced when viewed against a strong background, and emphasizes the lightness of the ripples.

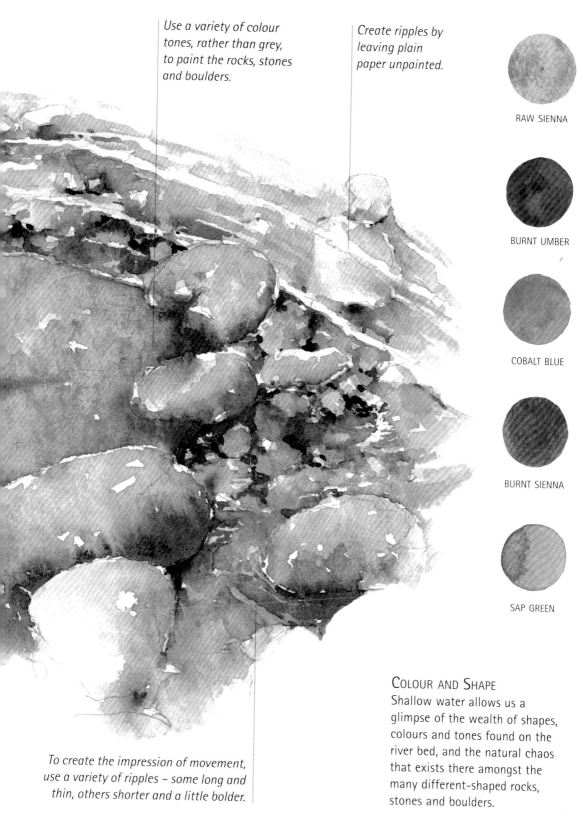

Use a variety of colour tones, rather than grey, to paint the rocks, stones and boulders.

Create ripples by leaving plain paper unpainted.

RAW SIENNA

BURNT UMBER

COBALT BLUE

BURNT SIENNA

SAP GREEN

To create the impression of movement, use a variety of ripples – some long and thin, others shorter and a little bolder.

COLOUR AND SHAPE

Shallow water allows us a glimpse of the wealth of shapes, colours and tones found on the river bed, and the natural chaos that exists there amongst the many different-shaped rocks, stones and boulders.

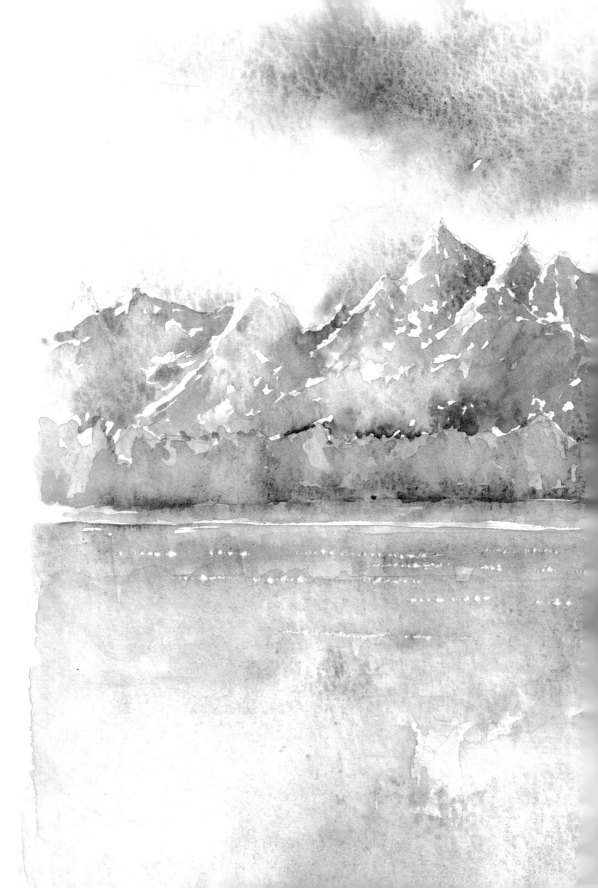

PRACTISE YOUR SKILLS

Different types of water require different treatments to record them – the brushstrokes, colours and methods of application vary according to the weather and season. The projects that feature in this section are designed to take you step-by-step through the processes that I use to create a finished painting, and examine the effects of the weather on the way.

Fishing

There is rarely a shortage of fishermen along any length of river, provided that the weather is warm and the mood of the day is a lazy one.

Before starting a full-scale composition, I always make a small study or two to get the feel for a particular subject – in this case, painting the positioning of the arms and the general proportions helped me to prepare for the full-scale composition.

Next I had to make some positive decisions about the colours I would use. As the day was soft and warm, I chose to make full use of the warm colours, especially raw sienna and sap green. Both colours combine particularly well to create the lush green foliage along the river bank, and also work very well when used for reflections in gently moving water.

As both paintings were made under the same conditions, it is no surprise to find that the same colours were used in both the study and the composition – the warm greens, browns and blues that combine to create the gently flowing water on a slow-moving summer's day are as much a part of a figure study as of a larger painting. In fact, I could probably have made both the study and the painting with four paints only – raw sienna, sap green, burnt umber and ultramarine – but the tiny flashes of colour that lift the scene and add sparkle to the day required the addition of powerful cadmium yellow.

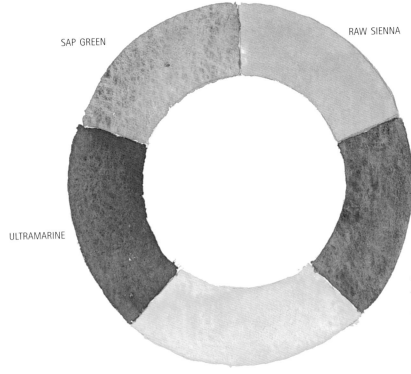

SAP GREEN

RAW SIENNA

ULTRAMARINE

BURNT UMBER

CADMIUM YELLOW

Colour Palette
The colours chosen for this project are those that most successfully evoke the warmth of a lazy summer day.

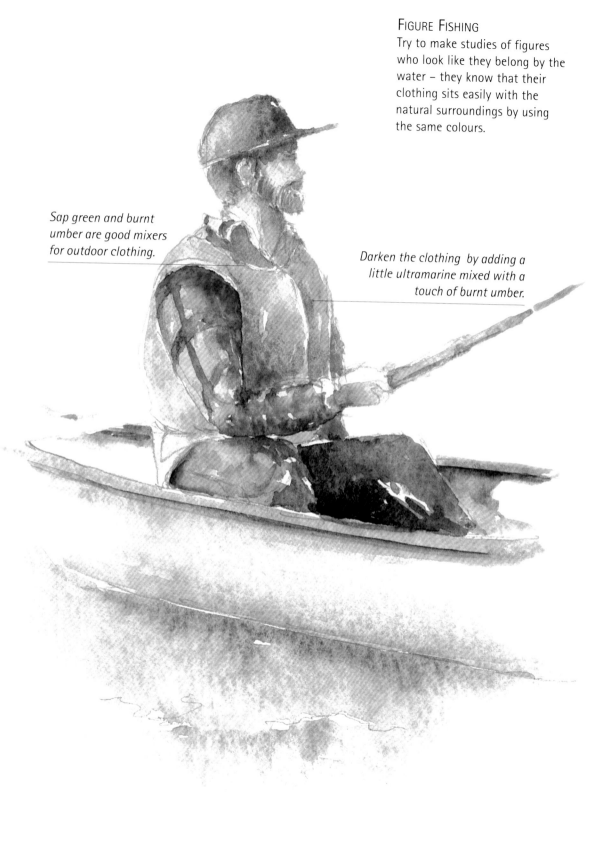

Try to make studies of figures who look like they belong by the water – they know that their clothing sits easily with the natural surroundings by using the same colours.

Sap green and burnt umber are good mixers for outdoor clothing.

Darken the clothing by adding a little ultramarine mixed with a touch of burnt umber.

FISHING FROM A JETTY

The limited amount of movement on the water surrounding this rickety old wooden jetty indicated that I needed to use a wide variety of reflections when painting the water – and that this certainly included an array of greens.

I could also see from the surrounding foliage that I would need to use a lot of water to create the blends and bleeds on the paper, rather than on the palette. I employed this technique when painting the trees and their reflections in the water.

MATERIALS

• 500 gsm watercolour paper

• Brushes – 1 large (size 12), 1 medium (size 8), 1 small (size 2), 1 chisel-headed

• Watercolour pan paints – sap green, burnt umber, cadmium yellow, ultramarine, raw sienna, burnt sienna

• Water container

1 *After making a preliminary line drawing, the first stage was to dampen the sky area and apply a smooth wash of the warm ultramarine with a medium brush. I then allowed the paint to dry to a smooth finish.*

2 *Next, I applied the base coat, or underwash, to the background tree shapes – this was a mixture of raw sienna and just a hint of ultramarine, which came from my water container as I dipped the brush into it.*

3 Before the underwash could dry, I applied a wash of sap green to the darker-shaded areas of the background trees and allowed it to blend with the raw sienna, diluting it in the process. *Inset:* I then applied a touch of cadmium yellow to the tree tops.

4 Next I washed in the foreground foliage, and used a small brush to apply a more controlled mixture of sap green with a touch of burnt umber and a hint of ultramarine to add some depth to the tone – on barely damp paper, this ensured a bleed, but a minimal one.

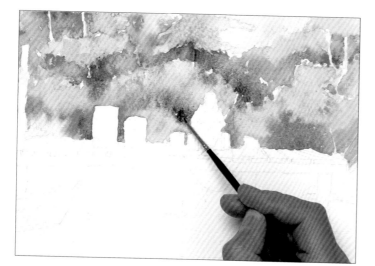

5 I used this deep green colour mix to paint the area directly underneath the jetty, including the water. Using a medium brush, I pulled the colour downwards onto pre-dampened paper.

6 To develop the water tones I added a mix of burnt umber and ultramarine for the shadow underneath the jetty, and allowed this to bleed. INSET: When it dried I used the same colour to paint in some ripples using a chisel-headed brush.

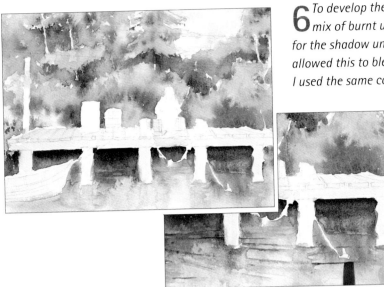

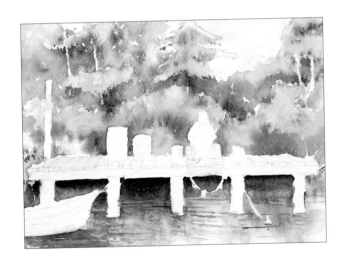

7 I continued this process around the boat and across the water in the foreground, leaving some light flashes of underwash showing to emphasize the light reflection coming from the jetty.

8 When all the water had dried fully, I used the pointed section of a sharp blade and carefully scratched a few lines into the paper, removing the surface and exposing pure white to suggest highlights and a little sparkle.

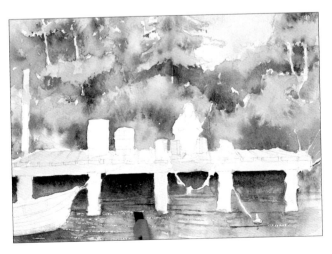

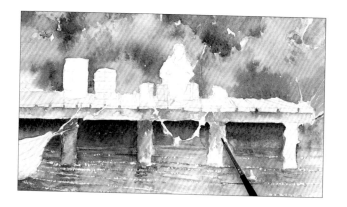

9 Returning to the jetty, I used a mixture of raw sienna, burnt sienna and a touch of burnt umber to create some texture using rough, broken brushstrokes with a small brush onto dry paper.

10 Once the main colours had dried, I introduced a little ultramarine to the mixture and carefully painted a broken line directly underneath any overlaps and left it to dry, creating a feeling of recession and depth.

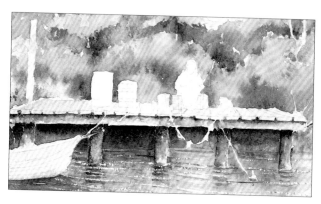

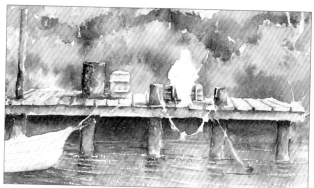

11 The clutter on the top of the jetty was next. I drew a few lines with a small brush to create the wooden planks, using the same mixture and technique as Stage 10, and painted the rusting can by applying pure burnt sienna onto wet paper.

12 The final details of the figure and the boat were all painted using a small brush and careful observation of shape and colour, especially on the inside of the boat, where the lighting was important to create a three-dimensional effect.

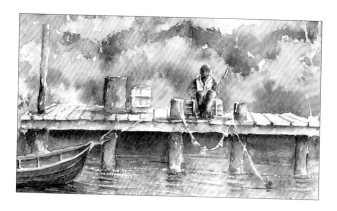

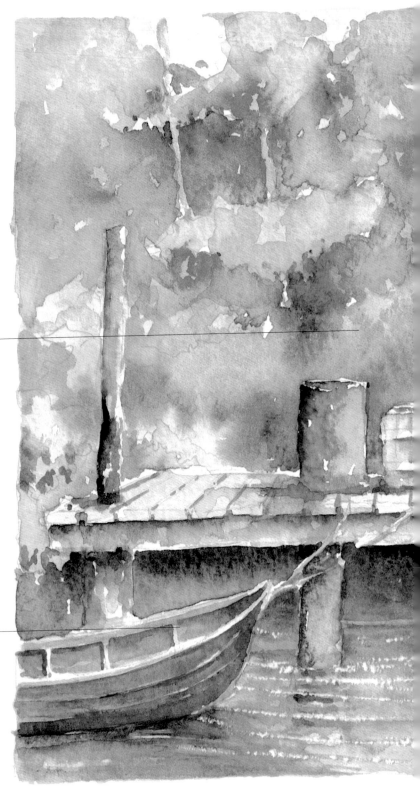

GENTLY MOVING WATER
The feeling of gentle, lazy water movement can be created by combining the techniques of pulling down paint to achieve recognizable reflections, painting a few ripples on top, and finally scratching away a few highlights to reveal the white paper underneath.

To create a more natural look, allow tones of trees and bushes to mix on the paper.

Draw details onto dry paper in the very last stages of the painting.

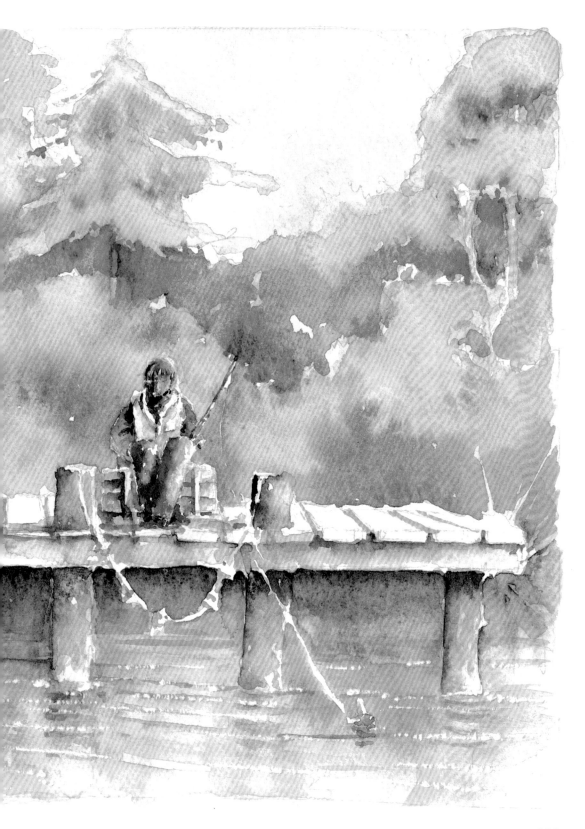

MOUNTAIN REFLECTIONS

The higher you climb in a mountainous environment, the sharper and clearer the light becomes, and the more you become aware of atmospheric conditions.

The one thing that was clear from the beginning with both the study and the finished painting was that I needed to use a particularly strong blue and an equally able red /mauve to tint the blue and remove any coldness from time to time. My choice was Winsor blue for both pictures. This is a very strong colour that has a tendency to stain paper very soon after being applied, making it quite difficult to blot out cloud shapes – either in the sky or the water – unless you work very quickly and blot the required shapes within seconds of applying the paint. Alizarin crimson was the next choice, to create the soft violet tones that can be seen in distant mountains. This paint is similar to Winsor blue in that a little goes a very long way, so only the slightest touch was required to take the edge off the coldness of the blue.

I also used raw umber and yellow ochre – both natural earth colours, but both on the cooler end of the colour spectrum. Although the sun was bright, casting shadows onto rocks and snow, creating very attractive scenes for both study and painting, there was little warmth to be found in the high mountains, and for most of the time the colours were used to impart a feeling of sharpness and chill.

WINSOR BLUE

ALIZARIN CRIMSON

RAW UMBER

SAP GREEN

YELLOW OCHRE

COLOUR PALETTE
The colours chosen for this project were an unusual mixture of fresh, sharp colours and slightly flatter natural earth paints.

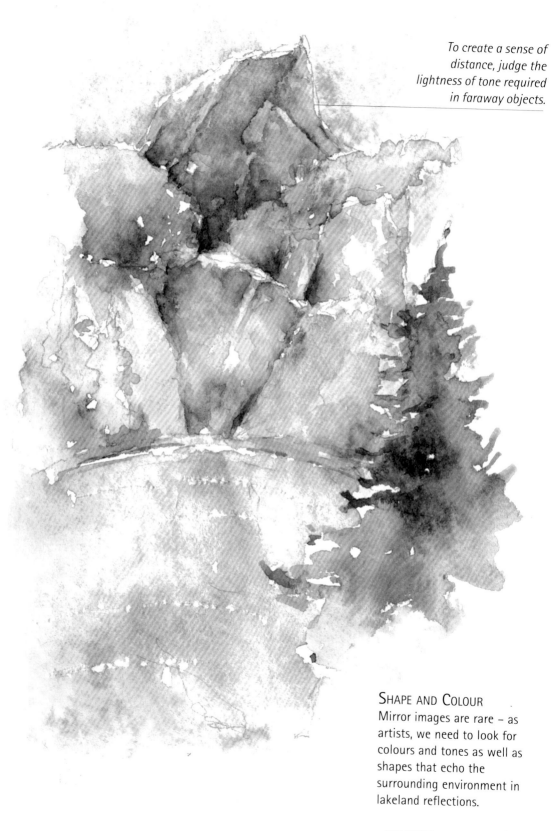

To create a sense of
distance, judge the
lightness of tone required
in faraway objects.

SHAPE AND COLOUR

Mirror images are rare – as
artists, we need to look for
colours and tones as well as
shapes that echo the
surrounding environment in
lakeland reflections.

Winter Lakeside

The cool, sharp atmosphere of a mountain lake is a true pleasure to witness. Painting this scene involves making a few choices about the colours you need to use, and these come largely from the cooler end of the colour spectrum – although not exclusively. You usually find a balance in nature where colours and tones harmonize: the warmer tones on the rocks and trees in the middle ground, for example, sit easily with the cooler grey colours of the snow fields of the distant mountains.

Materials

- 500 gsm watercolour paper
- Brushes – 1 large (size 12), 1 medium (size 8), 1 small (size 2), 1 chisel-headed
- Watercolour pan paints – Winsor blue, alizarin crimson, sap green, yellow ochre, raw umber
- Kitchen paper
- Water container

1 To begin, I dampened the sky area and, using a large brush, applied a wash of Winsor blue and allowed this to flow evenly across the paper. I actively encouraged the paint to accumulate at the top of the paper, leaving a lighter section along the ridges of the mountains.

2 I blocked in the grey tones of the mountains using a mixture of raw umber and Winsor blue on dry paper with a chisel-headed brush. INSET: I then used a small brush to intensify the stone-grey paint by adding a touch of alizarin crimson.

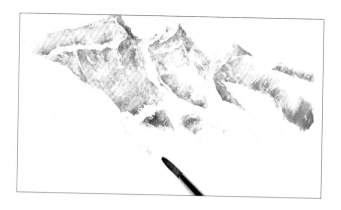

3 The shadows cast onto the snow used a very diluted mixture of alizarin crimson and a touch of Winsor blue, and I washed them out at the edges to prevent hard lines occurring here.

4 The middle-ground rocks and pine trees were all treated to a yellow ochre underwash to visually anchor them into the same part of the composition. This was allowed to dry completely.

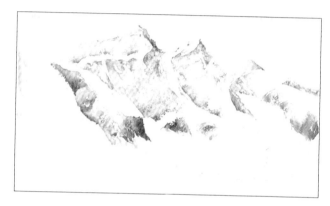

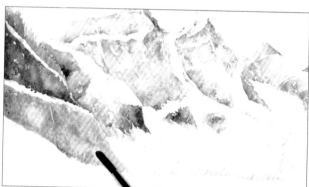

5 I painted the middle-ground rocks using a combination of raw umber and Winsor blue, applied with a medium brush. I pulled the colour across the dry paper using broken brushstrokes, allowing the underwash to show through.

6 Before this mixture had time to dry fully, I pulled a little of the rock colour down onto the snow directly below to act as a shadow, tonally harmonizing the different aspects of the scene.

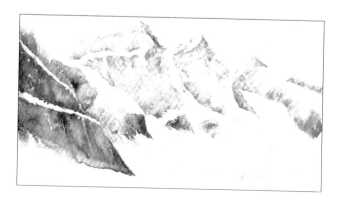

7 *I mixed a little sap green with raw umber and a touch of Winsor blue to create a cold, distant blue/green, and painted it onto the middle-ground trees using a small brush. INSET: I then blotted the top areas with kitchen roll to expose the yellow ochre underwash.*

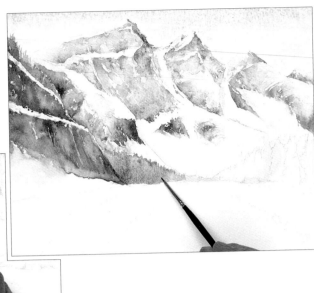

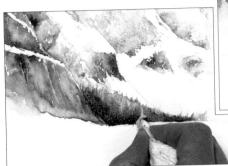

8 *This process was continued across the middle ground until the entire section was complete. I could now see very clearly which colours I would need to pull down onto the water for the reflections.*

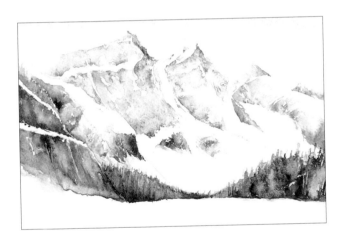

9 *Using a large brush I dampened the lake area and, using the colours left in my palette, applied the colours (working around the snow field reflections) using vertical brushstrokes.*

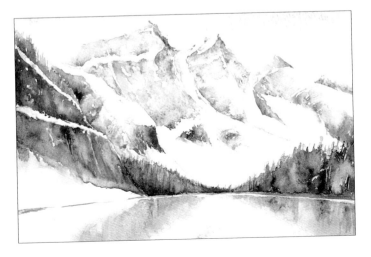

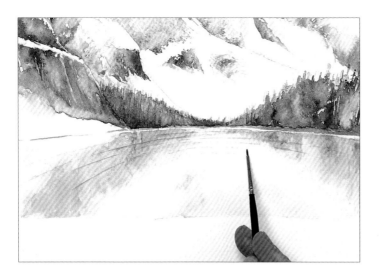

10 *When this had dried, I took a small brush, mixed all the paints together in the palette, and painted on a few thin lines of ripples, moving outwards around the edge of the lake.*

11 *Once the reflections and ripples had fully dried, I scratched out a few areas of sparkle to enhance the effect of light.*

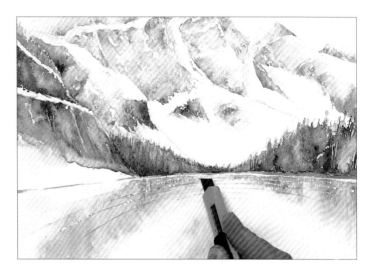

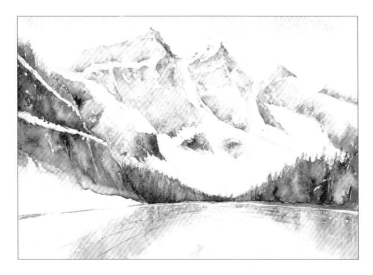

12 *The final stage was to sharpen up any edges or shadows that needed reinforcing and to make a final check that all the elements in the composition were visually balanced.*

The soft grey of the distant mountains contains a hint of violet.

The shadows on the snow are diluted versions of the surrounding colours.

BALANCE

Aim for a balance of all elements in your paintings: the warm and cold colours, and the stillness of the background and the movement in the foreground. Both sit together particularly well in this painting.

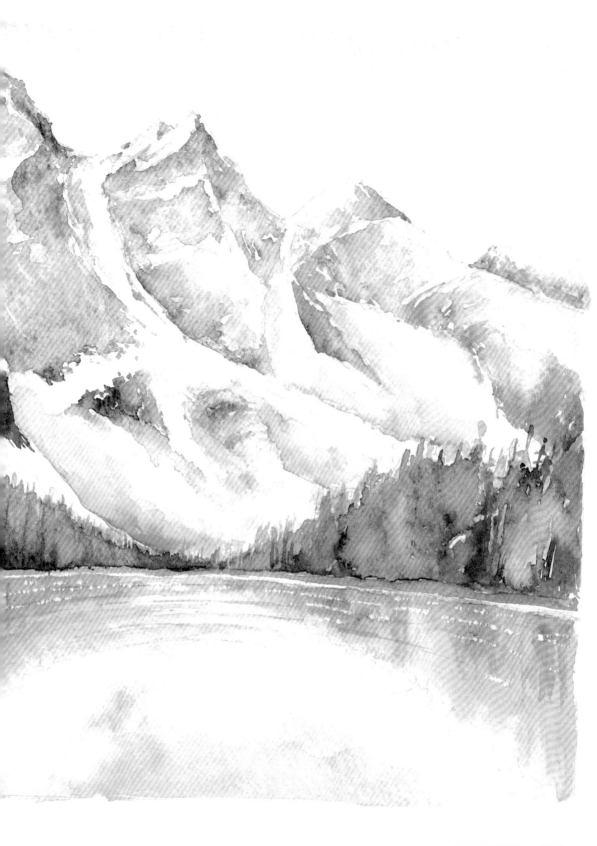

WILDLIFE

At certain times of the year, wild geese instinctively know that it is time they should start moving to warmer climates. This allows us the opportunity to sketch and paint them as they sit and feed, or on their graceful flight paths. While these birds gather in their flocks around the shores of lakes, we are offered a rare chance to capture them in pencil or paint as they make preparations for their annual migration. Some of the best times to witness these gatherings and flights are in the early evening as the autumnal sun begins to set, casting a gentle golden cover across the sky. To record this, apply a strong mix of raw sienna, which imparts a feeling of warmth to any scene.

As geese fly across the sky, they appear as graceful white shapes, extended as their elegant necks lean forward. To paint these birds on the ground involves closer observation of their natural colours. The grey of a goose's neck can be recorded with Payne's grey, toned down with a hint of burnt or raw umber (depending on the species), and the pure, soft white of its feathers needs only the slightest touch of yellow ochre to take the sharpness from the white of the watercolour paper.

As with all wildlife painting, suggestion is the key to success – you won't be able to paint all the feathers, so just use a few brushstrokes or water-soluble pencil marks to indicate that they are there.

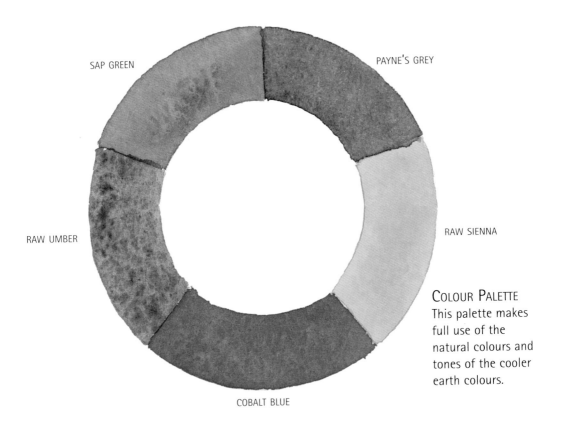

SAP GREEN

PAYNE'S GREY

RAW UMBER

RAW SIENNA

COBALT BLUE

COLOUR PALETTE

This palette makes full use of the natural colours and tones of the cooler earth colours.

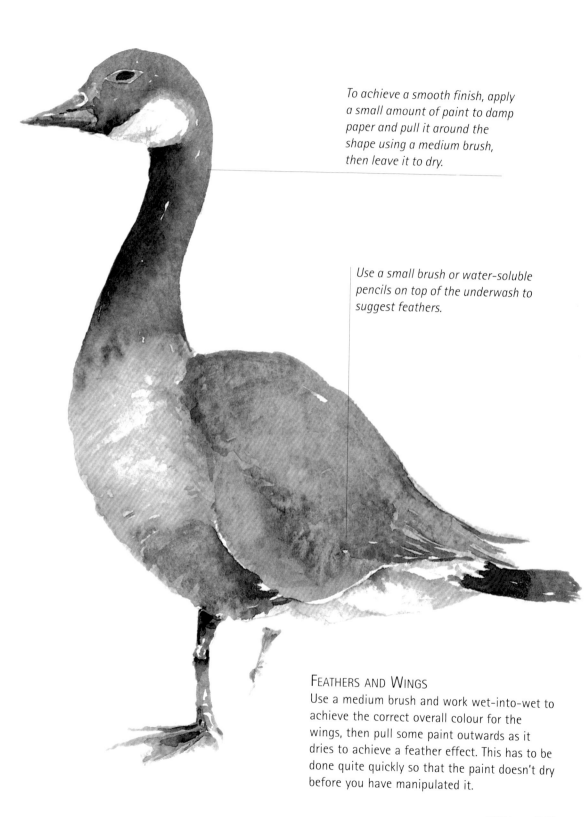

To achieve a smooth finish, apply a small amount of paint to damp paper and pull it around the shape using a medium brush, then leave it to dry.

Use a small brush or water-soluble pencils on top of the underwash to suggest feathers.

FEATHERS AND WINGS
Use a medium brush and work wet-into-wet to achieve the correct overall colour for the wings, then pull some paint outwards as it dries to achieve a feather effect. This has to be done quite quickly so that the paint doesn't dry before you have manipulated it.

FLYING GEESE

As the sun starts to set in the autumnal sky and the shadows start to lengthen, the side of a lake is a good place to paint – and if a small flock of geese should fly past at the same time, then all the better.

In this composition, the geese appear almost as negative shapes, but this is because they are viewed against a dark backdrop that emphasizes their whiteness. This is called the push-pull technique: one colour appears to push the other forward or pull the other back.

MATERIALS

- 500 gsm watercolour paper
- Brushes – 1 large (size 12), 1 medium (size 8), 1 small (size 2)
- Watercolour pan paints – sap green, Payne's grey, raw sienna, cobalt blue, raw umber
- Water container

1 *The first step of this painting was to dampen the sky and then, using a large brush, apply a wash of cobalt blue to the top section. When this was nearly dry, I added a wash of raw sienna to the lower sky area just above the trees.*

2 *Using a medium brush I mixed sap green, raw umber and a touch of Payne's grey and began to paint the far-distant trees with a few brushstrokes where the sky colour could show through them. INSET: I continued until all these trees had been painted.*

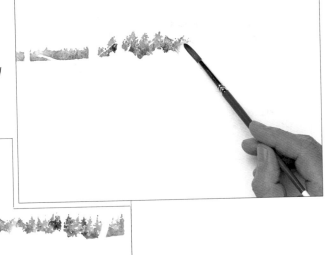

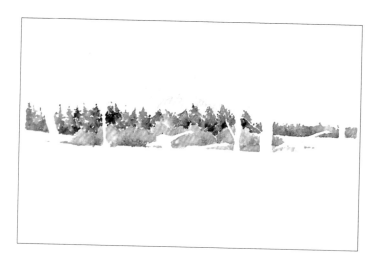

3 Using a little cobalt blue instead of Payne's grey in the mixture, I painted the middle-ground bushes on the island so that they appeared a lighter tone than (and so would stand out against) the background colours.

4 To paint the lake, I used exactly the same colours and techniques for painting the sky, except that this was an upside-down version painted using a medium brush.

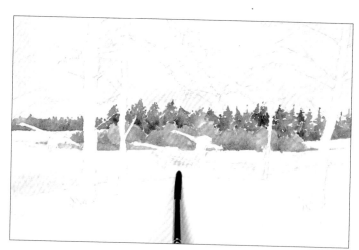

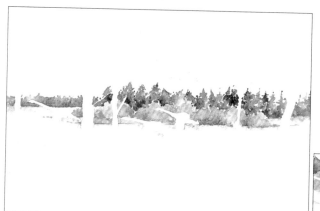

5 The final touches could now be put onto the middle ground. Using a small brush I sharpened the line of the beach and the water's edge. INSET: I then painted in the shadows and reflections from the far-distant row of trees.

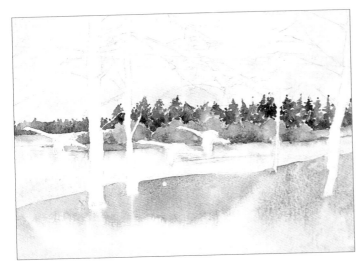

6 To begin painting the foreground, I mixed sap green with a little raw umber and washed this onto very damp paper using a large brush. This paint bled naturally and dried with shapes that suggested clumps of grass.

7 I strengthened the foreground underwash with a second wash, only less diluted and therefore tonally stronger. This included directional shadows from the trees.

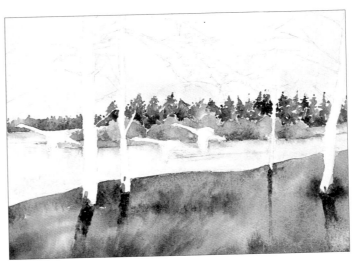

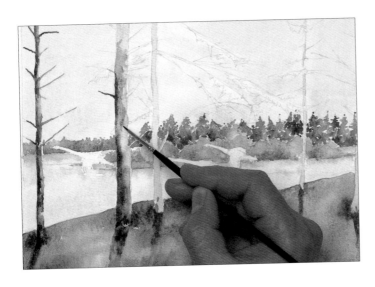

8 Next, I treated the trees to an underwash of raw sienna, before painting a mixture of raw sienna and cobalt blue onto their shaded side.

9 *I pulled this paint around the shape of the tree, leaving flashes of underwash showing through as highlights. The few feathery sections of greenery were then painted using the grass paint.*

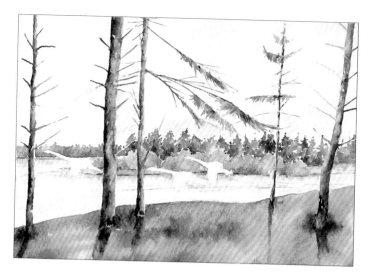

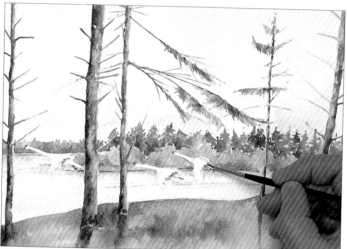

10 *The geese required some detail to be added on their heads, undersides and legs. I painted these with a small brush using a combination of cobalt blue and Payne's grey.*

11 *As usual, the final stage of this painting involved tidying up any loose edges, and sharpening reflections, shadows and the tiny details that can make a painting feel complete.*

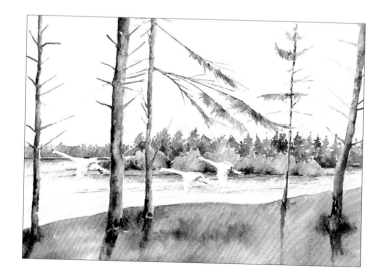

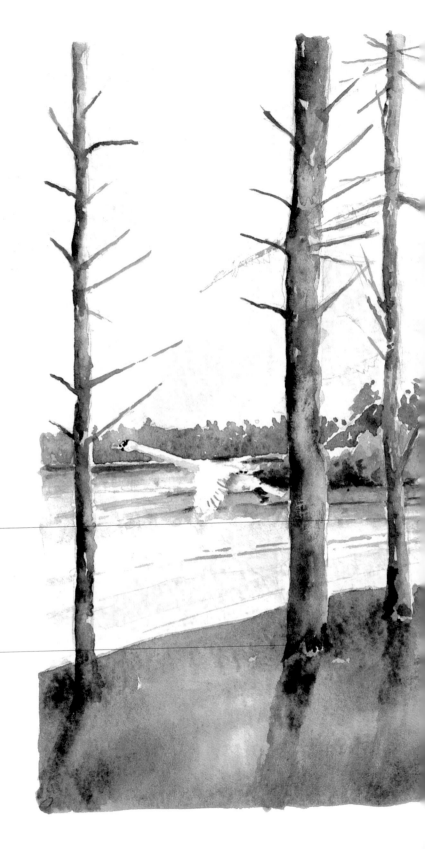

MOVEMENT

The sense of movement created by these graceful geese owes much to the fact that they are being visually pushed forward by the background colours. In addition, they cast no shadow and have no reflections – tricks that artists usually employ in order to anchor objects onto the ground.

Virtually every colour used in the landscape and sky is used in the reflections in the water.

Strong tones and colours in tree shadows help to suggest the time of day.

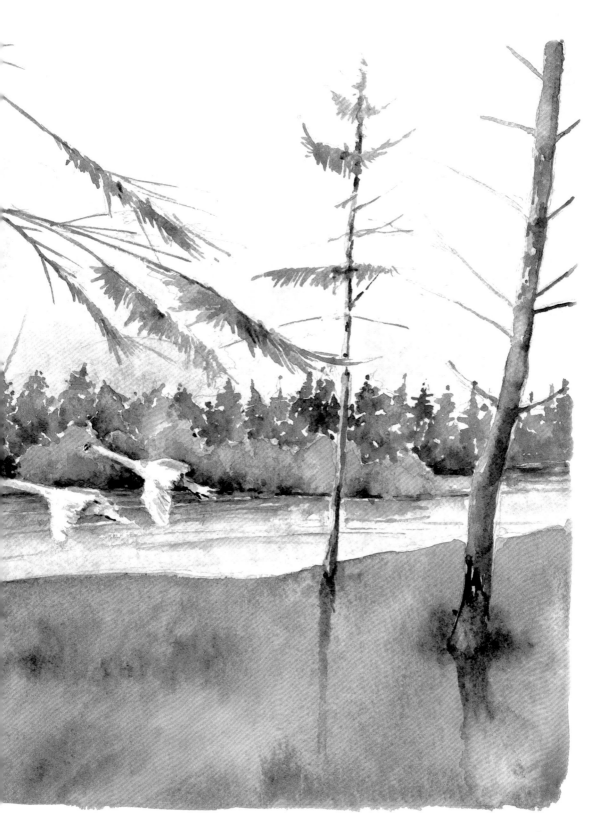

WATERFALL

Waterfalls come in a wide variety of shapes and sizes, ranging from the smallest trickle across a collection of boulders to vast falls that plummet across treacherous and inhospitable rock faces.

The main decision to make here is whether or not to use masking fluid: although it allows you to reproduce a very effective spray, it can, if over-used, give a slightly unnatural effect to a picture.

As mentioned before, I find it very useful to make a brief study of my subject. In this case, the waterfall was not powerful enough to warrant the use of masking fluid, and I kept the white paper untouched by paint to create the effect of fast-falling water. The study maintains an element of spontaneity by my not overworking the water. Too much paint applied to rapids can flatten them and reduce the effect of movement – the more paper left unpainted here, the more successful.

The toning that did occur on the water was created by using a lightly diluted version of the rock colours, touched on gently in a vertical direction with a small brush.

The colours used in the rocks and boulders are a combination of natural earth colours with a touch of cobalt blue (one of the cooler blues) to prevent the scene from appearing too warm, helping to at least suggest the cool nature of the water falling from this mountain stream. This, combined with the sharpness of the white paper, completes the tonal balance between the warm rocks and the cold water.

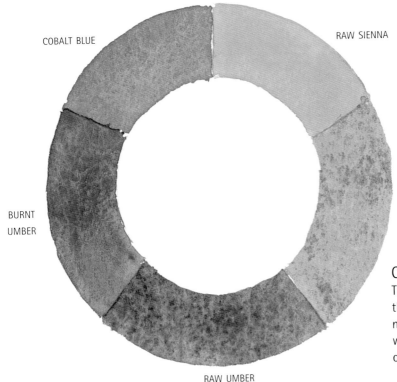

COBALT BLUE

RAW SIENNA

BURNT SIENNA

BURNT UMBER

RAW UMBER

COLOUR PALETTE
This palette balances the warm and cool natural earth colours, with the addition of only one cool blue.

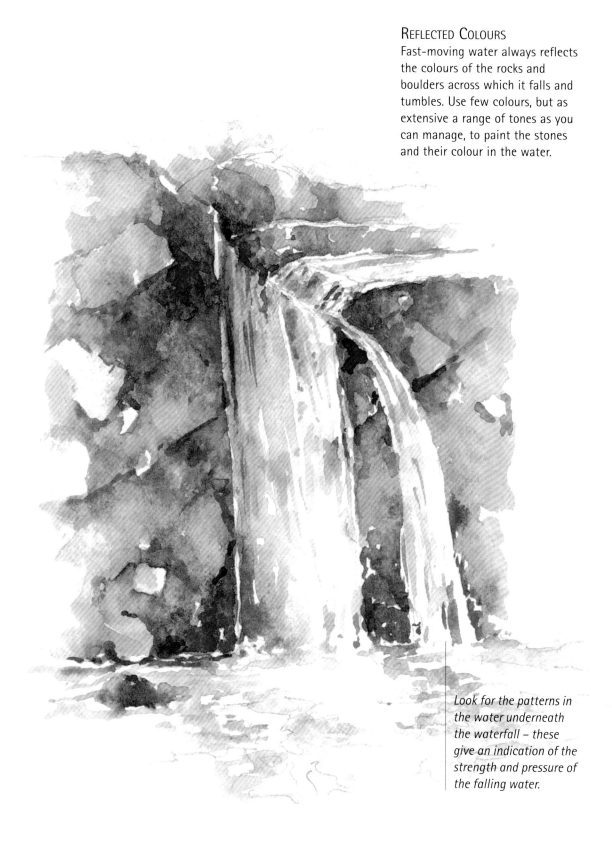

Fast-moving water always reflects the colours of the rocks and boulders across which it falls and tumbles. Use few colours, but as extensive a range of tones as you can manage, to paint the stones and their colour in the water.

Look for the patterns in the water underneath the waterfall – these give an indication of the strength and pressure of the falling water.

Tumbling Water

Even though this particular waterfall was quite small compared with many that you might encounter, the water was tumbling across the rocks and boulders with enough force to create a series of large splashes as little droplets of water flew outwards across the scene.

It soon became clear that – unlike the study I had made – this scene would need the use of masking fluid if I were to produce a painting that did it justice, and that it would have to be applied vigorously to create the best effect.

MATERIALS

- 500 gsm watercolour paper
- Brushes – 1 large (size 12), 1 medium (size 8), 1 small (size 2)
- Watercolour pan paints – cobalt blue, raw sienna, burnt sienna, burnt umber, raw umber
- Old toothbrush
- Masking fluid
- Water container

1 *The first stage of this painting was to dip an old toothbrush into a saucer of masking fluid and flick the fluid up across the paper following the direction of the water spray.*

2 *Once this had dried, I applied an underwash of raw sienna to wet paper with a large brush. INSET: While this was still damp, I flooded burnt umber and cobalt blue mixes onto the darkest rocks.*

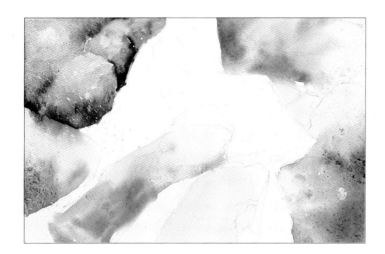

3 The grass area of the water's edge was painted onto the raw sienna underwash, and I created a little definition by drawing onto the rock shapes with a small brush and a very dark tone.

4 Using a small brush I added texture to the rocks by dropping pure earth colours onto wet paint, one after the other in rapid succession. This allowed the paint to create its own mixes, which dried at different speeds, creating a sense of texture.

5 This process was continued across the rocks, where I worked carefully around the white sections of water. INSET: I applied burnt sienna, raw sienna and raw umber wet, and allowed them to dry unevenly.

6 Moving on to the rocks in the middle, I added a little Cobalt blue to darken the tones, ensuring that the darkest sections were those low down at the waterline.

7 Working carefully, I added texture to all the rocks, and I then used a small brush to sharpen up any lines or ridges with the darkest of colour mixes.

8 For the water, I used a small brush and very diluted versions of the rock colours already in the palette to paint some of the areas of rock visible through the water.

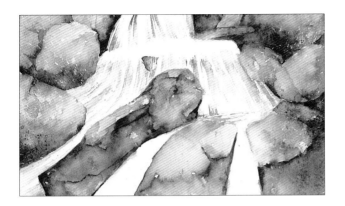

9 Working downwards, I carefully followed the direction of the flow of the water around and across the rocks. The less paper I applied paint to, the faster the water appeared to be flowing.

10 The water in the immediate centre foreground was the darkest as it flowed underneath an overhanging boulder – I made confident one-stroke applications with a small brush using the darkest of tones.

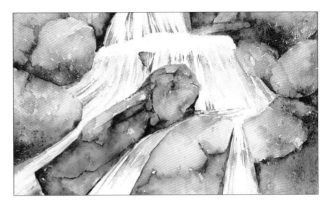

11 Once all the paint had thoroughly dried, I removed the initial spattering of masking fluid by gently rubbing over the surface of the picture with a putty rubber. It's worth restating that the paint must be completely dry, otherwise the rubber will smear it.

12 The final stage of this painting involved using a small brush to sharpen up the edges on a few boulders, carefully avoiding any of the pure white paper that I had revealed by removing the masking fluid.

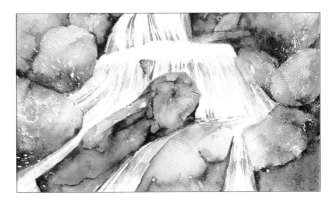

ENERGY

The feeling of power, energy and movement in this painting is largely the result of a vigorous application of masking fluid to create the spray, and strong, directional brushstrokes along the line of the water flow. The close-up framing of the picture also contributes to the sense of movement that is present within the scene.

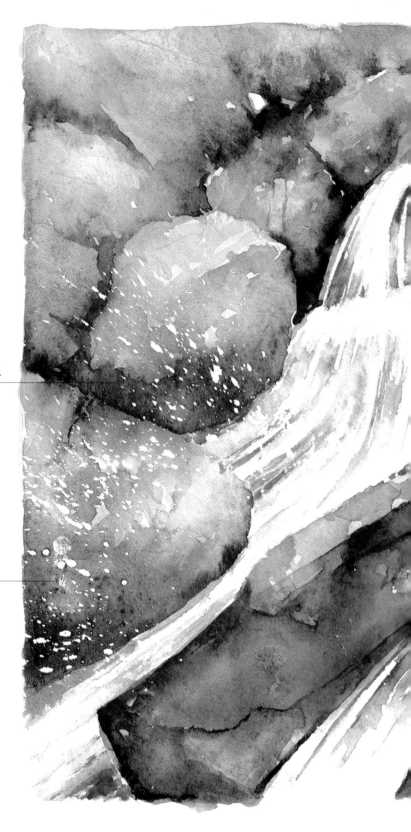

The darkest tones and rock detail are drawn onto the underwash with a small brush.

Directionally spraying masking fluid helps to establish a feeling of movement and energy.

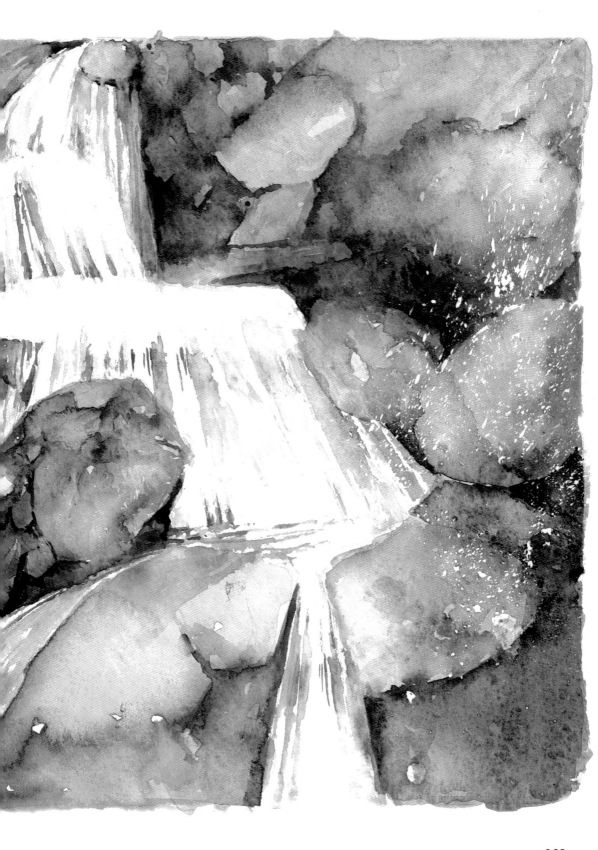

INDEX